THE ARTS OF JAPAN

translated and adapted by
Glenn T. Webb

photographs by Takahashi Bin

THE ARTS
OF
JAPAN

Late Medieval to Modern

SEIROKU NOMA

KODANSHA INTERNATIONAL LTD.
Tokyo, New York, and San Francisco

Distributed in the United States by Kodansha International/USA Ltd., through Harper &
Row, Publishers, Inc., 10 East 53rd Street, New York, New York 10022.
Published by Kodansha International Ltd., 12-21, Otowa 2-chome, Bunkyo-ku, Tokyo 112
and Kodansha International/USA Ltd., 10 East 53rd Street, New York, New York 10022 and
44 Montgomery Street, San Francisco, California 94104. Copyright © 1966 by Kodansha
International Ltd. All rights reserved. Printed in Japan.

Library of Congress Cataloging in Publication Data

Noma, Seiroku.
 The arts of Japan.
 Translation of Nihon bijutsu.
 Includes bibliographies and indexes.
 CONTENTS: v. 1. Ancient and medieval. —v. 2. Late
medieval to modern.
 1. Art—Japanese. 2. Art—Japan. I. Takahashi,
Bin. II. Title.
N7350.N63913 1978 709'. 52 78-18531
ISBN 0–87011–335–6 (v. 1)
ISBN 0–87011–336–4 (v. 2)

First deluxe edition, 1966 LCC 65–19186
First standard edition, 1978 ISBN 0–87011–336–4
Third printing, 1982 ISBN 4–7700–0654–3 (in Japan)

CONTENTS

TRANSLATOR'S PREFACE

Noma Seiroku passed away in Tokyo on December 18, 1966, after a long illness. Before his death he had completed a preliminary manuscript for this volume on the arts of Japan, and it has been my privilege, albeit a sad one, to develop the manuscript into its present form. Mr. Noma's illness had earlier prevented him from writing the second volume of the Japanese edition. For the English edition, however, it was hoped that for the sake of continuity Mr. Noma would be able to write a new text. It was with this in mind that he composed the manuscript. Incomplete though it was, it contained a wealth of information, original insights, and poetic imagery that only one who has been intimate with Japanese art over a long period of time could possess. More than that, it proved that at the time of his death Mr. Noma was almost alone among his contemporaries in allowing his imagination the freedom to see things in very broad terms and, further, in having the courage to express the vision he had of the totality of Japanese art and society.

In the past there have been Japanese scholars whose treatment of Japanese art is equally imaginative and fearless—I am reminded particularly of cultural historians such as Nishida Naojirō, who weaves a pattern in his 1937 *Nihon Bunkashi Josetsu* similar to the one found in Noma's works—but today most scholars in Japan (and certainly in the West, as well) are concerned with research on specific aspects of Far Eastern art history, which they rather expect will change the grand schemes set forth by earlier writers. (Nishida, for example, today has a somewhat tarnished reputation among Japanese scholars, not unlike the one Spengler has with Western historians.) Like writers of the earlier generation, Mr. Noma chose always to deal with broad themes. His view of Japanese art is in many ways unique, and emerges as one of the latest and most comprehensive ever to appear in print. Since a candid examination of East-West relationships figures significantly in this view (sometimes in a manner that seems bound to elicit controversy) there is much that the English reader may find stimulating and new.

In preparing the manuscript for this volume, I have been obliged to expand it on all counts, which has frequently meant nurturing a germ of an idea into the mature argument it might logically have developed into. By so doing, the obvious possibility that I have distorted Noma's meaning is unfortunately ever present. Any errors in factual

information are also entirely mine. This book is organized somewhat differently than the first volume, with chapters arranged by topic rather than chronologically or geographically. A glossary has been omitted, since relatively few unfamiliar terms would need to be added to the glossary of Volume I for an understanding of material presented here. Such terms have instead been explained in the text, and in the back of the book there are lengthy explanatory notes designed to supply students with at least a minimum of documentary information. For their assistance in completing the book, I am deeply indebted to Imai Toshizo and Suzuki Takako of Kodansha International, and to Eleanor Duff Howard (who did a splendid job of editing my text), Professor Millard Rogers, and Nishi Toshio of the University of Washington.

GLENN T. WEBB

Seattle, 1967

INTRODUCTION

The art of Japan's Early Modern age, that is to say, primarily of the seventeenth and eighteenth centuries, is particularly appealing to the modern eye. Moreover, we can be sure that it has always seemed exciting, and that its appeal was never greater than when it first appeared. Japanese art, at least up until medieval times, was more often than not the redoubtable handmaid of religion; to know one was to know the other. But by the beginning of the sixteenth century art was no longer performing a formal religious function and its visual appeal was direct and uncomplicated, often used as a vehicle for the celebration of purely secular matters of human concern. Japanese religious icons are necessarily complicated and full of mystery. To the priesthood and the nobility of past ages they represented higher powers, symbols of superhuman solutions to eternal questions. There were few, however, that an ignorant laborer could look at and gain reassurance that life was good, that he did not have to tremble and fear. He was in fact supposed to be awed by them, to feel their presence and know that they, by their very beauty, were superior, unearthly, divine. His human condition was ridiculed, made to seem unworthy, condemned. Here, perhaps, is the reason for the popularity of later Japanese art: fearful, mysterious elements disappear and a feeling of familiarity is created in art, as in life, whenever the human spirit is not suspect. The difference between Early Modern age art and the art of previous centuries amounts to a difference between an art that embraced the real world and one that rejected it.

When religion has flourished in Japan, it has usually done so at the expense of the common people. Not only were their physical labors exploited to further the prosperity of the Church, but spiritually, mentally, religion caused them anguish. Even so, when human discontents were many, religion was the only thing held out to ease the suffering. In the more hopeful periods of Buddhism's history in Japan, the lives of the people were made less wretched by prerequisites to salvation that were not too difficult to accomplish, and dreamlike visions of the next (heavenly) world where things would be better offered a means of counterbalancing all-too-real descriptions of Buddhist hells. Finally, however, the Japanese people stopped taking religion seriously. They placed their faith in the present, were awakened to the reality of the human condition, and religion lost its power. Japan today is undoubtedly one of the most unecclesiastical nations in the world.

The secularization of Japanese society occurred in stages. The first stage began sometime in the eleventh century as Buddhism lost the ability to make spiritual inquiry meaningful. Its priests were comfortable in a life of ritual, attracted to aristocratic pleasures, and commanded armies of steadily increasing military power that had to be broken finally by force. The practicality of power was realized in the second stage as twelfth-century military strategy put an end to patrician disputes. In the third stage, people's eyes were focused on the world as never before when Zen priests of the thirteenth and fourteenth centuries went about telling of truths that are to be sought in appearances. The fourth stage was characterized by the interminable wars of the fifteenth century that caused a victimized populace to seek personal, independent power. Finally, a strong faith in man's ability to control his own destiny emerged in the sixteenth century when, in the course of bringing some semblance of political order to the country, Oda Nobunaga rendered impotent a last vestige of religion's relevance by destroying the military power of the Buddhist Church. To the extent that man's part in all life's roles, even those of heroes and saints, was admitted, old fears disappeared and life grew brighter.

As the divorce between art and religion became final, traditional art forms were discarded and new ones sprang up, inspired by the needs of a vigorous secularism. Creativity was at fever pitch, and artists were free to experiment. Much of what passes today as uniquely Japanese in art was born at this time, a time when the lower classes, unimpressed by anything that was not personally meaningful, were on the rise. Formerly art had been the possession of the titled or cloistered, and meant nothing to those who in the Early Modern age moved swiftly into positions of power. For it to retain its significant role, Japanese art had to pass from one social position to another, resulting in a series of artistic transformations of originality and great beauty.

The developments in Japanese art of the Early Modern age are interesting not merely as stages in one country's artistic evolution, but as a fresh and vigorous manifestation of a modern attitude toward art (genre painting is but one facet) that had parallels at approximately the same time in artistic developments all over the world. It will be remembered (see Volume I) that through medieval times Japanese art had developed in the three capitals of Nara, Kyoto, and Kamakura. In Early Modern times the main art centers were Kyoto and Edo (Tokyo), but the organization of the country into districts, each having a center of its own, made for an art of unusual variety. This was also the period when Japanese had their first contacts with Westerners, and it is important to observe just how foreign things were received, assimilated, modified— or rejected. It must be said, finally, that the art of the Western world has for some years exhibited many "Japanese" characteristics that were formulated for the first time during the Early Modern age. Impressionism, Art Nouveau, contemporary ceramics, landscaping and architecture, interior design, the emphasis on simple forms in sculpture and on flat patterns in painting—all these owe a debt to the artistic developments in Japan that this book undertakes to reconstruct.

1

CASTLE ARCHITECTURE: IMAGE OF AUTHORITY

Nobunaga and Azuchi Castle

In 1576 people were startled to see a strange kind of tall building taking shape on a hill near the edge of Lake Biwa, east of Kyoto. It was Azuchi-jō, the castle of Oda Nobunaga, the military hero whose will was to become the new law of the land. Nobunaga's foresight was extraordinary. He was quick to appreciate the power of the gun, which had but recently been introduced by the Portuguese, and to use it most effectively in subduing his enemies, among whom he counted the militant Buddhists of the time, who were finding it easy to shape government on their own terms. Nobunaga saw that something more permanent than the conventional mountain fortress, a kind of temporary campsite built in time of war, was needed to survive the onslaught of cannonballs in gun warfare, and Azuchi Castle was his solution. Beyond this, of course, a structure of such size and splendid decoration was very real evidence of its owner's power, a monument to his greatness. Today we have only the foundation stones and the written testimony of Japanese chroniclers and of the Portuguese Father Luis Frois to remind us of the castle's former glory: Azuchi Castle was burned to the ground seven years after work on it had begun.

The principal feature of the castle was a multistory building, known as a *tenshu-kaku*, possessing a massive wooden superstructure and thick earthen walls. The very top level commanded a view of the entire surrounding countryside and served most effectively as a lookout post. From below, the view of this giant tower against the sky was a spectacle of color—stark white, bright blues and reds, black lacquer and gleaming gold— that no doubt inspired open-mouthed awe in all who saw it. The interior was decorated by the leading painting master of the time, Kanō Eitoku, and in some of the rooms Nobunaga's visitors could amuse themselves with exotic objects their host had acquired from Westerners. That the entire project took only four years to complete is probably due in no small measure to Nobunaga's ambitions (which were backed by a very quick temper) and the fact that he was by this time in control of much of the country and commanded the support of a sizable number of powerful clans.

Monumental architecture heretofore existed in large Buddhist lecture or worship halls and pagodas, but few of them could compete with Nobunaga's castle in terms of

scale or decoration. On the other hand, castle architecture in Japan, beginning with Azuchi-jō, was not devoid of references to these earlier forms. The massive construction of walls and foundation was strikingly new, but in the tall tower one finds structural innovations, systems of roofing in particular, that derive directly from traditional techniques and styles of religious architecture. As a military man, not bound by tradition, Nobunaga had the good judgment to allow his planners the freedom to experiment and to concern themselves with principles rather than formulas of construction. The idea of incorporating several stories and roofs in one building was bold indeed and the result could have been quite bizarre. Instead, with its truncated-cone silhouette, Azuchi Castle conveyed a dominant impression of stability and order, embodying all the elements necessary to meet Nobunaga's demand for a radically new architectural form.

While they were moved simply by its beauty, as we are today by castles of the same period, the people who saw Azuchi Castle for the first time received messages that would easily escape us. One was certainly a declaration of Nobunaga's personal power, but another may have been clearer: the message that a new age had begun and that the past was dead. That this is so is supported by the way Nobunaga went about creating a setting for his castle far away from all relics of the past. Not only did he put his monument in a remote area outside the capital, but he imported people of all classes and occupations to live around it—creating a town, a castle town, with no history at all!

He even encouraged Westerners to come and live there by giving their religion his active support, so that Azuchi became the newest, most innovating of Japanese towns as well as a flourishing center of modern and international culture. Nobunaga was destined to have few real friends, although he didn't seem to need them, and to die a violent death at forty-nine when his retainer, Akechi Mitsuhide, murdered him in Kyoto in 1582. His accomplishments as a politician, administrator, military strategist, and art patron will be remembered forever. His passion for contemporary art set a precedent for succeeding generations, whose cultural inheritance was characterized by a style of architecture and of painting that began with Azuchi-jō.

FEATURES OF JAPANESE CASTLES

Unlike the case in other countries where one often finds castle towns entirely surrounded by fortified walls, the Japanese castle compound included only those buildings that offered protection to the master of the castle and to his retainers. The civilians, left seemingly defenseless outside the walls, needed no such protection in Japan, where aggression by invading foreigners was unheard of. Japanese wars were fought between individuals rather than races, nations, or even large sections of the country, and except for the principal figures in battle, it was possible for the remainder of the population to be relatively safe even during wartime.

The earliest castles were, as defensive strongholds, quite sturdy and designed to withstand the heaviest attack from outside. Later, however, when castle construction was at its peak, the castle's massive, fortresslike appearance was modified to reflect the master's excellent taste—in which opulence, inside and out, was the chief characteristic. Since the last castles were built when wars were no longer being fought, their function seems to have been purely propagandistic; their towers were useless, and when they burned they were not rebuilt. Two subsequent events resulted in the near extinction of Japanese castles altogether: hundreds of the castles extant in the nineteenth

century were ruthlessly demolished when Tokugawa feudalism collapsed, and virtually all those still standing in this century were razed in the course of World War II. In recent years, happily, the scenic beauty of a number of places has been enhanced by the rebuilding of ancient castles, using old plans and documents. While it is perhaps discordant suddenly to discover these old-fashioned castles in Japan's Westernized cityscapes, one must recognize the spiritual values of these remembrances of the past and respect their appeal to many Japanese people. The reappearance of old-fashioned castles in Japan's modernized cities is contributing to the rebuilding of national pride, and for the first time the Japanese people have a word equivalent to our "nostalgia."

In their earliest stages, when fighting was less sophisticated, castles were built on hilltops, where they were easily defended as much because of their inaccessibility as their sturdy construction. As the techniques of war grew more complicated, forcing warlords to maintain more men and material, it became necessary to move castles to sites that would provide more space. It is phenomenal that, with its origin in mountain fortresses built far from civilization, the Japanese castle became the focus of civilization—of urban living and government—to the extent that every population center had its castle. Today in the center of most Japanese cities of any size there is a large park, which is often all that is left of the spacious castle complex of an earlier age. The castle itself was always surrounded by water-filled inner and outer moats built not so much for protection, one feels, as out of consideration for a native taste that finds the combination of water and architecture beautiful. A synthesis of man-made and natural beauty was achieved again in the planting of trees inside the castle compound. With buildings thus surrounded by small forests, fire was undoubtedly a constant danger in time of war, but to the Japanese mind the exclusion of nature (trees) from the setting would have seemed equally foolish. These aesthetic considerations are not to be taken lightly, for matters of taste were in large measure responsible for the origin of the Japanese castle even in times when it served a military function; later when the castle became a symbol of power and prestige rather than a tool of defense these matters of taste assumed the major role in castle construction.

HIMEJI CASTLE

The white walls of the buildings at Himeji have earned the castle another name, "Castle of the White Herons": the architectural units, all in white against the blue sky, resemble nothing so much as the spectacular configuration of large groups of white herons taking flight. But the important allusion to nature here is of a somewhat different sort, one that has to do with the utilization of land and the organization upon it of suitable buildings. Himeji-jō, an early castle of immense size with numerous attached buildings built on an elevated area in what was at one time the center of a town, displays most delightfully the kind of synthetic beauty that is characteristic of the best Japanese castles where architecture and landscape are in accord.

In 1581 Toyotomi Hideyoshi (who was, at the time, a trusted retainer in the service of Nobunaga) had managed to bring the western provinces under his control and had a new castle built at Himeji. In 1609 it was enlarged to its present proportions and remodeled, incorporating concepts of building and orientation that were being canonized in other castles of the same period. The principal building in five levels (four actual stories) soars skyward, protected first by inner and outer moats, and then by three small towers of similar design that are connected to the main tower and to each other by a system of

corridors. At close range the immediate impression of this mountainlike complex is one of absolute coordination; indeed, it is difficult to imagine a better structural solution to the problem of creating both real and aesthetic stability than this ingenious grouping of architectural elements. Beyond the confines of the castle compound, with its moats and enclosure walls, the plan was carried even into the arrangement of the homes of the town's inhabitants, with those of the military retainers defensively circumscribed in the nearest perimeter, and those of the merchants and townspeople combined with temples and shrines in the outlying area. In this order of things the castle became something more than an isolated citadel. At Himeji, perhaps for the first time, the castle's significance began to be measured in unmistakably aesthetic terms.

OSAKA CASTLE

The castle whose soaring form arose in Osaka during the last decade of the sixteenth century, producing an ostentatious drama in black and glittering gold quite unlike the pure-white castle at Himeji, was another of Hideyoshi's projects, this one undertaken at just the time he was assuming supreme administrative authority as regent. Hideyoshi's experience and interest in castle building was fortunate, for in Osaka Castle, the largest and most splendid castle ever built, he had just the monument he needed when his prestige as regent was at stake. As fate would have it, the Toyotomis were overthrown in 1615 and the castle was burned, leaving nothing but the stone foundations. The structure one sees today in the heart of Japan's second-largest city and commercial capital was rebuilt some years ago on the site of the first castle with the aid of old maps; however, it is but a shadow of the original. The single reconstructed building represents only a fraction of the first grand complex and conveys nothing of the richness of the former castle's decoration. The missionary and secretary of the Society of Jesus in Japan, Gaspar Coelho, who had an audience with Hideyoshi in 1586, and other firsthand observers have described in detail the splendor of Osaka Castle. Five *tenshu-kaku* dominated the center of the compound, the tallest of which reached nine stories and was filled with precious treasures of all kinds. The inclusion of luxurious living quarters in the plan was a strikingly new feature revealing a fundamental change in building concepts. With no loss in its effectiveness as a fortress, the castle now functioned as a permanent residence as well.

To the delight of those in attendance, audiences had on occasion been held in Azuchi Castle, but in more peaceful times the need arose for special audience and residence halls, elegantly appointed buildings that were not so obviously military in character—of which Osaka Castle was the first. Although of a slightly later period, Nijō Castle is the best example that can be seen today of this palatial style of castle architecture.

NIJŌ CASTLE

Located in Japan's ancient capital, Kyoto, Nijō-jō well illustrates a style of castle architecture that grew up in peaceful times and was developed from such sumptuous residences as those on the grounds of Osaka Castle. Nijō Castle was built in 1603 as the official Kyoto residence of Tokugawa Ieyasu, who snatched the reins of government after Hideyoshi's death and established himself as shogun. The moat and wall surrounding Nijō are little more than symbolic, for the castle itself was not built to withstand military assaults from outside. Ieyasu had, in fact, a superb castle—his principal resi-

dence, in Edo (now Tokyo)—and the Kyoto edifice was used for the most part as a place where the activities of the imperial family could be superintended. The architectural style of Nijō's individual buildings is best described as palatial, and is basically the same as that of certain villas and temples that are discussed at length in other chapters.

OTHER EARLY CASTLES

The emperor's residence today in Tokyo, that is, the Imperial Palace in the heart of the city, occupies the site where the castle of Tokugawa Ieyasu once stood. Built first in 1590, Edo Castle was rebuilt many times, but its grand design was retained for nearly three hundred years, a tribute to the Tokugawa shoguns' ability to maintain the order Ieyasu brought to the country in the early seventeenth century. However, with the expansion of the city in modern times, the outer moat has been almost completely filled in so that only the inner moat remains, and of the buildings only an isolated castle gate and some scaffolding are left. Strategically, there had been almost from the beginning no reason to maintain the castle, for the Tokugawas had the advantage of a rigid feudal system of government that completely eliminated the need for defensive architecture. Complicated administrative procedure involved, among other things, the granting of ranks, the celebration of traditional holidays, and hundreds of state ceremonies. Especially suitable for such occasions were the spacious floors of the old castle; yet they were not indispensible, for when the great towers of the castle burned they were not restored, and the ceremonies were held instead in great halls in the currently popular palace style. These later structures were usually of one story and their fragile, open construction leaves no doubt that their defense was not an issue. It was in structures of this sort, rather than in castles, that the emperor and members of the nobility had always lived. They were then, as now, oases of natural beauty and tranquillity, the elegant legacies of a long-forgotten feudal society. Their presence in our own time, in cities buried in concrete and choked with buildings, is indeed welcome.

One of the most famous of all Japanese castles, Nagoya-jō, was destroyed during World War II and later rebuilt as a museum. It, too, had many palatial buildings, but its establishment by Ieyasu in 1592 was meant to counter the power of the western provinces and therefore its defensive character was pronounced. Katō Kiyomasa (1562–1611), a military man skilled in castle building, was put in charge. The design employs structural features of great sophistication and the elaborate fish-shaped ornaments, made of gold and attached to the roof-ends of the *tenshu*, were known throughout all Japan as symbols of Tokugawa authority. Once built to repel any future attack, Nagoya Castle is today a park, a place where people with a sense of the past can dream, and children play.

The same Katō Kiyomasa who designed Nagoya-jō also built the castle at Kumamoto in Kyūshū, which he had received in fief from Hideyoshi in 1588. It seems that while Kiyomasa built it as a residence for himself, he also planned to allow Hideyoshi's son and successor Toyotomi Hideyori to use the castle as a place of refuge (to no avail, for the Toyotomi line was overthrown not long thereafter). For this reason defense was of definite concern and to a great extent determined the design of the castle. What one sees now of Kumamoto Castle is a faithful reconstruction of only the main walls and buildings; after surviving some three hundred years, the castle was destroyed in the Meiji era.

Matsumoto Castle, built in Nagano Prefecture in 1597, although not particularly important historically and relatively small in scale, is one of the most beautiful castles

in Japan. Its charm lies in a straightforward architectural statement of strong contrasts characteristic of provincial military tastes. The lower portion of the white plaster walls at each level is protected from blowing snow by dark wooden siding. These alternating light and dark areas set into motion a steady play of light and shade. Standing against the snow-covered mountains in the distance, Matsumoto Castle has endured for centuries the long and bitter winters of this area.

In 1606 a castle was built on the east shore of Lake Biwa, from which Kyoto could be notified of approaching danger. Its residents, the Ii family, were staunch supporters of the Tokugawa cause. For a provincial castle, Hikone-jō is extremely well preserved. It was designed to be defensible from sea as well as land attack, and the intricate structures that resulted add considerably to the castle's beauty.

Other castles remaining in areas of Japan that were once provincial fiefdoms reflect stylistic canons of different times and the personal tastes of many individual warlords. They often do not possess the magnificence of castles in metropolitan centers; nevertheless, they are interesting for their variety, and their use in military operations often influenced the course of Japanese history. More importantly, they are additional links with a formative period in Japan's cultural history.

1. Remains of Azuchi Castle, Shiga. Late sixteenth century.
Azuchi Castle was built in 1576 by Oda Nobunaga, the great warlord who succeeded in bringing peace to Japan after a century of continuous warfare. According to extant documents, the grandeur and magnificent decor of the castle overlooking Lake Biwa, east of the ancient capital, Kyoto, far surpassed that of any building ever seen in Japan up until that time. When Nobunaga was assassinated in 1582 by Akechi Mitsuhide, one of his leading generals, this castle was burned to the ground—only six years after its completion. The photograph shows the remains of a stone wall that surrounded the seven-storied tower (tenshu-kaku), which was the castle's principal structure. Such monumentality must have made Azuchi Castle seem eminently superior indeed to the small and rather provisional defense structures of medieval times.*

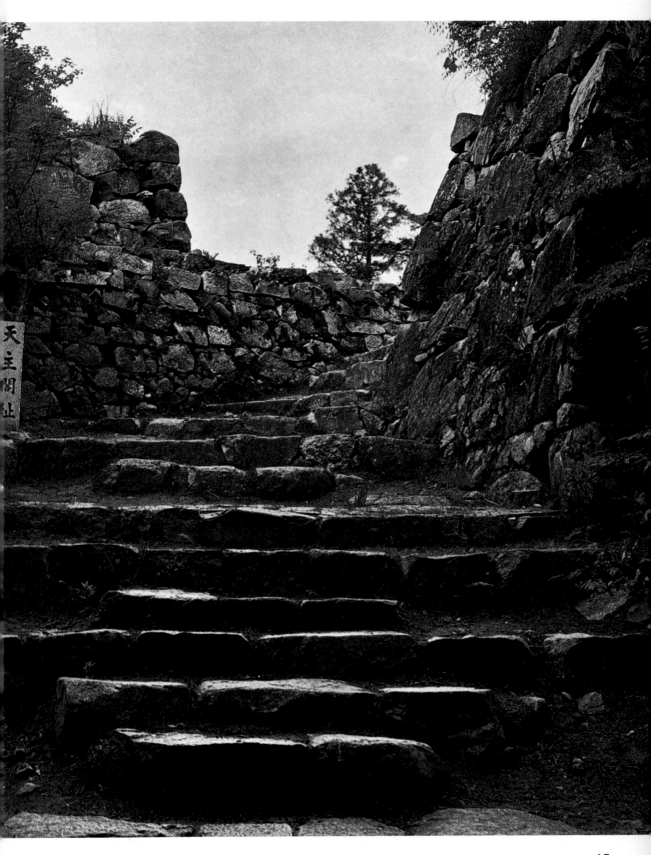

天主閣址

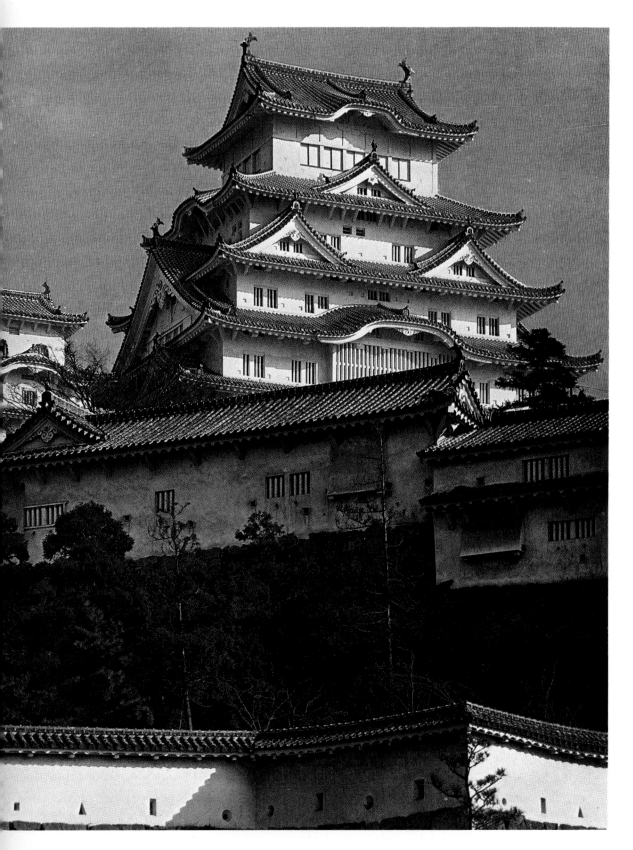

2. Himeji Castle, Hyōgo.

Although the primary purpose of Japanese castles was to serve as military installations in time of war, the great age of castle building came after the country had begun to enjoy a period of relative peace. The castles that were extant before World War II were for the most part, like Himeji Castle, extravagant symbols of authority and had not experienced military attack, even though they were designed to withstand the worst onslaught imaginable at the time. Because of their expense and possible threat to the government, the Tokugawa shogunate prohibited the construction of castles soon after complete military control of Japan was assured in 1615. The actual period in which castles were built was therefore of short duration—something like four decades. Nevertheless, Japanese castles must have numbered at one time in the hundreds, and those that are extant today, including the ones that have been restored, are but a tiny fraction of the original number.*

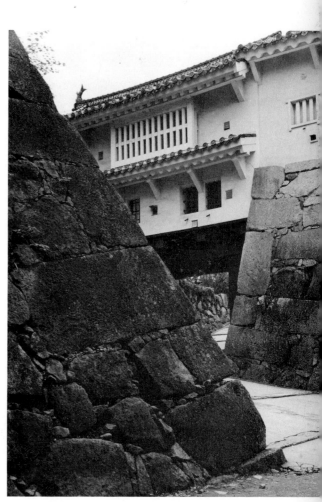

3. The *nu* gate of Himeji Castle.

Usually the gate leading to a castle is a two-storied affair with the ground floor providing the actual entry and the upper story functioning as a lookout tower. This gate at Himeji Castle is unique in having two upper stories. The ten gates at Himeji are referred to by the Japanese alphabetical characters, of which *nu* is tenth in order.*

4. The clay walls of Himeji Castle.
This is a section of the wall located on the south side of
the *ha* gate (''third'' in the alphabet) and serves as one
of the strategic strongholds of the castle. One side of
the winding, sloped passageway is blocked by a stone
wall and the other side by this clay wall. Triangular
and rectangular openings in the wall, besides serving
the very useful purpose of crenels, create an interesting
pattern in light and shade.*

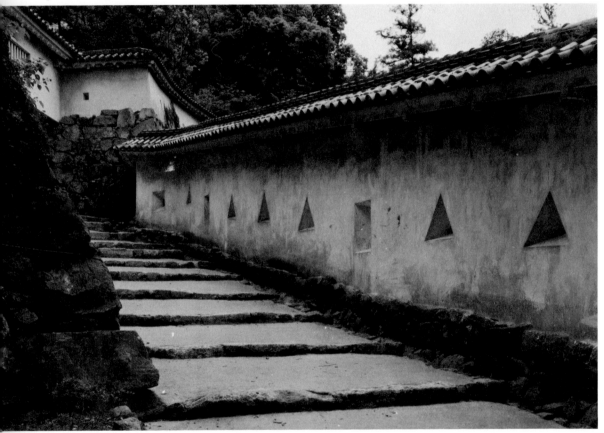

5. The *ni* gate of Himeji Castle.
Defense was an extremely important consideration in
the construction of castles since their value as fortresses
depended greatly on how defensive measures were in-
corporated architecturally. The defensive cordon
around this gate was undoubtedly effective, although
it is not entirely clear why the passageway is placed
under one side of the tower gate instead of in the
middle. Such peculiarities as this can only be accepted
as part of the castle's original defense program, the
intricacies of which were forgotten in the process of
three centuries of peacetime remodeling.*

6 (overleaf). Entire view of Himeji Castle.
This group of white-walled structures located on a
slightly elevated terrain makes up the complex known
locally as the "Castle of White Herons." The balance
and distribution of the buildings and especially their
graceful forms and color contrasts make Himeji Castle
the most beautiful of all the numerous fortresses con-
structed by feudal lords of the early seventeenth
century. The tallest *tenshu-kaku,* seen on the right, has
five roofs and six actual stories, the strictly horizontal
lines of the roofs broken here and there by the arcing
contours of gables that include the elegant Chinese-
style *kara-hafū.**

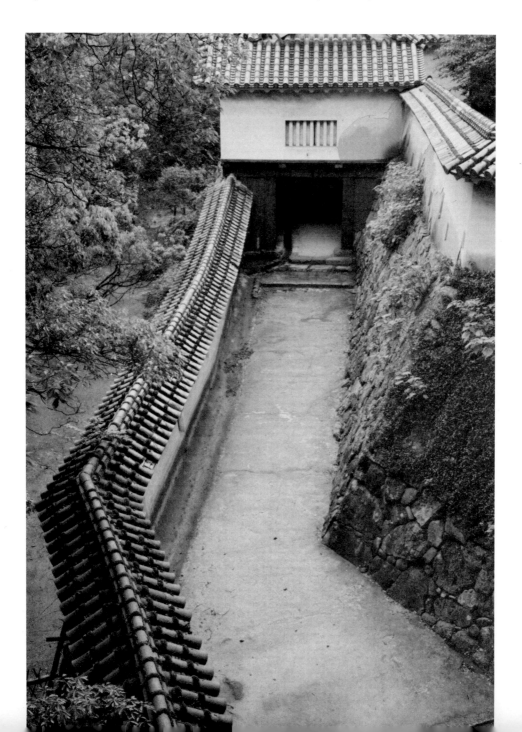

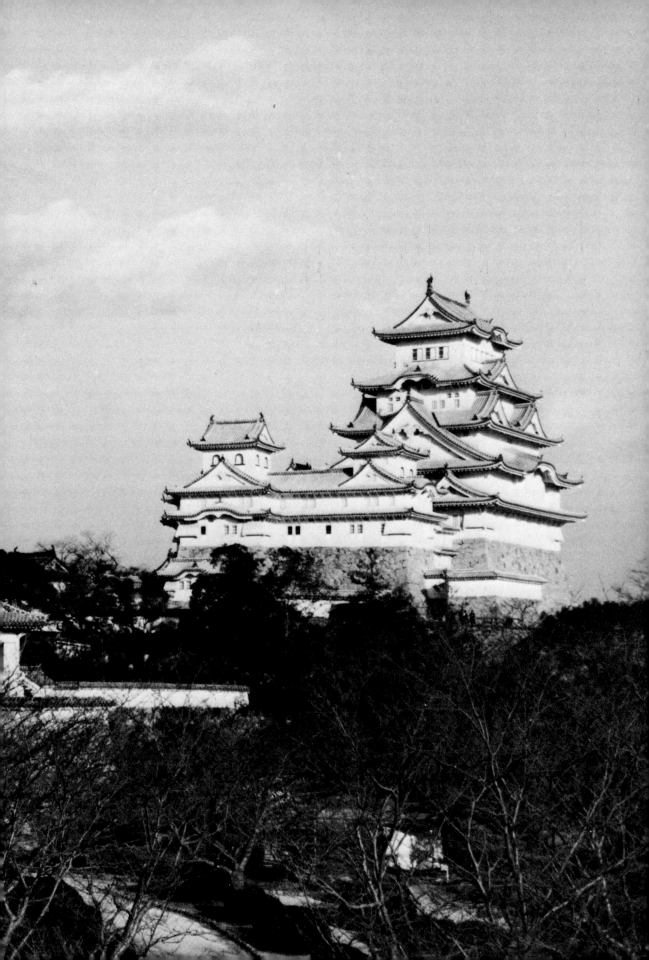

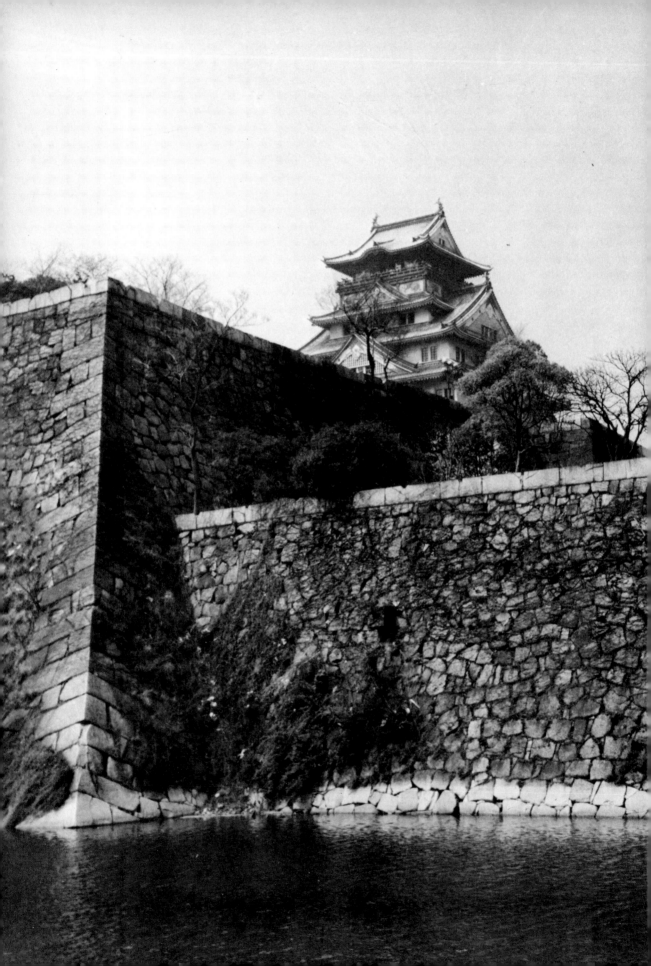

8. The Montanus illustration of Osaka Castle.
The only illustrations that are considered to be of the original Osaka Castle are the sketches owned by the Nakai family (whose members often served as chief architects for the Tokugawa shogunate) and the screen painting, formerly in the collection of the Kuroda family, of the 1615 Summer Battle at Osaka Castle. This illustration from the book by Arnoldas Montanus, which was published in the seventeenth century, is not of the original castle, but of one built towards the end of the Kan'ei era (1624–44). One assumes, however, that the original castle was quite similar in form and scale.

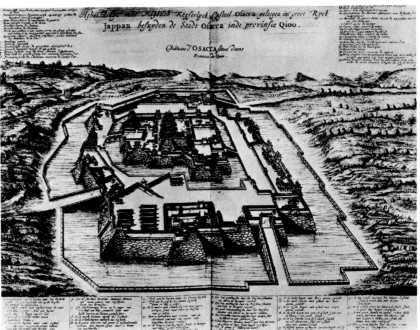

7. Original stone wall of Osaka Castle. Late sixteenth century.
Toyotomi Hideyoshi, who succeeded Oda Nobunaga as the military ruler of the country, had a magnificent castle constructed, beginning in 1583, at a site in Osaka where the fortress-temple known as Ishiyama Hongan-ji had stood before it was burned by Nobunaga three years earlier. The castle was thus meant to symbolize once and for all the victory of secular militarism over the powers of organized religion. The compound, which covered some seven-and-one-half square miles, and its walls of gigantic blocks of stone reflect not only Hideyoshi's own tastes but also the unlimited resources that were at his command. The Toyotomi rule was brief, ending with the destruction of Osaka Castle by Tokugawa forces in the summer of 1615. The stone wall in the illustration is the only surviving part of the castle; the present *tenshu-kaku* was built in 1931 with the aid of old-plans.*

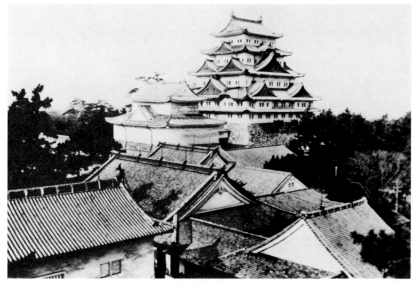

9. Nagoya Castle. Seventeenth century.
The castles at Himeji and Nagoya have often been paired as examples of the best in Japanese military architecture, Nagoya Castle being considered the more "classic" of the two. This photograph is of Nagoya Castle prior to its destruction in the last world war. Shown in the left foreground is the front gate, the court entrance of the main residence hall on the right, and the major *tenshu-kaku* surrounded by the smaller ones in the background.*

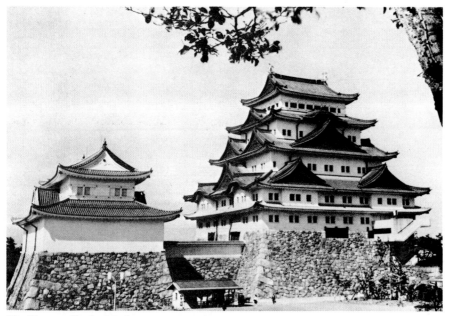

10. Nagoya Castle. Modern reconstruction.
After World War II the major *tenshu-kaku* and the other smaller ones were all rebuilt with modern materials and were modeled generally after the originals. The beautiful white residence hall of the *hommaru* was not reconstructed.*

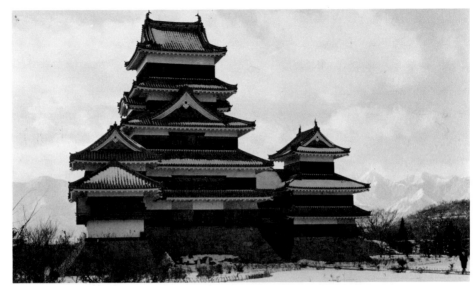

11. Matsumoto Castle. Late sixteenth century.
This castle is located near the center of Matsumoto plain in Nagano, 150 miles northwest of Tokyo. High mountains surround the plain, providing an exceptionally scenic setting for the castle. With its simple forms and severe contrasts of light and dark, Matsumoto Castle, of all examples of castle architecture, is the one in which native tastes are most apparent.*

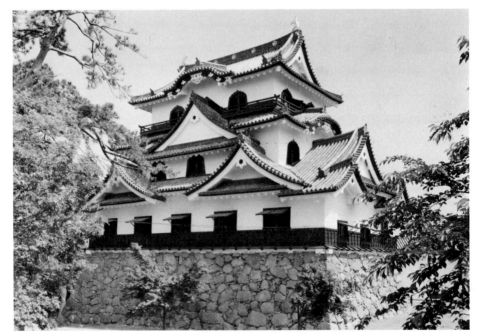

12. Hikone Castle. Early seventeenth century.
It seems that the *tenshu-kaku* of Hikone Castle may have originally been a five-storied structure. In its present form it is not as imposing as some of the major fortresses built earlier, but innovations, such as use of gold and lacquer trim, became standard in later castle design.*

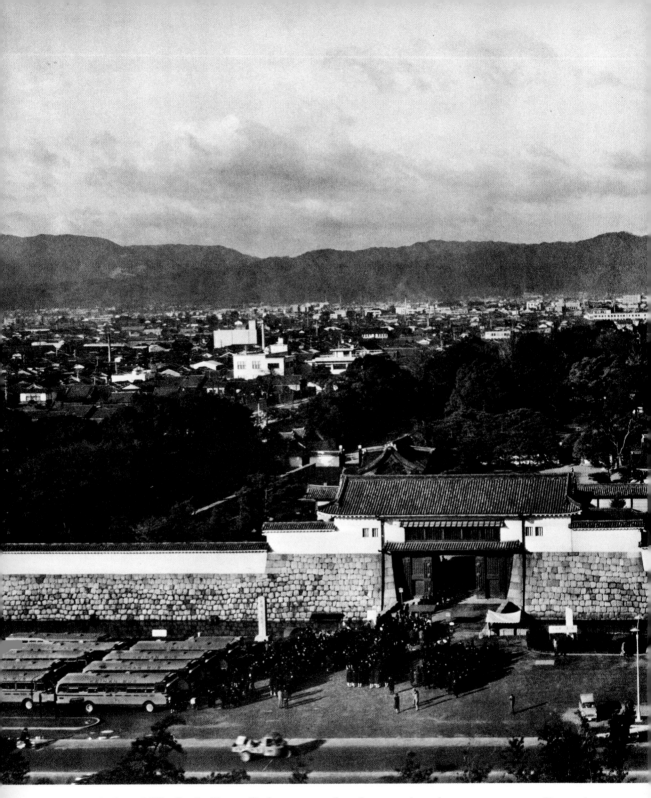

13. General view of Nijō Castle, Kyoto. Early seventeenth century.

The moat-surrounded architectural and garden complex known as Nijō Castle takes up a vast area within the southwestern section of Kyoto. It was constructed by Ieyasu, the founder of the Tokugawa shogunate, as a residential castle and was subsequently used by other shoguns when they came to pay calls on the emperor in Kyoto. The residential buildings of Nagoya Castle and Nijō Castle were the only extant examples of palatial military architecture until the former were destroyed during World War II, leaving only those of Nijō to bear physical testimony to that particular phase of feudalism in the Early Modern age.*

14. Uto Tower, Kumamoto Castle. Early seventeenth century.
Noteworthy more for its grand scale and defensive measures rather than for elaborate decoration or beauty of design, Kumamoto Castle was begun by Katō Kiyomasa in 1601, immediately after the Battle of Sekigahara, and completed in 1607.*

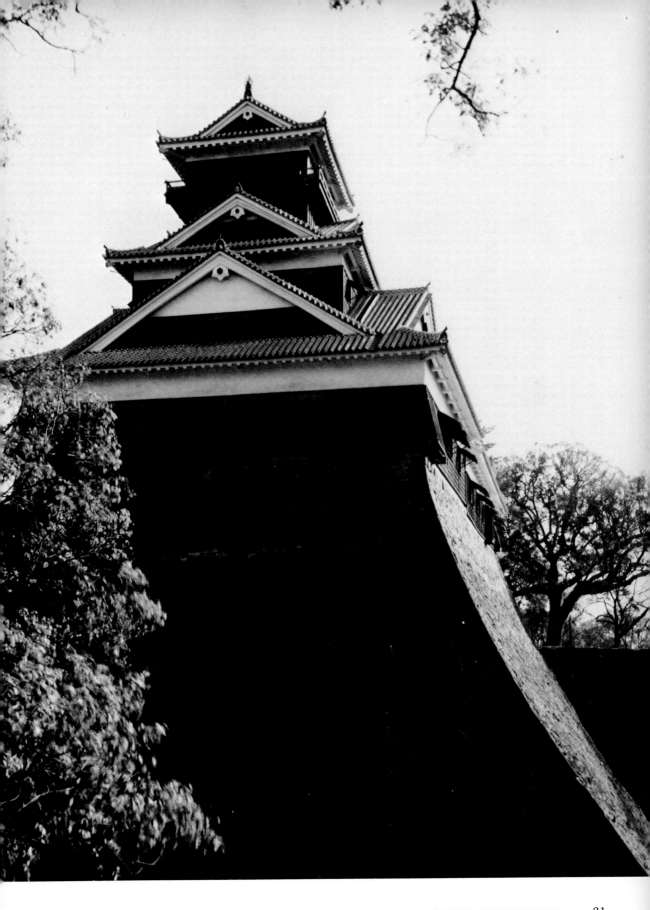

<p style="text-align:center">~≋ 2 ≋~</p>

ACCOUTREMENTS
OF BANQUET SOCIETY

PALATIAL ARCHITECTURE OF THE MILITARY

Castles were effective machines of defense and propaganda in time of war, but they were particularly unsuited to peacetime needs. As living quarters they were uncomfortable, gloomy affairs with large rooms and tiny windows, hardly the sort of thing that would set the right mood for gay parties or satisfy a typically native preference for spacious, open interiors that do not shut out nature. To compensate, the new leaders had artists cover the interiors of castles with elaborate decoration in gold and in bright colors, but almost from the very beginning there was a better solution: the castle compound was expanded and separate buildings were established for the sole purpose of providing atmosphere for grand banquets and audiences. Warlords built living quarters of an elegance seen theretofore only in the Imperial Palace, and the great halls in the castle compounds at Osaka and Fushimi (see below) rivaled the most elaborate structures ever built under Buddhist inspiration.

All the earliest examples of palatial architecture are gone, and information about them comes from documents, maps, paintings, or illustrated books. Ōtomo Sōrin, a famous daimyo (a feudal lord) who visited Hideyoshi at Osaka Castle, writes that Hideyoshi's audience hall and bedroom were buildings each measuring 52 feet on all four sides. The regent's bed was elaborately carved and gilded, and records suggest it was similar to a European *lit clos*. His tea house, which was also gilded, provided a refuge from military affairs. In the women's quarters there was a special area for an extensive wardrobe of gowns that were, in number and design, without equal or precedent in Japan. In that part of the castle known as Sanri-no-Maru the buildings possessed such graceful forms and were of such costly material that they seemed to be, as the name given them suggests, fantastic birds from some remote mountain region.

JURAKU-DAI

In 1586 Hideyoshi began a castle in Kyoto that was to show an astounding change from the fortress Nobunaga built at Azuchi just ten years previously. Records available indicate that Hideyoshi built this castle in the capital solely for the purpose of enter-

<p style="text-align:center">32</p>

taining the emperor. It was called Juraku-dai ("Palace of Assembled Pleasures") and was the penultimate in lavish castle construction, with even the roof tiles patterned and gilded. Persuaded that Hideyoshi's creation was worthy of the imperial presence, the Emperor Goyōzei accepted his invitation. When the emperor emerged from the palace enclosure, 6,000 troops lined the streets to control the throngs who had come to witness what was the event of a lifetime: no imperial procession had taken place in living memory, and no emperor had deigned to visit a subject in some 150 years. During the full day required for the cortège to travel the mile to Juraku-dai, the emperor's subjects no doubt took every opportunity to satisfy their curiosity about this man who, for them, represented divinity, and about his family and attendants, whose secluded existence within the walls of the Gosho was a source of mystery to those who lived in the outside world.

On arriving at Hideyoshi's castle, the emperor may have noticed that it was comparable in size to and shared certain structural features with his own palace, but his attention was more likely captured by the lavish ornamentation within and without this complex of architectural jewelry set in a natural landscape of lush vegetation. Goyōzei must have appreciated the contrast between Juraku-dai and the austere buildings and barren grounds of the Imperial Palace, and between the pleasures offered by his host and his own existence, for he extended his visit from three to five days.

FUSHIMI CASTLE

After leaving Juraku-dai in the care of his adopted son Hidetsugu in 1592, Hideyoshi had another castle built on a hill in Fushimi to the south of Kyoto. The castle was in fact a kind of military club where several important daimyos under Hideyoshi's command lived in luxury. With the addition of several of the buildings from Juraku-dai, which were dismantled and brought to Fushimi in 1592, the castle stood until it was demolished sometime in the second decade of the seventeenth century, and the last of the great architectural monuments of a mighty hero disappeared. Peach trees were planted on the hill after the castle was demolished, a fact that historians had in mind when they gave the name Momoyama, or "Peach Tree Mountain," to the last part of the sixteenth century.

FEATURES OF CASTLE INTERIORS

With grand halls and mansions playing an important role in the lives of military leaders, it comes as no surprise that much of the art of the period is connected directly to them. They established new ideas of form and organization that have been incorporated in monumental buildings, both secular and religious, from that time on. A prescribed order of room arrangement was one innovation, and this order was reflected in the interior decoration. The openwork friezes (ramma) above the tops of sliding doors were carved with subjects selected according to a hierarchy of what motifs were proper for a given room. (Prior to this time, carved decoration had been used only in the most sacred part of Buddhist buildings—the central altar room—but in the new architecture it was used lavishly to decorate the living quarters and banquet halls of heroes.) On the sliding walls (fusuma) of these great buildings were painted colorful, decorative themes that were also suited to the significance of each room. To be in harmony with the architecture, these paintings were done on a large scale, their bright colors applied

thickly and in combination with brilliant gold leaf. Overhead, the rich display continued on the coffered ceiling, again following a progression in subject matter and the elaborateness with which it was treated, as one moved from the more distant waiting rooms to the audience chamber *(jōdan-no-ma)* of the lord.

The numerous examples of decorative painting from the Momoyama period now in temples and shrines in the Kyoto area should not be taken to mean that religion had regained its power. For the most part, these paintings were presented to the temples after the military mansions were torn down. Some of them were given by the warlords themselves, who, apprehensive about death, left such presents with full confidence they would thus secure places of honor in the spiritual world. In medieval times (tenth through fifteenth centuries) it was common practice for upper-class families to found family mortuary temples. This custom was continued in Early Modern times, but the practice of donating portions of one's own residence was new with the wealthy military leaders.

At this time, the imperial household began to do much the same thing; but, whereas the gifts of the warlords might be considered spiritual bribes, the apartments of the Gosho that were donated to temples were given more out of benevolence. The court was traditionally the strongest supporter of the Church, but at the beginning of the Early Modern period the royal treasury could not meet the tremendous expense of creating new temples. The gift of an apartment deified by the imperial presence was, however, considered a worthy substitute.

MASTERS OF DECORATIVE PAINTING

The first artists receiving commissions to decorate the castles and palaces of the new military leaders came from the ranks of the Kanō school, a family of artists whose members had served the Ashikaga shoguns in the preceding Muromachi period. The school's reputation had been founded on Chinese-style ink painting in which line plays a major part, but Kanō artists were also trained in native *yamato-e*, a style of painting characterized by bright, opaque colors and traditionally Japanese subject matter. The visual symphony produced by the skillful blending of certain aspects of these two styles is the triumph of the school's most illustrious painting master of the sixteenth century, Kanō Eitoku, a fourth-generation descendant of the school's founder, Kanō Masanobu. His talents were recognized immediately by Nobunaga, who commissioned Eitoku to do the interior of Azuchi Castle, where the number of paintings, judging from the very long list of picture titles recorded by contemporary chroniclers, was quite large, with Confucian and Buddhist themes predominating. They were done on a grand scale, as many as twenty-four full-size *fusuma* (perhaps as large as six by four feet) providing picture space for but one theme.

With several square miles of picture space to be covered and Nobunaga demanding the work be completed as soon as possible, Eitoku had to devise a radically new method of painting. This involved use of apprentices to execute the overall design created by the master. Eitoku continued to use this method as the master designer of Osaka Castle, Juraku-dai, and Fushimi Castle. What a great loss that none of these paintings still exists. Two magnificent works, one in the collection of the imperial household and one in Tokyo National Museum, are generally taken to be characteristic of Eitoku's style. Now mounted as screens, these are of fantastic lions *(karashishi)* and giant cypress trees *(hinoki)*, respectively. Both are reduced from their original size but even now the smaller

of the two measures some six by fifteen feet. When looking at reproductions of these works it is important to keep in mind their enormity, for this influenced to a great degree the way they were executed. For example, the texture lines of the cypress trees were done with something on the order of a house painting brush. We see in both paintings rich, opaque colors and great expanses of gold leaf representing ground and clouds. There is a simplification of forms bordering on coarseness, with all the objects (trees and fantastic animals) reduced to their most essential, readable images, and a deliberate choice of large, intrinsically powerful forms that can more easily create a sense of drama in large compositions. A heightened sense of reality results from objects being painted as though in the immediate foreground, and the several elements cover the entire area in a way that makes them seem to extend even beyond the borders of the picture.

SANRAKU

Eitoku's best disciple was not a Kanō by birth, but an adopted son whose talents were recognized by everyone, including the Regent Hideyoshi. While still in his twenties, Sanraku assisted with the decoration of Osaka Castle. He learned Eitoku's style well, and yet it is obvious today, when looking at the room of peony paintings at Daikaku-ji that are attributed to Sanraku, that calm, steady drawing has replaced the boldness of Eitoku's brush. To the extent that social conditions are mirrored in art, it is significant that Sanraku's generation was enjoying a period of peace, whereas Eitoku's had had few moments' respite from war. But the essential differences in their works can also be explained simply by the fact that Eitoku was the originator, Sanraku the inheritor of a unique style.

Just as ambition and ability were the only qualities needed for men of obscure background to attain positions of honor in the first stages of Japan's Early Modern age, so too were these qualities sufficient for artistic success at that time. Some of the greatest masters of the period, such as Hasegawa Tōhaku, Kaihō Yūshō, and Unkoku Tōgan, were not members of the traditional schools of painting, but fiercely independent artists whose careers were intimately related to the great decorating schemes of military heroes.

TŌHAKU

A self-styled follower of the great fifteenth-century Japanese master of Chinese-style ink painting, Sesshū, but without any apparent connection to a known atelier, Hasegawa Tōhaku (1539–1610) came to Kyoto from the northern provinces, fully confident that his ability to paint would win the attention of important art patrons in the capital. Foremost among the works attributed to him today are the lovely wall paintings at Chishaku-in with the central theme of maple and cherry trees. Although it is evident from their present condition that they have been cut and were originally much larger, the monumentality of these paintings is nevertheless overpowering. The combination of bold, heavy forms and a myriad of delicate blossoms and jagged limbs is never confusing, cluttered, or repetitious, but is filled with dramatic intensity achieved by color values beautifully balanced against a background of reflecting gold.

If, indeed, the attribution of the Chishaku-in paintings is correct, Tōhaku must also be credited with an astounding versatility, as a comparison of figures 26 and 86–87 will show. His ability to please a patron may well have been due to his adopting the Kanō

usage of opaque colors and gold leaf then in vogue. In any event, it is significant that an artist not affiliated with the shogunate-supported Kanō school could attain success.

Yūshō and Tōgan

Kaihō Yūshō (1533–1615) was a famous painter whose background combined military and Buddhist influences. At first he patterned his work after the Sung priest-painter Liang K'ai, painting only monochrome ink pictures; but, as many colorful screens at Myōshin-ji in Kyoto show, he was a man of his time who could also respond to the demand for pictures in the decorative manner. During his lifetime Yūshō was respected as a great master, even by Kanō artists, with whom he occasionally cooperated on important commissions.

Like many other artists of his time, Unkoku Tōgan (1547–1618) was socially of the military class. He was so impressed by Sesshū's long landscape scroll when it was shown to him in 1593 by his lord, Mōri Terumoto, a powerful daimyo in the western provinces and a collector of Sesshū's works, that he pledged from that day forward to paint in the master's style. Tōgan's paintings are not as immediately appealing today as are his rival Tōhaku's, mainly because of his preference for dry ink strokes rather than lush ink tones. However, his strong, drybrush work and compositional devices were continued by his followers, the artists of the Unkoku school.

The Admiration of Gold

Decorative beauty is the one trait found in every art form of the Early Modern age. Color, gold, and skillful, extraordinarily visual designs made paintings of the period exciting to look at even when their iconography was foreign and difficult for the uninitiated to understand. In the minor arts subject matter was of still less importance. For items of household use and personal possessions, the exotic touch of a Confucian theme was unnecessary; the military man was delighted as much by the familiar motifs of flowers, birds, trees, and water. The only requirement was that the world's treasures, which were his to enjoy at last, be obviously beautiful, and what could be more beautiful than pure gold?

Silver and gold mines provided much of the wealth of the new Japanese leaders and were their insurance of continued success in costly military campaigns. While silver was plentiful (so much so that it was a major item of export), gold was scarce and had to be imported. The possession of objects made of gold was thus a sure sign of affluence and power. The military's weakness for gold was not without historical precedent (gold had been highly prized in ancient times and was used lavishly in the days of the Fujiwaras— that is, the tenth through twelfth centuries), but in the sixteenth century the public display of so much gold must have seemed at first nothing less than open sacrilege. For centuries the austere aesthetic of Zen Buddhism had eliminated any form of ostentation from Japanese life and art, and gold in particular was a despised substance. Shogun Ashikaga Yoshimitsu had been something of an innovator in the late fourteenth century with his Golden Pavilion (Kinkaku), but that was a special case—a private Buddha hall built in a secluded spot at the base of mountains and away from public view. Kinkaku was also considerably smaller than the great gilded buildings of the military era; since much less gold was being produced locally in Yoshimitsu's day, a larger gold-covered chapel may have been prohibitive. Hideyoshi, on the other hand, took pains

to see that ample gold was available, and he proceeded to put it on roof tiles, walls, ceilings, furniture, teabowls, serving ware, garments, armor—everything, in fact, that he wanted the world to recognize as his. It was a boastful display, to be sure, and vulgar by all traditional standards. It was also a new artistic venture in which the dazzling beauty of gold was shamelessly exploited and enjoyed for its own sake.

A case in point is the elegant lacquerware known as *kōdai-ji maki-e*. Working in gold lacquer was a centuries-old art form in the sixteenth century, a traditional technique of lacquer decoration found on serving dishes used by the aristocracy. In military society its use was extended to other household objects and even to architectural features such as rafters and doors, with the technique reaching a flamboyant climax in the elaborate designs of *kōdai-ji maki-e*. Kōdai-ji, a temple that was built for Kita-no-Mandokoro, the wife of Hideyoshi, contains such an abundance of this particular type of *maki-e* decoration on furniture, dishes, cabinets—and most strikingly on the Buddhist altar—that the name of the temple has become synonymous with the technique.

Along with the conventional use of gold dust in delicate designs that enhance the lustrous beauty of the black lacquer ground, one finds in *kōdai-ji maki-e* generous additions of gold flecks and large expanses of embossed gold. These designs echo the bold and lively forms in contemporary paintings without the slightest decline in technical excellence; if anything, with so much actual value at stake, artistic standards became higher than ever. On the interior of Tsukubusuma Shrine and on the Chinese-gabled entrance to Hōgon-ji (two monuments coming possibly from Hideyoshi's mausoleum, but situated since the seventeenth century on the small island of Chikubushima in Lake Biwa), one finds additional examples of *kōdai-ji maki-e*. If such treasures were being made at the expense of the general populace, the story would certainly be different. As it happened, the nation was enjoying unheard-of prosperity, and this is clearly reflected in the richness of its art. The message one receives is that wealth is desirable and offers unlimited pleasures.

Hideyoshi's passion for gold was shared by his peers and ultimately by all Japanese. Armor and weapons had always been more colorful than other items of costume, and iron swords and scabbards were inlaid with delicate designs in precious metals. Hideyoshi very ingeniously applied this same principle to a large iron bell that he had decorated with paulownia flowers (his insignia) in gold, and he chose to sheath his own swords in scabbards covered completely with plates of gold on which elaborate designs were worked by the greatest goldsmiths of the day. Weapons of ordinary military generals were only slightly less extravagant.

ELEGANCE COMES TO CLOTHING

In medieval times other personal items, including fans, mirrors, incense boxes, combs and other hair ornaments, were commonly decorated with complicated designs in precious materials, but dress had been very modest in color and design ever since the end of the Heian court at the end of the twelfth century. Thus, when military heroes, aristocrats, actors, and a large number of the rest of the populace all took to wearing colorful garments in the late sixteenth century, it was the most radical change in the history of Japanese costume since ancient times.

Attempts at brightening up traditionally drab Japanese clothing included experiments incorporating some use of gold in most fabric designs. The difficulties in producing the colorful and elaborate textiles created by Momoyama craftsmen made them

very expensive, but they were highly regarded by the upper classes and were much in demand. Present-day techniques, synthetic materials, and modern dyes make possible an endless variety of color and texture in textile design, but the craftsmanship and uniqueness evident in Momoyama fabrics is rarely seen today.

Gold and silver brocades from China were highly prized, so much so that some wealthy Japanese put numerous small pieces of this brocade together with other rich fabrics, in patchwork-quilt fashion. From these composite fabrics were fashioned the remarkably handsome *kosode* (the ancestor of the present-day kimono) that was the new fashion in sixteenth-century Japan. As soon as the Japanese learned the weaving methods of Chinese gold brocade, the Nō stage suddenly took on the otherworldly luster of a medieval Buddha hall, as actors moved about in glittering gold costumes, like gilded Buddha images come to life. Similar brocades were used in the lavish gowns of the beautiful Kita-no-Mandokoro.

Stylish *kosode* were by no means seen only on the stage or in villas and palaces, for anyone who could afford these garments wore them. *Kosode* were sometimes done entirely in embroidery, a cheap and effective substitute for brocade, with gold thread adding highlights to floral motifs worked out in rich shades of blue, green, red, and pink. (The mountings of paintings were, incidentally, often executed in this way.) The technique that best advanced Momoyama ideals in color and texture, however, is known as *surihaku*. For this, gold leaf was pressed over designs built up with paste, the result being something like gold brocade, but producing much freer designs than were possible in any kind of woven fabric. When *surihaku* was combined with embroidery for a wider range of color and texture, it was known as *nuihaku*. The creativity involved in the making of Nō costumes, which has always been considered an art form, flowered more at that time than at any other in history.

Not surprisingly, the art of fabric dyeing made its greatest strides in this period. *Shiborizome,* a resist-pattern method of dyeing that involves pinching and tying the fabric before dipping it into the dye, was perfected and used in combination with embroidery and painted patterns.

Thus designers of fabrics and costumes rivaled the painters of the time in meeting the new demands placed upon their crafts. These lavish, imaginative creations were worn by men and women alike, and with very little heed paid to what are now considered masculine and feminine differences. Also, for a while at least, there was no strict separation, in terms of costume, between soldiers and civilians. The freedom of action typical of this period of transition between the Ashikaga and the Tokugawa shogunates was manifested even in such day-to-day concerns as fabric and costume design.

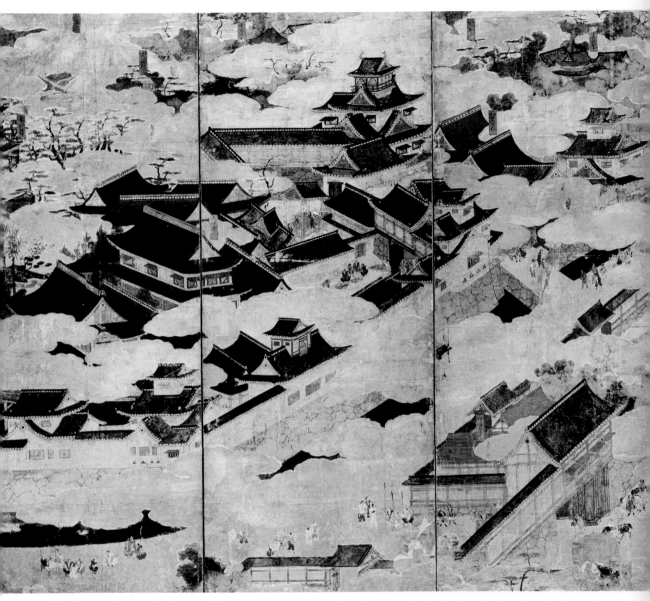

15. Screen showing Juraku-dai (detail). Late sixteenth
century. L. 156 cm. (61.1 in.), w. 355.2 cm. (139.2 in.).
Juraku-dai was the mansion Toyotomi Hideyoshi
constructed at Uchino in Kyoto in 1587 (15th year of
Tenshō) for the specific purpose of inviting Emperor
Goyozei there for a lavish party. Juraku-dai was com-
pletely destroyed in 1595 when Hidetsugu, Hideyoshi's
adopted son, who had been put in charge of the
gorgeous mansion, was ordered to commit suicide after
he seriously offended Hideyoshi by not showing proper
enthusiasm for the war being waged by Japan in Korea.
Although records claim that Juraku-dai was illustrated
in many paintings of the time, this is one of but a few
that have survived. Such paintings furnish the only
visual clue to the expansive architectural compound
that took up a reported eighty-two acres of land inside
the capital. The mansion had towers, moats, and stone
walls characteristic of a castle, but its residential build-
ings were grander and more elaborate than anything
built previously. The roofs of some of these buildings
are shown thatched with cypress bark, while roofs and
eaves of others are in gold, thus corroborating accounts
that say the buildings of Juraku-dai were roofed with
tiles covered with thin sheets of gold. Mount Hiei and
Mount Atago to the north of the city are shown in the
background.*

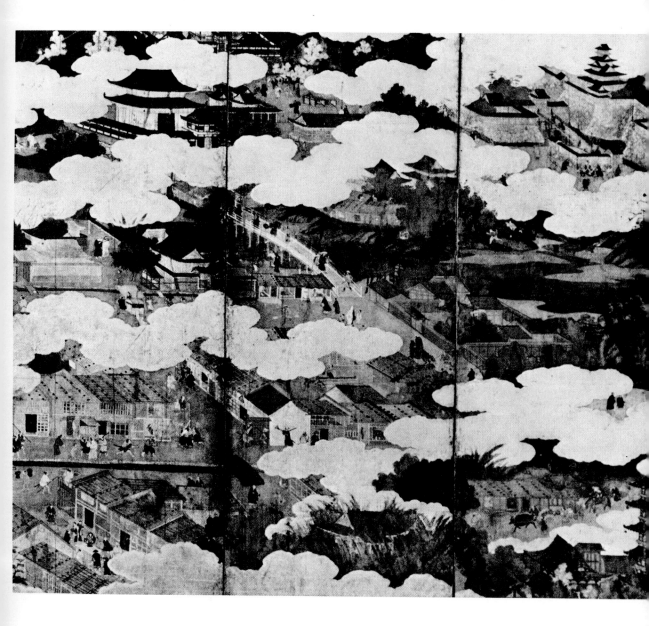

16. "Views of Kyoto" (*Rakuchū-rakugai*). Detail. Pair of six-fold screens. L. 153 cm. (60 in.), w. 356.4 cm. (139.7 in.).

The view of Kyoto depicted in this screen is an incongruously abbreviated one of the entire eastern area of the city up to the Kamigamo Shrine and, in the background, Fushimi Castle, which was actually located considerably to the south and much farther away from the capital than it appears in the painting. The horse races that still take place at the shrine every year on the fifth of May can be seen in the upper left of the illustration. Pink and white flowering cherry trees dot the landscape. This is one of a number of paintings of Hideyoshi's Fushimi Castle, which was first constructed between 1592 and 1594, and again after the great earthquake of 1596. It is perhaps the latter structure that is illustrated here: the castle as it appeared before being dismantled by the Tokugawa shogunate in 1622 because of its association with the Toyotomi family.

Tradition holds that various parts of Fushimi Castle were moved to Nishi Hongan-ji and Hōkoku Shrine in Kyoto and to Tsukubushima Shrine on Lake Biwa. The hill on which the castle was located in the village of Fushimi was later planted with peach trees (*momo*), which accounts for the use of the term Momoyama, or "Peach Tree Hill," to designate the period when Hideyoshi was in power. (In 1962 a castle was built at Fushimi in the old style, thus restoring to the area something of the appearance it had when Hideyoshi's famous landmark was there.)*

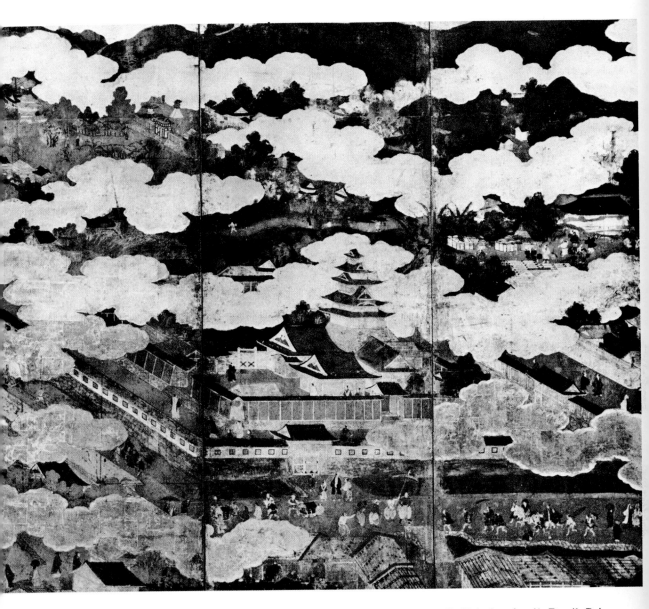

17. "Views of Kyoto" *(Rakuchū-rakugai)*. Detail. Pair
of six-fold screens. L. 153 cm. (60 in.), w. 356.4 cm.
(139.7 in.).

This screen shows Nijō Castle, a portion of the Gosho,
and the mountains of Kurama-yama and Arashi-yama
in the background, their hillsides patterned with bright
autumn maples and a few bare trees of early winter.
With the towering *tenshu-kaku* of its *hommaru* still in
position, Nijō made a more impressive spectacle than
it does today. The painting is probably quite accurate
as regards the castle's form prior to the removal of many
of its buildings in the 1620's. The procession of foreign-
ers on their way to the castle with presents of rare birds
and animals is particularly interesting, as are the
unusual types of carriages seen in the streets. The
horizontal patterns of gold-leaf clouds are skillfully
worked into the composition to give emphasis to certain
objects and to obscure others.*

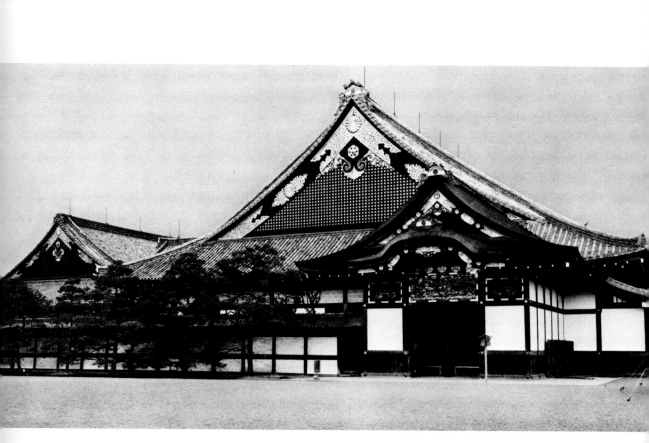

18. The *ni-no-maru* of Nijō Castle. Seventeenth century. The *ni-no-maru* is located in the eastern half of the castle compound. In this area are the only buildings of Nijō Castle that have survived intact since the seventeenth century. They include an elaborate entryway *(genkan)* and a series of five spacious reception halls or apartments. The visitor approaches the buildings from the south and follows their diagonal arrangement from southeast to northwest in passing through them. With the exception of the two back apartments, which are more modest in design and were meant to be used as private quarters for the residents (including first Ieyasu and later his and his successors' representatives in Kyoto), the function of these sumptuously decorated buildings was primarily to impress visiting dignitaries with the glory and authority of the Tokugawa shogun.*

19. The principal *jōdan-no-ma* of Nijō Castle. 1626 or later.
The principal place of honor, or *jōdan-no-ma*, of Nijō Castle is in the main ceremonial hall, the *ōhiro-ma*. It was used by the shogun to receive official visitors when he was in Kyoto. The entire size of the great hall is roughly 750 square yards and consists of the room illustrated here and five other rooms. As the name suggests, the floor level of the *jōdan-no-ma* is a step higher than that of the other rooms. On the walls are paintings attributed to Kanō Tan'yū and his followers. The architectural metal fittings, colorful wall paintings, and the coffered double-*oriage* ("bent upward") ceiling with its brilliantly painted and gilded floral designs present an accurate impression of the ultimate in military interior design of the seventeenth century.*

20 (overleaf). Audience hall *(taimensho)*, Nishi Hongan-ji, Kyoto. 1630's.

In this vast room, which is two hundred *tatami* mats (approximately 395 square yards) in size, many distinguished worshipers have gathered for meetings with the chief abbots of the temple. There are three floor levels within the room and the relief carvings of storks on the transoms *(ramma)* just below the ceiling have earned the room another name, *kō-no-ma,* or "stork room." Because of the immense size, the interior tends to be dark most of the time, with reflections of gilded surfaces and the small amount of light that filters in from the outside providing just enough illumination for the richly attired Chinese court nobles painted on the walls of the highest elevation to seem actually alive.*

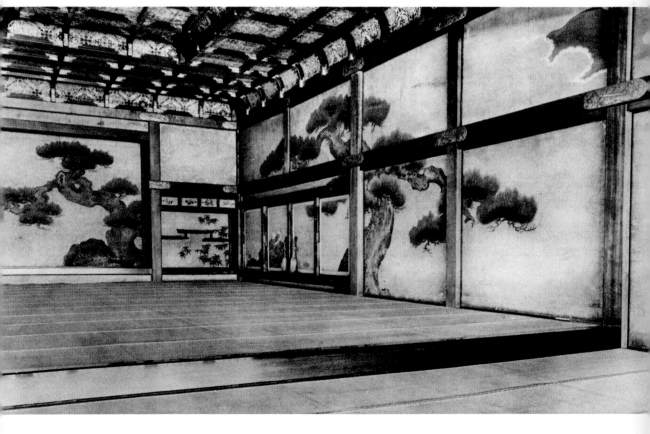

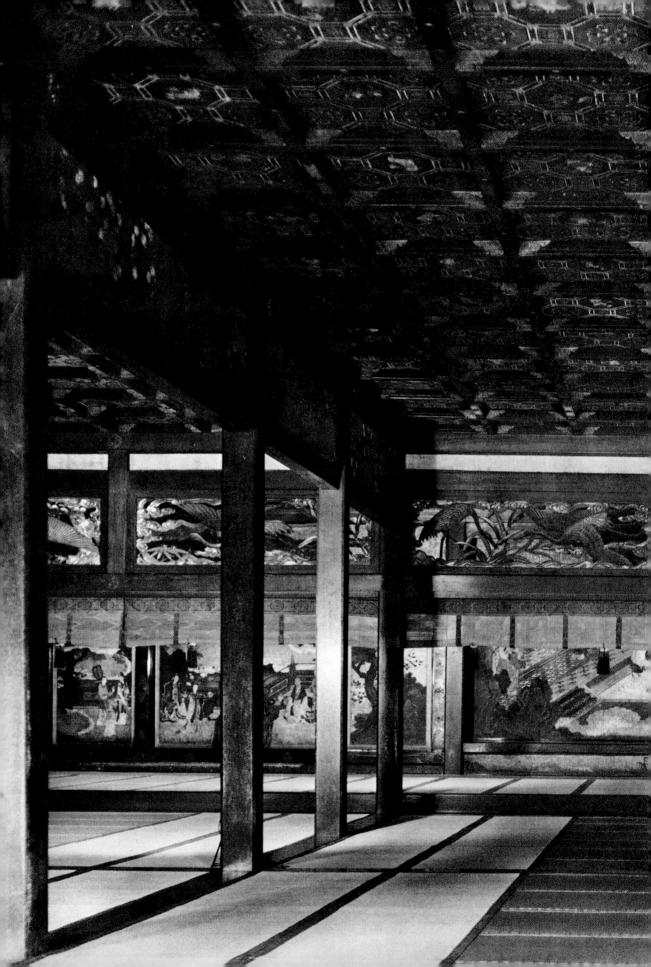

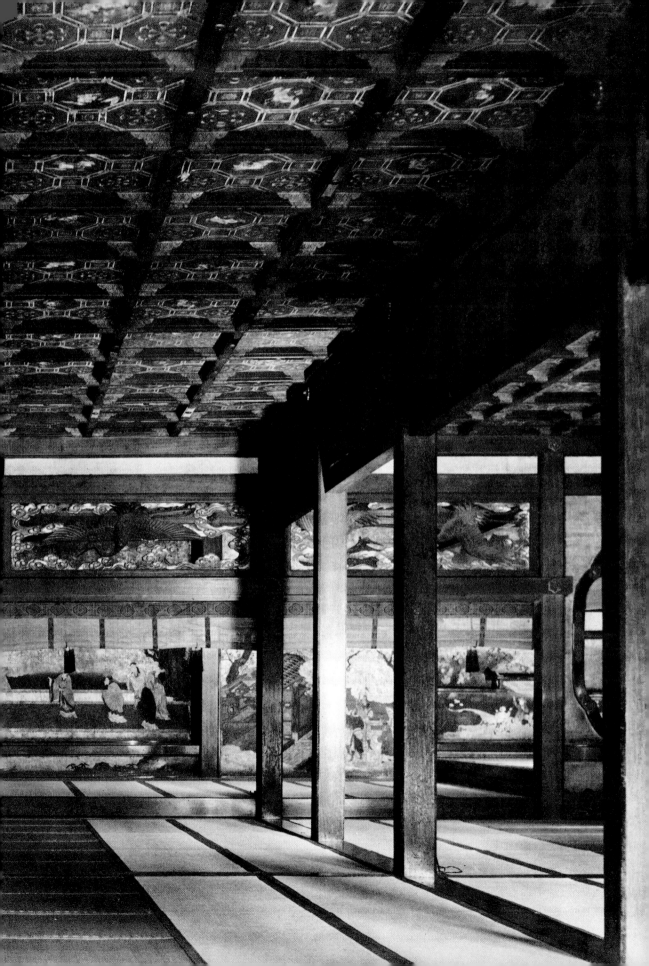

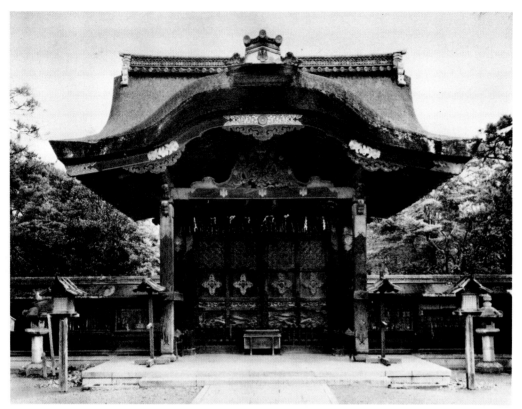

21. *Karamon* of Hōkoku Shrine, Kyoto. Probably late sixteenth century.

This elaborate gate is noted especially for its bold design and decoration that includes a prominent *kaeru-mata* (apron-shaped, decorative wooden piece) between the lintel and roof. In addition to its use as a gate, the *karamon* (''Chinese gate'') was regarded rather as an offering to deities, which could mean great men living or dead, as well as Shinto gods and figures in the Buddhist pantheon.*

22. "Sun and Moon" landscape screen (one of a pair). Kongō-ji, Osaka. Sixteenth century. H. 149.1 cm. (54.5 in.), w. 316.9 cm. (124.2 in.).

This lovely screen and its companion are quite unlike the other decorative paintings of the period in both motif and technique. The rolling hills typical of the Japanese landscape, the patterned water, and the groves of pine trees represented here all seem alive with movement, as though responding to some gay, unheard melody. The mannerisms and Chinese subject matter of Kanō-school painting are absent entirely, and in their place one finds a composition and color scheme (rich blues, greens, warm earth tones, and white accents) that recall scroll paintings of late medieval times. The heavy use of silver and gold is also reminiscent of Momoyama lacquerware design.*

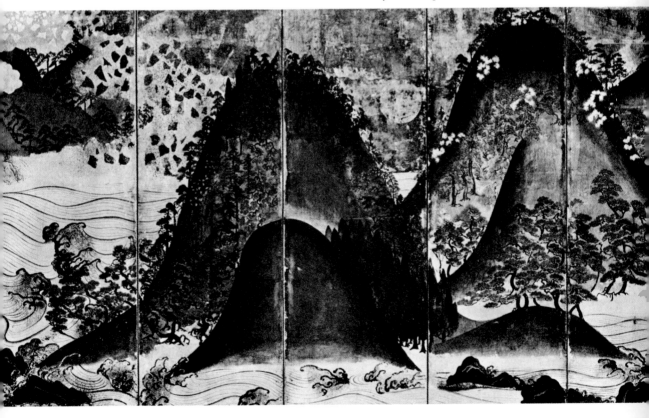

23. "Cypress Trees" *(Hinoki)*, attributed to Kanō Eitoku (1543–90). Eight-fold screen. H. 170.5 cm. (66.8 in.), w. 462.4 cm. (181.3 in.).

The artist of this monumental painting has made every effort to capture the reality of his subject. Against a background-obscuring pattern of gold clouds that break open twice to provide a glimpse of earth, rocks, and deep blue water in the left side of the composition, the principal tree sends out pulsating, snakelike branches to the right and left. Every sprig of foliage is drawn with great precision and the bold forms of trunks and limbs are also brought into very sharp focus. Such emphasis on clarity is not peculiar to this one screen but is characteristic of the decorative paintings done for the interiors of the new castles and palaces of military leaders in the late sixteenth century. (See color plate 3.)*

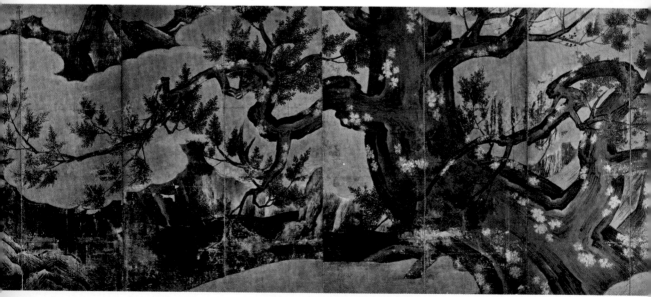

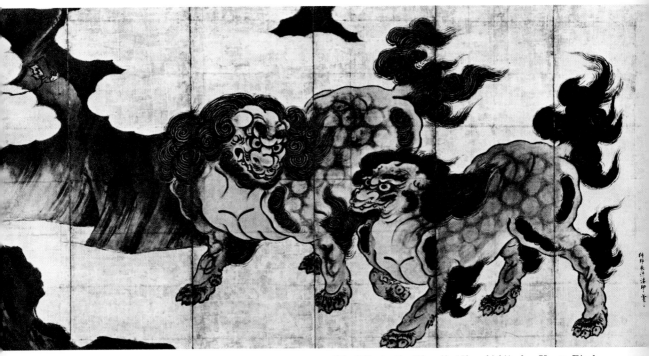

24. "Fantastic Lions" *(Karashishi)*, by Kanō Eitoku (1543–90). Six-fold screen. H. 225 cm. (88 in.), w. 459.5 cm. (180.1 in.).

The subject of two fantastic creatures, a pair of male and female mythological lions, is probably Near Eastern in origin. In Japan they were favorite symbols of feudal authority at various times, but in no other work of art has their majesty been captured so well or on such a colossal scale as in this painting by the great master of the Kanō school in the sixteenth century. They are shown in a majestic setting of rocks and gold clouds, the heavy black outlines imparting a sense of sturdiness and volume to their bodies, and their manes and tails making wispy, flamelike patterns in the wind.*

25. "Pheasant and Plum Tree" *fusuma* attributed to Kanō Sanraku (d. 1635) and his son, Sansetsu (1590–1651). Tenkyū-in, Myōshin-ji, Kyoto. H. 184 cm. (72.1 in.), w. 370 cm. (145 in.).

This four-panel painting in the west room at Tenkyū-in shows early seventeenth-century Japanese painting at its best. The principal motifs—the elegant bird, rocks amidst decorative clusters of bamboo leaves and tangles of autumn-colored ivy, and the gnarled tree—are perfunctory and idealized, stripped of weight and depth. The artist has felt no compulsion to extend the branches and trunk of the old plum tree naturally back into space, but has pulled its dramatic shape up close to the surface of the picture where textures, details, and clear tones of color break through the mask of natural shapes to enchant the eye with their beauty. Such an arrangement of ideal images is consistent with the sentiments of an age in which peace and order under the Tokugawa shogunate seemed assured.*

26. "Maple Tree" *fusuma*, attributed to Hasegawa Tōhaku. Chishaku-in, Kyoto. 1593 or later. H. 138.5 cm. (53.9 in.), w. 172.5 cm. (67.6 in.).

In 1590, when Tōhaku was forty-eight, Eitoku and his disciples in the Kanō school were engaged to paint the *fusuma* of the new *sentō-gosho,* the palace of residence that Hideyoshi was having built for the retired emperor. But when the time came to paint the *fusuma* of the accessory buildings *(tai-no-ya),* Tōhaku let it be known through the shogunal official in charge of the palace's construction, Maeda Gen'i, that he would like to take Eitoku's place. His request was denied by Imperial Counselor Harutoyo of Kanshū-ji. At this time Tōhaku was simply known as "that person called Hasegawa." Tōhaku did manage to move into official government service and, in 1593, the Shōun-ji was built as the burial chapel for Hideyoshi's daughter, Sutegimi, and Tōhaku did the painting. It is thought that the famous paintings of maple and cherry trees at Chishaku-in are the remains of that work. (See color plate 4.)*

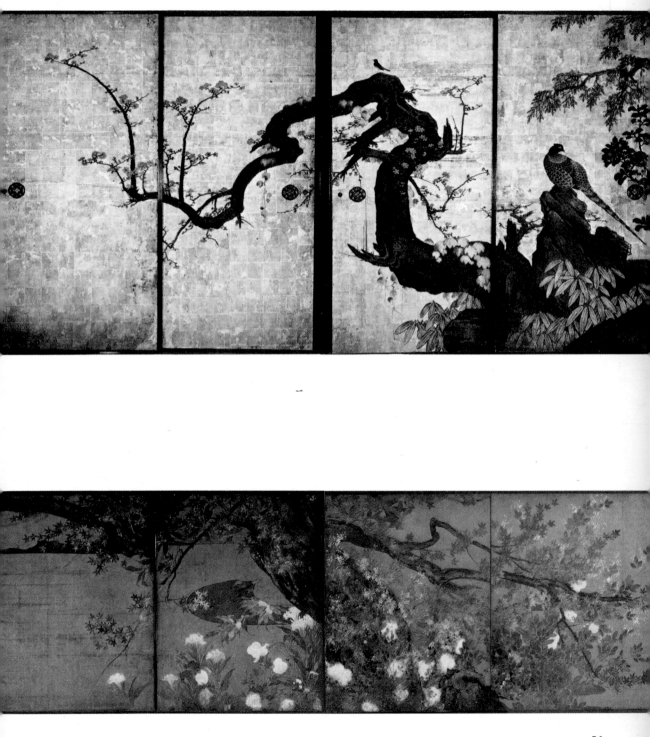

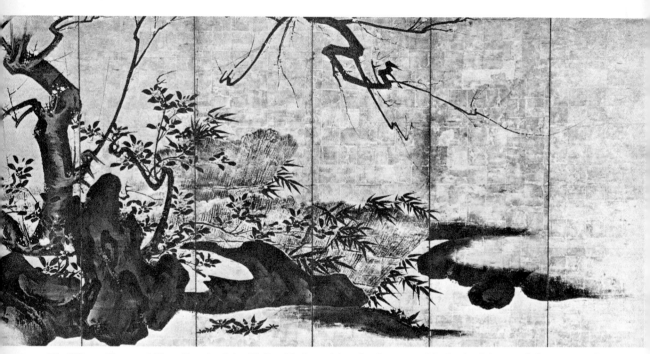

27. "Plum Tree and Tree Peonies," by Kaihō Yūshō (1533–1615). Myōshin-ji, Kyoto. Pair of six-fold screens. H. 177 cm. (69.4 in.), w. 362 cm. (141.9 in.). Most of Yūshō's works are monochrome paintings rendered in powerful brushstrokes and broad ink washes, but he, like Tōhaku, also explored the new fashion of painting in rich colors against gold leaf. In this pair of screens with the dual theme of plum tree and tree peonies, he combined color and ink and retained something of the classic qualities of Chinese ink paintings, much as Kanō artists of the time did, although in such mature works as these Yūshō avoided the pictorial devices he had earlier borrowed from Kanō-school paintings.*

28 (below). "Crows on a Plum Tree" *fusuma*, attributed to Unkoku Tōgan (1547–1618). Each panel: h. 166.3 (65.2 in.), w. 156.06 cm. (61.2 in.).
Only three "colors"—black, white, and gold—are used in this set of sliding doors to capture the stark realism of five black birds on a plum tree covered with snow. The composition is extremely simple. The top of the tree disappears in a cold morning haze that also obscures all but the curved edge of a snow-covered cliff in the background; one of the tree's branches reenters the picture in the top left, creating a dramatic diagonal line that points menacingly in the direction of the birds on the right. The colorful and compositionally complex wall decorations of architectural monuments built for Nobunaga and Hideyoshi gradually were superseded in the seventeenth century by more refined, delicate paintings or by such bold artistic statements as these, which were greatly appreciated by a new generation of military families as symbolic of their own positions of power and dignity in society.*

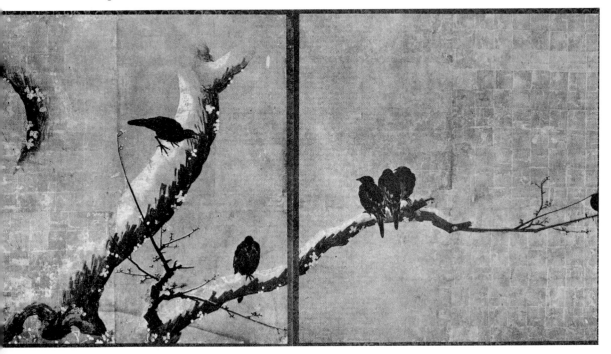

29. Writing cabinet with *maki-e* design of autumn flowers. Late sixteenth century. Cabinet: l. 22 cm. (8.6 in.), w. 31.5 cm. (12.4 in.), h. 38.1 cm. (15 in.). Case: l. 23.5 cm. (9.3 in.), w. 33 cm. (13 in.), h. 37 cm. (14.5 in.).

This portable cabinet with matching case was used by Toyotomi Hideyoshi's wife, who after the death of her husband in 1598 became a nun and lived at Kōdai-ji in Kyoto. It seems likely that she may have personally specified the design motif of autumn flowers used in the decoration of the temple and its furnishings. Both the unusual abundance of gold over black lacquer and the motif of autumn plants are elements of what is known as *kōdai-ji maki-e*.*

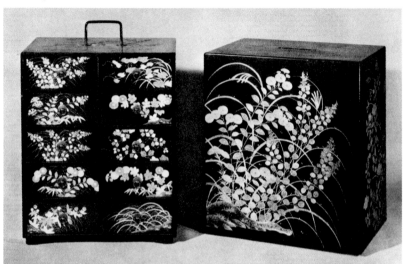

30. Saké pitcher with *maki-e* design. Late sixteenth century. D. 18.5 cm. (7.3 in.), h. 12.9 cm. (5.1 in.). This saké pitcher is also a *kōdai-ji maki-e* piece. The rich design of chrysanthemum flowers and scatterings of paulownia crests rendered in fine gold lines and aventurine (sprinkled gold powder) on a black lacquered ground is handled with the same sense of near abandon that one sees in contemporary paintings, for example at Chishaku-in in Kyoto.*

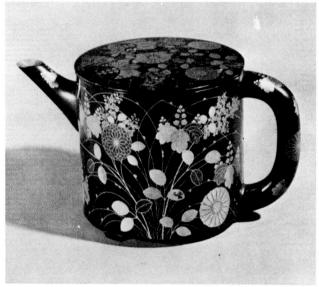

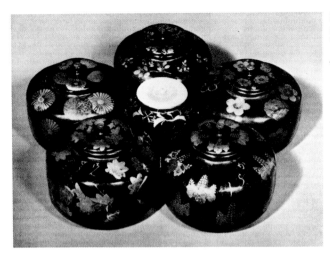

31. Spice container set decorated with *maki-e*. Late sixteenth century. D. 22 cm. (8.7 in.), h. 7 cm. (2.8 in.). This unusual object is made up of six small porcelain jars joined together in the shape of a five-petal plum blossom and coated with black lacquer. The smallest container in the center has an ivory lid; the others are of lacquered wood. Maple and paulownia leaves, chrysanthemums, pinks *(nadeshiko)*, and plum blossoms are the principal motifs in the *maki-e* decoration, and the names of the spices that belong in each container are inscribed in stylish calligraphy.*

32. Letter box with *maki-e* design. Late sixteenth century. L. 50 cm. (19.5 in.), w. 30.9 cm. (12.3 in.), h. 26.6 cm. (10.5 in.).

This box was used as a container for letters, writing paper, and books. The design on the box's lid and on its four sides is composed of large diagonally cut patterns, half of which have a bamboo motif rendered on an aventurine (gold-sprinkled) background, the other half a composition of autumn grasses in gold on black lacquered ground. This type of design was extremely popular around the turn of the century and is referred to as *katami-gawari,* or the "alternating sides" design.*

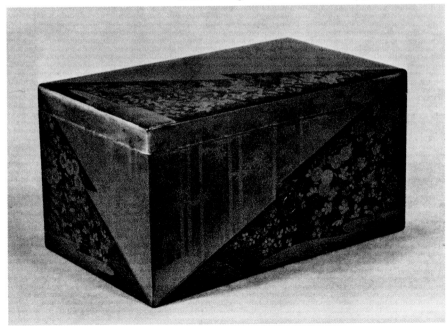

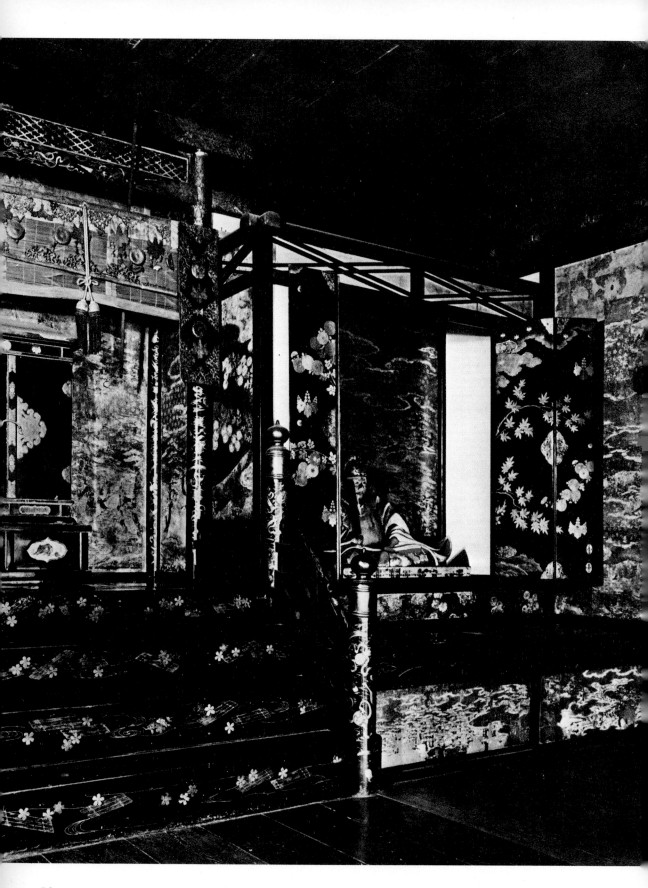

33. Interior of the sanctuary *(tamaya)* at Kōdai-ji, Kyoto.

The Zen temple of Kōdai-ji was constructed for Toyotomi Hideyoshi's wife Kita-no-Mandokoro in 1605, incorporating some of the furnishings from earlier architectural monuments. Kita-no-Mandokoro took religious vows, and, as the nun Kōdai-in, resided at this temple, praying for the peace of her husband's spirit until her death in 1624.*

34. Nō costume, *nuihaku* type. Late sixteenth century. L. 137.6 cm. (54 in.).

The combination of heavy embroidery and gold-leaf appliqué was a common device developed by Momoyama fabric designers to meet the demand for garments that would impart to their owners an unearthly sense of beauty. Nowhere was this beauty better appreciated than on the stage. The Nō actor who wore the costume above, which was made specifically for female roles, could move about the stage with the full assurance that the audience would catch the subtle nuances of meaning in the costume's design in which poetry cards, footbridges, and flowers of the four seasons are spread over alternating panels of vermilion and cream-colored silk. (See color plate 5.)

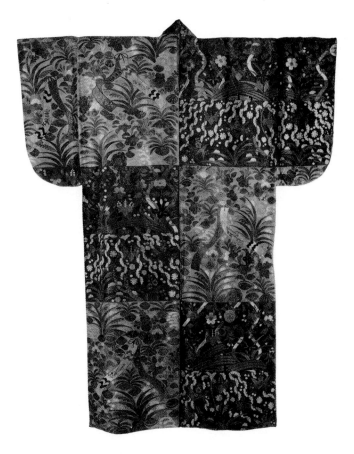

36. *Uchikake*. Late sixteenth century. L. 110 cm. (43.2 in.).

An *uchikake* is an outer garment for women. This silk costume with tortoise-shell pattern rendered entirely in embroidery and gold and silver appliqué was most likely worn by Kita-no-Mandokoro, the wife of Hide-yoshi. The contrast between the dense and formal design of this garment and the boldly simple one of the *dōbuku* in figure 35 could hardly be greater. The former is clearly the less modern of the two, an instance where Chinese influence, in this case, of Ming embroidery, has not been fully assimilated.*

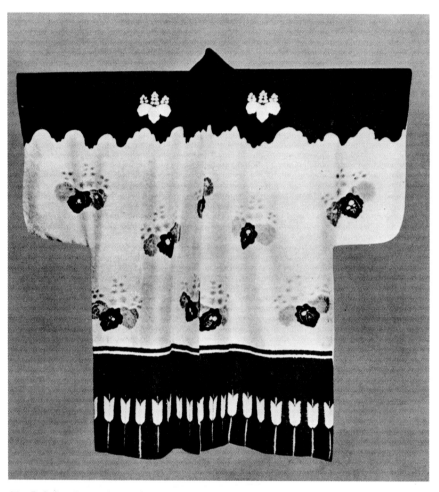

35. *Dōbuku*. Late sixteenth century. L. 109.6 cm. (42.5 in.).

It has been suggested that this *dōbuku* (a short coat for men) was possibly worn at one time by Toyotomi Hideyoshi himself. The sole means of creating its designs was the extraordinarily difficult tie-and-dye technique associated with the term *tsuji-ga-hana*. The paulownia crest of the Toyotomi family is the prime motif in the design: those spaced across the purple ground of the upper portion of the garment are done in reserve pattern, while those scattered over the neutral color of the midsection are in shades of yellow, purple, green, and pale blue.*

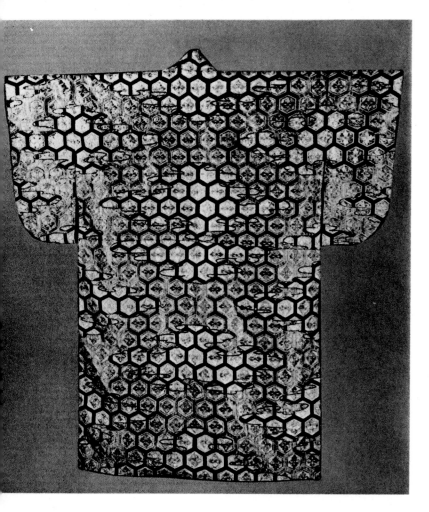

37. Matching sword set. Early seventeenth century. Long sword, 95.1 cm. (37.3 in.); short sword, 61.9 cm. (24.3 in.)

Throughout the Early Modern age it was the fashion for the samurai to wear matching long and short swords. This pair of swords was presented to Mizoguchi Hōki-no-kami, daimyo of Shibata, Niigata, by Hideyoshi around the turn of the century. Two strands of gold coils varying in width are wound around the red lacquered grounds of both scabbards, the subtle difference between them being only that the order of the wide and narrow coils is reversed in each case. Swords of this type often appear in seventeenth-century genre paintings. (See color plate 6.)*

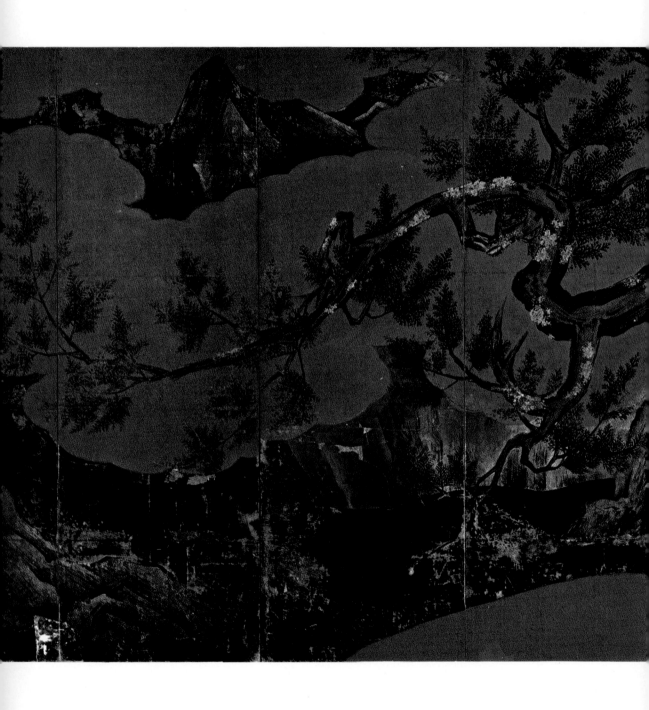

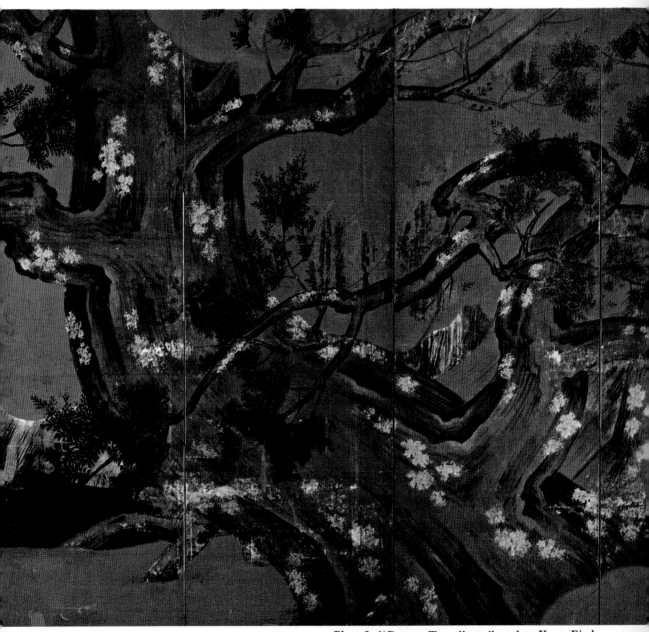

Plate 3. "Cypress Trees," attributed to Kanō Eitoku (1543–90). (See also figure 23.)

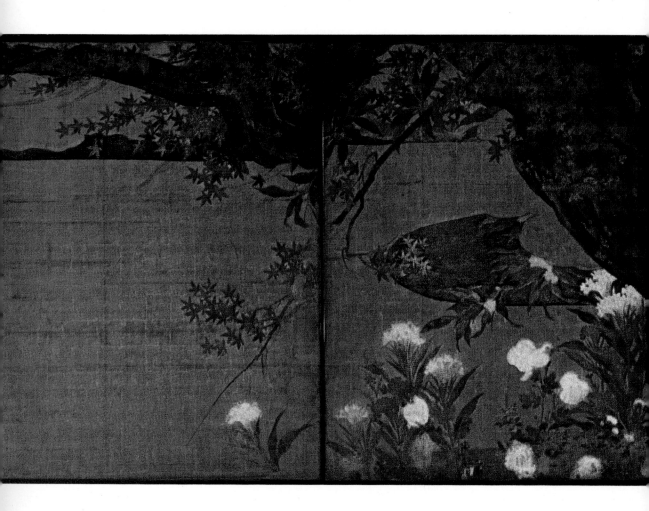

Plate 4. "Maple Tree," attributed to Hasegawa Tō-
haku. 1593 or later. (See also figure 26.)

Plate 5. Nō costume, *nuihaku* type. Late sixteenth century. (See also figure 34.)

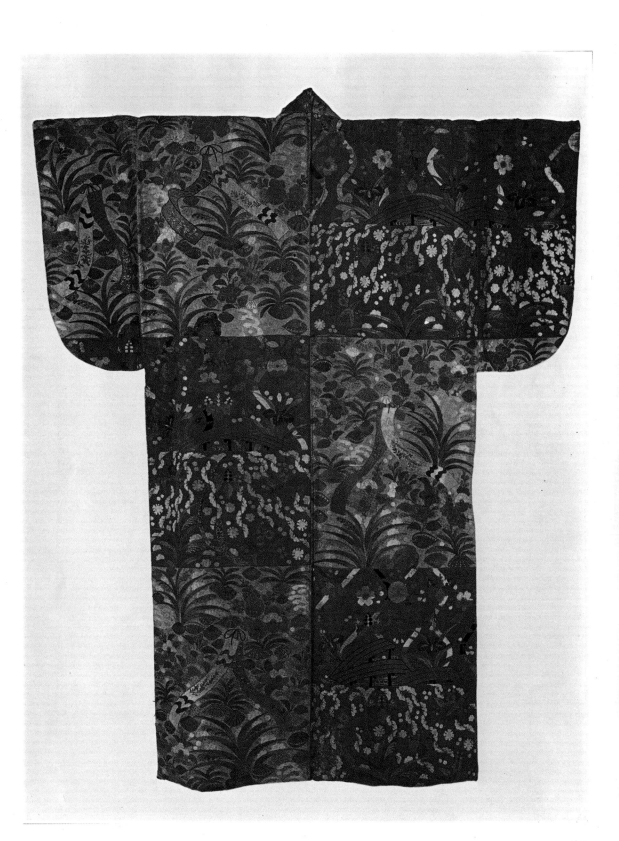

Plate 6. Matching sword set. Early seventeenth century. (See also figure 37.)

3

PUBLIC PLEASURES

The dawn of secularism at the end of the sixteenth century brought light to the lives of not only the military leaders and nobility, but to Japanese from the lower classes as well. Families of merchants, farmers, and craftsmen also pursued pleasures that had long been denied them by poverty and religious restrictions, and these classes steadily grew in social strength as they shared in the affluence brought by peace and political stability. The gaiety, optimism, even the boastful extravagances of the upper classes were testimony that life was not actually ugly or painful. The peace that came to Japan at this time was far more than a lack of war; new values that allowed for joy and hope took root, and dispelled the fears that for centuries had overshadowed the lives of the Japanese. For life had long been grim for most people, who had to live within narrow boundaries dictated by social station and an austere religion, and who were constantly endangered by the battles all around them. Death promised no relief, for it meant a hell of endless agonies, and indeed fear of death was another of life's burdens. When the military leaders came to power, they did more than bring order to the country: they liberated the lower classes from a tradition of fear and anonymity, and provided them with a new outlook and identity that were to pervade Japanese life and art from that time on.

Matsuri

Beginning with Hideyoshi, the new leaders made their benevolence known by holding numerous festivals *(matsuri)* in the territories under their control. These were joyful occasions for everybody. From ancient times, religious festivals had provided bright moments in the humdrum life of the townspeople—rare times when everyday cares were forgotten. The people had been spectators at such affairs; now they were directly involved in the festivities. Often colorful dramas were staged, with townspeople playing leading roles. The very spontaneity of these events added to the pleasure they brought the people, for the *matsuri* were not confined to or predicted by a religious calendar, or by changes in the seasons. Certain places gradually took on the character of pleasure resorts, and indeed some of them have remained through present times as holiday towns where people now go to relax without needing the excuse of a festival.

Some of the *matsuri* themselves became traditional events. Today in Kyoto one can still see the *Gion Matsuri*. This gay festival, which dates to the sixteenth century, is highlighted by a procession of very old floats or carriages, one from each area of the city that by tradition has had a part in this festival since it was first held. A stroll along Shijō Street on the night before the procession is a time-honored custom. Here the close contact with the ancient floats being readied for another showing provides ties with the past. Even the overhead trolley lines are not allowed to interfere with the occasion; they are taken down so the tall masts of the floats can pass by unhindered.

Somehow one gets the feeling that Nobunaga, Hideyoshi, and the other leaders were not just showing off with these festivals. It appears that they took real pleasure in seeing their subjects happy, and they joined in the merrymaking themselves. On New Year's, 1578, Oda Nobunaga took a great crowd of people into the principal buildings of Azuchi Castle and entertained them with a brilliant military review in the courtyards; it seems rather amiss to interpret this as no more than a crass show of power. Similarly, a great tea ceremony given by Hideyoshi at Kitano Shrine in 1587 was not so much a display of his own affluence as it was a sincere effort to encourage and support the new standards of beauty being promulgated by the best tea masters and other artists of his day.

GENRE PAINTING

Around the beginning of the seventeenth century, genre painting came into its own. By definition a realistic treatment of subjects from everyday life, genre painting theretofore had been an incidental part of narrative scrolls, providing background in stories illustrating events in the lives of famous heroes and saints of the past. With the birth of the Early Modern period, the emphasis came to be not on history, but on the present, with its radically new customs and beliefs.

From the ranks of the Kanō school came several artists who looked to the world around them for subject matter, rather than to the past or to the continent, which was the primary source of inspiration for the Kanō school in general—either through the religious paintings of Chinese Buddhism and Confucianism, or genre pictures of peasant life in that "most perfect Central Land," China. One of those Kanō artists was the great master Motonobu's son, Hideyori, who is believed to have done the screen painting "Maple Viewing at Takao," which is among the finest of all Japanese genre pictures in existence. It shows picnickers and sightseers enjoying the lovely autumn foliage of a still-famous area northwest of Kyoto (and no doubt at one time had a companion showing a springtime scene, since spring was generally contrasted with fall, and since it was traditional that screens be executed in pairs). It is significant that the people represented in the painting are not members of Chinese court society or famous priests or sages, but common people, citizens of Kyoto, out for a day in the mountains. If the painter of this screen was Kanō Hideyori, the patron must surely have been an important man: to be able to choose an artist from Kanō ranks was to be in a class with shoguns and princes. Clearly, both artist and patron were dissatisfied with conventional Chinese-style pictures, and with Japanese-style pictures of ancient themes; they preferred instead a lively genre painting that celebrated the pleasures of the modern era in Japan—a painting style that was self-directed, familiar, and wholly of this world.

Another Kanō artist, Eitoku's younger brother Naganobu, painted a pair of screens known as "Amusements under the Cherry Trees," most likely for some high-ranking

person in commemoration of a spring banquet held at his mansion, a party attended by military men and their friends. The work shows detailed, presumably accurate scenes of men and ladies dancing, carriage bearers at rest, and women preparing refreshments.

A work that resembles Naganobu's "Amusements" shows the figure of the aging Hideyoshi at a cherry-blossom-viewing party he gave at Daigo-ji (near Kyoto), a party of considerable renown in Japanese history. Knowing his life was drawing to a close, the great lord invited hundreds of friends and followers to join him in viewing the many varieties of cherry trees in bloom, for it was believed that people's hearts could be united through communion with nature's wonders. Hundreds of paintings must have been commissioned by the regent's guests, to honor the memory of the day spent strolling about the grounds of Daigo-ji, sharing the beauty of the cherry blossoms, and of the chapel and garden called Sambō-in. (As was true for many of Hideyoshi's architectural treasures that were modeled after, but often surpassed, various parts of the Imperial Palace, Sambō-in was a more lavish version of the *dairi* of the Gosho.)

There is no record of who commissioned either the screen of "Ladies under the Wisteria Trees" or the picture (now mounted as three hanging scrolls, but originally a single-leaf screen) of a *maiko* dancer surrounded by admirers. It seems quite likely that he was some important lord, and that the paintings were meant to capture actual events in his life.

RAKUCHŪ-RAKUGAI

Closely related to the genre paintings, which people treasured as permanent records of special occasions, is another kind of painting that became popular in the sixteenth century. Large six-fold screens known as *rakuchū-rakugai* pictures cleverly functioned as decorative guide maps to the many historic places and ancient temples and shrines in Kyoto. Besides providing a colorful spectacle in an interior setting, their presence in a home signified affluence and modern tastes. One of the earliest and best examples of *rakuchū-rakugai* screens is a pair that is believed to have been painted by Kanō Eitoku on the command of Nobunaga, who presented them to a powerful lord in the eastern provinces.

In some varieties of *rakuchū-rakugai* pictures, famous landmarks are the major item of interest; in others (there are twenty-one pairs of these screens extant) the focus is on the daily lives and the festivals of the townspeople. The pair attributed to Eitoku belong in the latter category. The charming little groups of brightly costumed figures constitute historically valuable vignettes of life in the capital around 1570.

Examples can be found of paintings that are equally exacting in their presentations of famous places and local customs in other towns, particularly Osaka and Ōmi. In all of them one feels the pride of the artist as he fills his picture with the new activities that were the townspeople's to enjoy in the modern age. Through a filigree of gold cloud patterns, one sees crowds of happy people watching Kabuki and Nō performances, others playing games, walking in processions or riding on colorful floats, or contentedly going about their daily business.

Hideyoshi died in 1598 and his shrine Hōkoku Jinja was completed in March of the following year. In early August, 1604, there was a special festival held at the shrine to commemorate the seventh anniversary of his death. At the time, the Toyotomi family was still powerful and commanded the respect of the entire nation. For the millions of Japanese to whom Hideyoshi had been a kind of demigod, there could not have been

a more appropriate way to honor his memory than to hold a spectacular festival. Citizens of Kyoto worked night and day to make this occasion the gayest, most colorful affair the capital had seen since their great hero's own parties had overflowed into the streets. Several works of art that have survived vividly reveal some of the activities that were enjoyed in the city during eight days and nights of merriment. One of them is a pair of screens by a painter named Naizen (by adoption, a member of the Kanō school, and thus often called Kanō Naizen), a militaryman turned artist whose career was a result of personal interest Hideyoshi had shown in his work. Performances of Nō, of *sarugaku* (the early form of the farce-plays known today as Kyōgen), and of colorful dances that took place at the height of the festivities are depicted on the left side of Naizen's screens. On the other side, one can see the entertainment going on in front of the great Buddha Hall that Hideyoshi had built on the site occupied today by the Kyoto National Museum.

We know from documents that the imperial family was similarly engaged in celebrations at the palace in the center of Kyoto, but the people who had the greatest cause for rejoicing and who surely enjoyed themselves the most were the newly wealthy townspeople. Their counterparts appear in paintings of festivals in Hideyoshi's honor held at shrines in other parts of the country—at Ōmi, Chikubushima, and as far away as Itsukushima.

POPULAR ENTERTAINMENT

In the early years of the new age of secularism, professional craftsmen and showmen traveled from town to town, performing and setting up amusement booths whenever and wherever a festival was to take place. Before long, these people began to settle permanently in one town or another, and in Kyoto they selected as the locus of their operations the area around the intersection of the two main avenues of Kawaramachi and Shijō. Today one can browse here in very old shops and large modern department stores by day, and find amusement and relaxation in theaters, bars, and restaurants by night. The craftsmen and performers occupied a very low position in Japanese society initially, and were not allowed to perform outside the area set aside especially for them. But since their area became the meeting place for everyone in the city, the restriction was of little consequence. Besides the public performances of plays, music, and dancing, one could see there many strange and interesting things, including imported goods and animals— even, on occasion, foreigners, the most exotic sight of all.

This bustling center of Kyoto's entertainment world was a favorite theme of the townsmen-painters who lived within it, and of patrons who bought their work, delighted to have such attractive souvenirs of this improbable circus. In the center of one of these pictures are some wide-eyed spectators whose expressions of childish bewilderment and fascination are readable across the centuries as very human reactions to a life full of wonderful surprises. In time, the obvious importance of Kawaramachi's pleasures to Kyoto society was recognized, and means were sought to perpetuate them. By the turn of the century, permanent theaters were built, and flowers and trees were added to enhance the charm of the meandering streets and canals.

These theaters housed a variety of dramatic and musical entertainments. Nō had been the important dramatic form developed in the fourteenth and fifteenth centuries. In the sixteenth century, it became the favorite of shoguns and powerful military men, and as it took on further refinements of style and presentation, it came to be

regarded as the proper type of dramatic diversion for the noble class in general.

The common people were for the most part unmoved by the subtleties of Nō drama. For them a form of dancing known as *fūryū-odori* was more meaningful. Hundreds of dancers in fancy costumes, dancing in large circles, singing and playing instruments, created these spectacular pageants of color, sound, and movement. *Fūryū-odori* ("elegant dancing") was a national folk dance of sorts, and by its very nature was simple and rather improvisational. It was by no means in the same class with the intricate dances performed by the young girls of *okuni-kabuki,* a rather bizarre form of theater that had suddenly become very popular because of the girls' somewhat mystical origins and their strange manner of dress. The first of these dancers were, so the story goes, virgins of the Great Shinto Shrine at Izumo, who were exceptionally skilled in singing and dancing. Later, as performers, they commonly disguised themselves as men—or as anything other than the traditional Japanese female. They were never more awesome than when they wore the habits and carried the rosaries and other paraphernalia of the Western clerics, whose presence in Japan had aroused the curiosity and excited the imagination of the Japanese as nothing else in memory. The actions of the girls on stage gradually became more important than their odd disguises, and a unique type of dance-drama *(onna-kabuki)* was born. In the main figure of the picture known simply as "Dancing," we have a delightful portrait of one of these young actresses at work. (Despite the apparent similarity in names, *onna-kabuki,* which is no longer practiced, is only distantly related to the famous all-male Kabuki theater, which is discussed in chapter 7.)

Yuna and Yūri

One favorite subject of genre painters of this time is noteworthy for its social implications, and that is the prostitute. Prior to the Early Modern age, prostitution was almost negligible in Japan. Sexual promiscuity, whether in a man or woman, was not particularly frowned upon at any time in Japanese history, but the rare woman who sold her favors had been the object of bitter and scornful criticism. The prostitute had been a social cripple who could never hope to be accepted as anything more than a contemptible subhuman. But the optimistic warmth that radiated throughout Japan at the end of the sixteenth century included even the unhappy prostitute in its glow, and her existence came to be not merely tolerated but even lauded. In addition to the justifications for prostitution familiar to the Western world was a new one: it provided income, shelter, and taught social graces to the many young girls that the war had left without families or homes.

In the provinces, young girls could enter the profession by becoming *yuna,* whose duties in the public bathhouses consisted of making male customers' visits as exciting and pleasurable as possible. In the cities, there were many avenues to harlotry besides working in the public bath, which for the more sophisticated or sentimental must have seemed unnecessarily crude and lacking in the proper romantic intrigue.

Ladies of pleasure appear again and again in paintings of the time as evidence of their acceptance in society. Compared to the fragile, passive ladies of the court, these girls are quite round of face and figure, and are often quite animated. This may reflect both the fact that many of them were of peasant stock and the fact that men's changing tastes broadened the concept of a beautiful woman.

By the middle of the seventeenth century, "pleasure houses" had become an accepted part of Japanese life. Their organization had become very complex, each house

catering to a clientele of a certain social class, and all of them nestled together in one particular part of town *(yūri)*. The day of the red-light district had arrived. Visitors to Japan who may have seen the brothels in Tokyo's Yoshiwara before it was abolished, each with gaudy curtains and neon signs announcing the house specialty, will be surprised by the subdued atmosphere of Kyoto's Sumiya, as will anyone for whom the term "brothel" conjures up visions of antebellum luxury. The only remaining example of a seventeenth-century brothel, Sumiya is thought to be typical of its time, following rather conventional ideas of residential and tea-house architecture. Pictured in chapter 5 amidst various tea houses, Sumiya reveals its special purpose only by occasional feminine touches in the design of screens and windows, and is today preserved as an unusual relic of an age when life on all levels was less hectic than the present one seems to be.

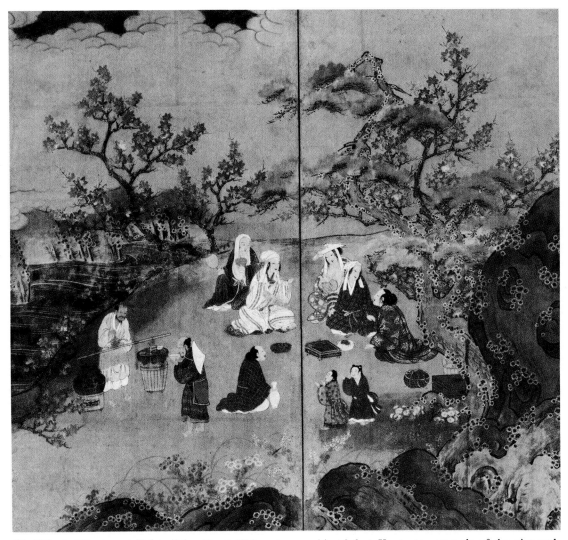

38. "Maple Viewing at Takao," by Kanō Hideyori. Detail. Sixteenth century. Six-fold screen. H. 148.1 cm. (58.1 in.), w. 363.9 cm. (142.7 in.).

The Mount Takao area to the northwest of Kyoto has for centuries been one of the most famous places in all Japan for viewing autumn foliage. (It is also the setting for two of the ancient temples discussed in Volume I, Jingo-ji and Kōzan-ji.) In the painting one finds groups of colorful figures representing not the Chinese heroes and sages of the past (whom Kanō artists usually chose as subjects) but Kyoto townspeople of the sixteenth century, dressed in contemporary fashions, doing ordinary things (the scene of the young mother nursing her baby is particularly charming). The early formulation of this theme by a Kanō-school artist reflects trends that were already manifesting themselves, both with regard to the important position townspeople were to occupy in Japanese history after the turn of the century and to the later popularity of this type of genre painting. (See color plate 7.)*

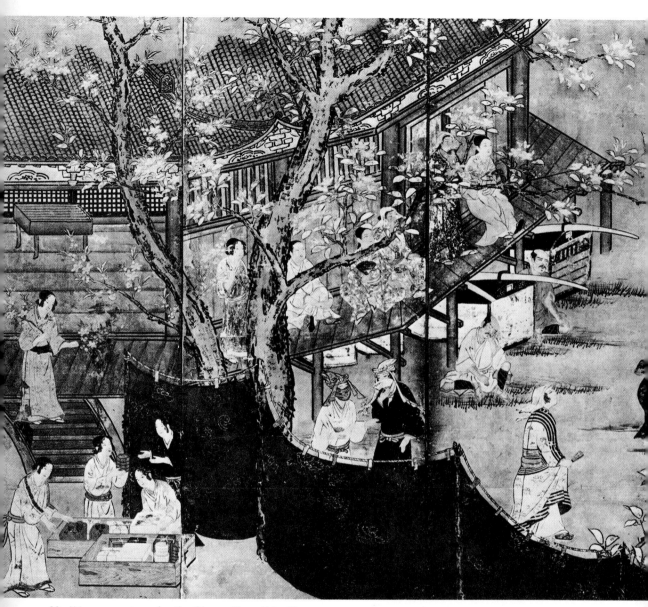

39. "Amusements under the Cherry Trees," by Kanō
Naganobu (1577–1654). Pair of six-fold screens. H.
149.4 cm. (58.6 in.), w. 356.1 cm. (139.7 in.).

From their vantage point on the porch of a building,
possibly a shrine, a military lord and his companions
are observing a group of young samurai dancing under
large cherry trees in full bloom. A palanquin-bearer
dozes beneath the porch while his comrade sits nearby
watching the festivities with a bored expression on his
face. In the lower left behind a curtain, servants are
busily preparing lunches for everyone to enjoy after
the dancing stops. One cannot help feeling that spring
is in the air and that the people are truly content. A
noblewoman and her ladies-in-waiting are the subjects
of the other screen, which has led some art historians to
theorize that the two screens have to do with the young
Toyotomi Hideyori (the "military lord" of this painting)
and his beautiful mother, Yodogimi.*

40 (overleaf, below). "Cherry Blossom Viewing at Daigo" (detail). Artist unknown. Late sixteenth century. Six-fold screen.

The subject of this painting is the famous party hosted by Toyotomi Hideyoshi at Daigo, southeast of Kyoto, in March of 1598. In the past Hideyoshi had devoted himself to similar affairs, including a grand public tea ceremony at Kitano Shrine, a party at his new mansion, Juraku-dai, for the emperor, cherry blossom viewing at Yoshino and a Nō performance at Kōya-san. But the amazing story of the boy from a peasant family near Nagoya and of his successful struggle to become a warrior, a great military hero, and finally to be in control of the entire country really ends with this party at Daigo: towards the end of the summer of that same year Hideyoshi died. In the painting above the aged leader is shown gesturing to some of his comrades who stand on the other side of a small footbridge. One servant holds a parasol over his head, while others bring his belongings, and a woman, perhaps his wife Kita-no-Mandokoro, walks at his side. His consort Yodogimi and their son, Hideyori, were also in attendance. The entire area of 16,400 square feet was cordoned off and guarded by thousands of soldiers. In the refurbished temple of Sambō-in and in a number of temporary pavilions set up on the grounds guests were served tea and encouraged to reminisce about the military experiences they had shared together.

41. "Ladies under the Wisteria Trees" (detail). Artist unknown. Late sixteenth century or early seventeenth century. Two-fold screen. H. 131 cm. (51.4 in.), w. 162 cm. (63.5 in.).

The full composition of this painting shows seven women and three little girls admiring the lovely blossom-laden branches of wisteria trees growing alongside a pond. The wisteria, which is rendered in gold and silver impasto, and the three figures in the detail are painted with a naive dedication to precision that precludes an acquaintance with established painting styles. It seems likely that these screens were done by a professional painter living in Osaka or Sakai. Such pictures of local beauties were the forerunners of the later "courtesan paintings" that were so popular in Edo. (See color plate 8.)

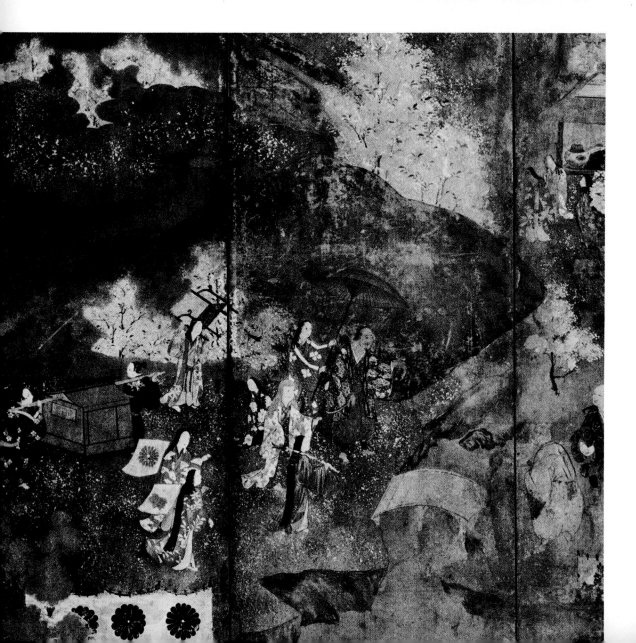

42. The *yamaboko* parade of the *Gion Matsuri*.
The illustration shows the procession of the colorful floats known as *yamaboko* that passed over the streets of Kyoto on July 17, 1964, as they have since the festival was first held in 869 when a float with sixty-six halberds planted on a mountain-shaped platform was presented to the Yasaka Shrine in hopes of bringing an end to an epidemic of plague. The largest *yamaboko* weighs twelve tons, is seventy-eight feet high, and the diameter of its wheels measures ten feet. The strength of forty men is required to draw it through the streets.*

43. The *yoiyama* part of the *Gion Matsuri*.
This event takes place on the evening of July 16, marking the beginning of the *Gion Matsuri*. Numerous lanterns are lighted and placed on the top of the *yamaboko* that line the streets before the next day's festivities start. Visitors are allowed to inspect them to the accompaniment of lively *Gion-bayashi* music that can be heard far into the night as throngs of people mill through the shops and eat the hot hors d'oeuvres specially prepared for the occasion.*

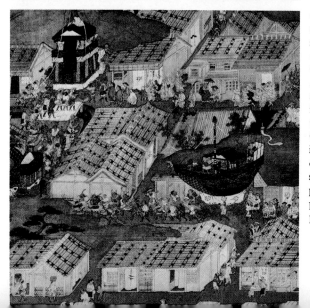

44. "Sights In and Around the Capital" *(Rakuchū-rakugai)*, by Kanō Eitoku (1543–90). Detail. Pair of six-fold screens. H. 159.4 cm. (62.5 in.), w. 363.3 cm. (103.3 in.).
On close inspection, this painted view of the *Gion Matsuri* as it was celebrated some four hundred years ago seems not so different from the photographs in figures 42–43. It is thought that the screens from which this detail is taken are the same *rakuchū-rakugai* screens Oda Nobunaga gave to Uesugi Kenshin in 1574. The illustration above is but a tiny portion of a maplike composition that includes all the famous landmarks, streets, shops, and markets of the capital, plus its people, their customs and dress. The screens are painted in the traditional *yamato-e* manner, using a full palette of bright, opaque colors. (See color plate 9.)*

45. "Pleasure Quarters at Shijō-gawara." Artist unknown. Seventeenth century. Pair of two-fold screens. H. 166.9 cm. (65.4 in.), w. 172 cm. (67.4 in.) each.
In seventeenth-century Kyoto, the one area of the city where townspeople could always find something diverting was located at the intersection of Shijō and Kawaramachi streets. It was there that the theater flourished and there, too, on the dirty banks of the Kamo River, that the more colorful citizens of the capital lived. On almost any day in summer the area must have looked much as it does in the two screen paintings illustrated above: souvenir stalls, Kabuki stages and ticket-booths, pens for exotic animals, fenced-in arenas for archery contests, acrobatics, and cockfights—all made of wood, crammed together and looking as though they had only been set up the night before; throngs of people of all classes milling about; children playing and animals being washed in the swiftly moving but murky water of the river. Prominent in the scene are Kabuki performances being presented by several all-women *(onna-kabuki)* troupes. Signs advertising future performances are displayed at the ticket windows. About the only things missing are the noise and the smell.*

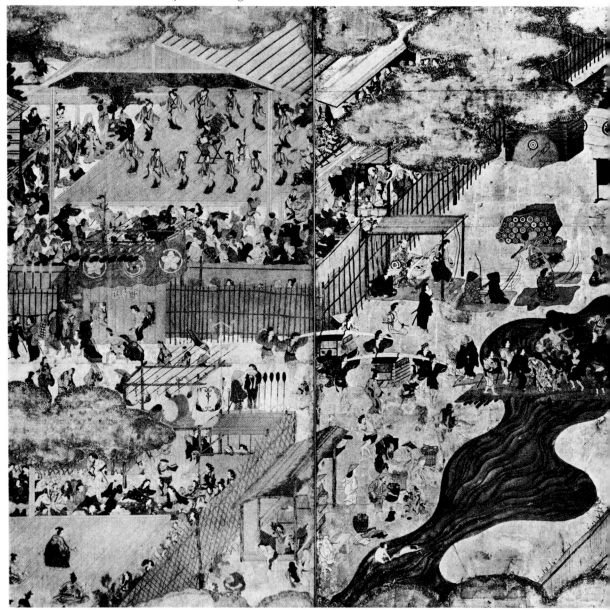

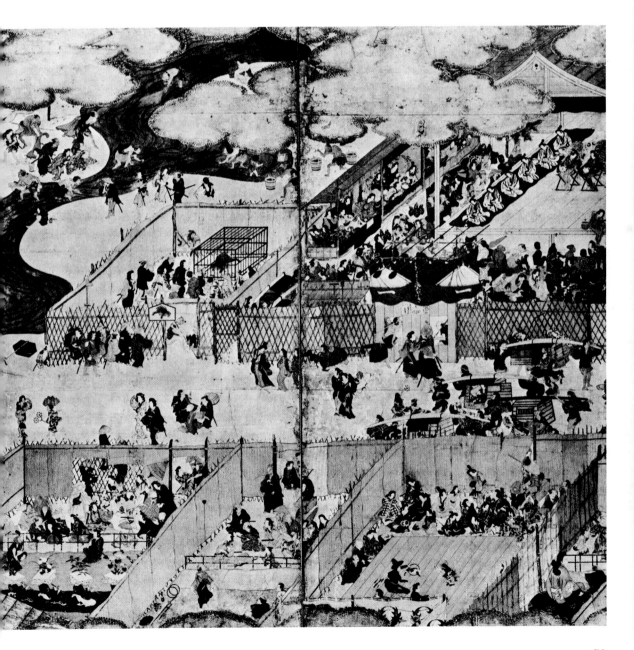

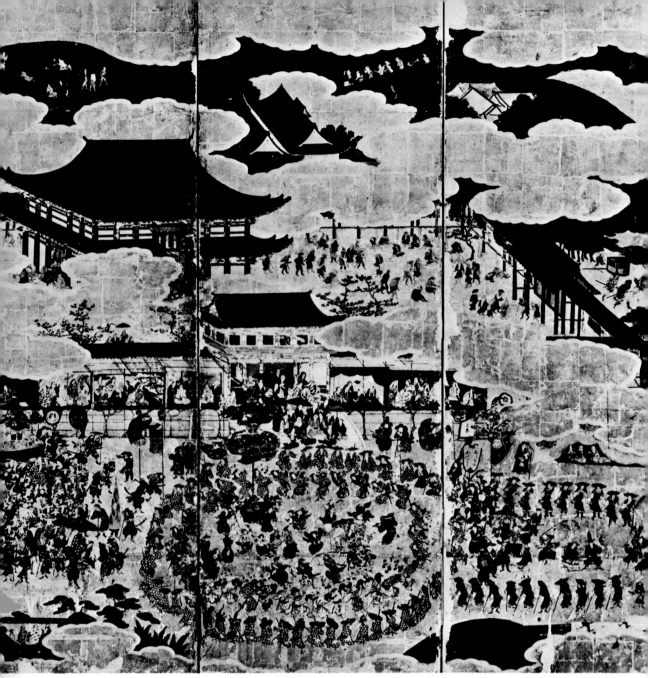

46. "Hōkoku Festival," by Kanō Naizen (d. 1616).
Detail. Pair of six-fold screens. H. 166.9 cm. (65.4 in.),
w. 362 cm. (141.9 in.) each.

By about 1625 it had become common for groups of
dancers from the patrician families in Kyoto to be par-
ticipants in public festivals. They competed among
themselves in performances of the folk dances known as
fūryū-odori and were enthusiastically encouraged in such
pageantry by a growing merchant class, who also lent
material support to other neglected forms of tradition-
al culture. This painting shows one of these competi-
tions, which was held on the fourteenth and fifteenth
of August, 1604, in front of the great Buddha
Hall established by Hideyoshi in 1589. This was the
occasion of a city-wide festival held in honor of Hide-
yoshi on the seventh anniversary of his death. The
festivities extended even to the grounds of the Im-
perial Palace itself, where the emperor and his court
were entertained by similar dances at the Shishin-den.
Although the dancers in the illustration are all drawn
in the same way, the particular age, station, and cos-
tume of each figure has been carefully observed, which
of course is the hallmark of genre painting.*

47. The *Album of Genre Paintings:* "Activities of The Twelve Months." Artist unknown. Early seventeenth century. Each leaf: 32.7 cm. (12.8 in.) × 28 cm. (11 in.).

Life in Japan around the time of the establishment of the Tokugawa shogunate constitutes the only subject matter of the twelve scenes in this album. In the painting illustrated, a group of dancers are performing a dance associated with the month of July, "Meditations on the Life of the Buddha," in the courtyard of a nobleman's residence. Neither of the two basic types of paintings known in Japan up until this time—one having to do with ancient Japanese history and legend, the other with pictures done in the Chinese manner—is related to purely native genre pictures of this kind. From this it is difficult to draw any other conclusion than that here, for the first time in history, contemporary Japanese life was looked upon as noteworthy.*

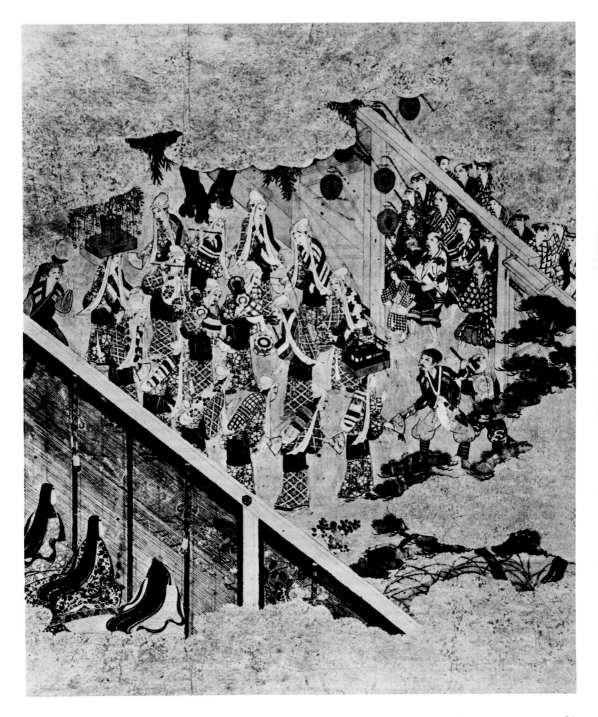

48. "Young Women." Artist unknown. Late sixteenth or early seventeenth century. Pair of six-fold screens. H. 154 cm. (60.3 in.), w. 363 cm. (142.3 in.) each.

These screens, which have long been known as the "Matsuura Screens" because of their association with a family by that name in northern Kyūshū, are typical of a style of genre painting that is thought to have been popular during the Keichō-Genna eras (1596–1624) in Japan. Instead of the more usual genre interest in candid views of the various activities occupying the daily lives of townspeople, the emphasis here is on contemporary costume, the figures serving only as manikins on which gaily patterned kimonos can be seen to best advantage, and the setting reduced to a bare minimum. These screens may very well have been used in a textile shop to illustrate the latest in women's fashions, including such foreign imports as the long tobacco pipe (displayed by the figure on the right in the screen above) and the Roman Catholic rosary (worn as a necklace by the third figure from the right in the lower screen). Proper female activities are suggested by a *go* board, playing cards, a writing box, a set of tea utensils, the *samisen*, etc. Nothing could be further from the earlier aristocratic ideal of female beauty than the appearance of these softly-clad ladies with their round, responsive faces.

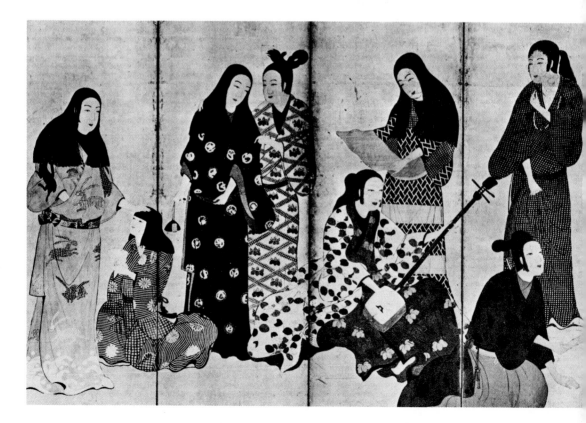

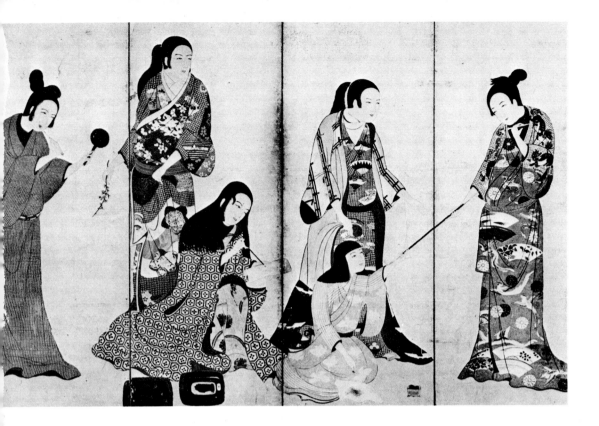

49. "Training Horses." Artist unknown. Late sixteenth or early seventeenth century. One of a pair of six-fold screens. H. 153.9 cm. (60.3 in.), w. 360.6 cm. (141.4 in.) each.

Anything having to do with the life of the samurai was an important aspect of genre painting done in the Early Modern age. The training of horses was very much a part of that life, judging from the sizable number of paintings extant with that subject matter. In this pair of screens, in which there is a total of twenty-one horses and nineteen samurai, it is interesting to note that the horses depicted are clearly not of a domestic breed but are the fine white, reddish-brown, gray, and black Arabians imported by European traders. The artist has managed to communicate their high-spiritedness rather well, and the horizontal distribution of the horses and men across the lower part of the composition sets up a rhythmic, silhouetted pattern of dark colors against gold that is visually quite exciting. The artist of the paintings is unknown, although it is generally assumed that they are the works of a minor Kanō artist of the Keichō era (1596–1615).

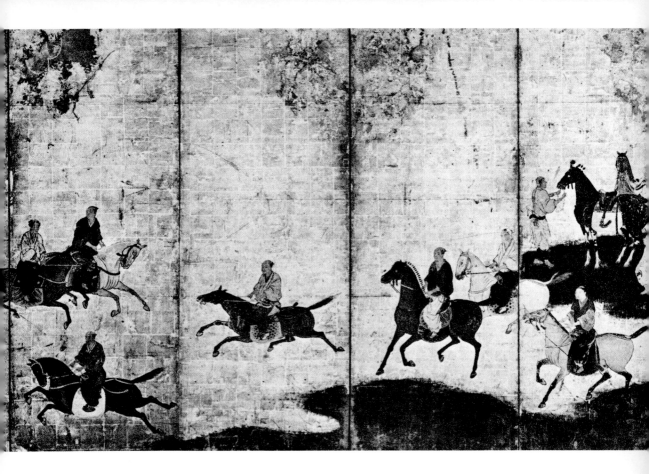

50. *"Yuna."* Artist unknown. Seventeenth century. H. 72.6 cm. (28.4 in.), w. 80.3 cm. (31.4 in.).

The clue to this picture comes from the design in the kimono of the second girl from the left, consisting of large circles in which the character *moku* (meaning "to bathe") is written in bold strokes. Although the artist's name and dates are not known, just looking at the figures leaves little doubt about his own attitude towards *yuna*, the young girls, often from the country, who had to make their living in the city by working in bathhouses. One can almost hear him snicker as he holds up to ridicule the audacious behavior and appearance of these parading creatures who washed people's backs by day and became the playthings of pleasure seekers at night. This painting would seem to date from about the mid-seventeenth century, since later, when public morals were at a more humane level, the same girls were painted with a bit more sympathy and their close descendants in the brothels of Edo with something akin to awe. (See color plate 10.)

51. "Dancing." Artist unknown. Seventeenth century.
Set of three hanging scrolls. Left, 119.5 cm. (46.4 in.)
× 50.3 cm. (19.7 in.); center, 119.2 cm. (46 in.) ×
50.2 cm. (19.7 in.); right, 112.3 cm. (44 in.) × 46.5
cm. (18.2 in.).

The outings and picnics that are so much a part of
Japanese life today go back some 350 years to a time
when large segments of society—with families of lower
ranking samurai and merchants predominating—
were first allowed enough social mobility to acquire a
degree of prestige and leisure time. The three or four
families depicted in the paintings above are from all
appearances members of the military class. Besides the
artist's obvious interest in the intricacies of the dance
that the barefooted *maiko* is performing, accompanied
by *koto* music and fashionably dressed in a short-sleeved
kimono *(kosode)* of the latest fabric and design, it is
also clear that he felt it important to include in his
painting such delightfully candid scenes as that of a
father explaining (by means of an outstretched fan)
the dance to his son, or another, in the lower left, of
three young people reading and smoking.*

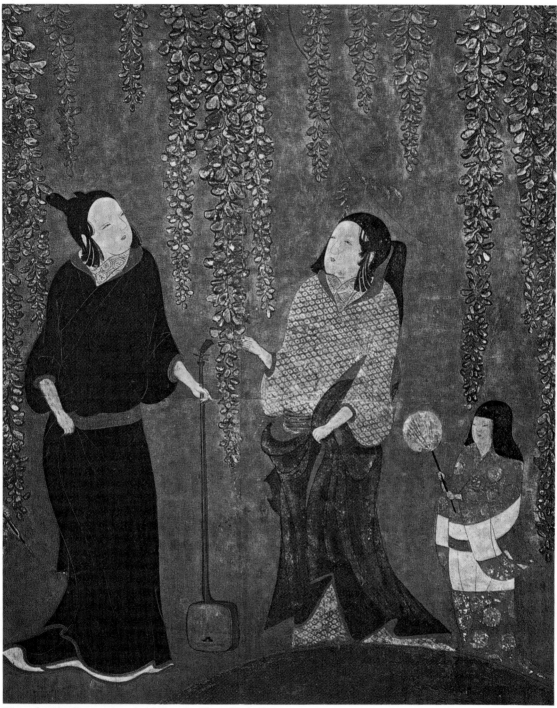

Plate 8. "Ladies under the Wisteria Trees." Artist
unknown. Late sixteenth or early seventeenth century.
(See also figure 41.)

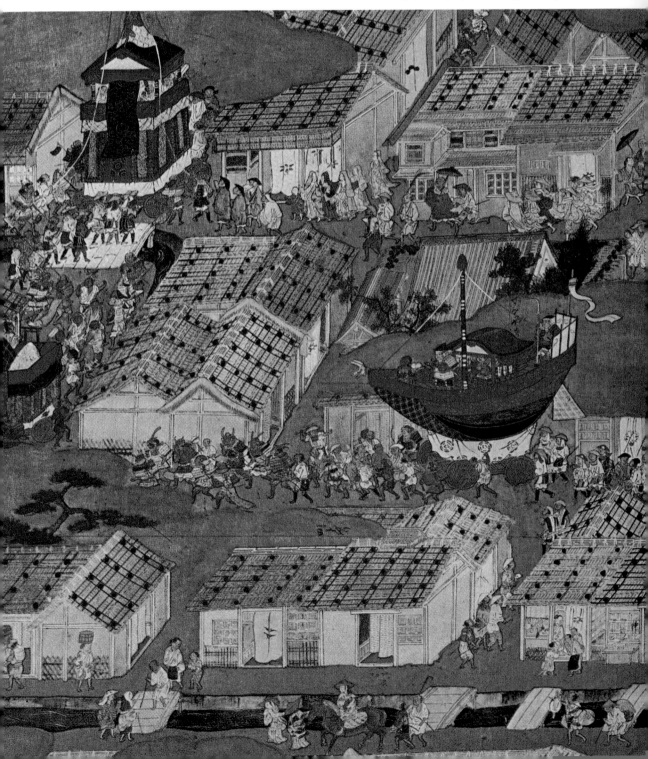

Plate 9. "Sights In and Around the Capital," by Kanō Eitoku (1543–90). (See also figure 44.)

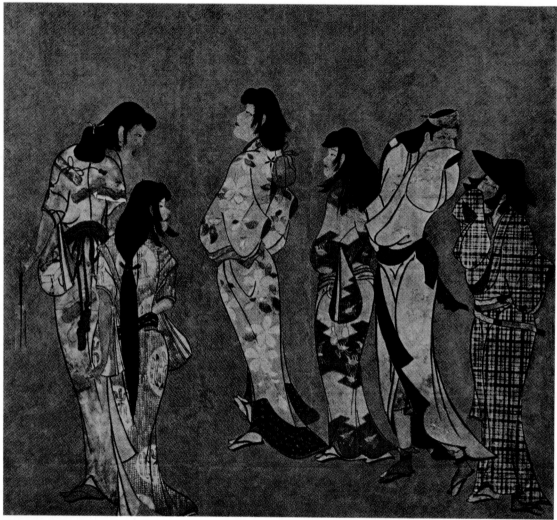

Plate 10. *"Yuna."* Artist unknown. Seventeenth century. (See also figure 50.)

FURTHER DEVELOPMENTS
IN MILITARY ART

During the Ancient and Medieval periods in Japan it was not unusual for important members of the imperial family and of the priesthood to acquire deification after death. Almost every shrine and temple in the country includes an image of Shōtoku Taishi, a prince of the imperial blood who served as regent from 592 to 621. The deification of the Shingon priest Kōbō Daishi (773–835) has been extended to the point that he is credited with an abundance of architectural monuments and other works of art that even a man of his talents could not have accomplished, so that, rather than finding images of Kōbō himself in shrines throughout the country, one finds Buddhist icons attributed to him. In nearly every Buddhist architectural compound can be seen a *kaizan-dō* ("founder's hall"), dedicated to the first priest to serve in that particular temple, and very often the priest's image is enshrined and regarded with as much reverence as any religious icon in the temple.

As the predominantly military government developed in the late sixteenth century, it became the custom for its leaders also to be elevated to positions as deities, and to receive the constant adoration of pilgrims at shrine-mausoleums known as *reibyō*. The earliest of these was the Hōkoku-byō, built for Toyotomi Hideyoshi and dedicated in Kyoto in 1599. When Tokugawa Ieyasu died, his son had a *reibyō* built for him on Mount Kunō, near the city of Shizuoka. It was called Tōshō-gū, or "Shrine of the Eastern Brightness," in a typically immodest reference to Ieyasu himself. A year later, in 1617, a temporary *reibyō* for Ieyasu's remains was prepared at Nikkō, north of Edo, and the elaborate complex one sees there today was finished before the middle of the century. The second Tokugawa shogun, Hidetada, was honored with a *reibyō* at Zōjō-ji in Edo, and two were built for his successor, Iemitsu: one at Kan'ei-ji (which burned in the nineteenth century) in Edo and the other, Daiyū-in, at Nikkō, a short walk from Ieyasu's. In the latter part of the seventeenth century two more *reibyō*, both known as Tōshō-gū, were constructed for Ieyasu at Edo Castle; still others were built throughout Japan for him and his successors until about 1750. After that time the existing mausoleums, which by then numbered in the hundreds, were used to accommodate subsequent Tokugawa rulers.

91

Paintings and plans of Hideyoshi's Hōkoku-byō show that it had all the features characteristic of later *reibyō*—combining elements of ancient tombs, Buddhist temples, and Shinto shrines—and so probably served as the model for later structures. The actual tomb of a *reibyō* is at the rear and innermost part, built in the shape of a small one-storied pagoda *(hōtō)*; in front of this are buildings where are enshrined the *ihai*, the small wooden tablets bearing the posthumous name of the deceased. These buildings containing the *ihai* are always connected together in the *gongen* style, consisting of a front chapel *(haiden)*, a central connecting room *(ishi-no-ma)*, and a sanctuary *(honden)* in the rear. (The *gongen* style is primarily associated with Shinto architecture, but is also found in Buddhist structures.) In front of these buildings, which are usually enclosed by a fence, marked by a large gate, are a water basin, some storehouses and stables, and often a multistoried pagoda.

The Ultimate in Military Art

The present buildings of the Tōshō-gū at Nikkō date from the mid-1630's, the time they were completed under the direction of the third Tokugawa shogun, Iemitsu. During his lifetime Ieyasu had selected the Nikkō area, and requested before he died that his remains be taken there. Today Nikkō is a national park of over 250,000 acres (more than twice the area of Grand Teton National Park in the United States), offering the sightseer a wealth of natural and man-made beauty. In addition to the Tōshō-gū and other temples and shrines are magnificent mountains and forests, Lake Chūzen-ji, the Daiya River, and Kegon Falls. The park is easily reached today by a short train ride from Tokyo, but when the Tōshō-gū was built, the area was remote, and like other out-of-the-way places, it had long been regarded as sacred. The trip from Edo at that time took four or five days of strenuous travel, even during the brief period in summer when cold and snow presented no problem.

After crossing the bridge spanning the Daiya River and walking along a path flanked on either side by giant cryptomeria trees, the visitor approaching Ieyasu's *reibyō* climbs a flight of steps to a stone *torii* that marks the entrance of the Tōshō-gū. Just to the left, the visitor's first experience with the architectural opulence of Nikkō begins with the vision of a fantastic Buddhist pagoda; but what he sees is an early nineteenth-century reconstruction of the five-storied pagoda that another famous warlord, Sakai Tadamasa, had built in 1650. The pagoda's unusual proportions make the hundred-foot structure appear to be top-heavy, an impression that lingers even after the viewer draws near to inspect the gleaming black and red lacquered surfaces of doors and walls, and the detailed, painted carvings decorating the walls below a network of bracketing supporting the first roof.

Leaving the pagoda and proceeding along the stone pathway leading to a short flight of stairs, the visitor passes through a Buddhist guardian gate *(niō-mon)* and finds a group of traditional Shinto buildings—three large storehouses and a stable (the only unpainted structure in the Tōshō-gū complex). Structurally these buildings are simple, and differ from their counterparts in other Shinto shrines only in the richness of their decoration. Further on, one again finds the juxtaposition of elements from the two religions in the side-by-side proximity of a Buddhist sutra house (where scripture is kept) and a Shinto water basin. The granite basin, where pilgrims can wash their hands before proceeding to the next level of the *reibyō* (just as they would before entering a shrine area), is covered by an elaborate Chinese-gabled tile roof supported by white granite pillars. On the

lintels there are intricately carved chrysanthemums, phoenixes, and dragons, painted in bright colors and touched with gold.

But even this cannot adequately prepare the visitor for the visual shock of the architectural monuments of the next level, beginning with a huge two-storied gate, the Yōmei-mon, which is so covered with ornamental carvings that it gives the impression of giant sculpture, rather than of architecture. The pillars are of rare, imported wood on which animals, flowers, and other patterns are carved in roundels; the crowning touch is a fine layer of whitewash polished to marblelike hardness. Like all the ornamental sculpture on the buildings of the Tōshō-gū, the subjects of the carvings on the upper stories of the Yōmei-mon are exclusively Chinese: Confucian sages, Taoist immortals, Buddhist patriarchs, and princes and ladies of the court, set off by a rich entourage of great mythical beasts that seem to emerge from the eaves and brackets of the gate, and by highly realistic animals and plants. Exquisitely engraved metal appointments (beam endings, bannister trim, nailhead covers) are plated with gold that contrasts smartly with the black lacquer covering the brackets and doors. Although executed primarily in black and white, the Yōmei-mon has numerous accents of bright paint and gold, creating an overall impression of a polychromatic scheme.

The next gate, the *karamon*, though much smaller, is also covered with dense, intricate relief sculpture, and has a basic color scheme of white, black, and gold. But here the red lacquer covering the walls and corridors of the main buildings of the Tōshō-gū (the chapel and sanctuary) combines with the white, black, and gold to produce a stunning climax of color and technical perfection. Arriving at the chapel, with its gleaming, polished floors, the visitor exploring its chambers may begin to sense the presence of Ieyasu's spirit—amused and pleased at the awe-struck expressions and muffled cries of surprise. The critical remarks of self-styled sophisticates, on the other hand, who dismiss such splendors as "decadent," can hardly be expected to please the old warlord, and in a very real sense such pronouncements do miss the point. It is often said that the architecture at Nikkō is not creative or original, and that too much is made of mere craftsmanship. Criticism of this kind, although not completely unjustified, overlooks one very important fact: it is precisely in organization and elaboration, rather than creation, that Japanese architects have always shown their originality. Rarely have they created new architectural forms. It is in their organization and elaboration that the buildings of the Tōshō-gū at Nikkō are most original, growing out of the style that began with Momoyama castles and palaces. Castle architecture itself was a development from earlier Buddhist structures, so that the transformations that took place between the original Chinese prototypes and the lavish monuments of Nikkō reflected a series of original contributions on the part of many Japanese architects between the mid-sixteenth and mid-seventeenth centuries.

While he lived, Ieyasu tried to make sure that Hideyoshi's architectural monuments were eclipsed by his own, and he refused to allow his predecessor's *reibyō* to be rebuilt after it had burned around 1610. Parts of it may have survived, however: Kōdai-ji in Kyoto is regarded today as a kind of substitute for the Hōkoku-byō, and Hideyoshi's memory is kept very much alive at Hōkoku Jinja, a Shinto shrine located just northwest of the Kyoto National Museum. And if tradition is to be believed, the *karamon* at Hōgon-ji, on Chikubushima Island in Lake Biwa, was brought from the Hōkoku-byō. Located on a high hill overlooking the lake, this heavy, multicolored gate has a massive beauty all its own. But it is instructive to see how much more elaborate and technically superior the *karamon* of Ieyasu's Tōshō-gū is by comparison. It is as though all such technical

problems as carving, gilding, and lacquering had been overcome in the few years separating the execution of the two gates. When Iemitsu ordered the completion of the Tōshō-gū at Nikkō in 1634, continuing his grandfather's posthumous rivalry with Hideyoshi at the architectural level, he was apparently inspired (or perhaps driven) by the love of pure flamboyance. Work on the monument continued for almost ten years, and involved over 1,600,000 carpenters, 23,000 gilders, thousands of unskilled laborers, an immense outlay of gold and silver, currency and rice, and dozens of master designers and artists, many of whom had probably worked on all three of the earlier *reibyō* projects in Kyoto, Shizuoka, and Nikkō. This Tōshō-gū was to be more than a shrine for the mighty Ieyasu: as the ultimate expression of the military ideal in art, it symbolized the invincibility of the Tokugawa government, for lavishness was equated with power. No clan, regardless of its feelings toward the Tokugawa regime, attempted to compete with this display of strength, and even the later shoguns saw that anything done in the military style thereafter could at best be an anticlimax, and might even be considered a foolhardy attempt to vie with Ieyasu, the mightiest and most revered of the Tokugawas. Opulence having reached its zenith at Nikkō, military art passed from the limelight.

CRAFTS

Craftsmanship is an indispensible part of all Japanese art, reflecting a deep native love of precision and order. There is no loss of technical excellence in even the most informal of teabowls; the effect of casualness was superbly crafted by those potters who followed Rikyū's concepts of naturalism (see chapter 5). When the effect of formality was indeed desired, as it was in the art commissioned by military leaders, technical considerations were necessarily uppermost in importance. Whereas the late sixteenth-century use of gold and silver in lacquerware was largely a matter of enhancing the dramatic qualities of objects with bold and relatively simple designs, in later times artists became so enamoured with technical procedures for applying lacquer and gilt that intricate, detailed work became the primary goal. The orderliness with which decoration was applied to late seventeenth-century lacquered objects makes them seem as formal as those of medieval times, though considerably more ornate. It is as though the rather freewheeling interlude of a century earlier had been forgotten and the fifteenth-century tradition resumed, with a new interest in very high relief lacquer designs emerging as one of the few real innovations. Like the buildings at Nikkō, later lacquerwares were encrusted with sculptural ornamentation.

Kōami Nagashige (1599–1651), whose forbears had worked for the Ashikaga shoguns, was typical of lacquerworkers of his day in that he was also a sculptor. His most famous works, the open-shelf cabinets, boxes, and cosmetic articles in the collection of the Tokugawa Museum in Nagoya, were commissioned as wedding gifts for Chiyo-no-hime, daughter of Shogun Iemitsu. Their designs of Chinese court scenes and landscapes (which are said to have been copied from paintings by Kanō masters in Edo) are rendered in high relief and gold and coral inlay, and are shaded with fine gold dust. It is evident that Kōami and his successors had fully mastered the difficulties of lacquerworking, and that in their day subject matter and excellent workmanship were the prime considerations, rather than form or design; by the end of the seventeenth century, the artist working in lacquerware was judged almost solely on his ability as a craftsman.

Two items of artistic interest, *inrō* and *netsuke*, developed along the same lines as the lacquerware and sculptured architecture that was commissioned by the military. *Inrō*

are flat, oblong containers made up of several compartments resembling little stacked boxes. Soldiers carried their personal seals and medicines in *inrō*. A cord running through the narrow sides of the container was tied at the bottom and top when the *inrō* was not in use, and the end of the cord was fastened to a fanciful ornament known as a *netsuke*. These items figured importantly as signs of status in the upper-class male wardrobe in Early Modern Japan, much as the watch and chain did in the West. Gold on black lacquer *(maki-e)* was the principal means of decorating *inrō*, but for variety inlaid shell, stone, and metal were also used in combination. Since they were always worn on formal occasions, special *inrō* were created for this; simpler ones were made for everyday use.

Netsuke are carved of ivory, stone, or wood. They sometimes have a direct connection with the design on the *inrō*, as with a *netsuke* in the shape of a baying hound and an *inrō* showing a moonlit village. *Netsuke* were also used with tobacco pouches, and those made for courtesans of the leading brothels in Edo (whose smoking habits are charmingly documented in paintings and prints) are among the most ingenious of all. The production of these winsome little sculptures increased greatly in the nineteenth century because of their popularity with foreigners, who treated them as good-luck pieces.

The decoration of ceremonial swords had been the duty of the Gotō family since Ashikaga times. This great family of goldsmiths enjoyed the patronage of the Ashikaga and Tokugawa shoguns and well-to-do military lords in the same manner as did Kanō painters. So famous was the name that no young craftsman aspiring to design swords for government officials could expect to have much success unless he managed to get himself adopted by the Gotō family. Like the Kanō, the family had branches in Kyoto and Edo and other major cities of Japan. The Gotō style is as distinctive in decorative sword guards *(tsuba)*, hilt ornaments *(me'nuki)*, and sheaths as the Kanō style is in painting. In the eighteenth century Gotō artisans were fond of doing landscapes in high relief very similar to contemporary lacquerware designs. The last active member of the family on record was Gotō Ichijō (1791–1876). His students continued the tradition for many years, but as the demand for the wares of the goldsmith declined, they were forced to depend increasingly on teaching in order to support themselves.

52. Road through cryptomeria trees, Nikkō.
Nikkō is only a two-hour train ride from Tokyo today, but it was a rugged four-day trip when the shogunal mausoleums were built there in the seventeenth century. Due to its remoteness, the area had for centuries before been regarded as a place of mystery. Two local mountains, "male-shaped" Nantai-zan and "female-shaped" Nyohō-zan, were both objects of worship for pilgrims; today they and the stately cryptomeria trees in the forest around Nikkō testify in moss-covered stillness to the transcendent length of nature's time.*

53. Yōmei-mon of the Nikkō Tōshō-gū. 1636.
This gate provides entry through an elaborate, covered corridor *(kairō)* encircling the compound to the main structures of Tokugawa Ieyasu's shrine-mausoleum *(reibyō)*, which include the *karamon* (a Chinese-style gate), the *shin'yō-sha* (a building in which the portable shrine is stored), the *kagura-den* (building with a stage for sacred dances), and the most important of all buildings, the *haiden* (front chapel) and *honden* (sanctuary). The Yōmei-mon is of Chinese-style *(kara-yō)* construction and is the most elaborately decorated monument of the Tōshō-gū at Nikkō.*

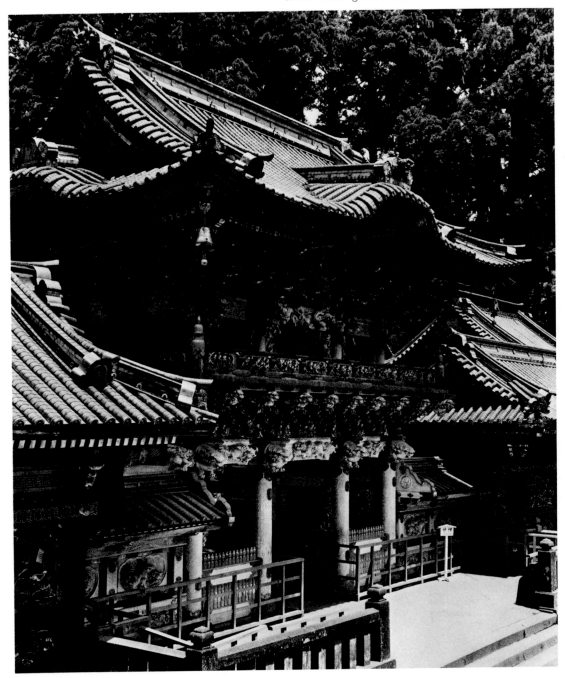

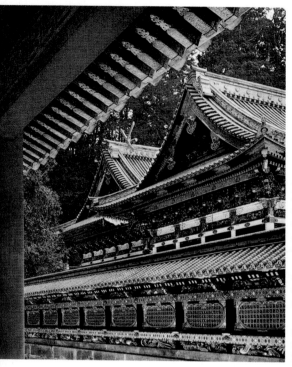

54. The main buildings (*haiden* and *honden*) of the Nikkō Tōshō-gū. 1636.

In this photograph, which was taken from the brightly colored *kairō* that borders the main compound of the Nikkō Tōshō-gū on the west, the glittering roof gables and brackets on the ends of the *haiden* on the far right and the *honden* in the rear are seen behind the roofed and exquisitely embellished fence in the foreground, which obscures the lower parts of the buildings. These two impressive structures reflect a variety of Japanese and Chinese architectural styles. Their interior and exterior decoration is carried out in lacquer, relief *maki-e*, inlay, painting, and gilding. The chapel in front (*haiden*) is connected to the sanctuary (*honden*) by a roofed stone pavement and is about thirty feet tall and fifty-four feet long. The *honden*, about the same in height, is only thirty feet long. (See color plate 11.)*

55. *Karamon* of the Nikkō Tōshō-gū. 1636.

This gate provides a singularly dramatic opening in the low tile-roofed fence surrounding the main buildings (in the photograph the front gable and roof of the *haiden* are seen above and behind the *karamon* and almost appear to be connected to it). The proportions of the gate are reduced to match the small scale of the fence, but its decoration of carved animals, plants, and human figures and color scheme of dark on pure white are in direct contrast to the fence's ornamentation of latticework openings and largely geometric designs that are consistently light on dark. Records show that construction costs for the *karamon* were extremely high compared to those of other structures in the compound.

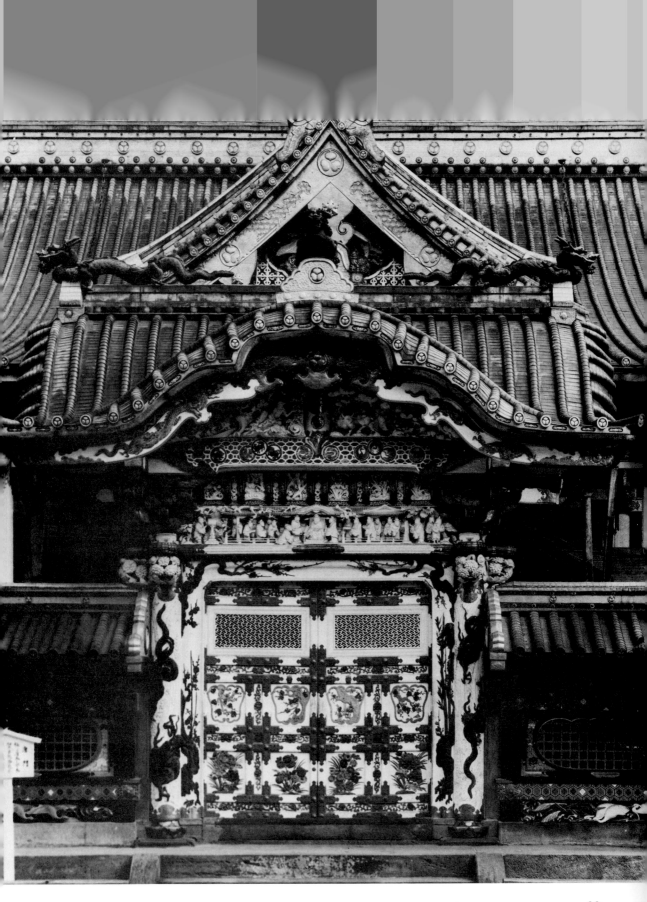

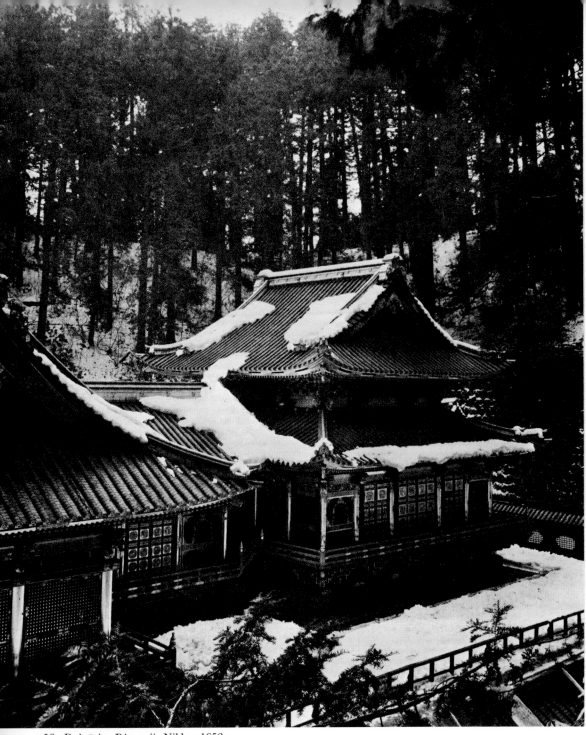

56. Daiyū-in, Rinnō-ji, Nikkō. 1653.
Daiyū-in is the shrine-mausoleum of Tokugawa Iemitsu,
the third Tokugawa shogun. As he requested, his
reibyō was constructed to the west of his grandfather's.
Construction work commenced in 1651, the year of his
death, and was completed in 1653.*

57. Ueno Tōshō-gū, Tokyo. 1651.

Four illustrious figures from Japan's past are revered at this Tōshō-gū, including, in addition to Ieyasu, his two friends, the priest Tenkai (d. 1643) and daimyo Tōdō Takatora (d. 1630). All the structures common to *reibyō* are present in the compound, many of them finished extravagantly in gold leaf, their interiors decorated with wall paintings by Kanō Tan'yū and other seventeenth-century Kanō-school masters in Edo.

The Ueno Tōshō-gū is also the *reibyō* of the kindly-remembered eighteenth-century Tokugawa shogun, Yoshimune.*

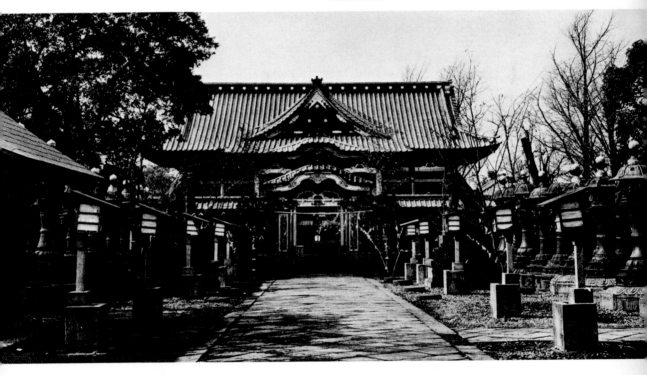

58. *Tebako*. Seventeenth century. H. 16.7 cm. (6.5 in.), l. 24.2 cm. (9.5 in.), w. 21.5 cm. (8.5 in.).

A *tebako* was used as a container for combs, powder, and other cosmetic aids. In this one the Heian-style buildings and gardens of the decoration, rendered in relief *maki-e* typical of the period, are meant to recall the elegant gardens and palaces of medieval court society. Tiny pieces of silver and gold inlay in the lacquered surfaces introduce an element of contrast and extravagance quite in keeping with the subject matter.*

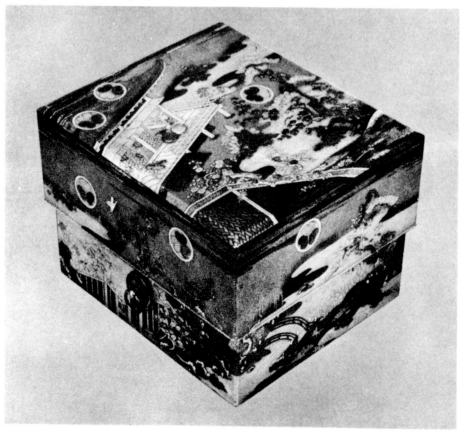

59. *Zushi-dana*, by Kōami Nagashige (1599–1651). H. 78.4 cm. (30.7 in.); l. top shelf, 100.4 cm. (39.3 in.), lower shelf, 85 cm. (33.3 in.); w. 39.4 cm. (15.4 in.). The appearance in the design of the hollyhock *(aoi)* motif set in golden medallions marks this combination shelf and cabinet *(zushi-dana)* as a possession of the Tokugawa family in Owari. It is one of three such objects in a collection of furniture and accessories known as *hatsune maki-e,* after the "First Song of the Year" *(Hatsune)* chapter of the eleventh-century novel by Lady Murasaki, *The Tale of Genji*. The designer, Kōami Nagashige, tried to match the articles of fine furniture described there, which Prince Genji saw displayed on a new spring day in the apartments of two of his loves, Lady Tamakatsura and the Lady of Akashi.*

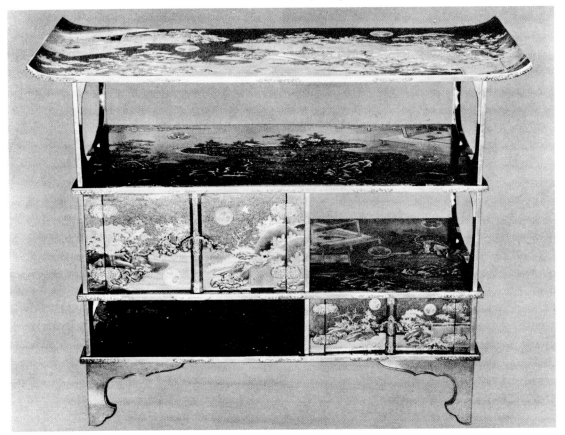

60. Examples of *inrō*.

Inrō, the small compartmentalized containers of medicines and personal seals used in late medieval times by military men, became standard equipment for men of almost all classes in eighteenth-century Japan. The bamboo *inrō* at top right is the work of Koma Kansai (1767–1835), a favorite *maki-e* craftsman of the Tokugawa shogunate. The choice of a cicada motif for its decoration, which is done in hard and shiny lacquer, is typical of the *inrō* designer's uncanny feeling for what is "natural"—to the artistic medium as well as to nature itself. The *inrō* in the center is of dyed and carved ivory with shell inlay, a technique that is believed to have been conceived in the late eighteenth century by a Shibayama craftsman whose work was popular in the Chiba-Yokohama area. (See color plate 12.)*

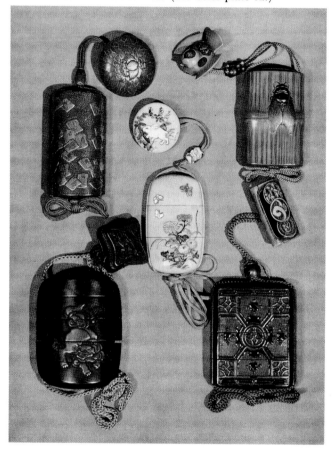

61. Summer kimono *(katabira)*. Eighteenth century. L. 175 cm. (68.6 in.).

This summer kimono of indigo-dyed, fine-quality ramie is perhaps the most extravagant of its kind in terms of dyeing technique and workmanship. It undoubtedly was worn by some high-placed woman in Edo society. The time-consuming *chaya-tsuji* method of dyeing used in its design involves covering the parts that should remain undyed with color-resistant paste on both sides.*

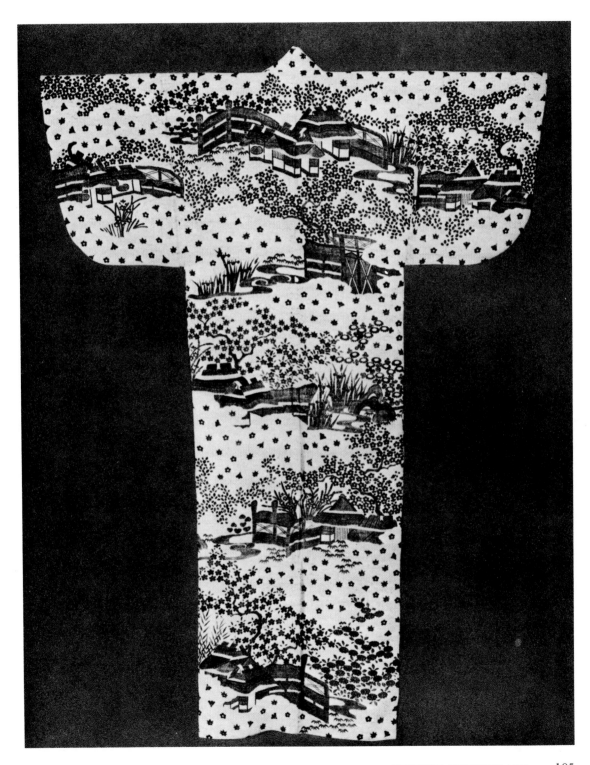

62–66. Set of sword accessories, by Gotō Ichijō. 1864.
The objects illustrated here are from the wardrobe of
some Edo gentleman. Made by one of the last great
masters of metalworking in the Gotō family, they are
of bronze and gold and silver inlay, with contrasting
motifs of cherry and maple trees: figures 62–63, a pair
of sword guards *(tsuba)*; figure 64, matching hilt or-
naments *(me'nuki)*; figure 65, two rods *(kōgai)* attached
to the sword sheaths and used in hair arranging; figure
66, two small knives *(kozuka)* that were also attached
to the sword sheaths.*

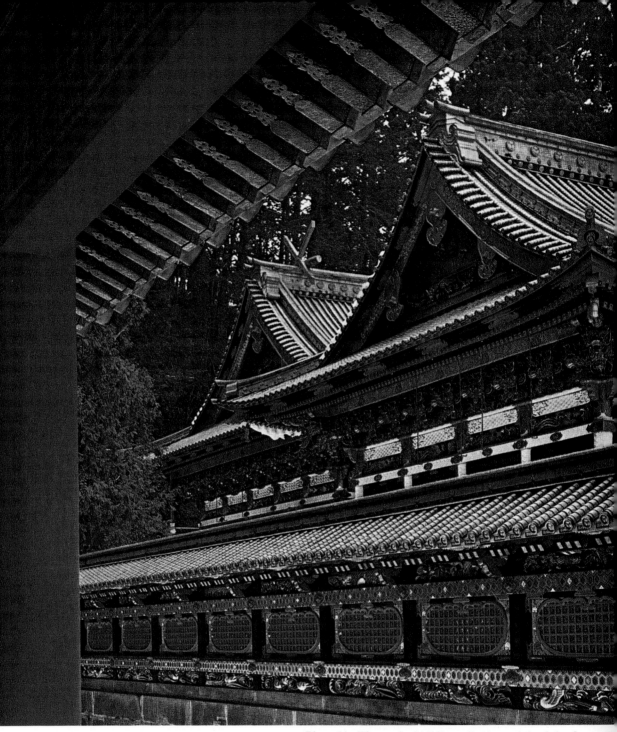

Plate 11. The main buildings (*haiden* and *honden*) of Nikkō Tōshō-gū. 1636. (See also figure 54.)

Plate 12. Examples of *inrō*. (See also figure 60.)

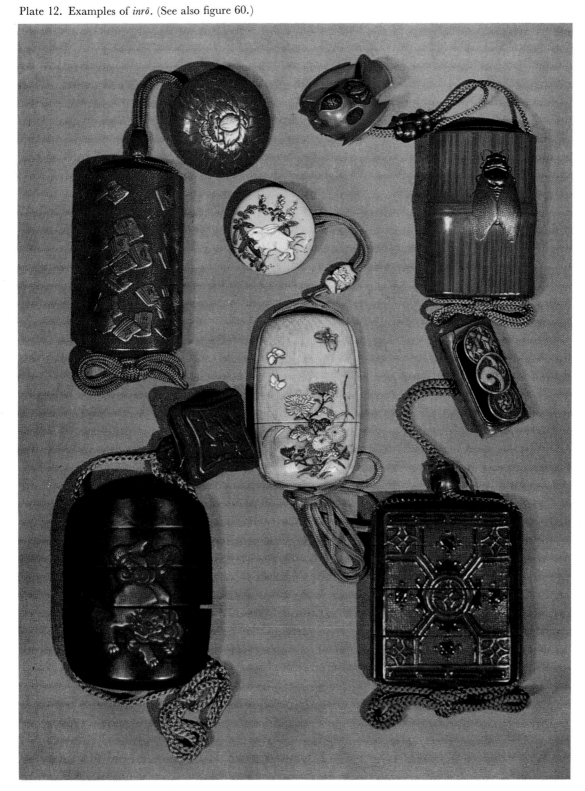

5

THE WORLD OF TEA CEREMONY

MOMENTS OF QUIET IN THE LIVES OF MILITARY LEADERS

As we have seen, military leaders of the time felt obliged to impress the world with displays of grandeur. But they, like other members of society, had their moments of quiet. Special buildings and apartments were created in which they could relax, watch Nō performances, and engage in tea ceremony activities. In the sixteenth century, a tea ceremony was one of those rare situations that allowed a person to be at ease, to relax and commune with his comrades with a total lack of pretense; the ceremony was, in fact, a time of deep meditation, and as such was conducted almost entirely in silence. In the private quarters set aside for *cha-no-yu*, there was no need for lavish display, and the restraint exercised in the design of a tea house is manifested even in the Hiunkaku, said to have originally been a part of Juraku-dai. Though by no means representative as a tea house, it differs markedly from Hideyoshi's other monuments (see, for example, figure 21). This "Pavilion of the Fleeting Clouds" seems to be a sedate relative of Himeji Castle, similar in its white walls and soaring roof lines, yet subdued by the natural wood roof, rice-paper walls, and the absence of large timbers. Inside, the dark woods and straw-mat floors are relieved only by the occasional use of pale gold leaf and by monochrome paintings on a few walls and sliding doors. Hiunkaku may be entered through conventional sliding doors, but one of its special delights is a water passageway beneath the house, leading to a small boat dock within. Approached by this route, the interior chambers seem even more a part of a secret, quiet world.

SEN-NO-RIKYŪ

The world apart sought by participants in the *cha-no-yu* may be better understood by an examination of the development of the ceremony, and of its underlying philosophy, much of which is expressed in the term *wabi*. Both the type of tea and the tea ceremony performed in medieval Japan had been introduced by Chinese Zen priests in the thirteenth century. By about 1400, members of the imperial court and of the Ashikaga shogunate had taken the ritual of tea drinking out of its exclusively Zen setting and enjoyed it as a polite sort of charade. But the foreign character of the ceremony was still

intact. In the following century, a wealthy merchant's son changed that: Sen-no-Rikyū (*ca.* 1520–91), sympathizing with fellow Buddhist laymen who were opposed to what they felt was a needlessly imitative interpretation of the tea ceremony, changed it radically. He stripped away all those elements that were meaningful only in a Chinese religious context and showed how personal involvement could bring beauty to the ritual of tea drinking, and could lead the participant to an understanding of his own place in the universe. This apparently cosmic emphasis was actually an affirmation of national identity, since it was the rare Japanese who knew of the world beyond the shores of his own country; for everyone else, the contemplation required by the ritual meant a time to think of his land, his ancestors, his family, himself. The rest of the universe was something unknown, something that had at its center his personal world. Rikyū went further than this to rid the ceremony of its foreign, meaningless features by insisting that naturalism be the encompassing theme. Natural beauty was something familiar to all Japanese and so provided a common bond with one's fellow creatures, living and dead. *Wabi* describes the rustic beauty Rikyū brought to the tea ceremony by the use of bare wood, old stones, simple earthen vessels, a small fire. *Wabi* also refers to the state of solitude and empathy with humanity sought by meditation during the ceremony. Applied to architecture, it means a building of utter simplicity—just a roof of straw over unfinished posts and mud walls. Such a building would be familiar to one's ancestors, and to ancient heroes and saints; here they would be comfortable. The same holds true for everything else the Japanese have instilled with the *wabi* touch: gardens, flower arrangements, pottery, painting, calligraphy, poetry, even cooking. Some people have found it strange that Rikyū did not set down his thoughts in a comprehensive theoretical treatise; for others, the fact that he did not is a revelation of his wisdom: by pointing to nature, he said all there was to be said; to elaborate would have denied the belief that the clearest communication of mankind is through a union with nature.

TEA HOUSES

Rikyū's ideals are nowhere better realized than in the tea house *(chashitsu)*, which may be a small, independent building, or just a room—specially constructed and reserved for tea ceremonies—in a larger building such as a temple or private residence. The room where the ceremony is held is small, but carefully organized. Although it may seem to the outsider to be merely a sparsely furnished room, its constituent parts are indispensable: a place on the floor for the utensils, including a brazier and an iron kettle; space just adequate for perhaps five guests and the host or tea master; an alcove *(tokonoma)* for a hanging scroll and a vase of flowers; a small window or two; and often a small door through which guests enter and leave. Sitting quietly in this simple, orderly environment, the participants may be transported to a world of equal tranquillity.

There remain some eight tea houses in Japan dating from the late sixteenth and early seventeenth centuries. Characteristic of all of them are light building materials, unfinished wood and bamboo, a few small windows, and no furniture of any kind. The homes of peasants living in mountain villages were most likely the direct prototypes for tea houses; for the nobility, military, and other people of means, the tea house was symbolic of a simpler life, offering respite from formal, ostentatious architecture and from the pressure of maintaining an exalted position in society.

Legend has it that Rikyū refused to let Hideyoshi marry his daughter, and the war-

lord retaliated by ordering Rikyū to commit suicide, after which the Sen family's holdings were confiscated by the government. An eventual reversal of judgment restored Rikyū's sons and grandsons as experts in the art of tea ceremony, and their descendants continue to teach Rikyū's ritual even today. In Kyoto there are two modest estates belonging to the Sen family. The one facing the street carries the name Omote-Senke, or "Front Sen Family." The tea house on its grounds, Fushin-an, was founded by Rikyū's son Shōan. To the rear is the Ura-Senke ("Rear Sen Family") estate and its tea house, Konnichi-an, established by Shōan's son Sōtan after his retirement in the latter part of the seventeenth century. During the Tokugawa era the Senke had representatives in various parts of Japan, and no other family of tea devotees enjoyed more prestige.

The concept of natural simplicity was extended to other forms of architecture, including residences. The term *sukiya* is commonly used interchangeably with *chashitsu* to mean tea house. *Sukiya-zukuri* (*sukiya* construction), on the other hand, is properly applied to the spacious dwellings of the *shoin* type that have the rustic feeling of the tea house. (The *shoin* arrangement refers to any combination of rooms, one of which has a *shoin* [a sort of bay window], a *tokonoma*, and a *chigai-dana* [shelves].) Sometimes tasteful, sometimes grotesque examples of *sukiya-zukuri* in present-day architecture are found in thousands of inns, hotels, and restaurants in large Japanese cities; in them the guest finds his quarters looking like a slightly prettied-up version of a tea room. But the purest and oldest examples of *sukiya-zukuri* are the two famous "detached palaces" (called *rikyū*, but not related to Rikyū; the Japanese characters are quite different) in Kyoto: Katsura and Shūgaku-in.

KATSURA AND SHŪGAKU-IN

Katsura was begun in the southwest outskirts of Kyoto by Imperial Prince Norihito in 1620. His son Prince Noritada continued the work, with the complex reaching its present form in about 1675. Both princes were men of taste whose activities corresponded perfectly to the innocuous role that the Tokugawa government envisioned as befitting royalty. The shogunate feared of the imperial family's taking an active interest in political matters, and encouraged its members to pursue an aesthetic life. It was hoped that building a garden and villa complex would provide sufficient diversion to keep patrician interest in government from developing.

The villa is situated on the Katsura River, which is channeled into a small lake on the grounds. Six buildings, the main one comprised of three apartments known as the *koshoin, chūshoin,* and *shinshoin* ("old, middle, new *shoin*"), are arranged informally around the lake. From the main apartments there is a view of the lake and the garden on the other side, with the pale straw roof of the Shōkin-tei tea house and the dark shadow it casts providing a subtle contrast to the dramatic shapes and seasonal colors of the garden's trees and shrubs. This is but one of the many delightful views that contribute to Katsura's charm. As the visitor strolls along the paths and bridges he is presented with ever-changing scenes and at every turn is given a chance to examine unusual groupings of rocks and plants. The buildings are simple wooden structures that do little more than provide an overhead covering and a floor of straw matting. Nowhere at Katsura has there been any attempt to put wealth and authority on display; this natural paradise was never meant to be enjoyed by anyone outside the imperial family. Even the construction of the buildings was lacking in premeditation, apartments being added

from time to time as the need arose. The *rikyū*, detached from the tedious, troubled world of protocol and court affairs, permitted royalty a rare glimpse of nature's unspoiled beauty.

Unlike Katsura, which is on relatively flat ground, Shūgaku-in is built on three levels on the hills skirting Mount Hiei, northeast of Kyoto. Tokugawa Ietsuna had Shūgaku-in constructed as a retirement villa for Emperor Gomizunoo. The upper and lower gardens and tea houses of Shūgaku-in were built in 1665, and those in the middle level were completed about three years later. The planners of this palace complex wanted to draw attention to the natural setting, and took pains to build around what was already there. The total effect is much more spectacular than that of Katsura, where the natural elements are on a smaller scale, and the beauties are discovered on an intimate, individual basis.

No attempt was made to integrate the three levels of Shūgaku-in, and as the visitor walks from one to another he has the impression of strolling in the country. Both buildings and gardens on each level are separate, complete architectural concepts. This arrangement influenced the gardens of the Imperial Palace in Tokyo, and is the most recent development in garden design in Japan. Until the seventeenth century gardens were largely visual in design; that is, they were meant to be seen—ideally from inside a building—and the spectator was not required to walk through them to appreciate their beauty. Raked gravel on the grounds of the Gosho in Kyoto covers almost all the land within the walls, and the white expanse is broken only by a few lakes, small bushes, and rocks. The "dry landscape" *(kare-sansui)* rock garden was a development of the Muromachi period, and found its finest expression in temple gardens such as those at Ryōan-ji and Daisen-in (shown in Volume I). The earliest rock gardens followed the contours of the ground, and utilized rocks and trees already there; by about the middle of the sixteenth century, garden designers required that the land be perfectly flat, and rocks and gravel (occasionally, trees and plants) were formally arranged on the surface. The gardens built on the estates of leaders in the Momoyama period are no longer in existence, but judging from the garden of Sambō-in at Daigo-ji, their emphasis was primarily visual, although the profusion of rocks, trees, and other vegetation made it necessary to include bridges here and there so that the spectator could get a closer look at things of special interest. Finally, the austere stone and gravel tabloid that merely symbolized a landscape, and the lush but untouchable garden both gave way to the concept of a place that was in perfect accord with the ideals of the tea ceremony—a small, private paradise where the spectator becomes a participant, lost for a time from the humdrum world.

PAINTERS

Of all the artists working at the beginning of the Early Modern era, none showed more sympathy with Rikyū's ideals than those in the circle of Hon'ami Kōetsu. The individualism of their various works (discussed in the following chapter) amounted to a true Japanese renaissance. Few other artists of the time were able to achieve the artless simplicity demanded by the term *wabi;* their works admirably manifest the references implicit in that term, both to Japanese antiquity and to nature. Outside Kōetsu's coterie were occasional artists who also produced paintings that contrasted sharply with the highly decorative ones typical of military styles. Though often not of Japanese origin, they were at least suitably restrained. Ink-wash paintings *(suiboku-ga)* had been the ma-

jor means of pictorial expression for Zen priest-painters in the fifteenth century. Then, and in the early sixteenth century there had been two approaches to painting with ink: the more important one followed the landscape, animal and figure painting styles of Chinese Zen priests, literati masters, and professional artists of the court academies; the other was an almost intuitive kind of ink play, through which Zen devotees sought to push themselves toward a deeper realization of their religious ideals. It is sometimes difficult to draw the line sharply between these types of painting, although in general it might be said that any picture meant to be instructive or beautiful belongs in the first category. In the second would be paintings that are playful, incomplete, not distinctive as to school or style, and very close to being unself-conscious scribblings.

Kanō artists often did monochrome ink paintings in the Chinese style, and in the later years of the Tokugawa era, particularly in Edo, they perfected a style of considerable sensitivity. Other major artists, such as Hasegawa Tōhaku and Kaihō Yūshō, also imitated Chinese Sung and Yüan models, but at least one of the works by Tōhaku, his magnificent "Pine Trees" screens, and the Chinese-style paintings rarely done by Sōtatsu so transcend their prototypes that in them may be found a true pictorial expression of Rikyū's interpretation of the tea ceremony. The itinerant Zen priest Takuan Shūhō (1573–1645) constantly dabbled in ink, deftly adding evocative ink landscapes and figure studies to calligraphic and religious documents. He thoroughly enjoyed the company of tea masters, and after settling permanently at Daitoku-ji in Kyoto, he had occasion to become acquainted with professional painters as well, including Tōhaku.

Paintings by Shōkadō Shōjō (1584–1639) and Miyamoto Niten (1584–1645) are so unusual that if for no other reason they should be considered in the second category of ink painting outlined above, despite the seemingly self-conscious beauty of some of them. Although Shōkadō was a priest and Niten a soldier, their works and lives were in many ways similar. Niten is supposed to have attacked paper with brush and ink much as he had earlier fought enemies with a sword, and often his subjects were shrikes and fighting cocks. Shōkadō's paintings were less aggressive, usually amusing little sketches of friends and anecdotes of some aspect of his activities as a busy Shingon priest (whose duties included such day-to-day considerations as officiating at wedding ceremonies, funerals, and preaching to laymen). The spontaneity of both artists' works aptly reflects Rikyū's tenets.

SCULPTURE

The works of two sculptors of the seventeenth century are particularly impressive examples of the range and vigor of nonmilitary art. Enkū (1628–95), a Buddhist priest whose convictions led him to travel the breadth of the country as a beggar for almost forty years, left wooden images of "gods" at temples and shrines everywhere. Sometimes these figures corresponded to traditional iconography, sometimes not. All those still in existence (he is supposed to have carved over 12,000) possess a sense of power and mystery that conventional works of the time lack, and might be considered the antithesis of the rococo forms at Nikkō. Chisel marks are plainly left in the wood, and the roughly suggested features of the images by their very vagueness impart a feeling of otherworldliness. Shimizu Ryūkei (ca. 1659–1720), another priest who expressed himself through art, was for most of his life completely orthodox religiously and artistically. But when his teacher Tankei, a famous priest-sculptor in Nara, died, Ryūkei turned from making Buddhist images and spent the last years of his life carving thousands of rough little

wooden figurines representing Kyoto townspeople, their individuality and candidness recalling the sketches of Shōkadō.

MINGEI

Within the last twenty years Japanese folk arts *(mingei)* have become enormously popular, both in Japan and in foreign countries, though this is not the first generation to discover them; almost four hundred years ago *mingei* products were fashionable much as they are today. Throughout medieval times the most highly prized ceramics were either imports or the Chinese-inspired celadons (high-fire, glazed wares) that a few Japanese potters had learned to manufacture as early as the ninth century. Native everyday wares, which were baked at a low temperature and usually not glazed, had gone unremarked until Sen-no-Rikyū, in his program to emphasize simplicity and native elements in the tea ceremony, was attracted to them and encouraged their use. These provincial wares were influenced by contemporary Korean ceramics brought back from Korea in the late sixteenth century by Hideyoshi's troops. This ware was strikingly informal compared to the celadons, but it was also more ambitious than provincial Japanese pottery in that it was glazed, decorated, and quite varied in style. It would be safe to say that all potters within a hundred-mile radius of Kyoto were influenced by the new imports, and kiln sites became known for their particular wares. Some of these sites are familiar to today's lovers of *mingei* pottery: Shigaraki, Iga, Tamba, Bizen. Among Rikyū's own disciples were individual potters (Chōjirō and Oribe are perhaps the most famous) who successfully modified the Korean styles to create vessels that were specifically designed for the *cha-no-yu*. Hand-molded, thick-walled shapes, indistinct designs, unfinished surfaces—these were the qualities in pottery that harmonized with Rikyū's philosophy. For additional emphasis on the Japanese character of the ceremony, Kōetsu added patterns taken directly from classical art.

Other *mingei* products that found favor included lacquerwares, bamboo objects, iron kettles, indigo-dyed fabrics, and rice paper: in short, almost all the objects in demand by twentieth-century lovers of Japanese folk art. Although much of the spirit of the *cha-no-yu* as conceived by Rikyū has died in the intervening centuries, perhaps because the Japanese are unaccustomed to acting with the spontaneity and individualism that should direct the ceremony, the popularity of *mingei* indicates that some of Rikyū's essential ideas have become firmly established in Japanese culture.

67. Hiunkaku of Nishi Hongan-ji, Kyoto. Late six-teenth century. Facade, 25.8 m. (84.3 ft.); side, 12.5 m. (40.8 ft.).

A number of records indicate that this airy, three-storied building was first constructed in the late 1580's as part of Hideyoshi's mansion in Kyoto, Juraku-dai, and that it was subsequently dismantled and transferred to its present location in the garden of Tekisui-en at Nishi Hongan-ji sometime during the Genna era (1615–24). It is a unique structure incorporating a number of architectural features common to grand castle-residences of the military as well as the restrained interior decoration and lightweight construction associated with tea houses of later periods.*

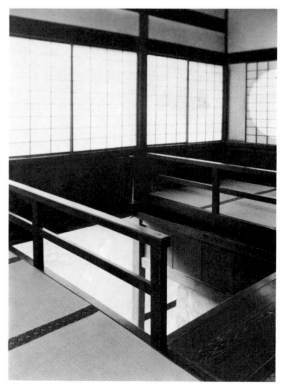

68. *Funairi-no-ma* (boat docking room) of Hiunkaku.

As the name indicates, it was into this ground-floor room that a boat carrying guests could enter from the small pond surrounding the building on the outside. The scale of the "dock" is quite small, but the act of boarding the boat from this position and crossing the narrow strip of water separating the building and shore-line could easily cause a visitor to feel that he had in-deed been removed for awhile from the ordinary world.*

69. *Waka-onna* ("Young Woman") Nō mask, by Kawachi. Early seventeenth century. Size, 21 cm. (8.3 in.) × 13.5 cm. (5.3 in.).

This mask, which is still used by one of the main schools of Nō theater in Japan, is probably a copy of a mask made during the Muromachi period. Its smooth planes and delicate coloring are indicative of the kind of enigmatic female beauty associated with the heroines of Nō plays. Kawachi was the fourth-generation master of the Izeki family residing in Ōmi province near Kyoto. He moved to Edo around 1610 and was reputed to be the most outstanding mask carver of the time.*

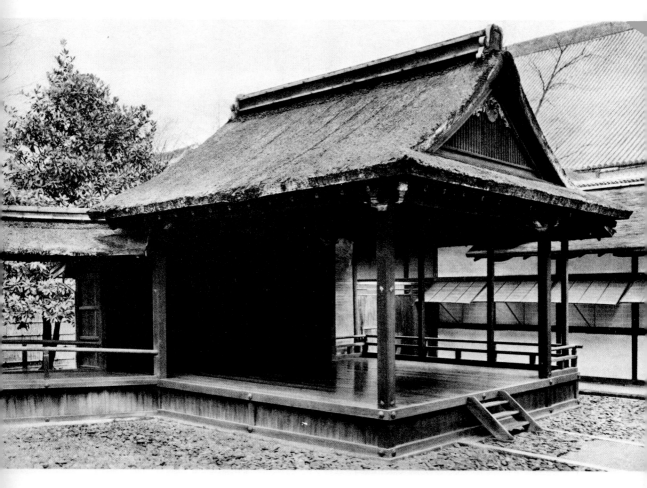

71. Nō costume. Early seventeenth century. L. 142 cm. (55.6 in.).
This Nō costume was worn by actors playing male roles. Its design is composed of contrasting gold brocade and vermilion satin. Six poems from an anthology are interwoven on each half in opposing colors. This type of design, known as *katami-gawari,* became popular around 1600 and was used in costumes as well as in lacquerware and other arts (see figure 32). (See color plate 13.)*

70. North Nō stage at Nishi Hongan-ji, Kyoto. 1581. Facade, 6.67 m. (21.9 ft.); side, 8.48 m. (27.6 ft.).
The most respectable form of entertainment in the Early Modern age was the Nō theater. In earlier times these plays were for the eyes of the aristocracy alone, and until restrictions were relaxed in the seventeenth century, only the highest ranking samurai were allowed to attend performances. The style and construction of this Nō stage is typical of those built during the sixteenth century and is one of the oldest examples extant.*

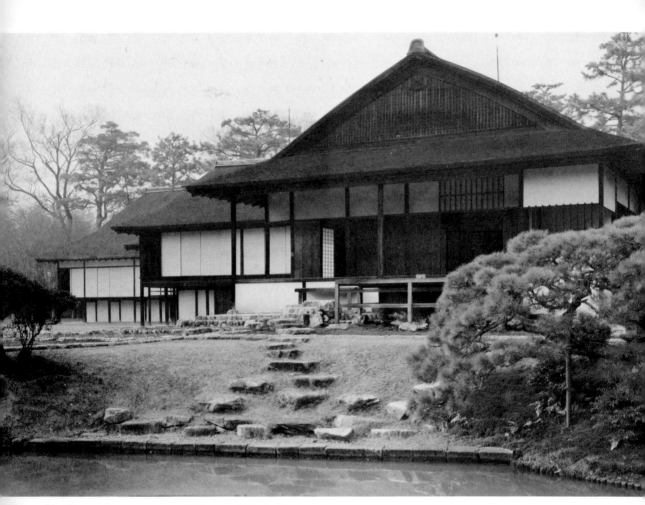

72. The main apartments of Katsura Rikyū, Kyoto. Seventeenth century. Total area covered by the buildings, 38.2 m. (124 ft.) × 36.5 m. (117.5 ft.).

In this photograph of the main apartments *(shoin)* of Katsura Rikyū are, from right to left, the *koshoin, chūshoin,* and *shinshoin.* They are connected to one another in a diagonal line, creating a single structure of extraordinarily informal design. Since 1933, when the German architect Bruno Taut first drew serious attention to the intrinsic beauty of the buildings at Katsura, foreign and Japanese architects alike have been intrigued by the idea of further developing an architectural form in which the emphasis is on interior spatial arrangement rather than on the sculptural monumentality characteristic of architecture in most parts of the world. Historically, the buildings at Katsura are related to the earliest form of architecture known in Japan.*

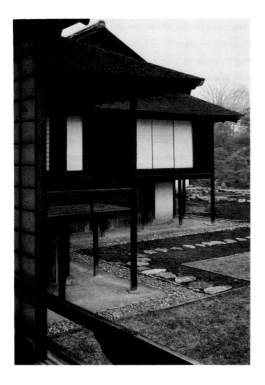

73. View of the *chūshoin* from the *shinshoin*.
The elevated floors, and the plain, lightweight materials of their construction make these apartments seem almost to be floating in air. When all the doors are open it is as though the building is part of the natural landscape, an umbrellalike structure providing comfortable sanctuary and protection from rain and sun. Every possible means of garden exploration was carefully mapped for the important princes who spent their leisure moments here. Conspicuous in this photograph is the ingenious way a necessary gravel bed (to catch the rain from the roof eaves) is combined with purely visual patterns of mosses, rocks, and bare earth. (See color plate 14.)*

74. Shelves in the dressing room of the *shinshoin*, Katsura Rikyū.
In this set of built-in shelves *(chigai-dana)* an unusually generous number of sliding-door cabinets and shelves are combined in a way that is both practical and attractively casual.*

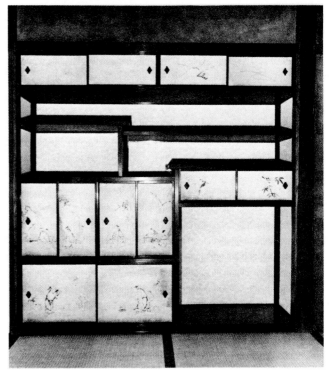

76. The Gepparō of Katsura Rikyū.
This rustic tea house, located just to the north of the *koshoin* and near the pond, has three small rooms, a pantry, and this earthen floor entryway. Its name, Gepparō, "Pavilion of Moon and Waves," seems eminently suitable. The roof is made of bamboo, reeds, and thin shingles of Japanese cypress *(hinoki)*. Architecturally, the Gepparō is quite the simplest and most unassuming structure at Katsura. The painting over the transom is of a ship used by the government in 1605 for foreign trade.*

75. Carriage entrance, Katsura Rikyū.
When guests disembarked from their carriages at this entrance *(mikoshi-yose)* to the apartments at Katsura, they must have been immediately struck by the similarity between its simple forms and the porches of provincial farmhouses.*

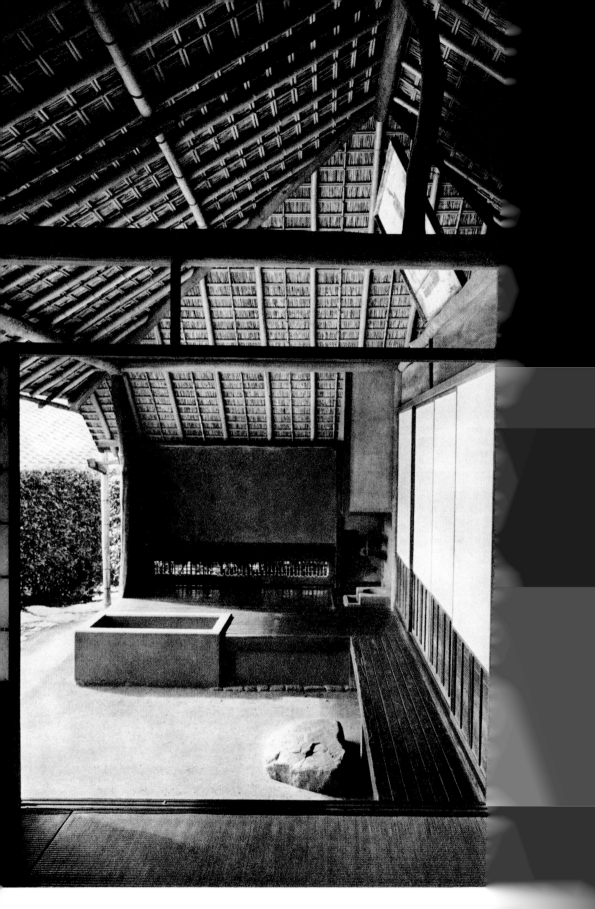

77. View of the Shōkin-tei, Katsura Rikyū.
In his formulation of the native tea ceremony, *cha-no-yu,* Sen-no-Rikyū stressed the importance of using only those basic materials that all Japanese people had had in common since the founding of the country: straw, mud, stone, wood, paper, water, charcoal, etc., with the articles of the ceremony itself—an iron kettle, powdered green tea, and low-fired teabowls—affording participants the means of communion with nature and history. Although it is built on a grander scale than the usual tea house, the Shōkin-tei at Katsura, seen here from the north across the pond, seems very much in accord with these principles.*

79. Rin'un-tei, Shūgaku-in Rikyū.
There are three *chaya* (rest houses) within the Shūgaku-in compound. Rin'un-tei, the "Arbor in the Clouds," is the main *chaya* of the upper garden, the most spectacular of the three gardens that make up Shūgaku-in Rikyū. The present building was reconstructed in the Bunsei era (1818–30), but it retains the general features of the original, which was part of the construction project begun for retired Emperor Gomizunoo in 1665. The intermittent periods when the villa was not used at all, the longest one lasting nearly a century, seem not to have damaged the carefully planned beauty of its gardens.*

78. Upper garden, Shūgaku-in Rikyū.
The high hedges bordering the path up the hill to Rin'un-tei (figure 79) tend to block the view until the building is reached; then this panorama of distant hills and remarkable garden suddenly appears. Equally delightful is the symbolism at Shūgaku-in: the chain of three small islands breaking the surface of the pond of the upper garden has been likened to a "bathing dragon" (hence the name of the pond, Yokuryū-chi), while the water around the islands forms a single Chinese-Japanese character whose meaning can encompass "mind," "heart," "mood," and "idea" all at the same time. (See color plate 15.)*

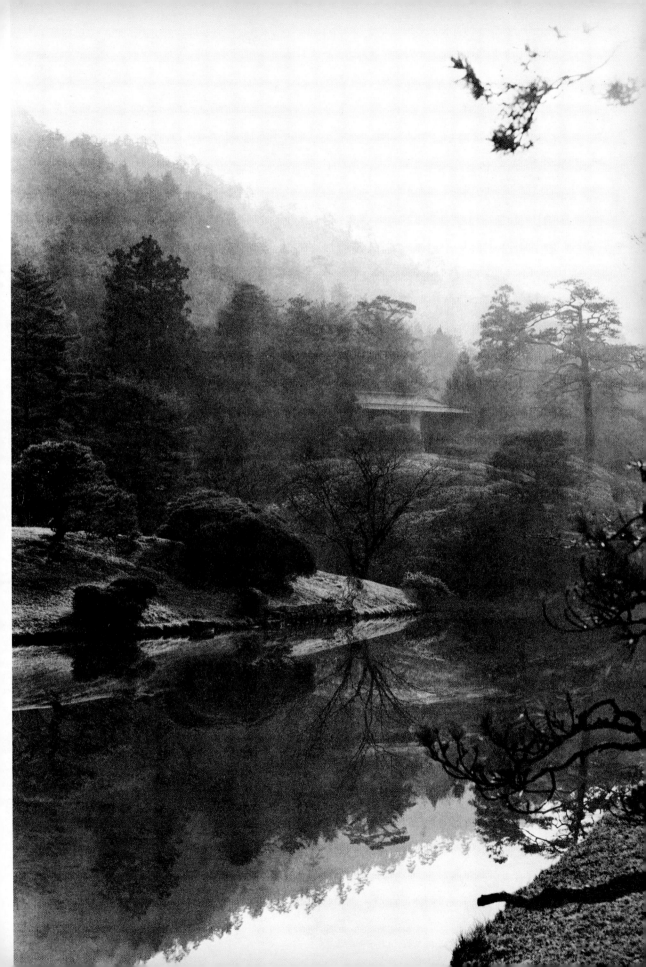

80. Pathway to Sa-an, Gyokurin-in, Kyoto.
As the fame of certain tea houses spread, the narrow
little garden paths *(roji)* leading up to them took on
more importance and were given special emphasis.
Many, including this stone pathway to Sa-an, the fa-
mous eighteenth-century tea-ceremony room at Gyo-
kurin-in in the Daitoku-ji compound, even acquired
sheltered rest areas known as *yori-tsuki* (on the right in
the photograph) to accommodate tired visitors.*

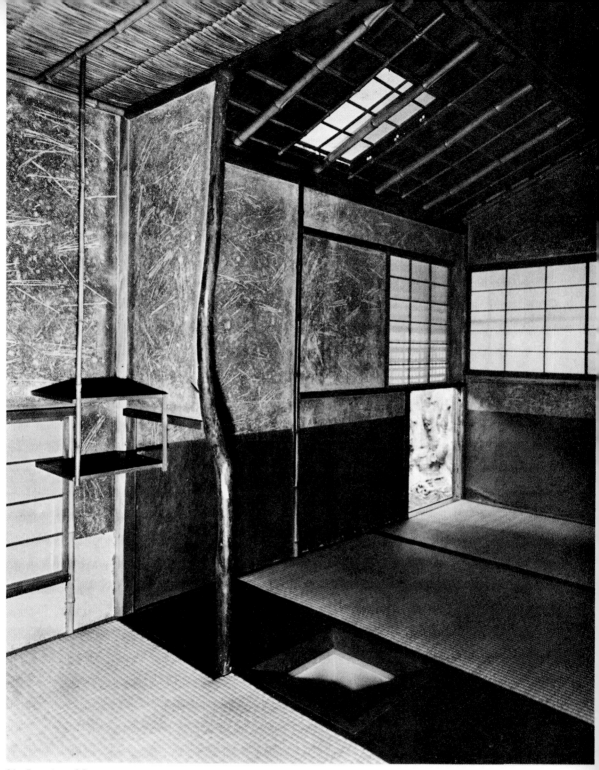

81. Interior of Sa-an.

The single straw mat *(temae-tatami)* that the tea master would occupy inside Sa-an can just be seen in the left foreground of the photograph above. The *nakaita-iri,* a strip of wood about fourteen inches wide into which a square hearth *(dero)* is built, separates the master from his guests, who would be seated on the two mats in the far side of the room. The distinction between master and guest is further carried out by a contrast of flat and sloping ceilings, and by a screen that juts out from the wall into the room.*

82. Tai-an of Myōki-an, Kyoto.

Many different types of Japanese tea houses have developed over the centuries, and theoretically, like the improvised meals of Zen priests, no two tea houses, even those built today, should be alike in all respects. One of the oldest, said to have been designed around 1582 by Sen-no-Rikyū himself, is the Tai-an at the Zen temple of Myōki-an, located in the Yamazaki area southwest of Kyoto. Its two-mat tea room (one *tatami* mat measures some 3 × 6 feet) has a *tokonoma* that is deeply recessed in the end wall and known, very appropriately, as "cavelike" *(murodoko)*.*

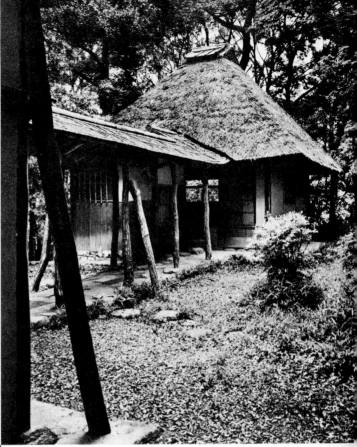

83. Karakasa-tei of Kōdai-ji, Kyoto.
Karakasa-tei and Shigure-tei, the "Umbrella" and "Shower of Rain" tea houses at Kōdai-ji, are said to have been brought from Hideyoshi's Fushimi Castle. A second (and younger) tradition holds that they were designed by Sen-no-Rikyū. This photograph shows the thatched, hutlike Karakasa-tei and (silhouetted at the left) one of the corner posts of Shigure-tei; the slender tree trunk supports of the roofed stone walkway connecting the two buildings further convey the sense of naturalness and improvisation appreciated by tea ceremony participants.*

84. Ceiling of Karakasa-tei.
Someone, looking up at the ceiling of this tea house after it had been in use for a considerable length of time, noticed how much it resembled the underneath side of an umbrella and dubbed the building "Karakasa-tei." But as the characters on the plaque in the photograph indicate, its true name is Ankan-kutsu, or "Place of Idleness."*

86. "Pine Trees," by Hasegawa Tōhaku. Detail. *Ca.* 1600. Pair of six-fold screens.
Velvety wash tones of black ink applied to the paper with a stiff fiber brush were used to create this vision, found almost anywhere in Japan, but particularly around temples and shrines in Kyoto, of tall pine trees shrouded in thick morning fog.*

85. Rokusō-an, Tokyo National Museum.
This *chashitsu* was built by the tea master Kanamori Sōwa sometime during the Keian era (1648–52). It originally was in the compound of Jigen-in, a temple affiliated with Kōfuku-ji in Nara, but was sold in early Meiji times, transported to Tokyo via ocean freighter and was rebuilt at the site that presently is within the premises of the museum. The name Rokusō-an simply means "building with six windows."*

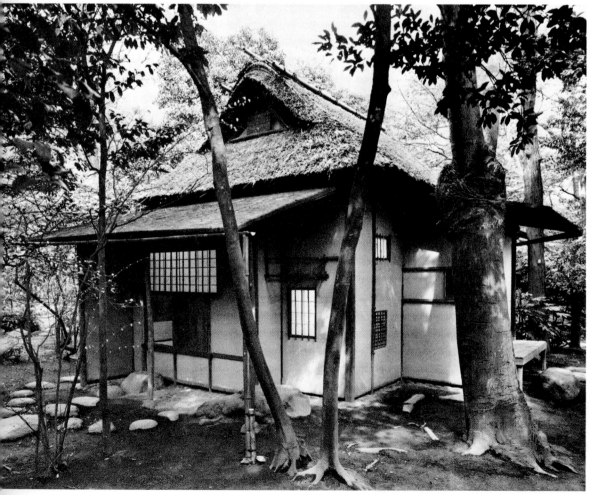

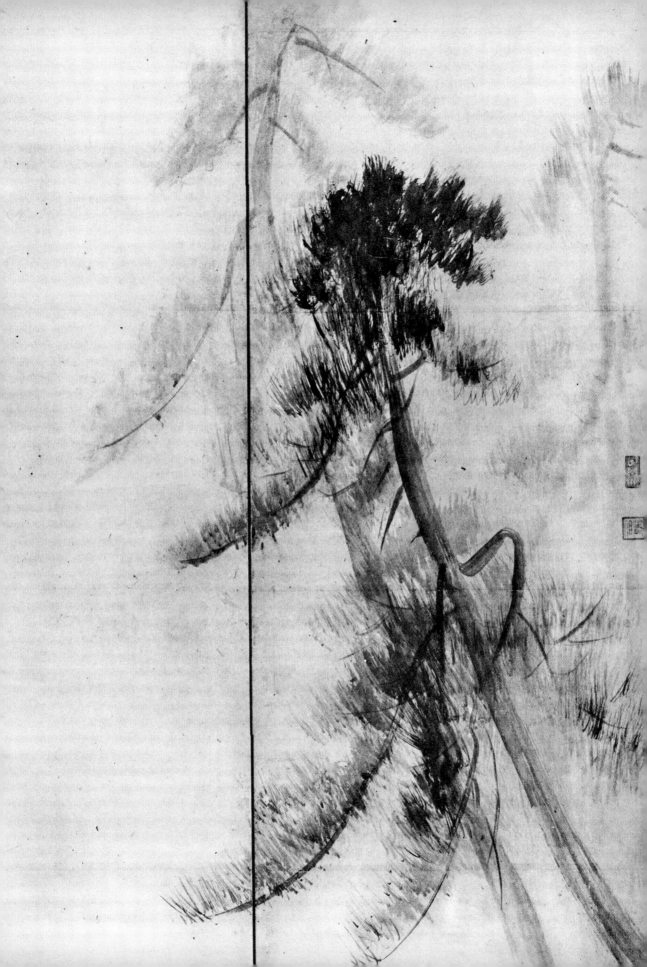

87. "Pine Trees," by Hasegawa Tōhaku. *Ca.* 1600.
Pair of six-fold screens. H. 155.7 cm. (61 in.), w. 346.9
cm. (136 in.) each.

It would seem that Tōhaku spent most of his life learn-
ing the motifs and techniques of Chinese ink painting
only to discard them later in order to create this one
work, a work so technically simple and direct in its
reference to an ageless Japanese reality that it becomes
the virtual equivalent, in pictorial terms, of Rikyū's
concept of the tea ritual.*

88. "The Fifth Zen Patriarch," by Takuan Shūhō (1573–1645). H. 68.5 cm. (26.9 in.), w. 31.6 cm. (12.4 in.). This disarmingly simple little ink sketch shows Hung Jên (602–75), the fifth patriarch of Ch'an (Zen) Buddhism in China, setting out to plant a young pine tree that he has tied to his hoe. Priest Takuan, the abbot of Daitoku-ji in Kyoto, also wrote the poem above the painting.*

89. "Cormorant," by Miyamoto Niten (Musashi) (1584–1645). H. 119.7 cm. (47 in.), w. 56.3 cm. (22.1 in.).
Orphaned by war, Niten was trained as a fencer and served several military families during his lifetime as a professional soldier. Only about ten of his paintings, which he obviously did for his own amusement, exist, but they all conform to the same playful ink style, with solitary, authoritative-looking birds the prime subjects.

90. "Mending Clothes at Sunup," by Shōkadō Shōjō (1583–1639). H. 111.4 cm. (43.7 in.), w. 30.6 cm. (12 in.).
This theme is usually accompanied by another, "Reciting Scripture by Moonlight." Both come from a Chinese poem extolling the virtues of labor and study for priests.*

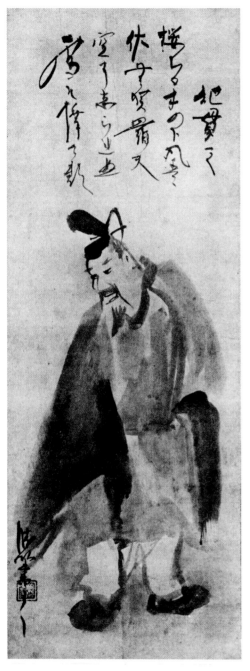

91–92. "The Poets Ki-no-Tsurayuki and Kakinomoto-no-Hitomaro," by Iwasa Matabei (1578–1650). H. 94.2 cm. (36.9 in.), w. 35.9 cm. (14.1 in.) each.

It seems quite appropriate that paintings of Japan's Thirty-six Great Poets, which are traditionally placed in Shinto shrines to provide amusement for the ancestral gods, should find their way into the circle of priests and art connoisseurs who were influenced by Rikyū's inward-looking, nationalistic interpretation of the Zen tea ceremony. The artist of these paintings has made some concession, however, by painting them in the monochrome ink style associated with Chinese-style pictures.*

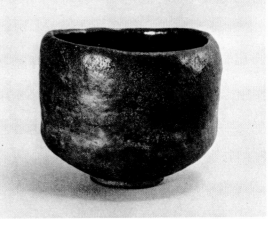

93. Black Raku teabowl (known as *Ayame*). Late sixteenth century. H. 9.5 cm. (3.7 in.), d. 13.5 cm. (5.3 in.). Raku ("Ease") teabowls first appeared in the sixteenth century during the lifetime of Sen-no-Rikyū. All other wares *(yaki)* produced then included vessels besides teabowls, but Raku-*yaki,* which is thickly coated with black, red, or white matt glaze and fired at very low temperatures, was exclusively a ceremonial teabowl ware.*

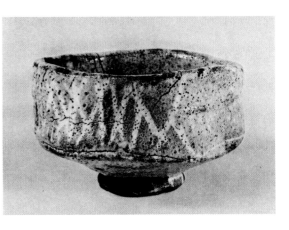

94. *Nezumi*-Shino teabowl (known as *Yama-no-ha*). *Ca.* 1600. H. 8.5 cm. (3.4 in.), d. 13.5 cm. (5.3 in.). This teabowl is a rare and outstanding example of the "mouse-gray" *(nezumi)* pottery produced around 1600 by Shino kilns in Mino (Gifu) east of Kyoto.*

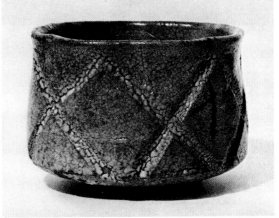

95. *Hori*-Karatsu teabowl. *Ca.* 1600. H. 19.1 cm. (7.5 in.), d. 12.3 cm. (4.8 in.).
Karatsu ware was first made by Korean potters who were brought to Japan by military men in the Korean expeditions of the late sixteenth century. Only two or three examples are known of *hori·* (incised) Karatsu pottery as old as this.*

96. Shino water jug (known as *Kogan*). Late sixteenth century. H. 17.8 cm. (7 in.), d. 18.5 cm. (7.3 in.). Even without any knowledge of the unique tea ceremony ideology responsible for the creation of this remarkable piece of Shino ware, one is struck by the evident love of simple forms and profound respect for the limitations of the medium that its maker had. The casual design of grasses and reeds around the body of the vessel has earned it a name, *Kogan*, which conjures up the image of a weather-beaten river bank. (See color plate 16.)*

98. *Nezumi*-Shino dish with lotus design. Late sixteenth century. H. 6 cm. (2.3 in.); inside diameter, 25.2 cm. (9.9 in.).

Simple as it is, the positive and negative design of this piece is decidedly more complex than the one on the *nezumi*-Shino teabowl of figure 94.

97. Old Iga water jug (known as *Yabure-bukuro*). *Ca.* 1600. H. 21 cm. (8.3 in.); top diameter, 15.3 cm. (6 in.), bottom, 18 cm. (7.1 in.).

The lavalike texture *(ishihaze)* and fissures of *Yabure-bukuro,* or "Bursting Pouch," as this vessel is appropriately named, are the results of intentional overfiring. Its interesting ochre and yellow-green glaze and dark burned areas were produced by ashes that were allowed to fall on the vessel during the time it was being subjected to intense, uneven heat.*

99. Oribe serving dish with clematis design. Early seventeenth century. H. 18 cm. (7.1 in.), d. 25 cm. (9.8 in.).

A note of wildness was struck in tea utensils with the colorful, patterned wares dreamed up by one of Rikyū's disciples, Furuta Oribe. This serving dish, decorated with clematis blossoms and bold stripes taken directly off foreign fabrics, is typical.*

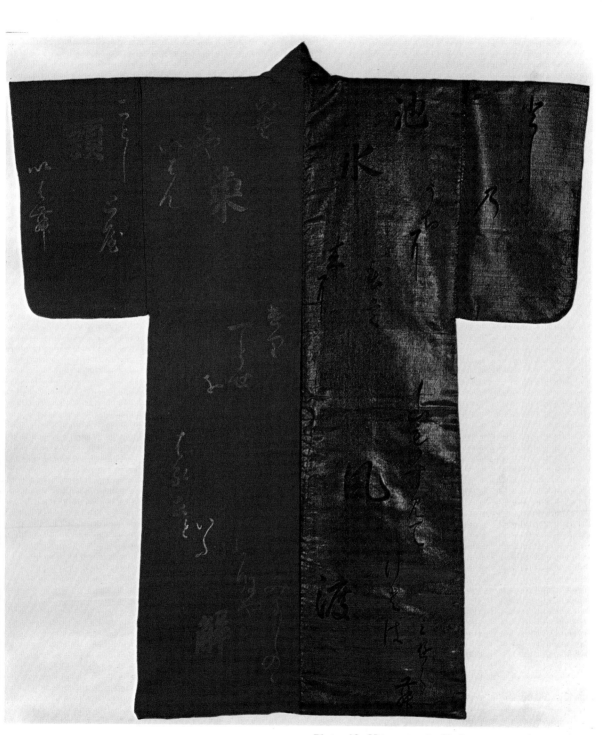

Plate 13. Nō costume. Early seventeenth century. (See also figure 71.)

Plate 14. View of the *chūshoin* from the *shinshoin*. Katsura Rikyū. Seventeenth century. (See also figure 73.)

Plate 15. Shūgaku-in Rikyū: upper garden. (See also figure 78.)

Plate 16. Shino water jug. Late sixteenth century.
(See also figure 96.)

$$\text{~} 6 \text{~}$$

KAMIGATA VALUES:
THE NEW ART OF THE KANSAI

After the young city of Edo in the eastern provinces was made the seat of the Tokugawa shogunate in 1603, Kyoto lost all claim to political power, although it had a decided advantage over Edo in terms of artistic strength. A distinctive aesthetic philosophy took root in the Kansai (the western provinces around Kyoto and Osaka), and it continued to thrive throughout the entire period of Tokugawa rule—that is, until the mid-nineteenth century. Even now there is a certain delicate beauty, a style of living, that is peculiar to Kyoto and Osaka and their citizens. The word *kamigata* (Kyoto pattern) refers to the unique flavor of Kansai dress, speech, behavior, and outlook. Traditional values were at the heart of the Kansai style, yet the spirit of refinement and sophistication that permeated every aspect of society reflected an entirely new set of attitudes. As Kyoto rebuilt itself from the rubble and ashes left by more than a century of fighting, it was natural that new artistic values would develop, and in some instances there was a complete reaction against the boastfully flamboyant art of the military, for even though the great military leaders were responsible for bringing peace and order to the country, their ostentatious castles and palaces were unwelcome reminders of terrible times.

Of the many divergent movements in postwar Kyoto's art world, the one that best represented what has come to be regarded as typically Japanese was the one most at variance with military art values. This movement was led by a coterie of painters, poets, merchants, and priests, whose mentor, Hon'ami Kōetsu (1558–1637), was indirectly involved in military matters before turning his attention to things artistic.

KŌETSU

Kōetsu's ancestors had been swordsmiths, and for a while he carried on the family tradition by serving regional warlords as a connoisseur of swords. But a man of his energies was not to be satisfied with this sort of work for long, and it is as an artist that Kōetsu is remembered by history. He was not blessed with the advantage of social position that would allow him to formally study literature and related arts. He seems to have trained himself—in calligraphy, for example—without the aid of a master. Kōetsu's success is attested to by the fact that in his own lifetime he was judged a genius, his style of writing

145

being particularly his own and of a kind never before known. A careful study of the calligraphy of the Chinese ancients, Wang Hsi-chih (*ca.* 321–79) in particular, perhaps served him better than a contemporary tutor ever could have. Kōetsu was likewise unschooled in the tea ceremony, but his own manner of conducting it was respected and admired by the greatest tea masters of his day.

Had Kōetsu been a professional craftsman it is doubtful that he would have been free to experiment as he did with lacquerware and pottery designing; as it is, the boldly inventive objects that bear Kōetsu's name are without equal in the history of Japanese crafts. Presumably he was skilled in drawing and painting, too, but since few, if any, of his works in this field have survived, it is less easy to speak of Kōetsu's talents in this regard. However, a very strong tradition holds that one of Japan's most original painters, Sōtatsu, was a pupil of Kōetsu; if he was, a study of his work will give an impression of Kōetsu's style.

Kōetsu was one of Japan's first modern artists, a man who dared to step outside the bounds of tradition because his own inclination demanded that he do so. It was precisely because he was not a professional that his interests were not those of any of the masters in the fields he chose to explore, and that his achievements were far more original than theirs. Great originality and strong influence by individual artists was not without precedent, but only in limited areas of art. Never before or since Kōetsu has the impact of one man's aesthetic philosophy been so far-reaching and enduring. Kōetsu's view of art was inextricably involved with life itself, and his immediate means included infusing elements of classical Japanese tastes into simple, everyday affairs. It countered, in large measure, the decorative art of the military heroes of the day, and yet it tended to be decorative itself because of the way artistic values were conceived. A quiet afternoon of private conversation took on the stylized form of an official audience, but moderation was the key, rather than dramatic display.

In his poems, usually those composed in thirty-one syllables in the form known as *waka*, Kōetsu celebrated the experiences of a man in communion with nature who is aware of life's joys and sorrows. He put these poems together as books or scrolls, and their visual beauty has made them treasures of museums. Gold and silver patterns mingle with the elegant "grass" script of Kōetsu's calligraphy with all the grace of natural companions—birds and trees, flowers and insects, mountains and streams. His inkstones and writing boxes are casually elegant, their forms and designs recalling motifs from classical Japanese literature and objects in nature as though they were one and the same thing.

In order to realize his aims, it was essential that Kōetsu live his life unfettered, owing allegiance to no man. Though much admired by Hideyoshi, Kōetsu never served him in any official capacity, and invitations from the Edo shogunate to serve as a cultural adviser where politely declined. He did, however, accept a government gift of a large area of land in northwest Kyoto called Takagamine, where he established an art colony in which many families of artists and artisans took up residence under his guiding hand. The influence of this guidance was far-reaching, for the descendants of Takagamine continued to make Kōetsu's theories known to later generations, including our own. In its day the colony was a haven for priests, poets, men of high or low station in life—anyone who, like Kōetsu, needed the freedom of solitude and the isolation from authority in order to formulate his own image of man. Retirement of this kind required courage, for it was, as it always has been, easier to accept the established forms and bow to authority. The courage and ideals of Kōetsu were soon shared by a great many

people, and in Kyoto, as in no other Japanese city, there developed a sense of identity that prevails even to the present day.

SŌTATSU

One of the most engimatic characters in Japanese art history was a member of Kōetsu's colony. Tawaraya (or Nonomura) Sōtatsu's origins and much of his life are obscure, but it seems that he was a local craftsman, a maker of fans, who at some point came under the spell of Kōetsu and used his own talents to realize in painting some of the master's aesthetic principles. The small body of works attributed to him can be divided into two styles: one a decorative, colorful vision of classical motifs, and another that owed its technique of somber washes of ink to continental inspiration, but whose subject was usually of native invention.

In all of Sōtatsu's paintings there is a playfulness that seems to reflect Kōetsu's abhorrence of anything grand and pompous. He believed art objects existed to stimulate one's sensibilities toward nature and history; for them to be appreciated, the artist's effort must not be apparent. How truly sensible this emphasis on creative involvement is becomes clear if, by contrast, one envisions the execution of *fusuma* paintings commissioned by government authorities: dozens of Kanō-school artists hard at work depicting subject matter of Confucian or otherwise Chinese derivation that was quite beyond the understanding of either patron or artist.

In the confines of the little community at Takagamine, the artist and his friends could share the beauty of their mutually complimentary arts. It was less easy for people on the outside to understand either Sōtatsu's innovations in ink painting (by puddling the ink in a certain way, which he called *tarashikomi,* he was able to give shape and substance to objects with a minimum of effort) or his fans and screens on which allusions to famous tales from Japanese antiquity were painted in bright colors. Nevertheless, the visual attractiveness of his art did not go entirely unappreciated, and his shop, the Tawaraya, became famous for its "unusual" fans. Later Ogata Kōrin made Sōtatsu's manner of painting (and, indirectly, Kōetsu's aesthetics) understandable to the public.

KŌRIN

Ogata Kōrin, who was active in the late seventeenth and early eighteenth centuries, was the son of a Kyoto dyer who had been associated with Kōetsu at Takagamine and whose shop had long been a favorite of Kyoto gentry. Although separated from Sōtatsu by at least a generation, Kōrin was an ardent admirer of his painting style, and endeavored to continue the tradition. His acquaintance with fabric design may have had something to do with Kōrin's extraordinary talent for pattern and composition, and for color and texture as well. Motifs and techniques from Sōtatsu's paintings were borrowed and orchestrated on a grand scale, regardless of whether the painting itself was a tiny fan or a giant pair of screens. The public was intrigued by the lyrical splendor of this art and for some time Kōrin enjoyed acclaim. The art patrons in this period were fickle, however, and once another style of painting came into vogue Kōrin found himself with no means of making a living. But the patterns of his fabrics and the compositions of his paintings, together with certain of his color combinations, did creep into the repertory of almost every other painting school of the period, and Kōrin's influence is felt even today, perhaps as strongly as ever.

In his later years Kōrin and his brother Kenzan moved to Edo, where they hoped to prosper as they had been unable to in Kyoto. Edo was becoming the most talked-about city in Japan, and several Kyoto artists had moved there—taking their characteristic styles and attitudes. Yet something in the new capital refused to accommodate those styles, and although Kyoto artists had some influence on the Edo art world, their styles were for the most part rejected. Kenzan was a skilled draftsman, but his Edo pictures were painted with a rather heavy hand—a trait that may indicate the influence of Edo tastes in art, which were opposed to the lyrical beauty peculiar to the arts of Kyoto.

MERCHANT TASTES

For several years after the Tokugawa family made it the political capital, the city of Edo was remarkably prosperous and seemed destined to have no rival in terms of economic power. By the end of the seventeenth century a rival did appear, however, in the form of a united cultural and economic force in the Kansai area. Sakai, Osaka's merchant harbor, became a major center of both foreign and domestic commerce. Its population of traders and merchants amassed a sizable percentage of all the wealth in the country, and they used this economic power to gain an advantage over the financially impoverished upper classes. Kansai merchants were thus in a position to advance themselves by building a social order of their own. The wealthiest ones actively sought to achieve equal social standing with the noble and military classes by adopting their manner of dress, type of housing, their habits and entertainments. The nobility and military, of course, never thought of the merchants as their equals, but the lower classes considered all three groups to be on equal footing, since their outward trappings were the same. The merchant was anxious to imitate whatever seemed in good taste, and nothing would have seemed so more than the arts of the Kyoto upper classes—more specifically, the revered traditional forms and the lavish displays that predominated in postwar military art. But he did not have the background to understand either traditional forms or the Chinese-derived art of the military. Imported foreign goods that were available in the Kansai area were hardly more exotic than objects from a patrician household in Kyoto, and at first the merchant class used aristocratic and imported luxury items with approximately the same amount of misunderstanding.

There arose a hybrid style in which elements of the past were blended with those of foreign cultures in a way that satisfied the merchants' need for art that was both colorful and meaningful. This new style possessed an elegance and charm that was unmistakably Kyotoesque. In contrast to the heroic and dramatic art of the preceding period, or even to the bold art of contemporary Edo (see chapter 7), the new art of the Kansai was quite restrained.

JAPANESE LITERATI

Members of the military class in eighteenth-century Japan were not afforded the opportunity to earn honors on the battlefield and thus distinguish themselves in the conventional manner. Life was much too peaceful for that—in fact, a state of lethargy had set in throughout the nation. The reason was that the stringent and complex rules set down by the Tokugawa shogunate regulated the lives of all Japanese to the extent

that people lived in a fixed framework of patterned behavior, with little hope of changing anything. For the military man thus made idle (and often resentful) this was an unbearable state of affairs. The prosperous merchant class was little better off, its excesses having been curtailed by the government, and many of its members as far removed from the entrepreneurial spirit of their ancestors as the contemporary military man was from the samurai code of the past.

More and more members of both these classes in society turned to a life of study and connoisseurship as a means of escaping the boredom of routine business and government. Some of them saw their situation as similar to that of the Chinese literati artists of the Ming and Ch'ing dynasties, and they sought to imitate the paintings and writings of those masters, which were being brought into Japan through the port of Nagasaki. Kansai artists were the first to call themselves by the name "literati" (*bunjin* in Japanese, the equivalent of the Chinese *wen-jen*), and they were also first in bringing to national attention the new style of painting. There soon arose a small circle of artists whose backgrounds were quite diverse, but whose aesthetic tastes were generally the same. Like the Chinese literati, their aim in painting was not to copy nature, but to use existing artistic prototypes (in this case, Chinese paintings of Chinese paintings).

Ike-no-Taiga (1723–76) was so utterly independent that to the Japanese his behavior seemed outrageous. He traveled about the country seeking out one remote area after another, and his disregard for family ties and obligations to superiors made him appear to be a sort of madman. Taiga's simple paintings somehow fail to reflect the deep feelings this complex man must have had, but they do indicate his whimsical attitude. Here and there one finds him departing from the conventional form of the Chinese landscape, and it is at these times that his paintings ring true.

Uragami Gyokudō (1745–1820) was once a warrior, but growing dissatisfied with his lord's policies, he abandoned the security of a retainer's life to wander the countryside with his favorite *koto* (an oriental zither) before turning to painting as a means of unburdening his heart. His landscapes are mostly variations on a single theme of tall mountains and remote village houses, all set down with great enthusiasm in rough patches of ink and spontaneous brushstrokes. Like Taiga, Gyokudō was at his best when paying less attention to Chinese models and giving full rein to his own inclinations.

Aoki Mokubei (1767–1833) began as a potter, working in Ming and Ch'ing styles. This gradually involved him in painting and drawing, so that, at first in his leisure moments and later as a full-time endeavor, he took to dashing off paintings that he traded to his companions within the literati circle in return for pieces of their calligraphy or poems.

Tanomura Chikuden (1777–1835), one of the more conservative literati painters, was a scholar whose father had been a physician in the service of a famous daimyo. Chikuden did not fancy the medical profession and left his family for the unconstrained life of a man of letters. He enjoyed drawing and poetry, and was soon drawn into the world of Chinese landscape painting, examples of which he copied meticulously, creating crisp and arid compositions that even a Chinese connoisseur might have praised.

The number of artists working in the literati tradition grew to respectable proportions within the Japanese art world, an indication of the popularity of the ideals they maintained. They found a ready welcome in Osaka and Kyoto among people of all classes who were likewise bored with life and who enjoyed the rebellious talk and the continental style of painting so beloved by this band of radicals.

THE REALISTS

The paintings of the Japanese literati were always sure to please the layman, for they possessed qualities that a class in modern art appreciation would also approve—bold colors and shapes, clever compositions, strong ink work, a sense of playfulness, a high degree of abstraction, etc. However, the layman was totally incapable of grasping the significance of the foreign subject matter and sophisticated references to literary works. To thoroughly appreciate paintings such as these required some knowledge of the Ming and Ch'ing literati and their works—knowledge that few people in Japan, even among the well educated, could have possessed.

At the same time the literati were active, a much more popular type of painting was being done by artists of the school headed by Maruyama Ōkyo (1733–95). Ōkyo was a resident of Kyoto who had studied all the native painting styles prevalent in his day as well as Ming and Ch'ing paintings and drawings and those canvases from Europe that occasionally made their way to Japan. Painters of this school worked out a method of painting simple, everyday objects in a manner that recalls Western rules of perspective and shading. Ōkyo advised his students to make sketches directly from nature and to observe effects of light and shade, instead of relying on drawing techniques devised by ancient masters. But the Westerner is not apt to discern any direct connection between Ōkyo's paintings and those of a European contemporary. For one thing, Ōkyo simplified his compositions: he often isolated a single object and gave only the slightest indication of its setting. His technique was also simple in appearance: the lights and darks were put down boldly, with little middle value, much as they appear in a coarse-grained photographic negative. The underlying principle seems to have been that the illusion of naturalness be immediate, and this idea, along with the unorthodox procedure of rendering it graphically, was strongly criticized by the existing painting schools for being too concerned with physical appearances. It was said that Ōkyo was no more than a slave to subject matter and that his paintings were entirely lacking in dignity for that reason. Laymen, however, were most impressed with the uncanny realism of Maruyama-school pictures, and gave their unqualified support to the artists who painted them.

At Daijō-ji, a temple complex in Kinosaki, Hyōgo Prefecture, on the Japan Sea, there is a large amount of work by Maruyama-school artists. On the *fusuma* of the eleven rooms of the *kyakuden* ("guest hall") are scenes of birds and flowers, landscapes, figures and animals by Ōkyo and his son Ōzui (1766–1829). Other paintings in this series were by some of his best pupils, including Goshun (1752–1811) and Rosetsu (1755–99). The latter's contribution is particularly noteworthy for the delightful way lush ink tones are used to give form to monkeys and other small animals painted in the room called *saru-no-ma*.

KAMIGATA CRAFTS

Kyoto and Osaka crafts have been in demand since the seventeenth century, and their traditional techniques and styles are famous all over the world: the foreign tourist is often as anxious to visit the shops and studios of weavers, dyers, potters, carvers, and lacquerware masters as he is to visit the ancient temples in the area. Kyoto's Nishijin textile center began life 500 years ago as a "cottage industry," in which a few talented artisans pooled their efforts to meet the needs of people in the immediate neighborhood.

It grew to a thriving studio of skilled specialists who had worked out problems of production and technique well enough to make the name of the studio famous throughout the nation. Miyazaki Yūzen (1681–1763) developed a special dyeing technique called *yūzen-zome* that became the specialty of Kyoto's dyeing and weaving industries.

In textile and garment design, Kansai artisans were relatively immune to foreign influence, much as their forbears had been. In other arts this was not the case—certainly not in painting or, with the single exception of Kōetsu's school, in pottery making, where foreign articles were considered the ultimate in good taste and imitation was encouraged. Chinese and Korean wares were immensely popular, and Korean potters who had come to Japan were eventually successful in finding local materials for the production of the highly acclaimed porcelain of their homeland. By the end of the seventeenth century, one Kyoto potter, Nonomura Ninsei, had managed to acquire the secrets of glaze and clay formulas and painting techniques of both traditional and newly imported continental wares. Ninsei had been trained in the pottery style of the Tamba region, but preferred Korean-inspired Seto pottery, and made copies of the enameled earthenware of late Ming times. His kiln at Ninna-ji in the Narutaki section of the city was at the service of the imperial family. Today, a good many Kiyomizu (Kyoto) potters (and some in the provinces, whose works are based on Kiyomizu ware) trace their lineage back to Ninsei.

Kōrin's brother, Ogata Kenzan, was Ninsei's best pupil, but his pottery is considerably less derivative of foreign styles than it is of the tradition of Kōetsu via his brother's paintings. The bold and playful designs on Kenzan's bowls and the whimsical pottery of Ninnami Dōhachi (1783–1855) gave rise to a ceramic style that today is reflected in the gay patterns and shapes of certain types of Kyoto pottery.

Kyoto continued to lead the field in lacquerware manufacture, and *maki-e* articles decorated with gold and silver designs in the Kōrin manner, and others with designs originating in the paintings of the Maruyama-Shijō schools, were finding their way into many more homes than ever before. Chinese styles of carved-lacquer boxes and trays were in great demand as well, so that in this art, as in others, one finds the two elements of native and foreign styles coexisting and sometimes mingling in ways that are often startlingly original and always executed with an eye to technical perfection.

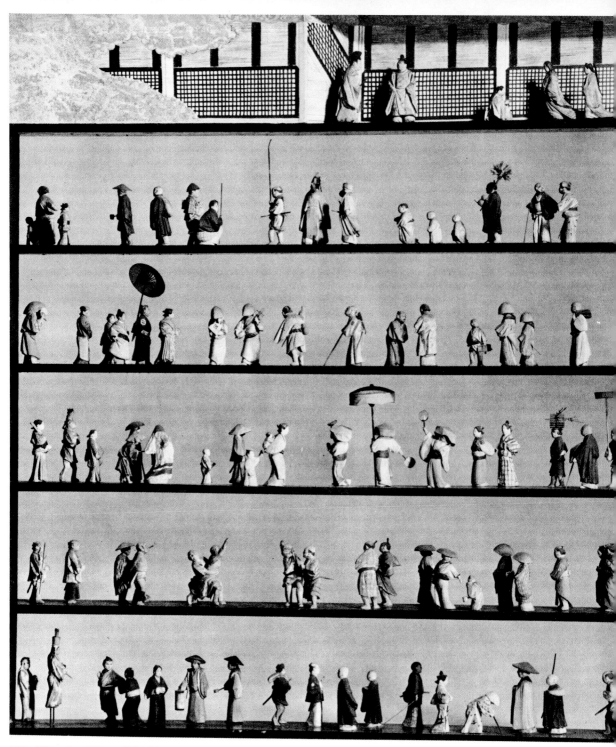

100. "People of Kyoto," by Shimizu Ryūkei (*ca.* 1659–1720). Early eighteenth century. Average height of dolls, 6 cm. (2.3 in.).

In 1717, after reaching his sixty-first birthday, the eccentric priest-sculptor Ryūkei began a project that took a full year to complete: out of the many types of people walking the streets of Kyoto he chose one hundred whose likenesses he carved out of small blocks of wood. The tiny dolls were shown to the reigning emperor and to the shogun in Edo.*

101. Exterior of Sumiya, Kyoto.
Perhaps at night, when music filled the air and the
street outside was striped with fingers of light coming
through papered windows, the effect was different. As
it is, one would hardly suspect that in the centuries-
old walls of Sumiya—this darkly sedate building in
Kyoto's Shimabara district and the oldest existing
brothel in Japan—are locked the secrets of countless
love affairs.*

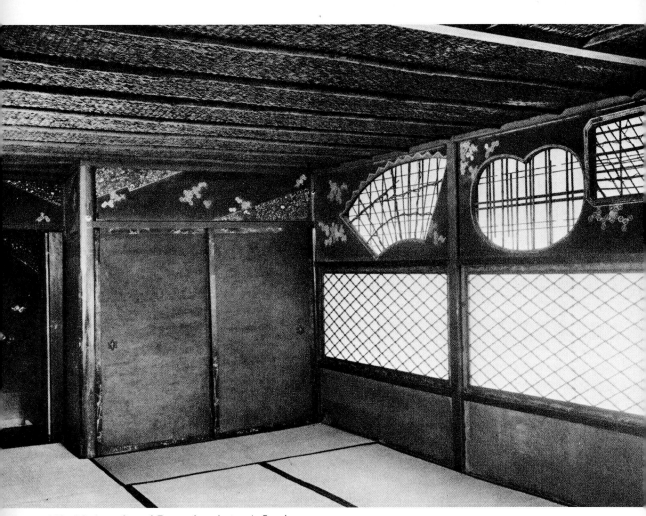

102. Mother-of-pearl Room *(aogai-no-ma)*, Sumiya.
Above the windows of the sliding doors and fanciful
windows of this room are the mother-of-pearl decora-
tions that earned the room its name and helped create
an exotic atmosphere of foreignness.*

103. *Shōji*, Sumiya.
Sumiya guests were no doubt enchanted by irregularities that seem unremarkable to the modern eye. To distinguish Sumiya from other Kyoto townhouses, its designers concentrated on modifying basic elements of the interior, such as replacing the traditional grid design of windows with surprising diagonals and curves.*

104. Stairway, Sumiya.
This stairway, like the wood of Sumiya's exterior, was originally stained with dark-red ferric oxide, but years of use and lantern smoke have turned it shiny black. Concealed in the side of the stairway are long drawers that seem the perfect place to store scrolls and paintings.*

105. Takagamine, Kyoto.
In 1615 Ieyasu granted Hon'ami Kōetsu a piece of land at Takagamine in Kyoto, which at that time was north-west of the city proper. Kōetsu, who was then fifty-eight, established a private colony of artists there. He and his followers often took as motifs for their works the cone-shaped hills (seen in this photograph) of the immediate area.*

106. Kōetsu-ji, Kyoto.
This is the path leading to Kōetsu-ji, one of the temples established by Kōetsu in his artists' colony at Takaga-mine. It was named Kōetsu-ji after the master's death in 1637. The present abbot of the temple is carrying on the lacquer-carving tradition begun there in the seven-teenth century, and special tea ceremonies are still conducted in the reconstructed tea house on the temple grounds.*

107. "Lotus Scroll," by Hon'ami Kōetsu (1558–1637).
L. 33.2 cm. (13 in.).

Kōetsu's poem-scrolls are very often complete tran-
scriptions of well-known anthologies. The "Lotus Scroll"
is of the *Hyakunin-isshu,* a collection of one hundred
poems *(waka)* compiled in 1235. The illustrated portion
shows a poem by the celebrated priest-poet Jien (d.
1225). Kōetsu wrote the "Lotus Scroll" poems in ink
and in his distinctive script on paper that was decorat-
ed (by himself or perhaps by Sōtatsu and others) with
lotus designs rendered in broad washes of ink and gold
and silver.

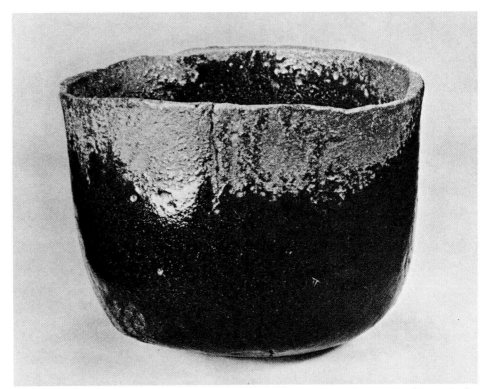

108. Black Raku teabowl (known as *Amagumo*), by Hon'ami Kōetsu. H. 9.3 cm. (3.7 in.); top diameter, 12.4 cm. (4.9 in.).

It seems that Kōetsu preferred a delicate, thin-walled Raku ware over the softer and heavier bowls designed by Chōjirō (see figure 93). The relatively precise contours of *Amagumo* ("Rain Cloud") impart a sense of elegance to the vessel that is more in keeping with Kōetsu's aesthetic ideals, certainly, than Rikyū's.

109. Printed text of the Nō play *Kantan,* by Hon'ami
Kōetsu. Each page, 24 cm. (9.4 in.) × 18 cm. (7.1 in.).
Kōetsu collaborated with Sumikura Soan (1571–1632)
in designing and publishing a series of decorated books
which included complete Nō plays and selections from
classical literature. Illustrated here is Kōetsu's frontis-
piece and beginning text for the play *Kantan.* The
calligraphy was printed directly over the pictorial de-
signs, which were printed by woodblock using a thick
white paste made of mica.*

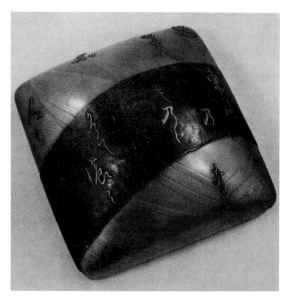

110. Inkstone box with bridge design, by Hon'ami
Kōetsu. L. 24.2 cm. (9.5 in.), w. 22.8 cm. (9 in.), h. 11.8
cm. (4.7 in.).
The genius Kōetsu displayed in his poem-scrolls for
combining pictorial elements and written characters
to allude to ancient themes is manifested also in a num-
ber of laquered objects, outstanding among which is
this inkstone box. The poem, from the twenty-volume
anthology of poems compiled in 951, the *Gosenshū,*
mentions a bridge at Sano (in Mito north of Edo),
which in Kōetsu's design is rendered in a wide band of
lead, with boats and water below it indicated in low-
relief gold lacquer. The characters of the poem are done
in silver inlay. (See color plate 17.)

112. "Lotus and Waterfowl," by Tawaraya Sōtatsu. H. 116.5 cm. (45.7 in.), w. 50.3 cm. (19.7 in.).

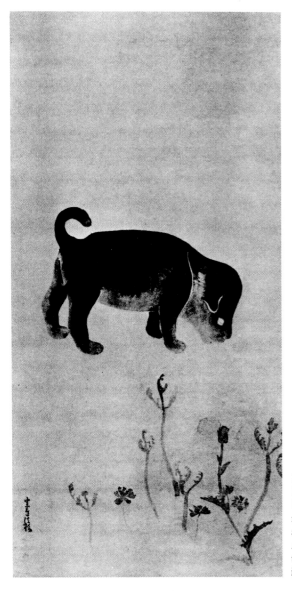

111. "Dog," by Tawaraya Sōtatsu (active *ca.* 1600–1640). H. 90.3 cm. (35.4 in.), w. 45 cm. (17.6 in.). In the two paintings in figures 111–12 one finds visual references to the painting styles of classical Japanese art (figure 111) and Chinese art of the Sung and Ming Academies (figure 112), but they are both handled in the playful ink style that was popular with tea cultists in the art colony at Takagamine.

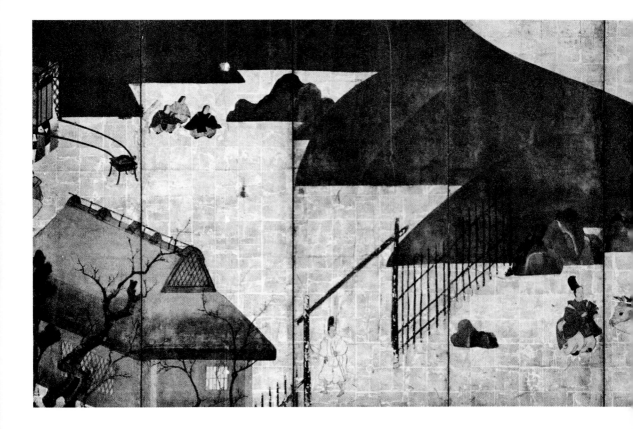

113. "Sekiya" and "Miotsukushi," by Tawaraya Sōtatsu. Pair of six-fold screens. H. 151.8 cm. (59.5 in.), w. 354.8 cm. (139.5 in.) each.

Because of Sōtatsu's preference for simplified shapes and casual attitude towards draftsmanship, the allusion to antiquity—in this case, to two scenes from the eleventh-century *Tale of Genji*—seems remarkably lighthearted, as indeed it does in all other works done in the Kōetsu tradition. The figures and carefully chosen landscape and architectural motifs of the screens are used in such a way as to emphasize the dramatic moments of each narrative, but are at the same time decorative components in an almost abstract display of color and gold.*

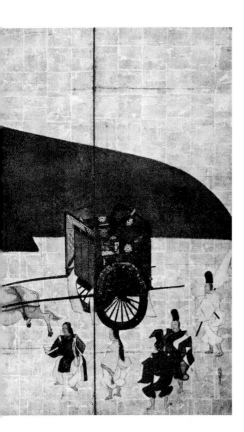

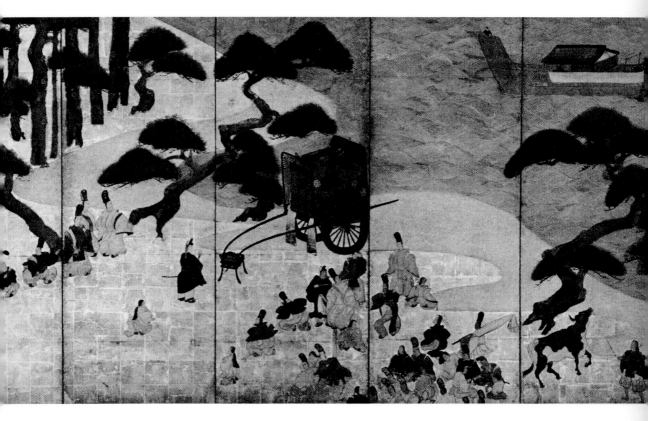

114. "Red and White Plum Trees," by Ogata Kōrin
(1658–1716). Pair of two-fold screens. H. 156.6 cm.
(61.4 in.), w. 172.7 cm. (67.7 in.) each.
Although deeply committed to a renascence of Sōta-
tsu's style, Kōrin was himself inclined to use fewer
motifs, classical or otherwise, which in his paintings be-
came intensely dramatic visual statements. Sōtatsu's
fondness for cropped compositions was for Kōrin—who
constantly allowed motifs to run off and then reappear
along the edge of the painting as they do here—a
cardinal rule. These screens were probably done some-
time between 1705 and 1710. (See color plate 18.)*

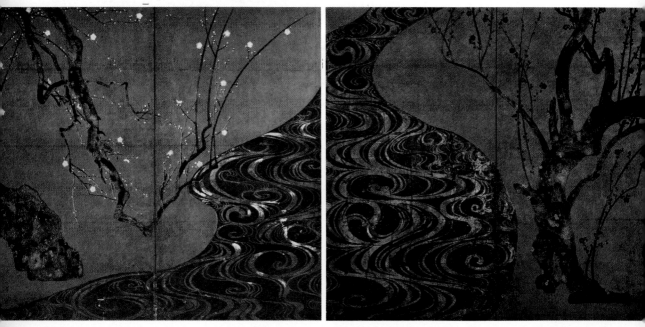

115. Painted teabowl, by Ogata Kenzan (1663–1743).
H. 8.7 cm. (3.4 in.); top diameter, 19.7 cm. (7.7 in.).
One sees in this teabowl a continuation of a vessel type
that was popular a hundred years earlier (figures
93–95, 108). But its clean lines show that Kenzan was
more concerned than his predecessors with precise
shapes, much as Kōrin was in his Sōtatsu-style paint-
ings. Kenzan's painted design of *yari-ume* (spear-
stemmed plum) recalls the bold designs on pottery by
Furuta Oribe (figure 99).*

116. Square ceramic dish, by Ogata Kōrin and Ogata Kenzan. Each side, 22.1 cm. (8.7 in.).

Like Sōtatsu before him, Kōrin (whose signature appears in the lower left corner of this dish) occasionally painted Chinese themes such as the one here of the "Sung poet Huang Shan-ku watching sea gulls." The long inscription on the reverse side reveals that it was Kenzan, Kōrin's brother, who made the dish. Joint efforts of this kind by Kōrin and Kenzan are fairly common, most of them dating around 1700.*

117. Ceramic plate, by Ogata Kenzan. D. 16.1 cm. (6.3 in.).

This design of boats and waves, which covers the plate like a piece of printed fabric, is one of the more obvious examples of how the textile designs that the Ogata family was famous for in Kyoto are frequently reflected in the works of Kenzan and Kōrin. The sails are rendered in black and yellow and are placed quite casually on a background of white and gray wave patterns. The plate is one of five, each one with a different design, which together comprise a complete set.

166 KAMIGATA VALUES

118. "The Bridge of Eight Sections" (*Yatsuhashi*), by Ogata Kenzan. H. 28 cm. (11 in.), w. 36.6 cm. (14.4 in.).

The small village of Chiryū to the southeast of Nagoya is the setting for one of the poems in the *Tales of Ise,* a ninth-century poetry-and-prose anthology of 125 chapters. There, beside a marsh crossed by a plank bridge constructed in eight sections "like the legs of a spider," the young travelers of this particular tale sat down to rest and, seeing the clusters of iris that were growing in the marsh, began to compose poetry. The shadowy images in Kenzan's painting, done in muted colors and in a limited number of brushstrokes, convey the totality of the visual aspects of the story in much the same way that the occasionally legible characters of the dissolved script cause the learned reader to recall the ancient passages in full.

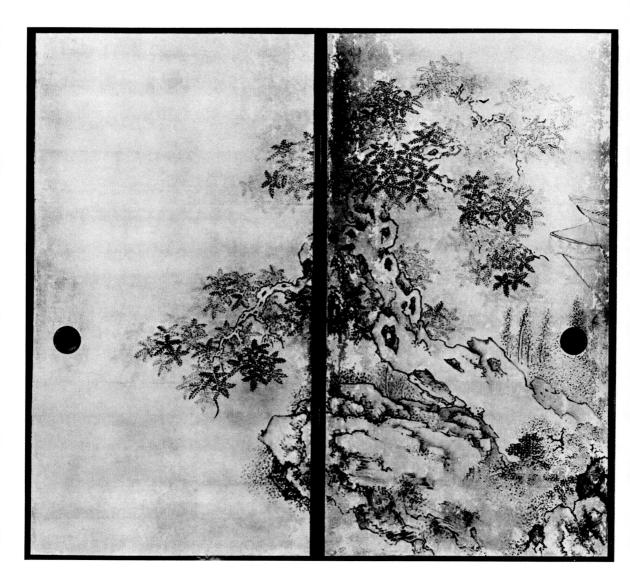

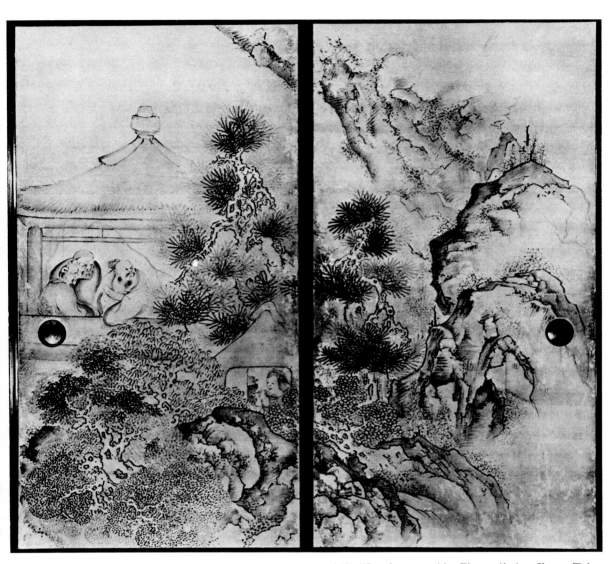

119. "Landscape with Figures," by Ike-no-Taiga (1723–76). Four-panel *fusuma*. Each panel: h. 170 cm. (66.6 in.), w. 92 cm. (36 in.).

Although derived from contemporary Chinese painting, "Landscape with Figures" is original in a number of ways. Like Kanō masters of the sixteenth century Taiga enlarged the Chinese compositions and spread them out on walls and doors as interesting pictorial elements in interior decoration. He systematized and contrasted in one painting the intuitive, playful mannerisms of Chinese literati artists, arranging them like so many notes in a musical scale, and thus bypassing (or ignoring) the Chinese artists' preoccupation with content and meaning. Oddly enough, Taiga's seeming concern for the almost purely visual effect of the painted surface is perhaps easier to understand in the twentieth century than it was in the eighteenth.*

120. "Mountain Range in China," by Yosa-no-Buson (1716–83). Handscroll. H. 29 cm. (11.4 in.), l. 242 cm. (94.9 in.).

Buson, who only began to paint after reaching forty (he is perhaps best known as a *haiku* poet), worked in the tradition of Chinese painting that was begun in the late fifteenth century by such Ming literati artists as Shen Chou and the poet-painter Yao Shou. In this long scroll, which depicts a famous range of tall mountains in Szechwan, Buson utilized all the conventions of lush ink, pastel coloring, broad brushwork, dramatically "spaceless" compositions, etc., that were developed on the continent.*

121. "Evening Snowfall," by Yosa-no-Buson. Handscroll. H. 27.3 cm. (10.7 in.), l. 129.3 cm. (50.7 in.).

Like the scroll in figure 120, this one carries a title (far right) that is taken directly from Chinese paintings, but the subject matter is in this case unmistakably Japanese. In his late fifties, Buson settled in Kyoto and often painted scenes of the old capital in the Chinese manner. Anyone who has spent a winter in Kyoto will want to see in this painting the ancient city itself, surrounded by mountains, receiving during the night a blanket of the snow that comes a few times each year only to melt very quickly before the children have a chance to fully enjoy its strangeness.*

123. "Winter Clouds and Sifting Snow," by Uragami Gyokudō (1745–1820). H. 133.3 cm. (52.3 in.), w. 56.6 cm. (22.2 in.).

In the early 1800's Gyokudō produced a large group of paintings possessing the darkly ethereal light quality and haunting beauty of the one illustrated here. Monochrome tones of bluish ink are blended together in a way that only emphasizes highlights, leaving the rest of the painting in darkness. The contrasting network of scratchy lines describing the trunks of old trees and bare limbs plays across the surface of the picture like shadows of ice crystals on frosted glass.*

122. "Porthole Vignettes," by Tanomura Chikuden (1777–1835). One of six paintings in an album. H. 21.2 cm. (8.4 in.), w. 13.4 cm. (5.3 in.).

Even though this album takes as its subject scenes from a trip Chikuden made through the Japanese Inland Sea, students of Chinese art will undoubtedly be struck by the "Chineseness" of the painting, recognizing in it stylistic elements found in album leaves by continental artists as far separated in time as Hsü Tuan-pên (active *ca.* 1500) and Ta Chung-kuang (1623–92).*

172 KAMIGATA VALUES

124. "Autumn in the Blue Mountains," from the *Smoke and Mist Album* of twelve paintings by Uragami Gyokudō. H. 28.5 cm. (11.2 in.), w. 21.9 cm. (8.6 in.). This delightful landscape is much more solidly in the tradition of Chinese painting, with overtones of works by the eccentric Buddhist priest Tao-chi (1641–*ca.* 1717) ringing loud and clear. The date of 1811 appears in a postscript written by Gyokudō and his friend Chikuden. With the exception of two paintings in the album—including this one—that are painted in light colors, all are done in bluish ink on yellow Chinese paper. (See color plate 19.)

125. "Morning at Uji," by Aoki Mokubei (1767–1833). H. 59.4 cm. (23.3 in.), w. 48.5 cm. (19 in.). With a little imagination, it is possible to see the similarity between the composition of this painting and the view one has looking south from Uji Bridge with Byōdō-in on the right. But Mokubei has transformed the rolling hills of the actual scene (Vol. I, figure 132) so that they correspond to the jagged mountain peaks depicted in the Chinese paintings that served as his model.*

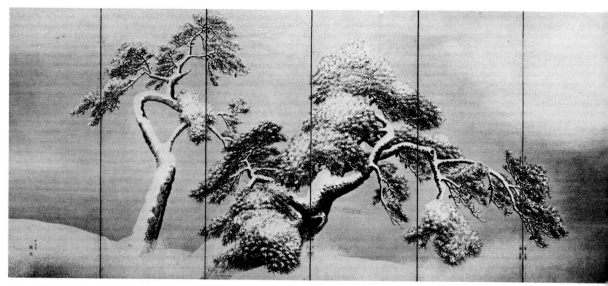

126. "Pine Trees Covered with Snow," by Maruyama Ōkyo (1733–95). Pair of six-fold screens. H. 155 cm. (61 in.), w. 359 cm. (141 in.) each.

One means devised by Kanō artists in the seventeenth century of making dark temple and palace interiors seem more spacious was to simplify the compositions of earlier wall paintings, isolating one or two motifs against reflecting gold backgrounds. By combining this scheme with Western drawing methods, Ōkyo created paintings with a strong sense of photographic reality, the illusion of giant trees, waterfalls, and other out-door subjects rendered stage-set fashion in light and shade. He painted these screens about 1785.

127. "Marsh Willows and Birds," by Matsumura Goshun (1752–1811). Pair of six-fold screens. H. 164.5 cm. (64.5 in.), w. 365.4 cm. (143.3 in.) each.

Goshun's paintings are lyrical statements in pastel tones of ink and color that show Ōkyo's influence only in occasional passages of Western-style draftsmanship. In all of his works, Goshun's subjects seem wedded to their settings in a totality of mood (rather than in a way that suggests spatial reality) beacuse of the importance he placed on a consistently beautiful ink quality—regardless of subject matter. These screens are usually dated *ca*. 1800.

128. "Cocks and Hens," by Itō Jakuchū (?–1800). Six-panel *fusuma* at Saifuku-ji, Osaka. H. 176.9 cm. (69.3 in.), w. 482.6 cm. (189.3 in.).

Several things about the works of Jakuchū, a professional Kyoto artist, suggest that he was something of an eccentric. In painting his favorite theme of barnyard fowl, he exhibits characteristics taken from his contemporaries—including a compelling sense of color and design similar to that seen in the works of Kōrin, and an aristocratic elegance of line borrowed from Chinese academic flower-and-bird pictures. His paintings were largely ignored until *nihon-ga* artists rediscovered them in the late nineteenth century.

129. "Monkeys," by Nagasawa Rosetsu (1755–99). Four-panel *fusuma* at Daijō-ji, Kinosaki, Hyōgo.

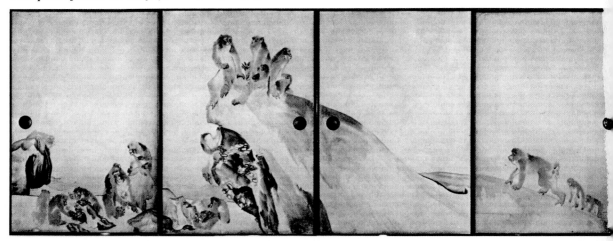

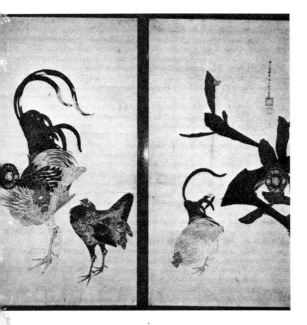

131. "Yama-uba and Kintarō," by Nagasawa Rosetsu. Itsukushima Shrine, near Hiroshima. H. 157.6 cm. (61.8 in.), w. 81.8 cm. (32 in.).

These three very different paintings point up Rosetsu's extraordinary versatility. Figure 129, with its isolated motifs of skillfully painted rocks and monkeys, is closest to the style of Ōkyo, Rosetsu's teacher. The extreme simplicity of figure 130 is reminiscent of the Zen ink sketches discussed earlier, but is much more explicit in its presentation of nature. For the third painting, Rosetsu borrowed the theme, one especially popular with *ukiyo-e* masters (chapter 7), from a puppet play of Chikamatsu (1653–1725) based on the ancient tale of Yama-uba, the witch of the mountains, and the young boy she raised to manhood, Kintarō (Sakata-no-Kintoki).*

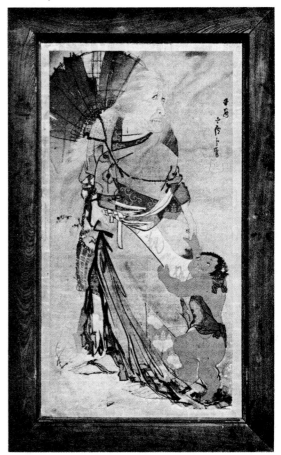

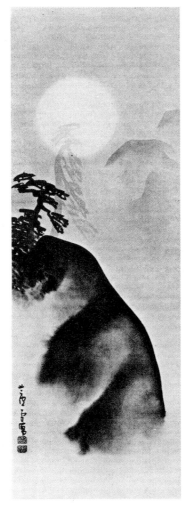

130. "Night Landscape," by Nagasawa Rosetsu. H. 98.4 cm. (38.5 in.), w. 35.5 cm. (13.9 in.).

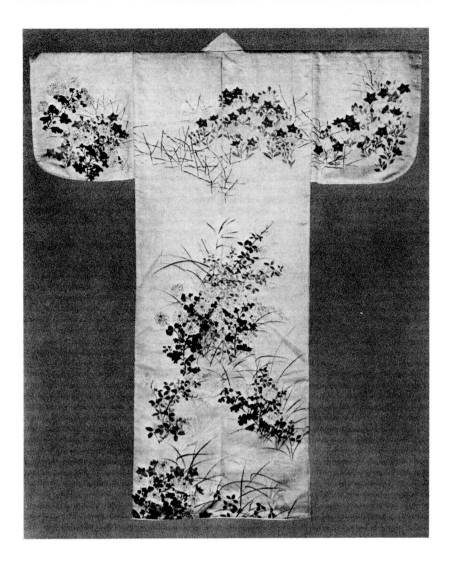

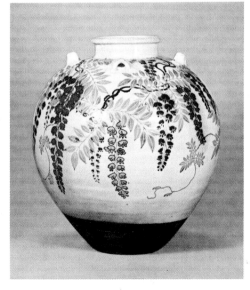

132. Jar with overglaze decoration, by Nonomura Ninsei (active *ca*. 1630–90). Atami Museum, Shizuoka. D. 27.3 cm. (10.8 in.), h. 29.2 cm. (11.5 in.).

Kyoto became a pottery-producing center in the late seventeenth century under the leadership of Nonomura Ninsei. The influence of Ninsei is clear enough in the works of Kenzan and one or two of his other students, but it was the numerous professional potters in the area who most faithfully carried out Ninsei's innovations, and it is their descendants who produce the bulk of Kyoto's ceramic market today. All the vessels in Ninsei's large repertory exhibited the exotic more than the traditional, as this one does, and appealed greatly to the general public because their shapes and decoration were derived from foreign wares—in this case, heavy Spanish amphorae and Chinese enameled porcelains. (See color plate 20.)*

133. *Kosode* with hand-painted design, attributed to Ogata Kōrin. Tokyo National Museum. L. 147 cm. (57 in.).

The clever distribution of the chrysanthemum, bush clover, and other autumn plants painted directly on this white satin garment in delicate shades of ink and color is firmly within the decorative tradition begun by Kōrin's ancestors at Takagamine. Even the rather shocking disregard for permanence manifested in the technique seems an affirmation of the ideals of Rikyū and Kōetsu.*

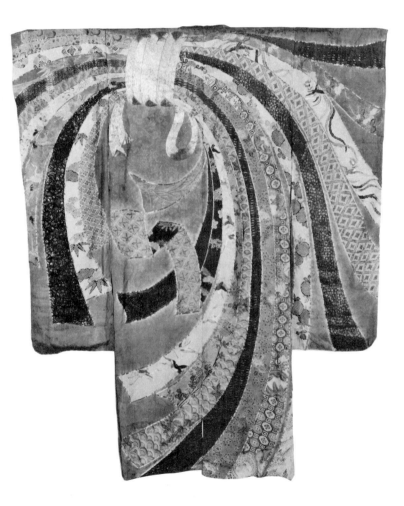

134. *Furisode*. Early eighteenth century.

A sheaf of *noshi*, the customary Japanese decoration (originally made of flattened and dried abalone) for important gift packages, is here the principal motif of this garment's design.*

135. *Yatsuhashi* inkstone box, attributed to Ogata
Kōrin. Tokyo National Museum. L. 27.4 cm. (10.7 in.),
w. 19.7 cm. (7.7 in.), h. 14.2 cm. (5.6 in.).
The *yatsuhashi* design here is the same one used by
Kōrin's brother, Kenzan, in the painting illustrated in
figure 118. Lead was used for the bridge, silver for the
stakes, mother-of-pearl for the blossoms, and thick gold
maki-e for the stems and leaves. In few cases are Kōrin's
outstanding talents better exhibited than in the skillful
combination of materials and the exquisite design of
this double-decked inkstone box.*

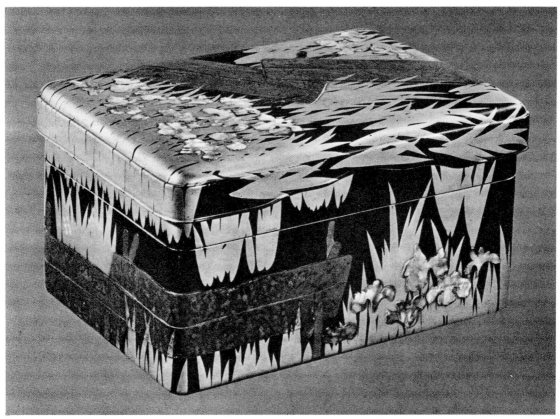

Plate 17. Inkstone box with bridge, by Hon'ami Kōetsu (1558–1637). (See also figure 110.)

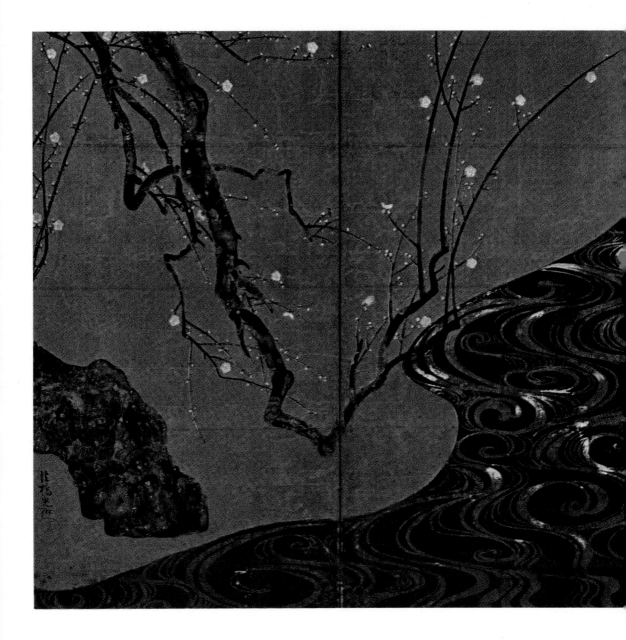

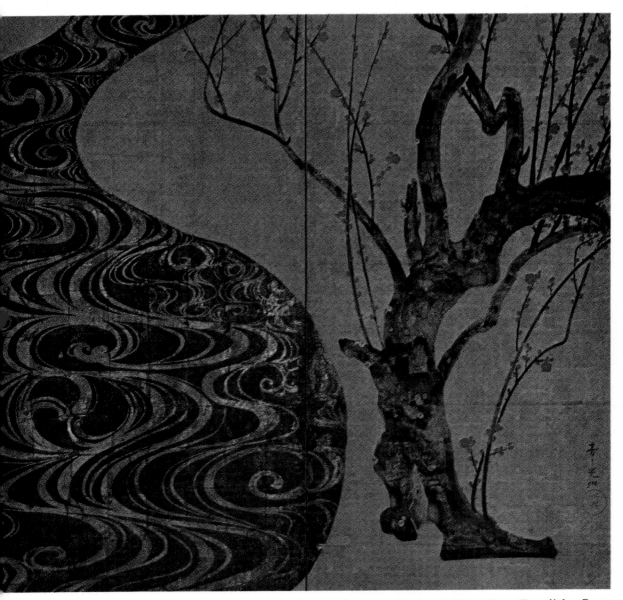

Plate 18. "Red and White Plum Trees," by Ogata Kōrin (1658–1716). (See also figure 114.)

Plate 19. "Autumn in the Blue Mountains," by Uragami Gyokudō (1745–1820). (See also figure 124.)

Plate 20. Jar with overglaze decoration, by Nonomura Ninsei (active *ca*. 1630–90). (See also figure 132.)

~ 7 ~

THE ARTS OF EDO

THE PROSPERITY OF EDO

Following Toyotomi Hideyoshi's death in 1598, Tokugawa Ieyasu and the Toyotomi family competed for national power. By 1603 Ieyasu's position was strong enough so that he was able to establish in Edo a central political mechanism, known as the Tokugawa *bakufu,* and he began his rule of Japan, although the Toyotomi powers were not completely overthrown until 1615. In the years before his death in 1616, the new shogun successfully expanded the nation's agrarian economy and encouraged mercantile interests. Gold and silver coinage was undertaken on a large scale, cities were put under the administration of shogunal authorities, and the government monopolized foreign trade. When Tokugawa Hidetada succeeded his father, the shogun's authority was absolute: dissident voices, military and religious, had been silenced, and the shogun commanded the obedience of every segment of the social structure—from the imperial house to the lowliest peasant. Government policies were based on Confucian sources, with edicts often transcribed word for word from Confucian texts. A totalitarian state was the goal, but it was to be in the nature of a new religion, with the shogun as supreme deity.

In 1635 Iemitsu, the third shogun, initiated a program called *sankin kōtai,* which perhaps more than any other single factor guaranteed Edo's prosperity: lords were required to live in Edo and their home provinces in alternate years. Wives and children, however, were to reside permanently in Edo, thus discouraging any plan a lord might entertain of attacking either the city or the *bakufu* ideology, since in both cases his kin would be endangered. In addition to the expense of maintaining two households, whenever a lord traveled he had to make up an entourage of specified size, according to his rank, and he was expected to assist in the building and repair of castles when called upon. These and similar demands on the finances of the nobility curtailed private power while increasing the flow of money in the new capital.

A READY-MADE CULTURE FOR EDO

Adopting the example of Nobunaga, who had created a town around Azuchi Castle, Ieyasu developed the city of Edo around the castle he had built in an unsettled area in

185

the Kantō (eastern provinces). Planners and laborers were brought in to lay out the new capital, and soon streets and buildings replaced rice paddies and pasturelands. Ieyasu's direction of the city's growth was not confined to economic and political concerns, and in choosing an art movement to support—and by which he would be identified—he quite naturally turned to the Kanō school. Previously the official art of the Ashikaga shogunate, and firmly established as the favorite of military society, Kanō art also offered the Tokugawas subject matter that was primarily Confucian, so that it was the obvious complement to *bakufu* policies. Here was ready-made culture for the newborn capital, and Ieyasu (as well as his successors) promulgated it with a typically heavy hand. Not content with personal support of Kanō art, the shoguns fully expected their subjects to follow suit, and those who did not were apt to fall into disfavor.

The belief that government subsidy leads to irrelevance and monotony in art is well corroborated in the works of the Kanō school during Tokugawa rule. Kanō masters painted almost exclusively in the formal Chinese manner, faithfully repeating formulas devised earlier for painting Confucian figures and monochrome landscapes deriving from the art academies of the Sung, Yüan, and Ming dynasties. Without denying the beauty of paintings done in this manner, it must be admitted that such mimicry left little room for variety or artistic growth. Nor was the government interested in having its chosen favorite demonstrate significant change, for this would have rendered it less immediately recognizable and therefore less useful as a symbol of Tokugawa supremacy.

The Shogunal Painting School *(e-dokoro)* had two principal divisions and each division had branch schools throughout the Edo area. At each branch a master teacher oversaw a large staff of artists. Chief appointments to the academy were for life, and the positions were passed on to succeeding generations, from master to favorite pupil. In the mid-seventeenth century, three grandsons of Eitoku were in charge of the most important branches of the academy's superior division. The government provided them with houses, small fiefs, and handsome stipends, placing them in the social category of minor samurai. The Kanō school of course had representatives in every major urban center, and the style was explicitly set forth in how-to-do-it manuals that leading masters produced for their students.

It is intriguing to consider what course Japanese art might have taken had Hon'ami Kōetsu accepted the government's invitation to become its cultural adviser. And those who admire Kōetsu's ideas should remember that the Tokugawa rulers supported him and his followers by providing the land at Takagamine for Kōetsu's art colony. The shogunate cannot legitimately be accused of hampering all artistic growth simply because it made the Kanō school its official choice.

An Indigenous Art Develops

Edo's population came from throughout Japan—people of widely varying tastes and habits. It was natural that the artistic styles of other cities and towns would be uniquely blended in the new capital, but the upper classes were not to take as active a role in the development of new art forms as they had elsewhere in times past. An aristocrat was more apt to publicize Edo fashions when he returned to his home province than he was to nurture provincial tastes in the capital, and this was not necessarily because he chose to do so.

It is difficult today to conceive of a bureaucracy as all-encompassing as the *bakufu*, but it went so far as to dictate what size house a man could build, how large a lot he

could built it on, how elaborate an entry gate he could have, and the number and kind of screens or scrolls he could use to decorate the interior of his home. Style of dress and proper social activity were stringently regulated as well. The wealthiest families faced the most picayune rules: the Tokugawas knew they had to eliminate any competition for power, and this meant controlling the nobility in every area of behavior. The merchant and laboring classes, not being considered any particular threat to the shogunate, were given somewhat more freedom. Thus it happened that these people came to be responsible for the artistic developments that took place in Edo, and since they had greater opportunity to enjoy the entertainments offered by the prospering new city, they established the link between the entertainment world and the visual arts that led to a lively genre movement, similar to the one that developed in Kyoto.

Edo townspeople found their principal amusements at the theater or in the brothels. Nō and Kyōgen *(sarugaku)* were the theatrical forms patronized by the government, but these moralistic dramas were too reserved and too far removed from real life for most people, who preferred the violence of Kabuki plays. The audience understood (and perhaps identified with) the hot-tempered heroes, who were generally sophisticated civilians, champions of good taste and right-thinking, rebelling against unjust and uncouth military men. (That the shogunate permitted such dramas seems astonishing to anyone familiar with the restrictions imposed on theater and literature by modern dictatorships. The probable explanation is that the government felt this mock rebellion would be adequate release for audience and actors alike, and so prevent actual defiance.) The theater became the style-setter for Edo's citizens, who adopted new fashions, manners of speaking, and attitudes as rapidly as they were presented in new plays—in much the same way that people of recent decades have been influenced by cinema and, most recently, by popular singing groups.

The theater, in turn, drew much of its material from the pleasure quarters, which were far more than mere houses of prostitution. They were another world, free from responsibility and worries—but quite a different world from that sought in the tea ceremony. It was called *ukiyo*, inadequately translated as "the floating world." In Japanese, the connotation is of freedom, of drifting like a cloud or like thistledown in a gentle breeze. The most famous brothels were in the Yoshiwara area, housing thousands of courtesans, in that part of the city now known as Asakusa. The patrons were first drawn from the high-ranking samurai, but as prosperity increased, lesser military men and ordinary citizens were able to afford the charms of Yoshiwara courtesans. Wealth, however, provided only the price of admission to *ukiyo;* to be successful in the game of love, a man needed wit and charm; the suitor boasting of financial success was considered boorish. Courtship techniques showing originality and ingenuity were the accepted means of establishing romantic alliances at Yoshiwara. The literature of the period came to be dominated by stories about suitors competing by all manner of amorous efforts for the affection of a particularly skilled courtesan, and by tales of love affairs—most of them tragic. An artistic tradition, the game of love its central theme, gradually developed in literature and in the visual arts.

UKIYO-E

By the middle of the seventeenth century, artists in Edo were producing works devoted to scenes in the brothels, much as genre painters throughout the country immortalized the courtesans of the day. The first artist to give shape and direction to this specialized

genre painting, this "art of the floating world" *(ukiyo-e)*, was Hishikawa Moronobu. During the thirty years or so before his death in 1694, Moronobu turned out numerous paintings, prints, and book illustrations depicting the lovers and their surroundings, often with remarkable frankness. His work was considered vulgar by most of the upper classes, as well as by more conventional artists (who often shared his fascination with *ukiyo* but felt it undignified to portray that side of life in their paintings). Moronobu believed it was the duty of the *yamato-e* painter to depict whatever subjects reflected the interests of his countrymen, and so proudly signed his works as a follower of the ancient *yamato-e* tradition.

A new emphasis in *ukiyo-e* was initiated by an early eighteenth-century master, Kaigetsudō Ando. Whereas Moronobu usually included the setting of the brothel when he painted courtesans, and often portrayed several figures in each scene, Kaigetsudō limited himself to individual portraits, a special genre called *bijin-ga* ("pictures of beautiful women"). By concentrating on facial expression, quality of movement, and lavishness of gown, he made it clear that his subjects were sensual creatures who did not need to be shown in a boudoir setting for their charms to be apparent. One of Kaigetsudō's contemporaries, Miyagawa Chōshun (1683–1753), was also a master of *bijin-ga*, though his portraits usually show courtesans of a more delicate sensuality. These graceful creatures are often captured in candid poses, perhaps bathing, dressing, or embracing a lover, as if glimpsed through a window or parted screen, and this element of voyeurism makes Chōshun's paintings far more erotic than formal portraits could be.

Like Hishikawa Moronobu, the Kyoto master Nishikawa Sukenobu (1671–1751) painted in a more conventional genre style, including the setting for his figures, whether they be worshipers at a temple or shrine, or pleasure-seekers in a brothel. Although Sukenobu was considered a master of the erotic print, his women never appear to be frankly pleasured by lovemaking, as do most *ukiyo-e* courtesans—an indication, perhaps, of the artist's old-fashioned tastes in feminine behavior. The technical refinement of his drawing and coloring is typical of the gentility usually seen in Kyoto art as a whole. Sukenobu is known as a Kyoto artist, although he spent the greater part of his life in Edo, and the influence of his style on his contemporaries in both the Kansai and the Kantō was considerable, making his contribution to the development of *ukiyo-e* important indeed.

A Modern Approach to Woodblock Printing

If artistic merit can be reckoned in terms of absolutely new ends, and of a truly original use of traditional means, then the *ukiyo-e* woodblock prints cannot be dismissed as a minor, albeit appealing, aspect of Japanese art.

Classical tales of military and religious heroes, Buddhist icons, portraits of Chinese sages—these subjects were of little interest to the city-dweller of Early Modern Japan. What made his life worth living, in a stultifying system of government-imposed rules, was an unequivocal search for pleasure. It would seem that any art arising from this quest could have few, if any, historical precedents, and that religion would certainly have nothing to contribute. But strangely enough, the artistic and technical traditions of the past, specifically the use of narrative scrolls and woodblock prints, were used by *ukiyo-e* artists to visually record the hedonism that was sweeping the country. Still, the modification of these traditions was such that it would be rash to claim that a close relationship existed between medieval scrolls recounting famous events or woodblock-

printed reproductions of Buddhist icons, and the lively illustrations in the sex manuals and romantic novels that were turned out by *ukiyo-e* artists in the late seventeenth century.

Moronobu was one of the first to use the woodblock printing process for the mass production of illustrated books. So vividly erotic were the prints produced by Moronobu and his imitators that illustrations were soon treasured over the texts of the manuals and romances. People began clamoring for individual prints done in the new style. The first woodblock prints were black-and-white line drawings; when color was used it had to be added by hand to each print, usually as semitransparent washes of vermilion and green, sometimes with touches of blue or umber. Such early color prints, which are among the most valuable of all specimens of *ukiyo-e*, are known as *tan-e*. By about 1740 a procedure had been perfected for printing colors, initially those that had been used as washes in *tan-e*. As many as four additional printings on the black-and-white master were sometimes called for. A remarkable variety of subtle color harmonies was achieved with this simple process, which demanded that the artist give specific instructions to his printer regarding the priority of the various complementary woodblocks. The best of these *benizuri-e*, as they were called, can charm as more technically sophisticated prints often cannot. The masters of *benizuri-e* were not concerned with reproducing lifelike color combinations; for them, color had its own appeal, and any aesthetically pleasing juxtaposition, no matter how unrealistic for a given subject, was acceptable. A similar use of color can be seen in the work of countless modern Western artists, one of the first of whom was Toulouse-Lautrec, who may well have been influenced by examples of Japanese art that made their way to France in the last half of the nineteenth century.

The next step in printmaking was perfected around 1765 by Suzuki Harunobu (1724–70), who produced full-color prints that won the approval of wealthy patrons—a fortuitous accomplishment, for his technique called for an unprecedented cooperation between publishers, artists, woodcarvers, and printers, who collectively required expensive papers, the best in colored inks, and quality woods. The financial backing of affluent lovers of *ukiyo-e* prints made possible an excellence of achievement that would have been impossible had production been left to the limited resources of individual artists. By turning over the actual engraving and printing to skilled craftsmen, Harunobu and other masters of the multicolored print (known as *nishiki-e*) were able to devote their creative energies to the special art of designing prints.

LATER EDO ARTISTS

The Torii family of artists were the unchallenged masters of portraying Kabuki actors from the 1660's until the last quarter of the eighteenth century, when Katsukawa Shunshō (1726–92), a follower of Harunobu, grew famous for his portraits of Kabuki actors. Shunshō found the Torii prints too idealized, and sought to create greater realism by emphasizing the individuality of his actor-subjects. His works influenced all of his contemporaries, including the last great Torii master, Kiyonaga. The interest in greater realism is exemplified by the *bijin-ga* of Kitagawa Utamaro (1753–1806), which show the Japanese woman in every conceivable mood, in youth and old age, and often in a setting that tells a great deal about the person portrayed. Shunshō's influence can also be seen in the character studies done by Tōshūsai Sharaku, which is not to deny striking originality in his works. Sharaku remains a mystery man in Japanese art, few facts having ever been turned up about his life. All his known works were executed in

approximately a year's period, around 1795, but so different are these from other *ukiyo-e* prints that they guarantee Sharaku an important place in the history of Japanese printmaking.

As evidence that the shogunate's official support of Kanō art did not stifle artistic growth (except in Kanō itself) is the success of such different artists as Hōitsu, Hiroshige, and Bunchō. Sakai Hōitsu (1761–1828) was among those artists who concentrated on the traditional subjects in nature. A follower of Kōrin, Hōitsu achieved a remarkable integration of bold composition and exquisite craftsmanship. Andō Hiroshige (1797–1858) turned to the landscape, although he often included people in his scenes. Like Katsushika Hokusai (1760–1849), he was a master of the scenic print, and each man blended in his own way elements of continental and European styles with printmaking techniques developed by the *ukiyo-e* masters. Tani Bunchō (1763–1840) was a literati painter, as was his famous disciple, the artist and writer Watanabe Kazan (1793–1841), but they did not follow Chinese models exclusively. Bunchō's paintings show a deft wit, and his skillful brushwork and fresh colors add to their appeal. Kazan looked to the West for inspiration, in art as in other matters, and the use of perspective and shading in his portraits marks a definite departure from classical examples. The government could tolerate Kazan's paintings, but the Western ideas expressed in his books led to political persecution and eventual suicide. He was one of the last martyrs to the Tokugawa dictatorship, which was soon to be overthrown, after more than two hundred years of undisputed rule.

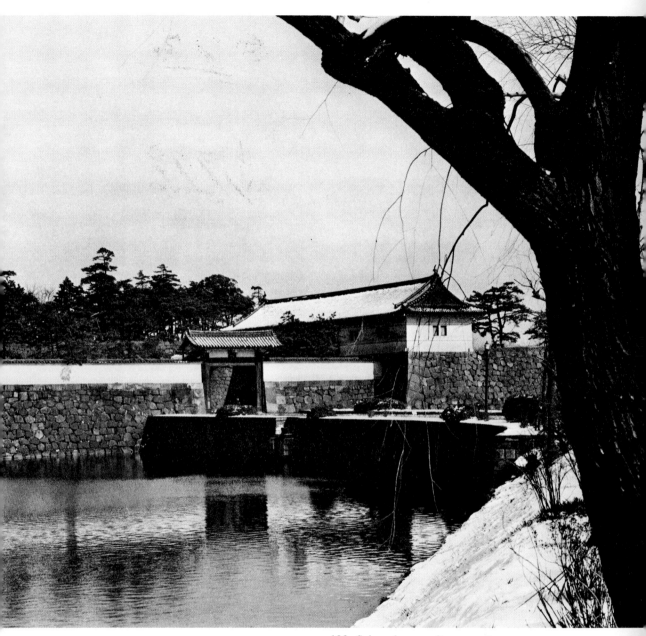

136. Sakurada-mon. Seventeenth century.
This gate, located within the inner moat on the south-western side of the Imperial Palace (formerly Edo Castle), is one of the few extant monuments to the two-hundred-fifty-year rule of the Tokugawas, and is now open to the public. It is known historically as the site where Ii Naosuke, chief minister of the Tokugawa shogunate, was assassinated by former retainers of the Mito clan—who strongly resented the oppressive policies against movements to restore political power to the emperor—on March 3, 1860, on a snowy day similar to the one shown in the illustration (see note 208).

137. "Cormorant Fishing," by Kanō Tan'yū (1602–74). One of a pair of six-fold screens. H. 163.45 cm. (64.5 in.), w. 359.9 cm. (140.1 in.).

The custom—rather art historical in its approach and practiced by the great masters of Chinese-style ink painting in the fifteenth century—of making sketches in the manner of certain Chinese artists was continued on an even wider scale by most Kanō artists, especially Tan'yū, who included in his numerous sketchbooks paintings after Japanese as well as Chinese masters. With this screen he was imitating a contemporary Tosa-school work whose subject has been a favorite of Japanese genre painters since the sixteenth century: night fishing with leashed cormorants (ducklike sea birds). Although it is now done more for fun than for commercial purposes, fishermen and spectators gather several times during each year in Kyoto's Arashiyama area to watch as the strange birds dive for the succulent little trout in the Hozu River.

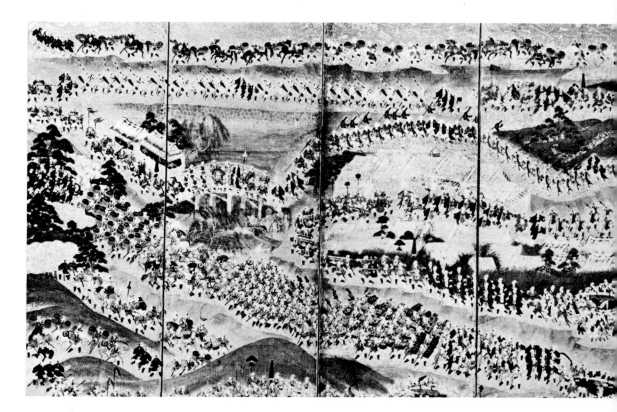

138. "Daimyo Procession." Artist unknown. Seventeenth century. Six-fold screen. L. 153.8 cm. (60.3 in.), w. 344.8 cm. (135 in.).

The grand scene of a daimyo procession, probably a daimyo on his way to Edo or returning to his province on a *sankin kōtai* trip, is depicted in this screen. Judging from the composition and soft lines, it was probably the work of a free-lance artist, who was not affiliated with the official Shogunal Painting School of Kanō artists. The scale of the procession, totaling about one thousand samurai and bearers, indicates that the daimyo was a wealthy and powerful lord. It is difficult to judge, however, from the crests of the banners etc. as to who the daimyo was.

139. "Portrait of Kimura Kenkadō," by Tani Bunchō (1763–1840). Osaka Municipal Museum. H. 69.1 cm. (27.1 in.), w. 41.8 cm. (16.4 in.).
Works by the so-called founder of Chinese-style literati painting in Edo are not always very Chinese looking, and for good reason: after first studying painting with a Kanō-school follower, Bunchō made a study of every type of painting currently practiced in Japan, and though he finally came to be known as a literati painter, his own works are wildly eclectic. This amusing portrait Bunchō did in 1802 of a friend and fellow admirer of Chinese art in Osaka is a composite of many different styles.*

140. "Portrait of Takami Senseki," by Watanabe Kazan (1793–1841). Tokyo National Museum. H. 115.4 cm. (45.3 in.), w. 57.3 cm. (22.5 in.).
At seventeen, Kazan became Bunchō's student. He later adopted Western laws of chiaroscuro and perspective, but did all of his work in ink and colors on silk or paper instead of utilizing conventional European media and materials. One has only to compare this portrait, which bears a date of April 15, 1837, with the one above by Bunchō to see how much more concerned Kazan was with giving volume to the figure by means of shading and anatomical drawing.*

141. "A Summer Evening," by Kusumi Morikage (active *ca*. 1640–1700). Single two-fold screen. H. 150.6 cm. (59.1 in.), w. 167.3 cm. (65.6 in.).

Morikage, another of the many Japanese artists about whom little is known, was supposedly dismissed from Kanō ranks in Edo, after which he may have lived for a time in Kanazawa. His last years were spent in Kyoto. The naive, unprofessional drawing of this screen makes it by far the most unusual work attributed to Morikage. Perhaps it was this sort of painting that caused his dismissal by the Kanōs.*

142. "Autumn Grasses," by Sakai Hōitsu (1761–1828). A pair of two-fold screens. H. 166 cm. (66 in.), w. 183 cm. (71.8 in.) each.

For Hōitsu, a well-placed member of the military class who became a Buddhist priest of the Shin sect in 1797, the taking of religious vows was a convenient means of escape from contemporary art and society. He spent the last twenty-one years of his life in virtual seclusion, absorbed in a study of the life and works of Ogata Kōrin. The important results of that study were two published books—for which Hōitsu was best known in his lifetime—containing drawings of Kōrin's works and those of his followers, and a large body of paintings in which Kōrin's flair for dramatic configurations and unusual techniques is seen again, but with a persistent emphasis on lyrical beauty. "Autumn Grasses" is actually the backside of a painting by Kōrin (his copy of Sōtatsu's "Wind and Thunder Gods"), which must have been almost a century old at the time Hōitsu laid squares of silver leaf over the decorative paper in back and painted a work that is today far better known than the one on the other side. (See color plate 21.)

144. "The Actors Nakamura Rikō and Mimasu Tokujirō," by Katsukawa Shunshō (1726–92). *Ōban* size.

This print is a scene from a play that was first performed in August of 1786 at the Nakamura-za, a Kabuki theater in Edo. The actors are dressed as courtesans: Rikō (left) played the role of Oyoshi and Tokujirō the role of Oman.*

143. "A Street in Yoshiwara," attributed to Hishikawa Moronobu. Late seventeenth century. One of twelve prints. H. 25 cm. (9.8 in.), w. 38 cm. (14.9 in.) (*ōban* size).

The streets of the largest red-light district in Edo, Yoshiwara, were lined with brothels whose clientele included men of every social class except, perhaps, for the highest and lowest. The episodic intrigues of this "floating world" and their dramatization on the Kabuki stage served early *ukiyo-e* artists such as Moronobu (who from about 1660 until his death in 1694 developed woodblock print designing into a major art form) with an endless source of interesting subject matter.*

145. "A Beauty," by Kaigetsudō Ando. Early eighteenth century. H. 119.4 cm. (46.8 in.), w. 84.9 cm. (33.3 in.).*

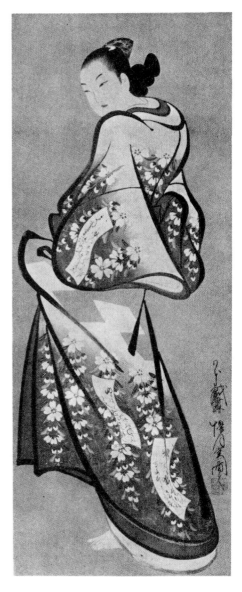

146. "Osen," by Suzuki Harunobu (1724–70). H. 28 cm. (11 in.), w. 20 cm. (7.9 in.) (*chūban* size).
This print of about 1770 shows Osen, one of the nubile beauties immortalized by Harunobu, and a fan seller at a tea shop near the entrance of Kasamori Shrine. Osen was the daughter of the proprietor of the shop, which sold tea, sweets, and painted fans to shrine visitors. Prior to Harunobu's time, most pictures of beautiful women had courtesans and professional girls in the city's licensed quarters as models, so that when Harunobu's prints of young girls first appeared, miraculously embellished with the wide range of imprinted colors the artist had successfully managed to incorporate in each print, they seemed the ultimate novelty. (See color plate 22.)*

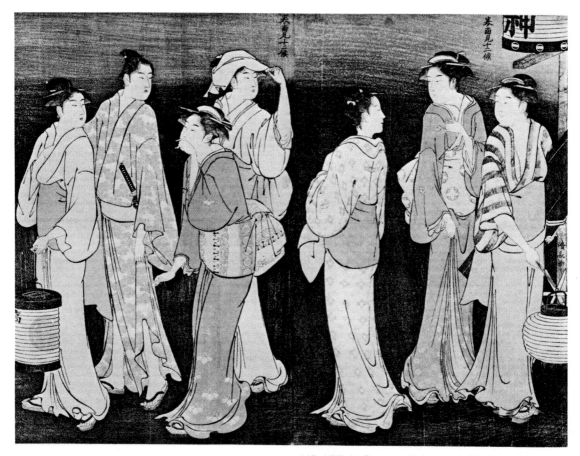

147. "Night Scene at Shinagawa," by Torii Kiyonaga (1752–1815). Ōban size.

Kiyonaga's idealized portrayals of fashionable people dominated the minds and hearts of Edoites for some twenty years after the death of Harunobu and before Utamaro's star began to rise in the 1790's. In this diptych—which is "July" in a set of twelve prints showing the monthly activities of the courtesans of the Shinagawa brothels located at the southern entrance to Edo—the thinly clad figures of six girls and a young man are set dramatically against a dark background, their gestures and costumes epitomizing all that was desirable in modern life.*

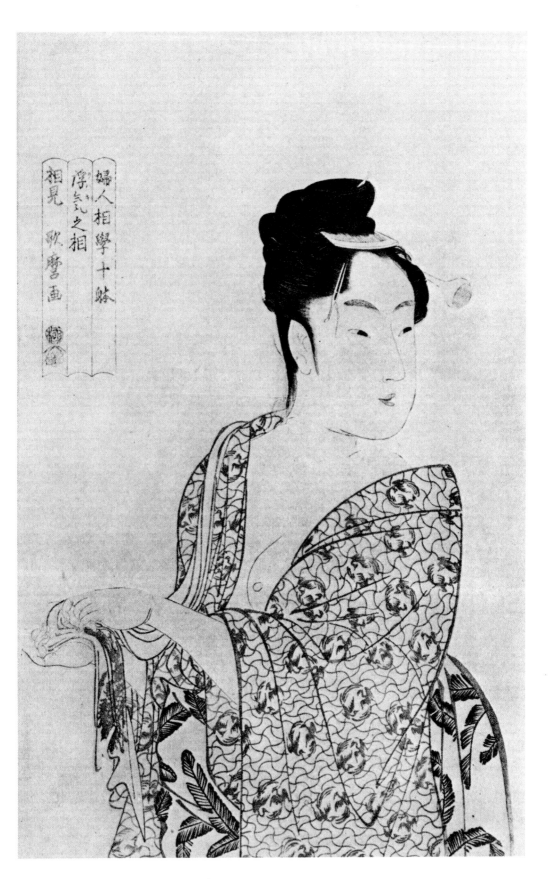

148. "The Fickle Face," by Kitagawa Utamaro (1753–1806). One of ten prints in a series. *Ōban* size.

Utamaro's passion for beautiful women drove him to make hundreds of studies such as the one at the right which were the unchallenged models for feminine beauty in Japan until the Occupation. For Utamaro, the female was a mysterious creature whose instincts and movements, more like those of wild animals than of human beings, were always perfect, natural, and beautiful. The woman of "The Fickle Face" has just emerged from the bath and wears her garment loosely, quite oblivious, at the moment, to the thought of impressing anyone. The pale shades of the woman's fair skin, green kimono, and yellow sash seem radiant with morning sunlight.*

149. "The Actor Ichikawa Ebizō," by Tōshūsai Sharaku (active 1794–95). *Ōban* size.

This print, which is from the earliest known group of Sharaku's "close-up portraits" *(ōkubi-e)*, shows the actor Ichikawa Ebizō in the role of Takemura Sadanoshin in a play performed in May 1794. To anyone unfamiliar with Kabuki theater and the heavy, stylized make-up its actors wear, this figure may seem grotesquely unnatural. The characterization is, however, quite correct with regard to actual appearances. Sharaku's genius lay in pictorial organization: he had a facility for capturing in flat patterns of color the salient features of a subject and arranging them in one tightly organized composition in which visual impact counts for everything, as it does, also, in the works of Sharaku's artistic descendants, the German Expressionists. (See color plate 23.)*

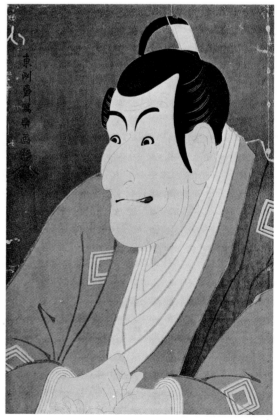

150. "The Waves near Kanagawa," by Katsushika
Hokusai (1760–1849). *Ōban* size.

Hokusai's *Thirty-six Views of Mount Fuji* series, pub-
lished in the 1820's, contains what are perhaps the
best known and loved Japanese prints of all time.
Their designs, dynamically alive with forms such as this
surging wave which is so beautifully expressive of na-
ture's inner forces, have by now become an unforget-
table part of the world's artistic heritage. Historically,
the time was right for Hokusai's innovations, for the pub-
lic had begun to tire of the usual *ukiyo-e* subject matter
of theater and brothel, and was thrilled by the novelty
of the landscape print. Artistically, the appeal of his
work was destined to cut across all national boundaries
and levels of historical awareness.*

151. "Rain at Shōno," by Andō Hiroshige (1797–1858). *Ōban* size.

The sketch for the print of "Shōno" from Hiroshige's *Fifty-three Stations on the Tōkaidō* must have been a favorite of the persons in the official shogunal party with whom the artist traveled on a trip from Edo to the Imperial Palace in Kyoto in 1832. It has continued to be popular ever since the complete print series was published, a tremendous financial success, in 1834. A definite sense of mood as well as place, and a delightful weakness for sympathetic presentations of the people of each locale, are the qualities that make Hiroshige's prints so endearing. (See color plate 24.)*

152. Combs and hair ornaments. (See color plate 25.)*

153. Blackwood tobacco set. The Japan Tobacco Monopoly. H. 18.8 cm. (7.4 in.), l. 21.7 cm. (8.5 in.), w. 17 cm. (6.7 in.). *

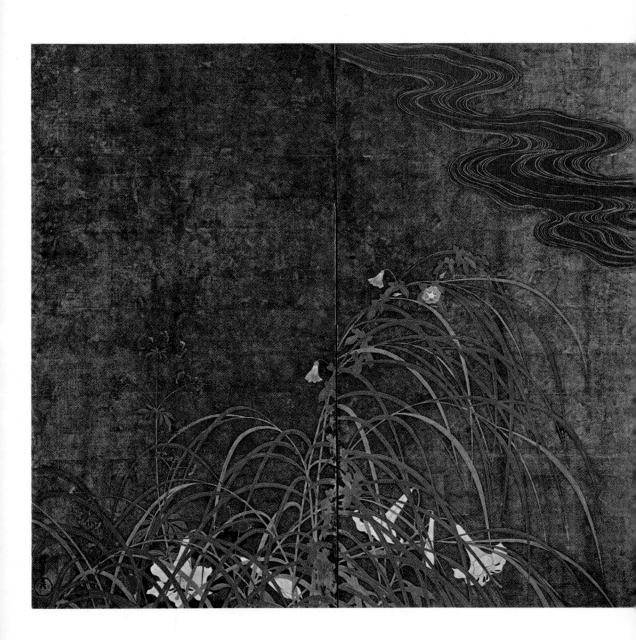

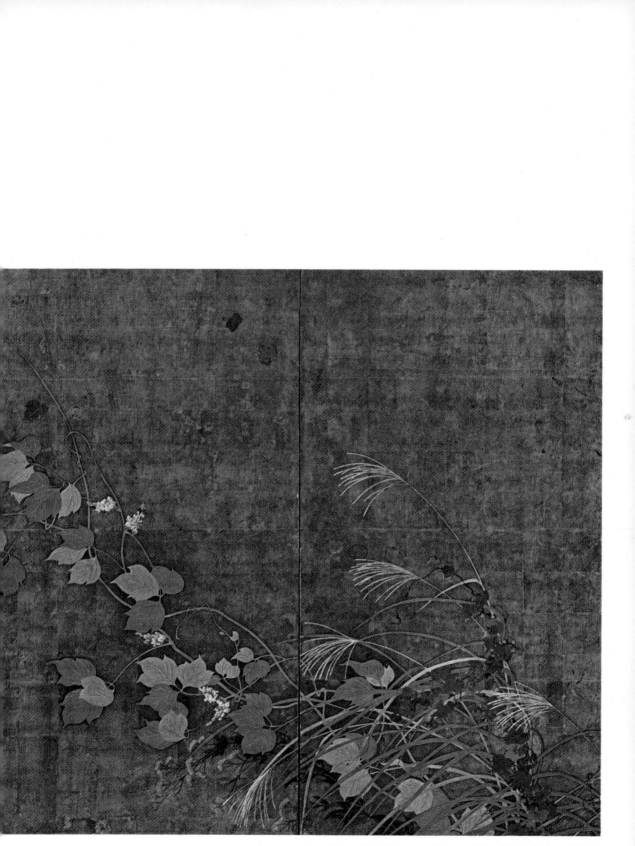

Plate 21. "Autumn Grasses," by Sakai Hōitsu (1761–1828). (See also figure 142.)

Plate 22. "Osen," by Suzuki Harunobu (1724–70).
(See also figure 146.)

Plate 23. "The Actor Ichikawa Ebizō," by Tōshūsai Sharaku (active 1794–95). (See also figure 149.)

Plate 24. "Rain at Shōno," by Andō Hiroshige (1797–1858). (See also figure 151.)

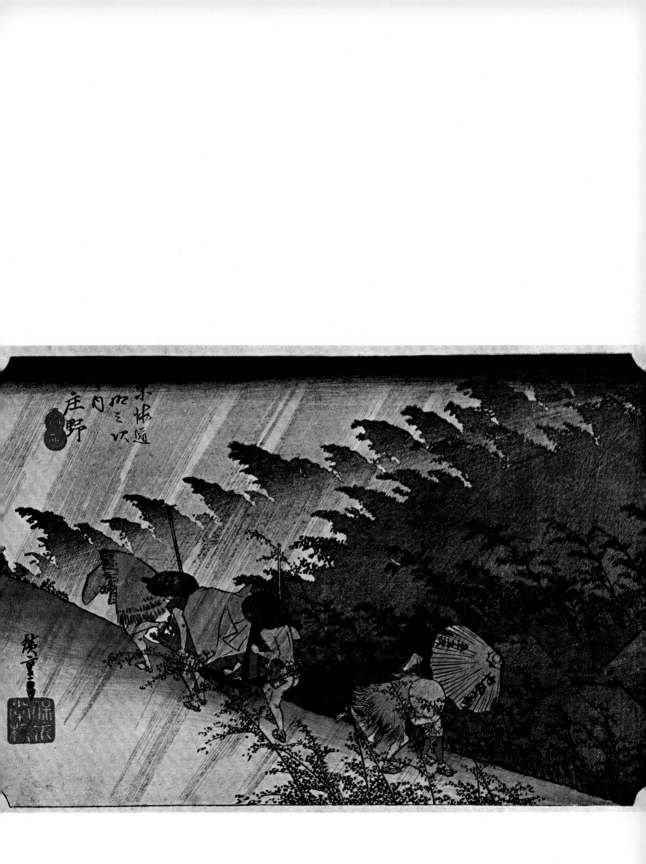

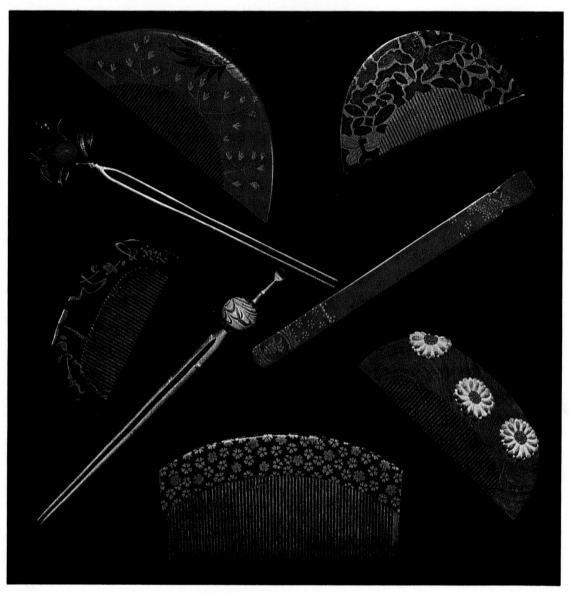

Plate 25. Combs and hair ornaments. (See also supple-
mentary note 152.)

8

ART AND POLITICS IN THE PROVINCES

Just before he died, Toyotomi Hideyoshi called upon the leading men in his government to swear fealty to his young son, Hideyori, and named his Five Elders to serve as a council of regency until Hideyori, who was only five years old at the time, was old enough to rule. Hideyoshi made few specific recommendations for the interim government's machinery, assuming that everyone shared his devotion to the child (Hideyoshi's love for his only son had reached manic proportions in his old age), and that this devotion would lead the council to govern wisely and selflessly. Tokugawa Ieyasu was one of the Five Elders, and was specifically charged with the upbringing of Hideyori (a responsibility he was to share with Maeda Toshiie) as well as being given major responsibility for governing. Some historians have accused Ieyasu of biding his time until Hideyoshi's death and then swiftly moving to power. The actual sequence of events (which has been oversimplified in preceding chapters) suggests that Ieyasu swore allegiance to Hideyori in good faith, but was forced to contend with various other lords who were jealous and fearful of his power. In order to protect Toyotomi interests, Ieyasu had to consolidate his own strength, for it would have been foolish for him to assume that the balance of power would remain static after Hideyoshi's death. The tradition of the country was for power to be transferred from one warlord to another, and Ieyasu knew he would face competition. His opponents seized on Ieyasu's every move as evidence of betrayal of Hideyori, however, and by the autumn of 1600 the political situation had given birth to a major battle between supporters of Ieyasu and of Ishida Mitsunari, who claimed to be acting in Hideyori's behalf. Ieyasu's forces scored a sound victory, but armed conflict continued sporadically until June 1615, when Hideyori committed suicide to escape capture and certain death at the hands of the Tokugawas, who, a year earlier, had decided the shogunate could not share the government of Japan with a regent and must therefore destroy Hideyori.

Following the victory at Sekigahara in the autumn of 1600, Ieyasu confiscated or reduced ninety-four fiefs held by his enemies, then redistributed the land among the families who had stood by him. In the case of a very few powerful enemies, especially in far-away Kyūshū, Ieyasu left their lands untouched. He was careful to place his most faithful supporters in strategic areas, where they were likely to be content and where

they could act as buffers against any opposing powers. Some of the most advantageous lands, both for the holders and for Ieyasu, were located along the Tōkaidō, the principal highway between Kyoto and Edo.

THE LANDS OF THE GO-SANKE

Ieyasu named his son Hidetada to succeed him as shogun, and to him went the Tokugawa lands in Edo as well as scattered holdings elsewhere. Three other sons, collectively known as the Go-Sanke, were given important fiefs in Owari, Kii, and Hitachi provinces. In Owari, Tokugawa Yoshinao and his family moved into the castle at Nagoya that Ieyasu had established in 1592. Nagoya-jō was a magnificent example of military architecture, and contained a collection of the best in Kanō art, second only to the one at Edo castle. These paintings (not all of which survived the bombings of World War II) were mostly Confucian in subject; the few that had easily understood subjects—such as Japanese peasants at harvest time, views of famous places in Kyoto, pictures of the ancient Heian court—were unusually progressive for that very reason.

Yoshinao's branch of the Tokugawa family was not particularly affluent, and this may explain their failure to continue large-scale support of Kanō art. Or they may well have genuinely preferred the locally made ceramics and metal wares for which the region had long been famous, and which helped to make Nagoya prosperous. Located on the Tōkaidō, the city was an important stopping place for travelers between the old and new capitals, who replenished their supplies of housewares at its markets. Korean-inspired Seto ware was the pottery that brought renown to ceramists of Owari, and late in the eighteenth century healthy competition developed between this Seto ware and a special blue-and-white porcelain of Ming influence (rather similar to the Imari ware produced in the southern part of Japan). The latter porcelain ware was manufactured under Tokugawa auspices. The metalworkers were noted for huge bells known as *owari-taku*, which were considered the best in the land, and for cast-iron tea kettles that were very popular with tea masters, who developed a particular style of ceremony using various combinations of local wares. In the field of painting, there was little of note that developed in Nagoya. The Tokugawa family employed a few Kanō artists, but local painters were generally undistinguished icon makers connected with small temples and shrines. To receive instruction in modern developments, the aspiring artist had to go to Kyoto or Edo. In theater, the artistic tastes of the government were perpetuated, and actors were busy in productions of Nō and Kyōgen, while Kabuki received little attention.

The branch of the Tokugawa family who resided in Wakayama in Kii province more actively supported the edicts of the Edo government. They were particularly conscientious in carrying out their duty to restore and preserve historical sites in their province. In nearby Kōya-san, the Kongōbu-ji and other famous temples, and Shinto shrines such as Kumano Jinja were carefully maintained, with Kanō artists from the Kansai or Kyūshū imported whenever redecoration was deemed necessary. Today's visitor to the reconstructed Wakayama Castle, looking out over the orderly arrangement of the town below, can still see the influence of the no-nonsense direction of the Tokugawa rulers—a direction that unfortunately seems to have affected the works of even the town's most famous artist. Gion Nankai (1677–1751), probably the first Japanese to adopt the ways of the Chinese literati, painted mostly calligraphy, but what landscapes he did paint

turned out to be arid understatements in few colors and dry brushstrokes, which were little more than academic recordings of continental models.

The third family of the Go-Sanke held a fief at Mito in Hitachi province. They never distinguished themselves in artistic endeavors, unless the making of fine quality paper qualifies as an artistic achievement, as it might for a painter who required the very best in materials to realize his visual conceptions. But support of scholarship, especially the study of national history and literature, was a major family enterprise, one in which the Mito Tokugawas were probably unsurpassed. Their support of nationalistic studies seems to have been a prelude to the extreme anti-Westernism that marked the Mito area in the nineteenth century, when Tokugawa Nariaki was the local patriarch.

THE CLANS OF HONSHŪ AND SHIKOKU

Maeda Toshiie, who had been designated to share with Ieyasu the upbringing of Hideyori, died just a year after Hideyoshi, and his sons divided over whether to support Ieyasu. Maeda Toshimasa fought against him, and later had his fief confiscated. Toshinaga, on the other hand, received a sizable increase (including his brother's lands) to his fief when the spoils of victory were divided, and so became the second wealthiest lord in Japan, although the revenues from his holdings were still less than half the value of Ieyasu's. A third brother, Toshitsune, received Toshinaga's lands when the latter warrior (who was childless) died. Toshitsune took part in the seige of Osaka Castle that brought about Hideyori's suicide. The shogunate favored the Maeda clan only in a financial sense, however, and the increase in revenues might well be considered a placation for an influential family that did not approve of the Tokugawa drive to power. Toshiie and his son Toshinaga had supported Ieyasu against Ishida Mitsunari, whom they recognized as a troublemaker, but they remained loyal to Hideyori. Toshitsune apparently threw his lot in with Ieyasu against Hideyori for reasons more pragmatic than idealistic; in any event the Maeda lords were considered to be *tozama daimyō*, that is, outside the Tokugawa family of vassals. As such, they were subject to demands on their finances (castle repairs, road building), but in general the shogunate deemed it prudent to tread gently on Maeda pride.

The Maeda fief was in Kaga province, extending into Etchū province on the northeast. Because of this relative proximity to Kyoto, the family had been an important one long before even Nobunaga rose to power, although other families surpassed it in economic terms until after the battle of Sekigahara. Kanazawa was the principal center of Maeda activity, and until modern times was considerably larger than Nagoya. Only Kyoto (which Kanazawa resembled) and Edo were culturally more advanced after the early seventeenth century, especially in the field of painting. Indeed, some of Kyoto's more progressive artists (notably Hasegawa Tōhaku) came from Kaga, and they remained closely associated with Kaga patrons after moving to Kyoto. In their home province the Maedas encouraged academic studies, local efforts in traditional theater, and practice of the tea ceremony. They also supported local craftsmen by exporting their distinctive wares to Osaka and Edo, where the fancy Chinese-style porcelains of the Kanazawa district were in great demand. Local versions of Kyoto *maki-e* and *yūzen-zome* developed in Kaga, thanks to Maeda subsidy of lacquerworkers and fabric designers, whose ancestors had been trained in the old capital when Hideyoshi was in power. Today there is still a bond of understanding between the people of Kyoto and

Kanazawa that makes these two cities seem similar, despite the distance separating them.

Ieyasu had originally belonged to the Matsudaira clan in Mikawa province (just southeast of Owari), and had taken the name of Tokugawa after he became an important lord associated with Nobunaga. After the Tokugawa shogunate was established, it became the custom to grant the name Matsudaira to valuable supporters, and the name was then hereditary. One important family of this name was descended from Ieyasu through his second son, Hideyasu, and in the late 1630's took up residence in Matsue in Izumo province on the Japan Sea. Matsue is the site of Japan's most ancient and sacred Shinto shrine, the Izumo Taisha, which has made the town a constant host to visitors from throughout the country. The town itself, located in a beautiful setting, and its tolerant, peace-loving people, have also been attractions for artists, scholars, and craftsmen. (At a time when most Westerners were quite scornful of the Japanese, the adventuresome American newspaper reporter Lafcadio Hearn [1850–1924] decided to settle permanently in Matsue, so enchanted was he with the rare combination of provincial quiet and creative vitality he found there.) One of the clan leaders, Fumai (1751–1818), was a leading exponent of the tea ceremony. He collected masterpieces of ceramic tea utensils and had such an influence on connoisseurship that his name became known everywhere. The century-old teachings of the tea master Kobori Enshū, which covered architectural and garden design, flower arranging, and the cha-no-yu itself, were modified by Fumai to conform to modern tastes and were widely disseminated by his disciples.

The Sakai family of Himeji, the Asano in Hiroshima (where the family was transferred in 1619, from the Wakayama fief they had received after Sekigahara), and the Kyōgoku on two small fiefs near Takamatsu were assigned by the shogunate to these places facing the warm and lovely Inland Sea. Except for those nearest the sophisticated urban society of Osaka and Kyoto, most people on the Inland Sea were artistically provincial and were content with the handsome local handicrafts, long ago evolved from Chinese and Korean prototypes into distinctly native designs, unique to each area.

To the north, at Sendai in Rikuzen province, lay the fief of the Date family, which, although removed from the major centers of population, had for many centuries been one of the wealthiest and most powerful clans in the country. (At Hideyoshi's death, Date Masamune was ranked as the sixth wealthiest lord in the country; after the battle of Sekigahara and the redistribution of lands—which gave Date a small increase—he ranked fourth in revenues.) The family's predecessors at Hiraizumi and elsewhere in the area had attempted to reconstruct on the same scale and in every detail the art and architecture of the old capital (an effort discussed at length in Volume I). At Sendai, they continued to maintain an interest in the arts that was uncommon among provincial clans. In addition to a magnificent castle in Sendai, the leader of the family built a splendid temple, Zuigan-ji, on the site of an ancient temple in Matsushima to the north, employing the same craftsmen and painting masters patronized by the Tokugawa shogunate. Cedar lumber for Zuigan-ji was shipped from Kii and the architecture was patterned after the great Tokugawa monuments in Kyoto and Edo. The temple's ornately carved entry gate is said to be an exact copy of those built in China during late Sung times. The wealth and cosmopolitan interests of the Date clan are further manifested by their sponsorship of a group of some thirty representatives, headed by Hasekura Rokuemon and the Franciscan Luis Sotelo, which toured Mexico, Spain,

and Italy on a mission of advertisement (but ostensibly of Christian piety) that included audiences with Pope Paul V and several heads of state.

Other families in the north included the Hoshina clan (called Matsudaira since the early seventeenth century) at Wakamatsu on Inawashiro Lake, the Tsugaru at Hirosaki in Matsu, and the Sakai at Tsuruoka in Uzen. (The latter family was closely related to the Sakai at Himeji.) Two clans considered *tozama daimyō* were the Uesugi at Yonezawa in Uzen and the Satake at Akita in Ugo. The Uesugi family descended from the great Fujiwaras, and the Satake were related to an emperor of the ninth century in the same way as were three families of shoguns: the Minamoto, the Ashikaga, and the Tokugawa. For this reason Ieyasu could not deal too harshly with these daimyos, who were less than enthusiastic over his mounting power, and so contented himself with moving them to less prestigious fiefs, at a considerable reduction in revenues. All the clans in the north, despite their lack of affluence, developed the resources of their lands to the fullest extent possible, perhaps invigorated by the climate of the region. Lacquerware and hand-loomed fabric, for which the area is still well known, were produced for national distribution. Modern production methods were encouraged, and in Akita particularly, which became known as a center of Dutch studies, attempts were made to develop agriculture and industry and to investigate mining prospects.

THE CLANS OF KYŪSHŪ

Several powerful families of known or suspected disloyalty to the Tokugawas held fiefs on Kyūshū, the southernmost of the major islands of Japan. The fiefs provided generous revenues and were the only ones near enough to Nagasaki to profit significantly from trade after the rest of the country was closed to foreigners (see chapter 9). The shogunate perhaps hoped these families would be satisfied with their situation and would not attempt to cause trouble on the main island, although at first glance it appears strange that such a congregation of potential foes would be permitted.

The Nabeshima family in the castle town of Saga in northwest Kyūshū was actively engaged in foreign trade, with their own licensed ships plying between Japan and Southeast Asia. Korean potters working for the family in the area around Arita were instrumental in popularizing continental styles in porcelain. They first trained Japanese apprentices in the blue-and-white underglaze tradition of early Ming and contemporary Korean wares, but it was the sparkling color of overglaze-decorated (enameled) wares imitating later Chinese porcelains that captured the attention of both Japanese and European connoisseurs from about 1690 to 1850. Different types of porcelains were developed in workshops in and around Arita, each with distinctive traits and carrying names such as Kakiemon, Nabeshima, Hirado, and Imari. All of them were known generally as Imari ware, a term familiar enough today to generate excitement among collectors everywhere.

In medieval times the Hosokawa family held most of the island of Shikoku, and provided the Ashikaga shoguns with several able prime ministers. Hosokawa leaders had sided with Nobunaga and Hideyoshi during their military campaigns, and Nobunaga awarded Hosokawa Tadaoki with the province of Tango, on the Japan Sea north of Tamba province. Although Tadaoki supported Ieyasu, both at Sekigahara and Osaka, and although the death of Tadaoki's wife was caused by Ishida Mitsunari, Ieyasu transferred Tadaoki to Kyūshū in 1602. He was given a fief in Buzen, on the northern part of the island, one that provided more revenue and was better-favored geographically

than the one at Tango, yet one that marked him as a *tozama daimyō*. It is not clear why Ieyasu took this action, but it may be that he questioned the loyalty of a powerful family that numbered several Christians among its members, and by this time persecution of Christianity had begun (see chapter 9). In 1632 the family was transferred again, to Kumamoto in Higo, with a sizable increase in revenue.

In his later years Todaoki (1564–1645) gave up a brilliant military career to become a priest and under the name Sansai retired to the family's Kōtō-in, a small subsidiary temple of Kyoto's Daitoku-ji, where he devoted himself to a study of the teachings of the great tea master Sen-no-Rikyū. In Kumamoto, other members of the family also devoted their energies to support of the arts,. and sponsored local craftsmen and painters. Elegant iron bells made by Kumamoto metalworkers were prized by the Hosokawas, and until recently the family owned the largest collection of paintings by Miyamoto Musashi (or Niten), the famous seventeenth-century swordsman and painter who settled in Kumamoto after a lifetime of wandering. Of all the Kyūshū clans, the Hosokawas were least affected by foreign influence (other than the early converts to Christianity), and were the most anxious to preserve ties with the past. The towns-people were treated to many of the same entertainments (poetry contests, street parades, *sumō* wrestling matches, Nō performances) that had for centuries been part of life in the old capital. One clan patriarch founded a school that became famous for training samurai. By welcoming scholars to the area, the family lay the early foundations for the pursuit of learning in their province, which became the site of a national university at the beginning of this century.

The Shimazu daimyos had governed Satsuma province since the end of the twelfth century, with headquarters at Kagoshima. At Sekigahara, Shimazu Yoshihiro fought against Ieyasu, but was later pardoned on the condition he give his lands to his son, Tadatsune. The latter paid homage to the shogun, who granted him the name Matsudaira as well as a character from his own name. (In the early nineteenth century, another member of the clan was accorded the same honor by Shogun Ienari.) Yet relations between the shogunate and the great Shimazu clan were often strained, and the government kept a strict watch on activities in Satsuma, while avoiding causing any grievance. The Shimazu lords were important in reestablishing imperial authority in the nineteenth century, but in the meantime they concentrated their energies on building up the resources of their province. Clan leaders were the virtual governors of the Ryūkyū Islands, and had a monopoly on the sugar market. The fief itself was a productive one, and profited from contact with foreign thought and science brought from Europe as well as China. In the fifteenth century the Shimazu family had welcomed Confucian scholars from the mainland, and in the next century people of Kagoshima witnessed the arrival of the first Christian missionaries, whom they treated with great respect. Satsuma was a Christian stronghold in the early seventeenth century, and the scene of many martyrdoms, but attitudes changed drastically in the ensuing years and the region became violently anti-Western in the nineteenth century.

In art, as in ideology, the Asian continent held the greater attraction, although Western influence can be seen in some phases of Satsuma art, such as the manufacture of cut-glass articles. Local ceramics, which were Korean-inspired and characterized by svelte shapes and restrained underglaze patterns, had marked Satsuma as a pottery center for several centuries. So-called later Satsuma ware, which featured overglaze decoration in imitation of Chinese porcelains, was introduced after Chinese artisans, whom the Shimazu brought from the mainland at the beginning of the nineteenth century,

taught their techniques to Satsuma potters. Despite their hostility to the shogunate, the Shimazu family supported "official" art, and invited back to Kagoshima a local artist who had attained success in Edo after being adopted by Kanō masters of the Tan'yū line. This was Kimura Tangen (1679–1767), the major Kanō-school representative in the Kyūshū area during the eighteenth century.

TENRYŌ, GŌSHŌ, AND GŌNŌ

While most of the country was held in fief by numerous clans, a portion of it was the personal property of the shogun, and this land was called *tenryō*. People working this land theoretically had direct access to the shogun. The urban center of a Tokugawa *tenryō* tended to have a fairlike atmosphere, with local produce and handicrafts lining the streets, the people apparently proud to be the personal vassals of the nation's ruler. Takayama, high in the mountains of Hida province, was such a place. In spite of Takayama's inconvenient location (when snowed in, as it is much of the year, it is difficult to reach even today with modern transportation), under Tokugawa administration it became a miniature capital, with attractive streets and neat little shops. Festivals similar to the *Gion Matsuri* in Kyoto have been the townspeople's main diversion and can still be seen today, although the modern tourist is more likely to visit Takayama in order to buy the local handicrafts—chairs, spinning wheels, looms, chests, rustic lacquerwares —that for centuries have been made according to traditional methods by families of artisans. These items, commonplace and utilitarian, are nevertheless beautiful, and deserve mention as works of art as much as do the wares of other regions.

Government measures aimed at increasing and improving industry, trade, and agriculture were generally effective. The beneficiaries of increased wealth in the provinces, other than the military elite, were not the multitudes of peasants (who, in fact, lost what little they had had and were reduced to working as tenant farmers) but a few rich merchants *(gōshō)* and wealthy farmers *(gōnō)*. *Gōnō* were usually men of obscure military background whose ancestors had turned to farming in time of peace and whose landholdings grew in size and prosperity under the cooperative effort of tenant labor. The *bakufu* carefully prevented the development of monopolies among both city and rural merchants, but the amount of wealth some of them amassed was on par with the income of many lords. Like the titled rich, the *gōshō* and *gōnō* became patrons of the arts in the various provincial towns that were largely of their creation. Artists from Edo and Kyoto traveling through such towns received the support of the local merchants and landed gentry, bringing big-city styles in art to out-of-the-way areas.

154. A canal in old Kurashiki.

Kurashiki, a small town in Okayama facing the Inland
Sea, has been a distributing center for rice growers
ever since its leading merchants supplied the provisions
for Tokugawa forces during the battle against the
Toyotomis at Osaka in 1615. In the photograph are a
few architectural relics in what was formerly the center
of the town, which still retains some of its Edo-period
features. The name Kurashiki derives from *kura-yashiki*
("mansions with warehouses"), and is a clear reference
to the affluence of the merchants who lived there. In
addition to the town's considerable charm—streets
dotted at every turn with rice shops and open-front
houses where *tatami* and other straw articles are made
and sold—Kurashiki has three other very important
tourist attractions in the Ōhara Art Museum, the
Archeological Museum (Kōkokan), and a justifiably
famous Folk Art Museum.

155. Yoshimura mansion, Osaka. Early seventeenth century. L. 41.16 m. (134.5 ft.); side, 11.3 m. (36.8 ft.). The construction of this building is basically quite simple. It is long and rectangular, and has a gabled roof that is partly tiled, partly thatched. Elements of mainstream, fashionable architectural styles, such as attached *shoin* and large reception rooms with *tokonoma*, are incorporated in the plan, but its massive, completely utilitarian frame and unadorned surfaces, inside and out, give it a quality of rawness typical of provincial architecture. For many generations after the opening of the seventeenth century the Yoshimura family was in control of the extensive and fertile area of Kawachi to the east of Osaka, regulating the production of rice and the activities of local farmers. The mansion was built in 1615 and enlarged in the late eighteenth century.

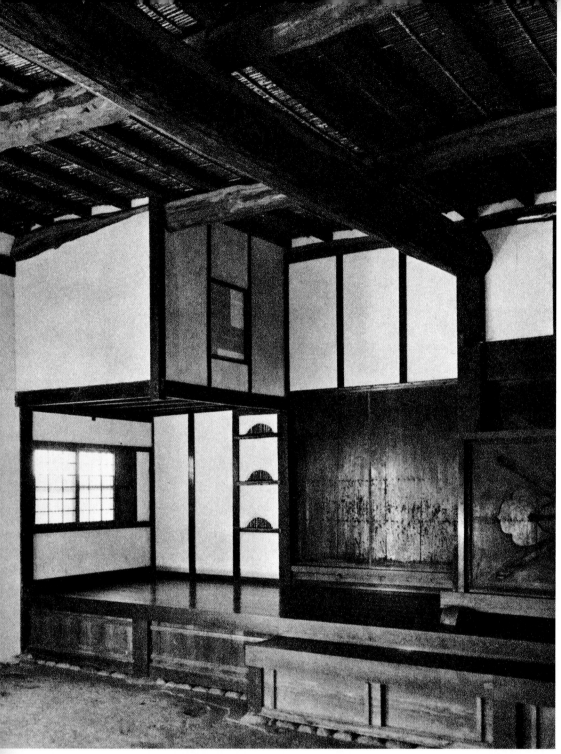

156. Yoshimura mansion, interior.
On entering the Yoshimura mansion, the visitor finds
himself in a large dirt-floor entryway (*doma*: in the
immediate foreground in the photograph) on the order
of those of large Buddhist temples (for example, Myō-
hō-in in Kyoto). A shallow stagelike facade of polished
dark wood and white stucco provides entrance to the
main reception room and living quarters, the *hiroshiki*.
The boxlike room suspended over one end of the stage
(far left) was used as maids' quarters.

157–58. Watanabe mansion, Niigata, interior and
entrance facade. Late eighteenth century. L. 33 m.
(107.8 ft.); side, 34.5 m. (112.7 ft.).

The Watanabe mansion is located at the northern end
of the Niigata Plain, another area noted for abundant
rice production. The building was constructed in 1788
after a fire destroyed its predecessor. For well over one
hundred years the exposed, smoke-blackened timbers
in the cavernous interior of the entryway have carried
the weight of a roof that is covered each winter with
tons of snow. A system of discriminating the ranks of
persons in attendance when farmers presented their
annual levy of rice is carried out in floor levels of slightly
different elevations, in imitation of the arrangement
at such military institutions as Nijō Castle. The en-
trance on the right in figure 158 leads to the dirt floor
area; the main entrance to the house is on the left.
Wooden shingles of the upper roof are kept in place
with stones.*

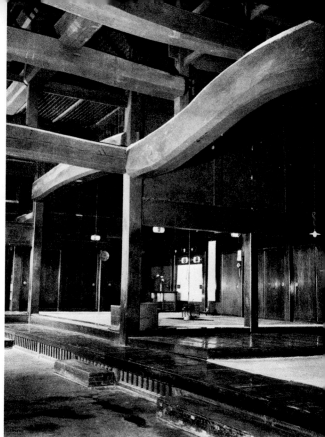

159. Karatsu dish. Early seventeenth century. D. 28.9
cm. (11.3 in.).
This dish, like the Karatsu teabowl of figure 95, was
modeled after Korean vessels of the Yi (Li) Dynasty,
although the Pennsylvania Dutch-like symmetry of
the painted iris design is a notable provincialism.

160. Nabeshima porcelain plate. Eighteenth century.
D. 20.3 cm. (7.9 in.).
The production of Nabeshima porcelain was subsidized
by the Nabeshima family in northwestern Kyūshū
from about 1630 until the end of the Edo period. The
design for this overglaze-decorated *(iro)* Nabeshima
plate consists of realistic tassels rendered in blue and
red overglaze enamel.*

161. *Ko*-Kutani dish with phoenix design. Late
seventeenth century. D. 34 cm. (13.3 in.).
This representative example of *ko*-Kutani ("Old"
Kutani) ware has an off-white kaolin body and over-
glaze decoration in colors of blue, yellow, green, red,
brown, and purple. The ware was first made around
1655 at Kutani near Kanazawa under the sponsorship
of the Maeda family.*

162. Imari dish. Late seventeenth century. D. 32.8 cm.
(12.9 in.), h. 5.9 cm. (2.3 in.).
The red and blue color scheme of this dish is in keeping
with the earliest style of Imari porcelain, but its over-
glaze decoration points to a later date, as do the two
dancing figures in the design who seem to have been
lifted from *ukiyo-e* prints of about 1700.*

163. Deep bowl with overglaze decoration, by Sakaida
Kakiemon (1596–1666). D. 30.3 cm. (11.8 in.), h. 21.3
cm. (8.4 in.).
In the 1640's the potter Sakaida Kakiemon was success-
ful in producing overglaze colors from native materi-
als, making it possible for Japanese potters to imitate
Chinese enameled porcelains with ease. He learned
the secrets of Ming bird-and-flower designs from a
Chinese potter in Nagasaki, and did a number of plates
and bowls (including this one) that closely resemble
continental prototypes. His later designs are somewhat
less derivative. European traders managed to get some
examples out of the country around 1650 and before
long imitation Kakiemon was being manufactured in
the leading European ceramic centers of Delft, Meis-
sen, and Worcester. (See color plate 26.)*

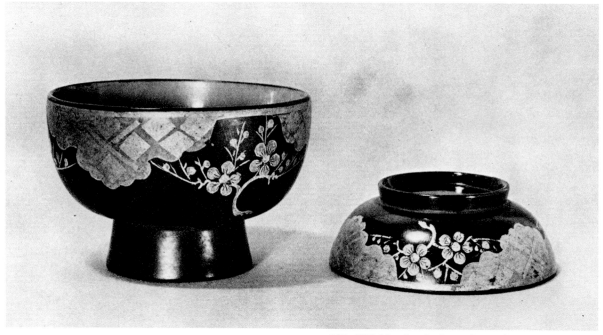

164. Hidehira bowl. Late sixteenth century. D. 12.5 cm. (4.9 in.), h. 11.2 cm. (4.4 in.).
The plum branch and cloud motif of this black-lac-quered bowl is carried out in red and gold lacquer and thin sheets of cut gold.*

165. Black and gold lacquered *kushige*. Seventeenth century. Tokyo National Museum. H. 23.7 cm. (9.3 in.), l. 27.8 cm. (10.9 in.), w. 21.5 cm. (8.4 in.).
A *kushige* ("comb cabinet") was used somewhat on the order of a cosmetics container. This one seems to have been designed especially for traveling. The odd combination of rabbits and waves, in *maki-e*, is seen also on the garment of a women in the Matsuura screens (figure 48).

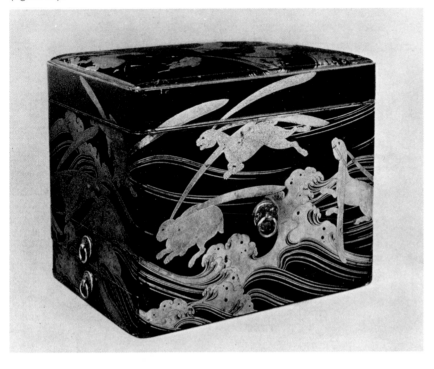

166. *Mitsuda-e* serving tray. Eighteenth century. Tokyo National Museum. L. 32.5 cm. (12.7 in.), w. 32.6 cm. (12.8 in.), h. 2.3 cm. (0.9 in.).
Mitsuda-e is an ancient Chinese lacquer technique that had been known of in Japan since about 700 A.D., but which did not become popular until after the arrival of Ming Dynasty *mitsuda-e* articles in the sixteenth century. By about 1700 the colorful creations done in this technique had many admirers in the "floating world" especially, who loved to serve refreshments to their guests in such trays as this green and red lacquered one illustrated with the figure of a Chinese court lady. (See color plate 27.)*

167. Statue of Nyoirin Kannon, by Priest Mokujiki (1718–1810). Hōshō-ji, Niigata.
Mokujiki was a monk who, like Enkū, traveled widely and left along the way carved wooden images as an expression of faith.*

168. Two wooden icons, by Priest Enkū (1628–95). Senkō-ji, Gifu. Left: h. 218 cm. (85.5 in.); right, 211 cm. (82.7 in.).
Using pieces of scrap wood and with a determination that people were unused to seeing in priests of the time, Enkū carved thousands of imposing icons during his lifetime of wandering.*

169. View of Takayama.
Takayama, located in the mountainous area of Hida
province (Gifu Prefecture), was a center of provincial
art and culture even before it was designated a govern-
ment-controlled city in the seventeenth century. It is
often referred to as "little Kyoto."*

170. *Ema* with design of peony and Chinese lion. 1613.
H. 22.8 cm. (8.9 in.), w. 29 cm. (11.4 in.).
The practice of offering votive pictures *(ema)* to shrines
and temples originated during the Heian period (794-
1185).*

171. *Ema* with design of black horse. H. 25.6 cm. (10
in.), w. 25.7 cm. (10 in.).
As the literal meaning of *ema* indicates, the classical
votive picture has a horse for its subject. This one bears
the date of 1707.*

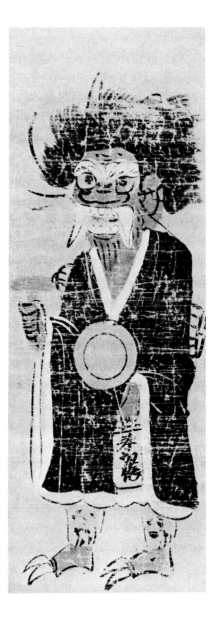

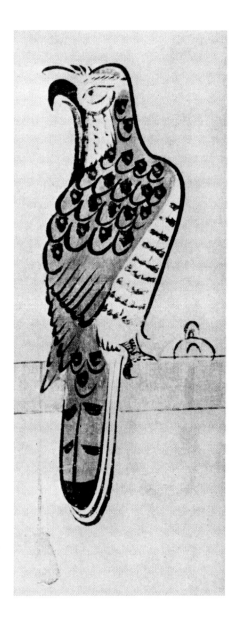

172. *Oni nembutsu, ōtsu-e.* Eighteenth century. H. 60
cm. (23.5 in.), w. 22.3 cm. (8.8 in.).
An ogre in priest's attire *(oni nembutsu)* is the subject
of this and many other of the crude pictures known as
*ōtsu-e.**

173. Hawk, *ōtsu-e.* Eighteenth century. H. 56.2 cm.
(24.9 in.), w. 22.3 cm. (8.8 in.).*

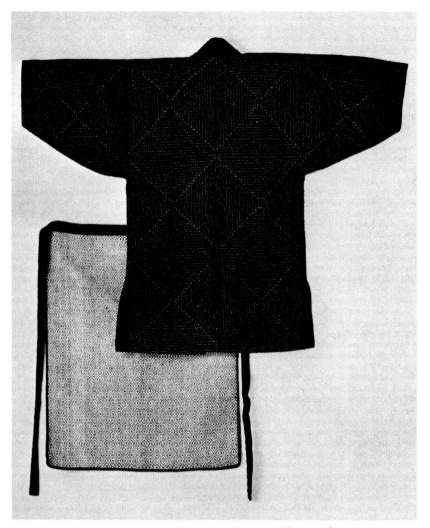

175. Stitched underwear. Nineteenth century.
Hand-stitching *(kogin)* on indigo-dyed cotton was the
means of making heavy underclothing for farmers in
northern Japan.

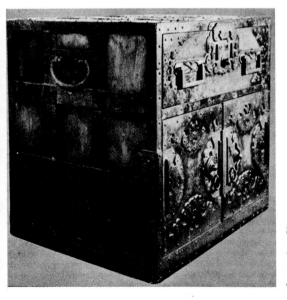

174. Ship chest.
Such massive chests as this were first made around
1750 at ports facing the Japan Sea. Thick Zelkova
boards were used for the outside, paulownia wood for
the inner part of drawers. The metal hardware is more
elaborate than that of ordinary Japanese chests *(tansu)*.

176. Ornamental kettle hanger. Seventeenth century.
L. 35.3 cm. (13.8 in.).
Iris and stylized waves is the motif carved out of this
wooden piece that serves as the catch for the adjustable
kettle support *(jizai-kagi)* hung over an open fireplace.
The piece has acquired a fine dark luster over the years.

177. Sword guard, by Hayashi Matashichi (1613–99).
Torn fans and cherry blossoms are the thought-
provoking motifs of this sword guard's elegant
gold-inlay design.*

178. Sword guard, by Hayashi Matashichi.
The Hosokawa family *kuyōmon* ("nine luminaries")
crest is used for the basic shape of this *tsuba*, with styl-
ized cherry blossoms done in openwork and gold inlay.*

179. Kaga-*yūzen kosode*. Eighteenth century.
The *yūzen* dyeing technique developed in Kaga province on the Japan Sea was referred to as Kaga-*yūzen* as opposed to the older Kyō-*yūzen* of Kyoto. The significant difference between them was in the rigidness of Kaga designs and a preference for a vignette effect accomplished here in purple on a white ground.

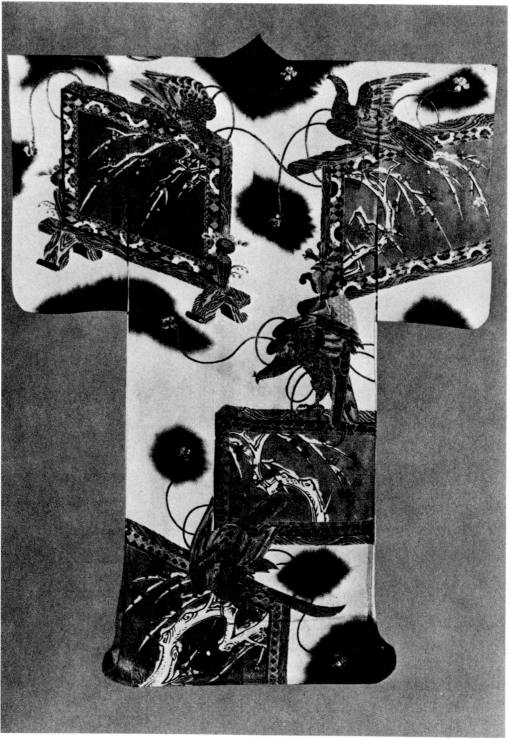

180. Large Hizen-ware bowl. Early nineteenth century.
D. 59 cm. (23.1 in.), h. 19.8 cm. (7.8 in.).
The pine branch design of this bowl is done in bold
shaded strokes using brown and green glazes over a
white clay body. The bowl is thought to be a product
of a kiln located around Odashi, Hizen province in
northern Kyūshū. This type of pottery is known as
Futagawa-*yaki* and is a popular *mingei* ware.

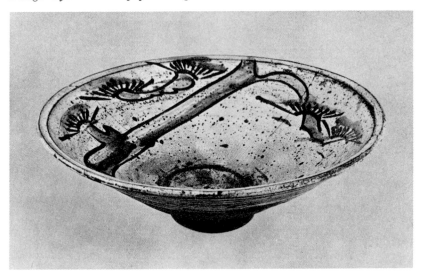

181. Nagasaki glass decanter and Satsuma cut-glass
cups. Nineteenth century. Suntory Art Museum.
Glassware imported from the West was imitated in
Japan after the sixteenth century under the sponsorship
of Kyūshū families. Representative wares are the blown
glass of Nagasaki and the cut glass of Satsuma.*

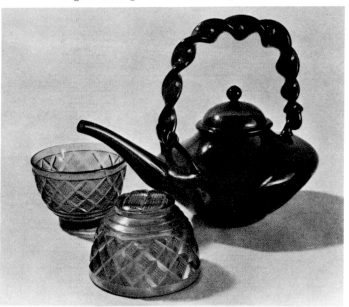

9

ENCOUNTERS
WITH THE OUTSIDE WORLD

JAPAN MEETS THE WEST

Marco Polo introduced the West to Japan with retold Chinese accounts of the Land of the Rising Sun, or Jipên-kuo. Polo's tales led a number of Europeans to entertain hopes of sharing the wealth of a land where the emperor covered his palace with gold. The Roman Catholic Church entertained equally high hopes of converting a people rumored to be "white, civilized, and well-favored" yet ignorant of the Christian message. With the irony that history so often provides, neither greed nor evangelism was responsible for Europe's first face-to-face meeting with Japan. It was instead a typhoon, which blew off course a Chinese pirate junk that numbered among its passengers some Portuguese sailors. Fleeing from Chinese coastguards, the junk was blown towards Japan and landed on the small island of Tanegashima, south of Kyūshū. (The date of this event is variously given as any time from 1541 to 1545, but 1542 is generally agreed upon.) Returning eventually to their homeland, the Portuguese reported that they had found the fabled land and had been well treated by its people. Missionaries and merchants soon set out, and both were courteously received by the Japanese.

This warm reception, so different from that often experienced by Europeans elsewhere in Asia, was due to essentially two circumstances. Japan had developed over the centuries from a tribal land to a unified nation through the conscious imitation of China, and as a result the Japanese were traditionally respectful of all foreigners and foreign learning (although their contact with foreigners was virtually limited to the Chinese and Koreans). This openness to outside influences was enhanced by the desire of powerful lords in the western provinces to increase their wealth and, therefore, their military strength through commerce (it will be remembered that the mid-sixteenth century was a time of great civil war). Anxious to be on good terms with the European traders, the daimyos extended their hospitality to the missionaries as well, for they noticed the religious men were treated with great respect by the traders.

The most immediate effects of contact with the Portuguese (who virtually monopolized European trade with Japan in the early years) were seen in the course of the civil war. The introduction of firearms made it necessary to change methods of warfare, and musket-bearing foot soldiers soon replaced mounted warriors who fought hand-to-

237

hand (although the latter method of combat remained favored by the aristocracy for many years). Fortresses that could withstand gunfire became an obvious necessity, and we have seen the steps taken by Nobunaga, Hideyoshi, and other warlords to meet this need. The influence for peace was also great, although not as obvious, for the booming commercial activity awakened the feudal lords to the truth of their dependence on people outside their immediate social and geographical domain and thus made them receptive to the idea of national unity.

CHRISTIANITY IN JAPAN

The spread of the Christian faith throughout Japan is a phenomenon that has interested religious historians and students of acculturation, and is the subject of a number of full-length books that treat in depth such considerations as linguistic and conceptual barriers, and the overlapping of evangelistic and expansionistic activities of the Portuguese. Here only a brief summary can be provided, but it will give a framework for understanding several important developments in art and in Japanese attitudes towards foreigners.

The first organized mission to Japan arrived at Kagoshima on Kyūshū in 1549, under the leadership of the Portuguese Jesuit Francis Xavier. Xavier and his few colleagues achieved limited but encouraging success in winning converts and establishing goodwill, but Xavier's journey to Miyako (the old name for Kyoto) to visit the "King of Japan" was to no avail, for the shogun had departed and the emperor was in retirement (if not retreat). Returning to Gôa, India (headquarters of the Portuguese government of the Indies), Xavier reported that Japan was a promising country for missionary work and spoke very favorably of the Japanese people. A later missionary, Father Gaspar Vilela, in 1560 succeeded in gaining an audience with the Ashikaga shogun, on whom he apparently made a favorable impression, for he obtained protection and permission to preach freely in the capital. Later that year violence in the city forced him to move to Sakai, where he remained until 1563. Buddhist monks, alarmed by growing Christian success, were by then demanding expulsion of all missionaries from the country, but the shogunate's protection of the Jesuits prevailed over this opposition.

Among the missionaries sent to Japan to assist Vilela was Father Luis Frois, who arrived in 1564 and remained until his death in 1587. With a good command of the Japanese language, Frois played a vital role in the Jesuits' work, both through his ability to teach the faith and through his cordial relations with the country's leaders. Frois won favor for himself and his church with the last two Ashikaga shoguns and with Nobunaga and Hideyoshi. (Nobunaga is known to have been especially benevolent toward Christians, and his open hostility for the Buddhists, whose military and political machinations he wished to end, greatly aided the missionaries' efforts.) In 1582, when the Jesuit Visitor-General Valignano came to inspect activities in Japan, the estimate of converts was 150,000, most of whom were in the western provinces. Some of these were devout, some had converted on orders from their daimyo, others were fascinated by the new and bizarre, and still others thought it wise to adopt the religion of the Portuguese merchants who could make them rich.

Three important Christian lords of Kyūshū sponsored a mission to Europe by four Japanese youths for a visit with the king of Spain and with the Pope. This constituted the first diplomatic visit by representatives of Japan with European countries, and was therefore another important accomplishment of the Jesuit missionary effort. Arriving

some three years after their departure from Nagasaki, the young emissaries were received in Madrid with dignity by Philip II, ruler of Spain and Portugal. From Spain they were taken to Florence and then to Rome, where they were honored with a splendid ceremony given by Pope Gregory XIII. The Jesuits were also honored by the Pope, who granted them a monopoly on evangelism in Japan, as well as a handsome stipend. The four Japanese, now young men, arrived back in Japan in the summer of 1590, eight years after having embarked on their adventure.

Three years before their return, Hideyoshi had done a sudden about-face in his dealings with the Christians. Although he still admired the Christian faith and its teachers, he had decided that, since its tenets undermined the ancient foundations on which his power rested, political prudence demanded expulsion of the foreigners. Hideyoshi's edicts were not enforced with any vigor for several years, however. Even when Spanish Franciscans, defying both Hideyoshi and the Pope (who had granted the Jesuits exclusive rights in Japan), began building churches and preaching openly, the Japanese government did not interfere. But late in 1596 a hot-headed Spaniard boasted that the priests and traders were forerunners of conquering expeditions, and Hideyoshi quickly arrested and crucified a number of Christians. From that time on both foreigners and converts were persecuted by the government, although still in a sporadic way. It was not until the rule of the second Tokugawa shogun that other affairs of the nation were under sufficient control to permit a concentrated effort to drive out all members of the foreign faith, now entirely associated with imagined plots to make Japan a colony of a Western nation. By the middle of the seventeenth century, Christianity had been driven underground and those missionaries who smuggled themselves into the country were all eventually found and put to death or died in prison.

Westerners in Art: Namban Screens

Namban screens generally show Portuguese ships arriving in Japanese ports, usually Nagasaki, which for some years was the nation's principal commercial center. (Since the Portuguese were associated with the southern ports, they were called "southern barbarians," or *namban*.) Despite the proscription and persecution of Christians and the destruction of things associated with them, more than sixty *namban* screens survived. Many of them are now on permanent display, along with other types of *namban* art (reliquaries, rosaries, icons), as the Ikenaga Collection of the Kobe Municipal Art Museum.

Although the composition and subject vary with each pair of screens, certain elements are common. There often is a scene of cargo being unloaded, and the foreign sailors may be extraordinarily tall, with rather grotesque features. Sometimes a Negro appears among the crew, adding both a touch of reality and further exoticism. Such a scene is generally paired with one showing sailors and missionaries marching through the city, with Japanese lining the streets, curiosity evident on their faces. Along with the houses and shops of the city, European-style churches and trading houses are often depicted. Some paintings show the foreigners in Japanese houses, but using Western furniture and carrying on definitely European activities (such as a family concert), of the sort portrayed in Dutch genre paintings of a century or so later.

A few of the earliest of these screens (which scholars generally date at around 1600) show technical and stylistic traits of Kanō artists, and were probably commissioned by wealthy men who sent their favorite Kanō masters to Nagasaki to paint the activities

they saw. Such early screens are probably accurate renderings of actual scenes. As *namban* screens became more popular, they became more fantastic. These more inventive efforts were done mostly by professional genre artists working in a provincial style that was a forerunner of *ukiyo-e*.

Westerners appear in the art of Osaka and Kyoto as well as in that of port cities. Portuguese, or people dressed in the Portuguese style, are among the crowds shown in the screens called "Amusements at Shijō in Kyoto," in some *rakuchū-rakugai* screens, and in a few of the screens (mentioned in chapter 3) commemorating the festival held in honor of Hideyoshi at Hōkoku Shrine. In some *namban* pictures there is an occasional "foreigner" whose facial features are decidedly Oriental, and this is not surprising, for a great number of Japanese were fond of the new styles (if for no other reason than that they were exotic). An occasional scholar has claimed to have identified Nobunaga or Hideyoshi, dressed in Portuguese clothes, in paintings of the period, and it is certainly within the realm of possibility that the two men did adopt foreign attire from time to time, since both were innovators and both were on friendly terms with Westerners.

EARLY WESTERN-STYLE ART

Christianity was the unifying element in all Western art brought to Japan in the sixteenth century. Missionaries introduced Western painting in the form of portable religious works that were used in Japan much as they were elsewhere in the world, to instruct and inspire. A painting could bring to life the story of Christ, and was doubly useful in a country where verbal communication was often difficult. Some on-the-spot conversions were reported to have been accomplished among Japanese eager to own an appealing, strange holy picture. When the supply of pictures brought by the missionaries began to dwindle, the enterprising Jesuits met the demand by training the Japanese in Western methods of painting and drawing. After European artists arrived to provide professional instruction, skillfully executed versions of Christian pictures began to replace the early, rather crude copies. In 1583 the Italian artist and priest Giovanni Nicolao came to Japan and established a workshop where he taught scores of young Japanese seminarians the techniques of fresco and tempera painting and of engraving. It is quite likely that the many existing paintings of the "Madonna and Child Surrounded by Fifteen Scenes from the Life of the Virgin" and others of St. Francis Xavier are from Nicolao's workshop.

Some Western-style pictures done at this time were not religious icons: the four-fold screen in the Kobe Municipal Art Museum of "European Kings Fighting on Horseback," a screen in the privately owned Hosokawa Collection showing "Westerners Playing Music Outdoors," and a painting in another private collection showing Christians battling with Ottoman Turks, are all examples of Japanese-created art providing information about the customs and history of the foreigners. The foreigners themselves would never have taken such pictures for Western works, but to the wealthy Japanese converts for whom they were probably made they must have seemed both authentic and appropriately exotic. The "European Kings" screen mentioned above is thought to have been painted for the redecoration of Wakamatsu Castle undertaken in 1592 by Gamō Ujisato, a lord in Hideyoshi's service and one of the most illustrious early converts to Christianity.

Both copperplate engraving and woodblock printing were used for the publication in Japanese of prayer books and psalters illustrated entirely in the Western manner.

Other Western designs, executed in lacquer, appeared on typically Western furniture and various utilitarian objects. Foreigners themselves were the favorite subjects, with Christian crosses incorporated in abstract patterns, along with stripes and floral designs copied from printed fabrics brought by the Europeans from the South Seas. Western influence is particularly evident in many of the patterns known as *tsuji-ga-hana*, in which several dyeing methods were combined to create a rich assortment of floral motifs in low-key, modulated colors. Similar abstract patterns can be found in the pottery style of the time known as Oribe-*gonomi*. Furuta Oribe (d. 1615), a master of the tea ceremony and a Christian, originated this style of pottery, which is characterized by bright glazes and by simple stripe and meander patterns, all rather derivative of South Seas influences. Oribe ware also included Western-derived shapes and copies of Portuguese candleholders and tobacco pipes. The general public, unconcerned with identifying prototypes, considered all Oribe-*gonomi* ceramics to be on an equal plane in terms of foreign appeal.

THE POLICY OF ISOLATION AND THE DEVELOPMENT OF DUTCH INFLUENCE

Many of the ideas and customs introduced by the West in the sixteenth century quickly took root and no doubt would have continued to grow had it not been for the drastic change in Japan's official attitude towards foreigners. When persecution began in earnest, the Portuguese and Spanish were the first to be deported, for their religious proclivities were thought to be tied up with expansionistic designs. A few Dutch, English (mostly scientists and traders), and Chinese were allowed to remain at Nagasaki, and then only as a carefully guarded and restricted group. All Japanese were forbidden to leave the country, on penalty of death.

Until the mid-nineteenth century, when Japan was forced by national and international pressure to end her policy of isolation, Nagasaki was the one link to the rest of the world, and the Japanese were able to absorb only those aspects of foreign cultures that the government permitted to remain there. Since the Dutch had never demonstrated any interest in "undermining" Japanese interests by missionary activity, they remained in reasonably good favor with the government, and consequently Dutch studies rose to a position of unusual prominence. Japanese scholars from all parts of the country visited Nagasaki to learn what they could about Western ways. Dutch residents were allowed to instruct the Japanese only in the scientific disciplines, and were themselves required to refrain from all religious observances. With Christianity's proscription went most Western art, and for a time the only Western art that had official sanction was what appeared as illustrations in medical and technical handbooks. These illustrations were important in that they conditioned the Japanese to Western principles of one-point perspective and shading based on a determined light source—principles that were adopted by Japanese Realists and that had a definite (though by no means equal) influence on almost every Japanese artist from that time on.

Hiraga Gennai (1728–79), who was sent to Nagasaki by his lord on Shikoku Island to learn the Dutch language and to study Western science, became knowledgeable in many fields of Western study, including oil painting, an art he introduced to the Satake clan in the northern city of Akita, when he was called there to give advice on mining and production methods—another area of learning in which he was an authority. Oil painting proved so popular there that Akita grew to be a leading center of what was known as Dutch painting. One of Gennai's pupils, Shiba Kōkan (1738–1818), abandoned the

Chinese style of painting he had been following and became an exponent of the new Western methods, working both in oil paints and copperplate engraving. Nagata Zenkichi (Aōdō Denzen; 1748–1822), another Western-style artist worthy of note, adopted as his favorite *gō* (something akin to a *nom de plume*) the name Aōdō, which incorporates the same characters as does the word for Eurasia, thus manifesting the artist's interest in both European and Asian art styles.

The Continuation of Chinese Influence

The imitation and study of Western ways was by no means an indication that they were necessarily superior to Japanese ones, and they were often regarded as merely amusing or exotic. But China had long been regarded as the epitome of all that was worthwhile and proper, and for centuries was the model most Japanese chose to copy—to the everlasting despair of ardent Japanese nationalists. Even during the period of isolation, when the Tokugawa government was endeavoring to strengthen nationalism in a way that has probably never been equaled, Chinese influences were still to be seen everywhere. Continental art styles were constantly the inspiration for Japanese artists, and the religious and political philosophy advocated by the Tokugawas had immediate Chinese antecedents. Unlike the quite reversible situation that prevails between Europe and America, the relationship between China and Japan has always been a one-way affair. China maintained her feeling of superiority even during Japan's occupation of Korea during the fourth, fifth, and sixth centuries, and seems to have viewed Hideyoshi's invasion and threats of further conquests as but another tiresome example of barbarism. In the mid-seventeenth century, the Chinese in Nagasaki were living in Chinese-style homes, building Chinese-style temples, and in every way avoiding any surrender to Japanese customs, while the Japanese watched and imitated their newest visitors from the Most Perfect Central Land.

At a time when Christians were being slaughtered, the emperor invited a representative of a new Zen Buddhist sect to Japan. The priest Yin-yüan (Ingen in Japanese) arrived in 1654, and began to instruct the Japanese in the ways of Ōbaku. The new religion, historically the third to develop within Zen, was more tolerant of the layman and somewhat less formal than the older sects of Sōdō and Rinzai. Ōbaku temples partially imitated late Ming temples, whose richly carved decorations were reflected in the architecture appreciated by Tokugawa shoguns. In Nagasaki the Sōfuku-ji was built for the Ōbaku faithful of that area, and in Uji province, just southeast of Kyoto on a large area of land given to Yin-yüan by Tokugawa Ietsuna, the Mampuku-ji was begun in 1661. Priests of the Ōbaku sect had brought from China scholarly parodies in the form of books and paintings (most of the latter by Ming literati painters), which Japanese artists found entertaining, and the temples attracted a number of artists who desired instruction in the newest Chinese mode.

Among the artists mentioned in earlier contexts who studied directly under Chinese artists were Gion Nankai, the literati painter from Wakayama, a student of I Fu-ch'iu, who came to Japan in 1720. Ike-no-Taiga, whose *fusuma* series "The 500 Disciples of the Buddha" belongs to Mampuku-ji, is thought to have been instructed by priests at that temple. The Chinese artist Ch'en Nan-p'in, scarcely known in his own country, became famous in Japan, although he spent just two years there, and is best known by the Japanese reading of his name, Chin Nampin. He arrived in Nagasaki in 1731 and introduced a new style of realistic painting. Maruyama Ōkyo's animals, flowers, and

birds show the influence of this "Nagasaki realism." Three Japanese artists produced works that are quite easily mistaken for Chinese paintings: Kumashiro Yūhi (1712–72), Sō Shiseki (1712–86), and Kinoshita Itsuun (1799–1866), all of whom were followers of Chin Nampin.

Ōbaku priests introduced a new ceremony that used a green tea *(sencha)* prepared by simply steeping the leaves in boiling water, in contrast to the use of powdered green tea in the *cha-no-yu*. The *sencha* ceremony was less formal than either the earlier Chinese version or the one introduced by Rikyū not long before. By this time Rikyū's ceremony had become too ritualistic for some people's taste, the traditionally important utensils having taken on the aura of religious relics. Other people turned to the *sencha* ceremony simply because it was new, and because it was introduced by Chinese masters. *Sencha* utensils were not supposed to be highly prized. Ideally, any kind of cup or bowl would do. But just as the majority of Japanese had created formality where Rikyū intended none in his version of *cha-no-yu*, so, too, did they begin to cherish the gaily decorated but commonplace Ming and Ch'ing vessels introduced by *sencha* tea masters, and potters began turning out wares copied from the Chinese ones. The *sencha* ceremony, such as it was, apparently was too freewheeling for it to appeal to the ritual-loving masses, and it was never widely practiced. Today visitors to Mampuku-ji can enjoy the locally grown "Chinese" tea served in one of the nearby tea houses, where the *sencha* ceremony is still followed with an informality that would probably please its Chinese originators.

So great was the continental influence at all levels of conduct that the actual relationship with China changed little when Japan ended her policy of isolation. It was the renewed exposure to Western cultures that brought about striking changes in Japan, changes that continue to the present day. In the concluding chapter, some of the circumstances and results of this new meeting of different cultures will be reviewed.

182. Port of Nagasaki.
The port of Nagasaki in Kyūshū, the southernmost of Japan, was opened for foreign trade in 1571 and remained the one place where contact with Europe and Asia was possible while Japan's doors were closed from 1639 until 1853. Since World War II, the city has recovered most of its former reputation as a mecca for East-West trade and religious confrontation.

184. *Namban* screen. Artist unknown. *Ca.* 1600. One of a pair of six-fold screens. Suntory Art Museum. H. 156 cm. (61.2 in.), w. 358 cm. (140.4 in.).
Because the Portuguese, the first Westerners to arrive, anchored their huge ships at ports in southern Japan, they were known as *namban,* "the barbarians from the south." In this typical painting of *namban*—here shown simultaneously entering the port and clustered together on the dock deciding what to do next—the artist (whose rendering of rocks and trees identifies him as a Kanō) went to great lengths to document the extraordinary size, elaborate costumes, and strange customs of the visitors. The Japanese, depicted in what are considered to be Keichō-era (1596–1615) garments, appeared equally odd to the foreigners, as the artist noticed when he recorded the one gesture both groups had in common: the pointing finger. (See color plate 28.)

183. "Nagasaki Harbor," by Shiba Kōkan (1738–1818).

The presence of Dutch and Chinese in the Nagasaki area attracted scores of young Japanese interested in the arts and sciences of foreign countries. For Kōkan and other artists who were experimenting with newly introduced Western drawing methods and techniques, the sweeping contour of Nagasaki harbor *circa* 1790 was perfectly suited to representation in one-point perspective.*

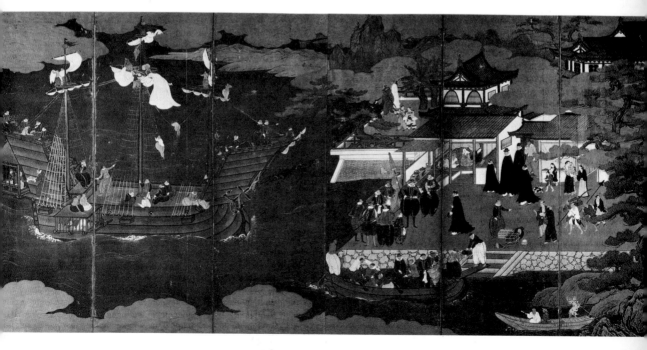

185. Sword guard with cut-out design of cross and plum blossom. Seventeenth century.
Although Westerners were sometimes annoyed by the peculiar ways their motifs were used by Japanese designers, they may have appreciated this combination of the Christian cross and the plum blossom, symbol of Sugawara-no-Michizane, the Heian-period hero who was regarded as the wisest man in Japanese history.

186. Sword guard with cross motif. Seventeenth century.

187. *Jimbaori*. Eighteenth century. Maeda Ikutoku-kai, Tokyo.
A *jimbaori* was originally worn on the battlefield, over a full suit of armor. One such as this, however, with its bold design of a crimson-sailed foreign ship, was used (quite probably by Maeda Shigehiro of Kaga) as an overcoat on occasions calling for a display of formality. It is made of many pieces of heavy woolen fabric sewn together in a basic color scheme of red and black on yellow.

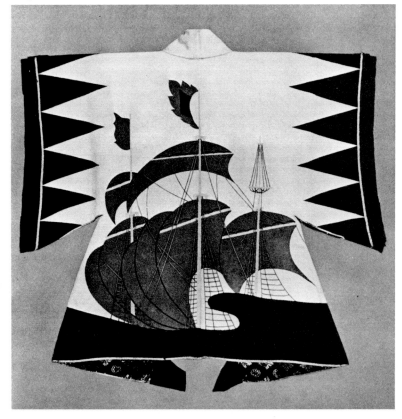

188. Wooden saddle with *maki-e* decoration. Early seventeenth century. Front, h. 27 cm. (10.6 in.); back, h. 26 cm. (10.2 in.).

By instructing the lacquer craftsman to use three foreigners in the design for this saddle, the owner was proudly exhibiting his own acquaintance with such strangers and the confused state of affairs their presence in Japan had created. No other motif was as exotic—or as fashionable.

189. Square Oribe dish. Early seventeenth century. L. 21.5 cm. (8.4 in.), w. 20.5 cm. (8 in.), h. 7 cm. (2.8 in.).

This handsome dish was made at a kiln at Mino, probably just before or only a few years after Oribe's death (see also figure 99). The best judges seem not to know what to make of the dish's design, except to deny categorically that it is abstract fancy. (The gold on the rim is repair work done with *maki-e* lacquer paste.) It is pleasant to imagine that the green area represents a field of tea bushes and the outlined rectangular shapes the wooden clappers *(naruko)* used in gardens to frighten away birds. (Other guesses as to the design's significance: a target field, a festival, roadside shrines, and grave markers.) The meaning of the design is of small consequence, however, when the dish is viewed, with modern eyes, as a ceramic creation. It then becomes an object of incredible sophistication. Among its admirers in the twentieth century was a former owner, Akutagawa Ryūnosuke (1892–1927), one of the most original writers in modern Japanese literature. (See color plate 29.)

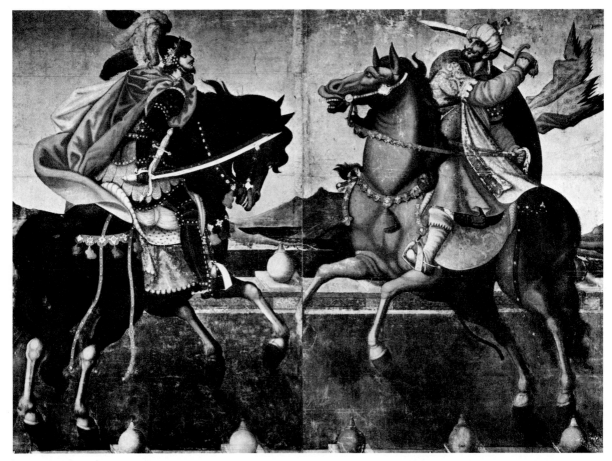

190. "European Kings Fighting on Horseback." Artist unknown. Early eighteenth century. Two panels of a four-panel screen. Kobe Municipal Art Museum. H. 162 cm. (63.5 in.), w. 234 cm. (91.8 in.).

An unknown European painting was undoubtedly the model for this screen and for others with the same design. Some of the three-dimensional quality of that Western work is lost here because of the trouble the artist had accommodating the flat patterns, which came easily for him, with unfamiliar procedures for shading (particularly noticeable is the odd rendering of the head of the horse on the right). Tradition has it that this screen comes from the group of wall paintings commissioned in 1592 by Gamō Ujisato for Wakamatsu Castle. However, since a post-1593 "King of France and Navarre" crest appearing on a similar painting identifies the figure on the left as Henry IV, the traditional dating seems a bit early.

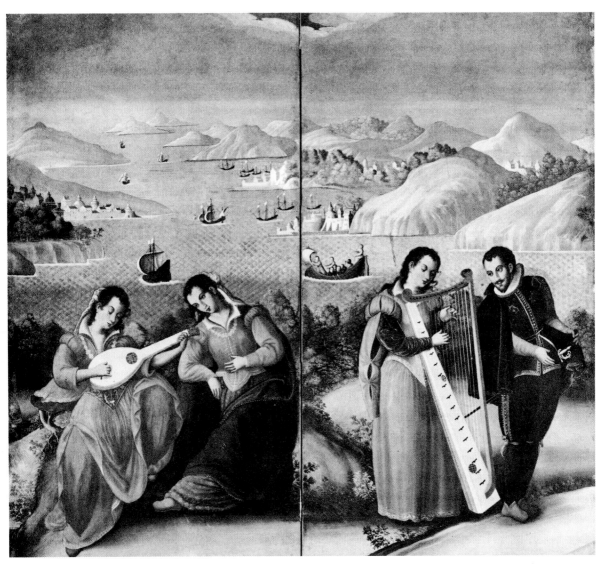

191. "Westerners Playing Music Outdoors." Artist unknown. Seventeenth century. Two panels of a six-panel screen. Atami Museum. H. 93.1 cm. (36.5 in.), w. 120.8 cm. (47.4 in.).

The European teacher of the artist of this painting (and of another almost exactly like it in the Hosokawa family collection) probably was at a loss to explain why his student, whose mastery of unfamiliar techniques and complicated pictorial details had taken but a short time, seemed unable to produce figures that were anatomically and spatially convincing. The basically flat, distorted form of the second figure from the left must surely have been a disappointment. Still, he probably found consolation in the thought that this was a decided improvement over the odd types of painting he saw other Japanese doing.

192. "Madonna and Child Surrounded by Fifteen Scenes from the Life of the Virgin." Artist unknown. Early seventeenth century. Kyoto University. H. 75 cm. (29.8 in.), w. 63 cm. (24.7 in.).
In the seventeenth century, Takatsuki, south of Osaka, was a castle town whose lord supported Christianity. This painting was found there in 1930, stored in a box that had been concealed in the roof of an old house. An almost identical work, owned by a Takatsuki family, was found later under similar circumstances. Although they resemble predella paintings, these works are on paper and seem to have been used as hanging scrolls.

193. "St. Francis Xavier." Artist unknown. Early seventeenth century. Kobe Municipal Art Museum. H. 91 cm. (35.7 in.), w. 54.5 cm. (21.4 in.).
The great founder of the Society of Jesus lived less than two-and-one-half years in Japan, but his influence there was deep and lasting. The artist of this portrait of him signed it simply, "Tamaki the Fisherman."

194. "European Woman," by Hiraga Gennai (1728–79). Oils on hemp cloth. H. 45.1 cm. (17.7 in.), w. 33.6 cm. (13.2 in.).*

195. "Dutch Physician," by Nagata Zenkichi (Aōdō Denzen) (1748–1822). Color on silk. L. 21.5 cm. (8.4 in.), w. 15 cm. (5.8 in.).*

197. "Scene of Kinryū-zan (Sensōji), Edo," by Nagata Zenkichi (Aōdō Denzen). Copperplate etching. H. 26 cm. (10.2 in.), w. 54 cm. (21.2 in.).
Though cluttered with signs of twentieth-century life, this area around Sensō-ji in Asakusa today has the same atmosphere as it does here.

196. "Scholars in Discussion," by Shiba Kōkan (1738–1818). Two-fold screen. L. 152.5 cm. (59.8 in.), w. 142.7 cm. (55.9 in.).
Kōkan, using oil-painting techniques, attempts to create a scholarly atmosphere, which probably was an expression of his positive desire to study things Western, in this painting (see note 183).

198. "Heron by the Waterside," by Odano Naotake (1749–80). Color on silk. L. 106.5 cm. (41.7 in.), w. 49.5 cm. (19.4 in.).
A definite trace of Chinese influence is seen in this brilliantly colored painting rendered in Western-style techniques. The artist, Odano Naotake, a retainer of Satake Shozan (see figure 199), spearheaded the activity in Akita *yōga* originated by Hiraga Gennai (see figure 194).*

199. "Camellia and Java Sparrow," by Satake Shozan (1748–85). Color on silk. H. 23 cm. (9 in.), w. 32 cm. (12.6 in.).
A mixture of Western and Oriental painting styles is seen in this work by Satake Shozan, the daimyo of Akita in northern Japan who also was the author of two books on the styles and techniques of Western art.*

202 (right). Founder's hall *(kaizan-dō)*, Mampuku-ji, Kyoto. *Ca.* 1675.

Mampuku-ji is located along the Uji River to the south of Kyoto. Its *kaizan-dō* is dedicated to Priest Yin-yüan, the founder of the temple who came to Japan from China in 1654. The swastika-patterned balustrade is unusual in Japan, as are the sharply upward-turned eaves and, for a temple, the dolphins decorating the roof.*

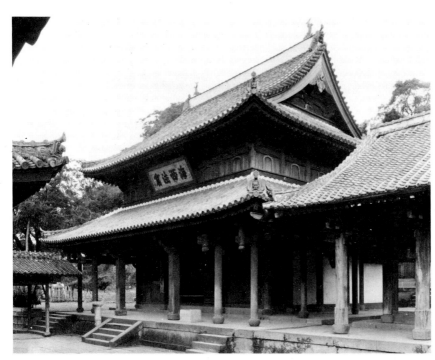

200. Main hall *(daiyū hōden)*, Sōfuku-ji, Nagasaki. Seventeenth century.

A Chinese atmosphere prevails at Nagasaki's Sōfuku-ji, a temple founded in 1629 by Chinese traders, who came to Japan in groups from Fukien. The young temple received recognition nationally after Yin-yüan, the patron saint of the Ōbaku sect of Zen Buddhism in Japan, stayed there in 1657, conducting services for some of the five thousand Chinese who were living in Nagasaki at that time.

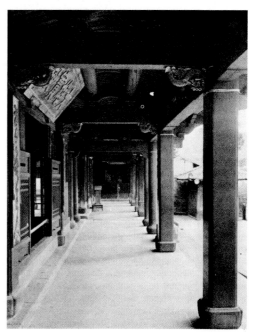

201. *Daiyū hōden,* Sōfuku-ji, entrance and portico. The structure and decor of the eaves of the portico and its ribbed, slightly arched ceiling are features taken directly from temple architecture of late Ming times. Records even indicate that the architects were brought from China to carry out the project.

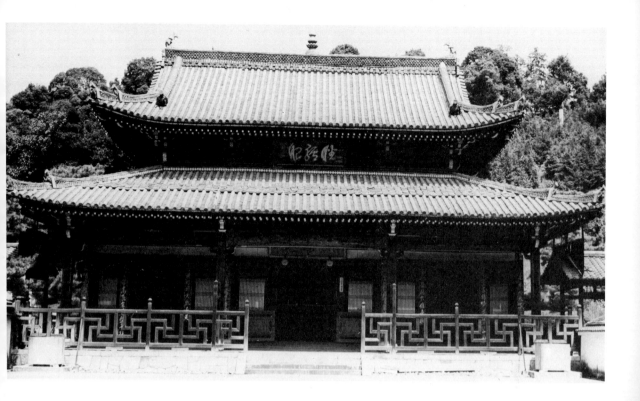

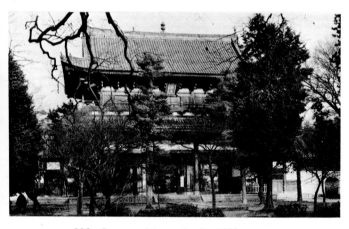

203. *Sammon*, Mampuku-ji. 1678.
The gigantic *sammon* at Mampuku-ji is the front gate-
way to the temple. It looks much like the gate at
Kenchō-ji (Vol. I, figure 167), which reflects a
Chinese style of some two hundred years earlier, but
the archetype in the minds of the designers of the heavy,
ornate roof—again with dolphins—of Mampuku-ji's
sammon existed in seventeenth-century China.*

204. *Sōmon*, Mampuku-ji. 1693.
The *sōmon* at Mampuku-ji is a smaller, outside gate.
It is basically a *shikyakumon*, a gate having four square
pillars and a roof, but shows later Chinese influence in
its elaborate three-part roof, and also in the addition of
two round pillars at the sides.*

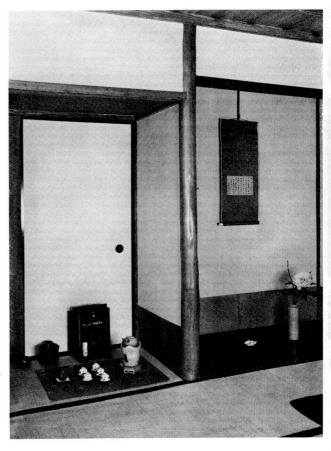

205. *Sencha* room of Hasegawa Shōshokyo, Tokyo.
Soon after the first Chinese priests of the Ōbaku Zen
sect began to arrive in Nagasaki in the 1650's, the
practice of drinking dried green tea *(sencha)* instead of
the powdered tea used in *cha-no-yu* was adopted by those
Japanese priests and painters under the newcomers'
influence. As this fully prepared room shows, little was
required in the way of special vessels or furnishings.

206. *Sencha* tea set, designed by Aoki Mokubei
(1767–1833). Tokyo National Museum.
This tea set, especially the cups with their floral designs
that are in relief and painted, could almost pass for
Chinese. In ceramics, as in other things, the Japanese
literati took great pride in their knowledge of Chinese
customs.

Plate 26. Deep bowl with overglaze decoration, by
Sakaida Kakiemon (1596–1666). (See also figure
163.)

Plate 27. *Mitsuda-e* serving tray. Eighteenth century.
(See also figure 166.)

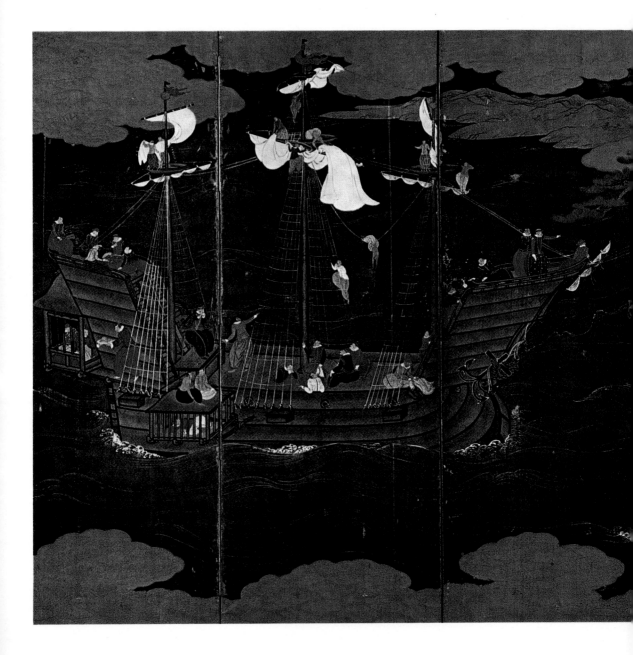

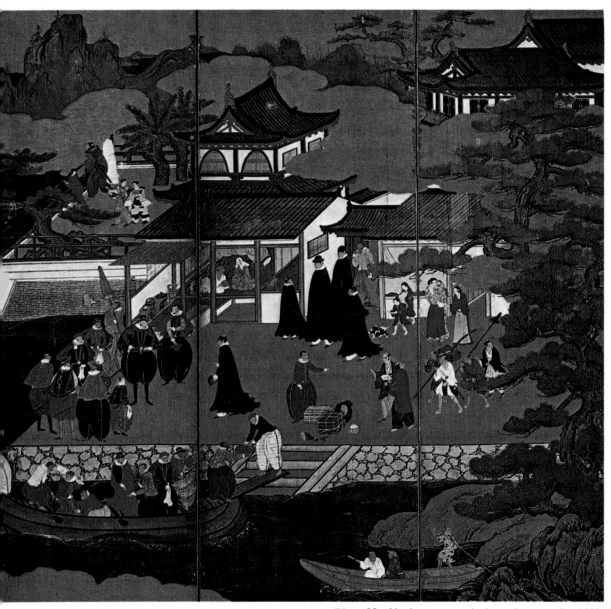

Plate 28. *Namban* screen. Artist unknown. *Ca.* 1600. (See also figure 184.)

Plate 29. Square Oribe dish. Early seventeenth century. (See also figure 189.)

~ 10 ~

THE PAST CENTURY

THE END OF THE SHOGUNATE AND THE BEGINNING OF A NEW ERA

The policy of isolation perpetuated by all the Tokugawa shoguns was to lead to enormous repercussions at both the national and international levels. Growing demands to open Japanese ports to trade were climaxed by the arrival of Commodore Perry in 1853 with American President Fillmore's request for a treaty. The shogun, after considerable delay, signed the treaty, which was soon followed by similar ones for England, Russia, and The Netherlands. Foreign ships were allowed entry at ports on the Izu Peninsula, on Hokkaidō, and at Nagasaki, with trading permitted and foreign consulates established. Full commercial treaties were initiated between 1858 and 1860, with more ports opened, import and export duties set, and immunity from Japanese law granted to foreigners. The shogun's advisors, with neither experience nor precedent to guide them, allowed trade agreements with few protective controls, and Western merchants were quick to take advantage of the situation. With no limits on exports, there soon developed a shortage of many consumer items and a resultant rise in prices; in less than a decade the price of raw silk trebled, tea doubled, soybeans went up fivefold, and rice increased as much as twelvefold. In some instances items identical to those produced locally had to be imported in order to meet the country's needs. The disparity in the value of gold in Japan and in the West enabled many an enterprising trader to make easy, enormous profits: a pound of gold bought up to twice as much the amount of silver in the West, so that a merchant or outright profiteer could buy gold in Japan, double his money in silver in the West, and return to Japan for still more gold. This disparity in the exchange rate caused a serious depletion of Japan's gold reserves. Further economic difficulties arose from the importation of cheap manufactured goods, particularly textiles. The Industrial Revolution in the West and cheap labor in colonies under Western rule made it possible for such goods to undersell the handcrafted items made in Japan. The rise in the cost of living touched everyone in the nation, and led to hostilities toward the foreigners and widespread opposition to the shogun.

This opposition to the shogun lent increasing power to the emperor, who ordered his rival to come to Kyoto· in 1863 to discuss the treaties. The shogun promised to comply with an imperial order to close all ports, but on his return to Edo, he assured

foreigners that the order would not be enforced. This and similar defiant actions brought on a brief civil war, with elements of powerful clans uniting with members of the court to overthrow Tokugawa rule. The war was ended by the shogun's resignation, marking the close of over two-and-a-half centuries of Tokugawa rule. Imperial power was restored, with councillors appointed to formulate and administer policies under the young Emperor Meiji. In 1868 the seventeen-year-old sovereign left Kyoto by coach for Edo. He made Edo Castle the new Imperial Palace, then rechristened the city as Tokyo ("Eastern Capital").

The early years of Meiji rule were marked by zealous imitation of Western ways, the explanation for which is not as illogical as many people suppose. It was clear from their actions in various spheres that the foreign powers considered Japan a primitive society, unworthy of respect. Japan therefore felt obliged to convince the West that her culture was equal to any, and for many years a great number of Japanese took this view to mean their culture must be identical to the West's. Thus national pride was, ironically, the motivation behind Japan's emulation of foreign nations. Whereas Western customs were imitated in the sixteenth century largely for their novelty, they were now embraced out of a fervent desire to counter the charges of inferiority implicit in the Westerners' dealing with Japan.

Yōga

In the art world, studies of Western ways began on an official basis as early as 1857, when Kawakami Tōgai (1827–81) became the head of a new academy of Western studies in Edo. In 1876, with interest in European art well established, the Japanese government invited several Italian artists to teach sculpture, academic portraiture, and landscape painting at the academy. Concurrent with the development of Tōgai's Western academy were the efforts of Charles Wirgman, an Englishman living in Yokohama. Between 1859 until his death in 1891, Wirgman, a painter and correspondent for the *Illustrated London News,* instructed many Japanese artists in Western painting methods, which came to be included in the curriculum of Japanese secondary schools.

By the end of the century, the best students of Western art were going to Europe to attend the leading academies. Some of the returning students founded their own schools of Western painting, or *yōga.* Among them was Kuroda Seiki (1866–1924), who became the hero of an episode that typified the incongruous elements of the Western culture Japan was trying to assimilate. A classic nude study Kuroda had done in Paris was almost excluded from an exhibition scheduled in Kyoto in 1895. Kuroda had great difficulty convincing the exhibit's officials that his subject was a popular one in contemporary European art, for they clearly recalled Christian teachings on the shamefulness of the human body. (This painting was destroyed during World War II.)

Loyalists

In contrast to the avid pursuit of Western studies, a sizable portion of the intellectual community turned to ardent nationalism. These loyalists also sought to establish Japan as a worthy contender in the international political arena, but they were convinced this should be done only by publicizing and nurturing native traditions. Their outrage over Westernization reached a climax in 1887, when government leaders attended two grand balls in Tokyo, decked out in the latest European fashions and making ludicrous

attempts to imitate their guests in every way. The loyalists denounced this behavior as insulting to the national character and indicative of moral decay, for it revealed a denial of Buddhist, Confucian, and Shinto teachings in favor of Western follies. (The three Oriental views were not themselves compatible, but the differences counted for nothing in the face of their mutual enemies: Western thought and Christianity.)

Even before the arrival in 1879 of Ernest Fenollosa, a young American scholar who was to give strong encouragement to the loyalist cause in art, many artists were refusing to adopt Western styles. In Tokyo, Kikuchi Yōsai (1788–1878), who combined Kanō and *yamato-e* styles, led the field as a loyalist pursuing a renaissance of Japanese qualities in painting. In Kyoto, the Maruyama-Shijō school leaders and literati painters were enjoying popularity. Artists of both schools were considered loyalists, for, whatever their styles and techniques, they chose native subject matter.

Fenollosa (1853–1908), a graduate of Harvard College, had been invited to lecture on philosophy at the newly established Imperial University in Tokyo. His colleague Okakura Kakuzō (1862–1913), whose writings (particularly *Ideals of the East* and *The Book of Tea*) were to influence a generation of Westerners, began to instruct the inquisitive American in the history of Japanese art. Okakura was a serious philosopher, with a broad knowledge of Indian and Chinese religious thought, and he was sensitive to Oriental artistic traditions, but it was Fenollosa who awakened him to the aesthetic value of Japanese religious art. It took the uninitiated and unintimidated eyes of one who knew little of Buddhist iconography to recognize the intrinsic beauty of works long considered solely as objects of worship. Fenollosa was surprised to learn of this great and ancient art, and found the Japanese themselves woefully unaware of its merit. He felt deeply that the enchantment of so many Japanese with Western culture would lead to the ultimate extinction of their own.

The pronouncements of Fenollosa and Okakura were vital in establishing the importance of Japanese art, and in persuading Meiji leaders to protect native religious art. The two men formed a group that attracted many loyalist artists and scholars, whose paintings were national in the fullest sense, with subjects taken from Buddhist iconography and the traditional repertory of landscapes, flowers, birds, and animals. In 1886 Okakura and Fenollosa headed a mission to Europe and the United States, to investigate contemporary Western art and to encourage the study by foreigners of Oriental, particularly Japanese, art. They were received as visiting dignitaries in the major capitals of the West, and in Boston, Fenollosa's home, the welcome was especially warm. Bostonians found Okakura the very incarnation of their image of an Oriental mystic, and responded with hospitality verging on adulation. When the two men returned to Japan in 1889, official research on Japan's traditional arts was well under way. In 1887 the Tokyo School of Fine Arts had been established, and Okakura was appointed principal on his return. *Nihon-ga* ("Japanese painting"), wood sculpture, and lacquer- and metal-working formed the school's curriculum—techniques and skills that had been fading from the artistic scene during the last years of the Tokugawas. The school sent a sizable collection of works to Chicago for an international exhibition in 1893, bringing world attention to these latest creative developments in Japan.

Western painting was introduced at the Tokyo School of Fine Arts in 1896, and despite the successes of native-style artists, advocates of *yōga* gained so much strength within the school that by 1898 they were able to bring about Okakura's dismissal. More than thirty faculty members resigned to join him in founding a new school, the Japan Art Institute *(Nihon Bijitsu-in)*. It happened that in a very short time important changes

took place in the styles of the institute artists and by 1900 even former admirers were complaining. Criticism centered on a new style characterized by "dim objects and hidden lines" *(mōrōtai-bossen)*. Derived from contemporary Western techniques, *mōrōtai-bossen* was said to "undermine the essence of Japanese art." Its defendants held that they were merely using a new way to depict traditional subjects, a way that gave a greater illusion of volume and, thus, reality. Two artists at the institute, Yokoyama Taikan (1868–1958) and Hishida Shunsō (1874–1911), published an explanatory pamphlet on *mōrōtai-bossen* in 1905, but their efforts by no means put an end to the dispute. Criticism also arose from the occasional choice of controversial subjects: for example, in Taikan's "Lost Child" a little boy is surrounded by Lao-tzu, Buddha, Christ, and Confucius— a profound enough statement, but hardly to the liking of ardent nationalists.

Several members of the faculty left the institute because of the criticism, and there were instances of artists committing suicide over the conflict that was to continue for several more years. Taikan, Shunsō, and Shimomura Kanzan (1873–1930) were among those who stayed with Okakura, cultivating an aesthetic that encompassed the arts of the entire Asian world, and that permitted a wide range of styles and techniques in the creation of native art. It should be emphasized that Okakura went beyond the shores of Japan in his definition of "native," for he appreciated the similarities among the Asian nations, and believed these similarities should unite the Orient in its competition with the West. After Okakura's death in 1913, Takian provided capable and evangelistic leadership for the many students who came to the institute, but its glory faded as the violent disputes between the two factions of loyalists were resolved.

The followers of Fenollosa and Okakura were of great importance in the decades just before and after the turn of the century. Their works were studied by all loyalist painters, and although their ways were not always appreciated or adopted, they served as catalysts in the crystallization of other styles. The activities of the various academies and guilds that were organized during the years of major conflict between the loyalists and Western devotees led to important changes, some fortunate, others not. The present-day Cultural Properties Commission *(Bunkazai Hogo Iin-kai)* is a direct outgrowth of the loyalist organizations, and continues to restore and preserve ancient works of art. In the West, a genuine appreciation of Japanese culture came to replace the often faddish imitations that abounded in the eighteenth century in response to the tales of returned missionaries, and credit for this appreciation must go to both Fenollosa and Okakura and to those students who went to Europe and America to learn Western ways, but inevitably taught their hosts a great deal about their own country. Probably the most distressing result of the disputes in the art world was the establishment of countless "schools" following a myriad of styles and substyles, each group of artists slavishly copying one prototype and never deviating from the chosen path. Japan's continued ambivalence toward the West can be dated to this period of conflict. The hostilities that coexist with great esteem for Westerners should not be written off as politically inspired, for they remain, to a great extent, a manifestation of the Japanese people's desire to retain their identity while sharing certain discoveries and developments of other countries.

RUSSO-JAPANESE WAR

The artistic feuds at the turn of the century were eclipsed by an event of incalculable international significance: the Russo-Japanese War in 1904–5. The ease with which

Japan defeated her foe convinced the West that the nation so recently thought to be "primitive" was definitely a power to be reckoned with. Moreover, that Japan could become so Westernized within just a half century after her unfortunate and humiliating entry into world affairs set an example for other non-Western (and often exploited) peoples. In Russia, the defeat awakened her people to the need for reform, and they responded with a series of strikes and rebellions that forever changed the character of that nation.

ARCHITECTURE

The trends in architecture paralleled those in other areas of Japanese life. In the years just following the institution of trade agreements with America and Europe, direct copies of certain kinds of Western buildings (particularly those without Japanese prototypes) made their appearance. Japan's first factory, an elaborate textile mill, was constructed in Kyūshū in 1858 with the help of British advisers. The oldest Western-style private residence in Japan was built around 1865 by T. B. Glover, a wealthy shipbuilder and merchant who made his home in Nagasaki. The Glover mansion is a sprawling bungalow that combines European, South Pacific, and Japanese features. (It has been suggested that this house inspired the setting of Pierre Loti's *Madame Chrysanthemum*, a novel based on Loti's visit to Nagasaki in 1885. Although a minor work, it is worth reading for the appalling frankness with which Loti, a well-educated, widely traveled European, reveals his contempt for the Japanese—convincing evidence that they did not imagine the high-handed superiority pervading the actions of Westerners.) Nagasaki was also the location of the country's first Christian basilica. Still an important architectural and historical landmark, it was designed in 1864 by a French Catholic priest and architect, Bernard Petitjean (1829–84).

In 1876 the English architect Josiah Conder (1852–1920) accepted a high post in the engineering school affiliated with Togai's Western academy. Only a few of the many buildings designed by Conder and his students have survived, but among these are two masterpieces—the Mitsubishi Office Building in the Marunouchi section of Tokyo, and the Byzantine-style Nikorai-dō (Church of St. Nicholas) in Tokyo's Kanda section. So unlike their surroundings as to appear transplanted, they are typical of the Western architecture reflected in banks, municipal buildings, and missionary schools in all major Japanese cities.

Some of the early loyalist attempts at preserving native architectural forms met with only mixed success. A curious compromise between East and West was effected in the 1885 reconstruction of Nishi-no-maru, a part of the Imperial Palace in Tokyo that had burned in 1873. Plans for the interiors called for crystal chandeliers, velvet curtains, heavy furniture, and thick carpets, but the basic plan of the complex followed the original *shoin* style of architecture. (Nishi-no-maru was again destroyed during a bombing raid in 1945.) In the early 1890's a completely traditional remodeling of the Heian Shrine in Kyoto was undertaken by Kigo Seikei (1844–1907), who had worked on the Nishi-no-maru project. Kigo, in collaboration with his student Itō Chūta (1867–1954), designed all of the principal buildings one sees today at the shrine. (Itō was also known for his interest in ancient architectural styles of India, an interest that paralleled Okakura's view of Asian art.) Purely Japanese styles and methods of construction were confined to restorative work from the mid-nineties on, as it became fashionable to use

Western methods of concrete and steel construction, even for temples and shrines (the Great Pagoda of Kongōbu-ji, at Kōya-san, is a notable example of this synthetic architecture).

By the 1890's Japanese architects were designing Western-style buildings on their own. The main office of the Bank of Japan in Tokyo, built in 1895, an Italian Renaissance-style structure of concrete and granite, is characteristic of the work of Tatsuno Kingo (1854–1919). Katayama Tōkuma (1854–1917) designed some of the most aesthetically satisfying Renaissance-style structures in Japan. He completed the national museums in Nara and Kyoto between 1892 and 1895, and in 1908 designed the Hyōkeikan (now the archaeological affiliate of the Tokyo museum). Katayama was also responsible for the Akasaka Detached Palace, built in Tokyo in 1909, which he modeled directly after Versailles.

SCULPTURE AND CRAFTS

With the advent of Meiji rule, Buddhist sculptors, who had received subsidies during the Tokugawa era, found themselves without a livelihood, for the new government placed its faith in science and social reform, and did not require religious icons. These craftsmen either turned to other occupations, or were reduced to making dolls, toys, carved animal souvenirs for foreigners, and the *netsuke* that appealed to countrymen and Westerners alike. Several guilds, with an eye to the foreign market, specialized in ivory or wood figurines done in a Western style but with Oriental subjects. The mercenary character of their enterprise did not prevent the artists from making works of very high quality, and those sent to the Chicago exhibition in 1893 were widely acclaimed. For the International Exposition in Paris in 1900, Asahi Gyokuzan (1843–1923) created a "Japanese Court Official" in exquisitely carved ivory that is a masterpiece by any standard.

Sculpture studies at the Western academy were directed by the Italian teacher Vincenzo Ragusa (1841–1928). Techniques of stone carving, clay modeling, and bronze casting were taught, and the Western custom of using a human model was quickly adopted. The Japanese students learned rapidly and made some excellent copies of statues of European statesmen and Greco-Roman goddesses. The use of local models did create a problem, for the combination of a Japanese in Western guise was rarely satisfactory. To both native and Western eyes, the sight of a Japanese woman taking the dramatic pose of a Winged Victory or of a Standing Venus was, to say the least, peculiar. A satisfactory compromise evolved that used a live model in creating formal portraits of Japanese statesmen, artists, and historical figures, and in informal studies of people from various walks of life.

CURRENT TRENDS

The Western imitation that began with the Meiji Restoration continues in painting and sculpture. European and American influences have replaced those of China that for centuries provided most Japanese artists with a point of reference. Japan's most striking contributions to international art have been in the medium of the twentieth century— cinema. Those who hope to see equal vitality and originality in other art forms are encouraged by recent interest in folk art *(mingei)*. In the architecture of the last two dec-

ades, and in the works of such contemporary artists as ceramists Kawai Kanjirō and Hamada Shōji, and printmaker Munakata Shikō, there is every promise that Japanese artists can draw from their rich Oriental inheritance while selecting the best of Western influences, and so create works of art that need no label to identify their homeland.

207. *Maki-e* box, by Shibata Zeshin (1807–91). L. 18.5 cm. (7.2 in.), w. 13 cm. (5.1 in.), h. 12.4 cm. (4.9 in.).

The herons on one side of this box are rendered in low silver relief on a gold-lacquered *(maki-e)* background, while the crows on the other side are in black lacquer relief, their eyes and the outlines of their feathers incised. Zeshin was the son of a sculptor, received training in lacquer techniques under the famed Koma Kansai (figure 60), and also studied painting. His superb craftsmanship and imaginative designs won him many commissions from the imperial household. Much of his work was made specifically for export. (See color plate 30.)

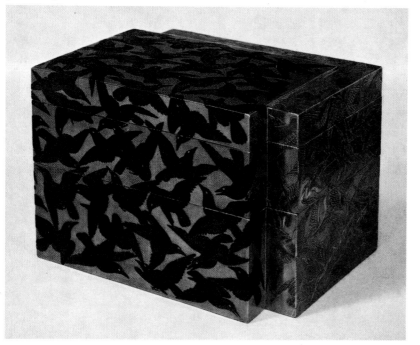

208. View of the Imperial Palace.
View looking west from the Hanzō-mon of the Imperial
Palace in the heart of sprawling Tokyo, showing some
of the palace grounds and city buildings in the dis-
tance.*

209. "Kannon, Bodhisattva of Compassion," by Kanō Hōgai (1828–88). Tokyo Art University. H. 196.7 cm. (77.1 in.), w. 86.4 cm. (33.9 in.).
Kannon (Avalokiteśvara), looking less masculine and a good deal more human than in earlier representations (Vol. I, figures 35, 192), is here shown standing in the sky, giving blessings to a baby inside a glasslike sphere, the symbol of all children about to be born in the world.*

210. "Deep Ravine," by Hashimoto Gahō (1835–1908). Tokyo Art University. H. 266 cm. (104.3 in.), w. 160 cm. (62.8 in.).
Gahō was a close colleague of Kanō Hōgai. Together they reformed Kanō painting and produced students whose works became the antithesis of the Western-style paintings then in fashion. Gahō was particularly concerned with creating a more explicit sense of deep space and volume in landscape painting than had ever been tried by Kanō artists. He borrowed concepts of perspective and shading from the Western paintings he abhorred, and applied these to the traditional landscape theme.

212 (right). "Rain and Mountains," by Yokoyama Taikan (1868–1958). Handscroll. H. 60.5 cm. (23.7 in.), w. 85.3 cm. (33.4 in.).
Taikan's early works have the same crisp imagery that his colleagues' works do, with Western "realism" the vehicle for Oriental themes. A trip to Europe seems to have convinced him, however, that descriptiveness in painting could be overdone. He immediately began to work with ink washes and with very generalized forms, maintaining that a painting was good only if it possessed "spiritual quality"—which he seems to have associated with the visual understatement of the kind seen in Chinese and Japanese *haboku* or "broken ink" painting (see Vol. I, figure 190).*

211. "Fallen Leaves," by Hishida Shunsō (1874–1911). One of a pair of six-fold screens. H. 157 cm. (61.6 in.), w. 362 cm. (141.9 in.).

The stillness of an autumn forest is suggested by an ingenious arrangement of trees, a carpet of leaves, and a solitary bird. The hair-fine clarity of depiction causes the screen's photographically true forms and colors, isolated against open spaces of paper, to seem tangibly real.*

213. "Ishiyama-dera in Moonlight, Autumn," by Imamura Shikō (1880–1916). Tokyo National Museum. H. 165 cm. (64.7 in.), w. 56.9 cm. (22.3 in.).*

214. Sketch for a portrait of Okakura Kakuzō, by Shimomura Kanzan (1873–1930). Tokyo Art University. H. 137 cm. (53.7 in.), w. 67 cm. (25.3 in.). The portrait Kanzan painted for the Ninth *Nihon Bijutsu-in* (Japan Art Institute) Exhibition in 1922 of his teacher, Okakura Kakuzō (Tenshin), was destroyed in the great earthquake of 1923. Kanzan had given this sketch to Langdon Warner (who had also been Okakura's student), but when he heard of the loss of the painting, Dr. Warner returned the sketch.*

215. "A Kyoto *Maiko*" by Hayami Gyoshū (1894–1935). H. 153.9 cm. (60.4 in.), w. 102.1 cm. (40 in.). The shallow space in which convincingly three-dimensional subjects in his paintings are forced to live suggests that Gyoshū may have been torn between Western and Eastern influences. This painting of a young *maiko* is typical of the minutely detailed vignette portraits he often did.

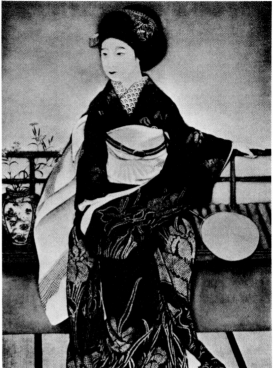

216. "Wang Chao-chün," by Yasuda Yukihiko (1884–1978). Color on silk. H. 87.5 cm. (34.3 in.), w. 55 cm. (21.6 in.).

Yasuda Yukihiko expresses the elegant nobility of Wang Chao-chün, a legendary beauty in the court of Emperor Yüan of Han dynasty China, with the combined use of rigid lines and the soft colors of the Kōrin-Sōtatsu style. Yukihiko emerged from the *yamato-e* tradition and was one of the second-generation followers of Okakura's Japan Art Institute loyalists. His studies in the classic arts of Japan were probably the cause for his interests in historical painting motifs.

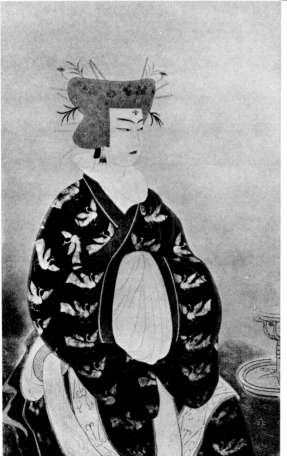

217. "Preparation," by Kobayashi Kokei (1883–1957). Tokyo National Museum. H. 173.5 cm. (68 in.), w. 108 cm. (42.4 in.).
This painting marks a high point in Kokei's career. The limitations the artist set for himself late in life of sharp line, clear color, and paper-thin forms produced paintings that recall the pale Buddhist icons of the fourteenth century, but whose subjects are those of genre and *ukiyo-e* masters.*

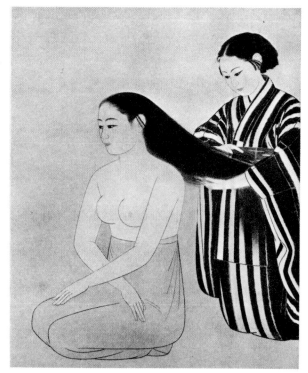

218. "Yoritomo in a Cave Hideout," by Maeda Seison (1885–1977). Two-fold screen. H. 191 cm. (74.8 in.), w. 278.7 cm. (109.3 in.).
Maeda Seison was experimenting with historical themes, as shown in this illustration of Minamoto-no-Yoritomo, founder of the twelfth-century Kamakura military government, and his followers, when this screen appeared in the sixteenth exhibition sponsored by the Japan Art Institute in 1929.*

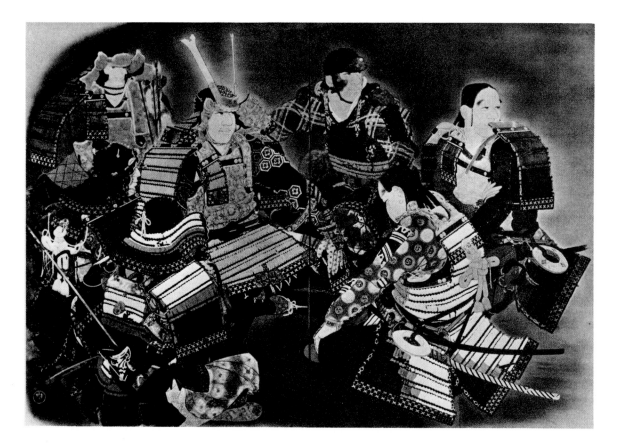

219. "Autumn Willow," by Murakami Kagaku (1888–1939). Detail. H. 22 cm. (8.6 in.), w. 53.8 cm. (21.1 in.).

Murakami Kagaku is perhaps best known for his paintings with Buddhist themes and his landscapes. Trees are prominent in many of his works, as here where the entire picture space is utilized to provide a view into the depths of a willow. A maze of lines perfectly descriptive of branches found alternately in sunlight, shadow, and haze and either near or far away creates an image that seems to pulsate, to flow with the rhythmic energy of life and growth.*

220. "The Colors of Rain," by Kawai Gyokudō (1873–1957). H. 88 cm. (34.5 in.), w. 117 cm. (45.9 in.).

All the elements of an autumn day in the country—the farmhouse, waterwheel, shocks of grain, umbrella-carrying figures, and mist-shrouded trees—are brought together to enliven this composition with the colors and mood of the season. Touches of sentimentality and a display of skillful draftsmanship are kept at a minimum, so that the pastoral landscape by itself can offer an appeal.*

221. "After the Rain, Sunshine," by Takeuchi Seihō (1864–1942). One of a pair of six-fold screens. H. 161 cm. (63.1 in.), w. 342 cm. (134.1 in.).
In his early years, before color became a strong force in his work, Seihō was painting in light tones of ink and with a "realism" he espoused as one of Goshun's most illustrious Shijō-school descendants (see figure 127). Seihō was the patriarch of Kyoto painting for much of his long life and went through many different styles, trying all the time to maintain the reputation he had for not following rules.*

222. "Spring Field," by Asai Chū (1856–1907). National Museum of Modern Art, Tokyo. H. 55 cm. (21.6 in.), w. 73.7 cm. (28.9 in.).
Asai Chū established the Meiji Art Society, the first organization of Western-style painting in Japan, in 1889. This painting, which was exhibited in the same year at the society's first exhibition, is basically dark brown with paint applied thickly. The rustic theme and heavy colors were traits inherited from the style of Antonio Fontanesi, Asai's teacher.*

223. "By the Lake," by Kuroda Seiki (1866–1924). The National Cultural Property Research Institute, Tokyo. H. 68 cm. (26.7 in.), w. 83 cm. (32.5 in.).
This most familiar of Western-style paintings by a Japanese artist was designated an Important Cultural Property in 1967. Although the introduction of Japanese subject matter probably has a great deal to do with how Kuroda's paintings are received today, his French training was strong enough so that even that did not change his style in any appreciable way. The paintings most immediately brought to mind by this portrait of a young Japanese woman are not the *bijinga* of *ukiyo-e* masters, but the figure studies of a conservative devotee of French Impressionism like Kuroda himself, the American Mary Cassatt (1845–1926).*

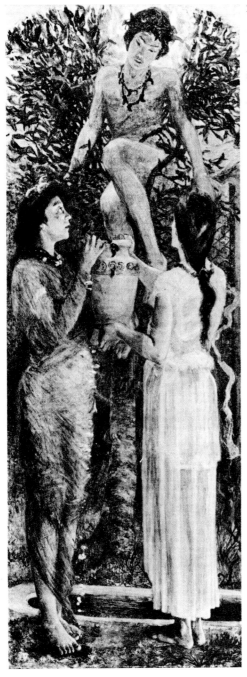

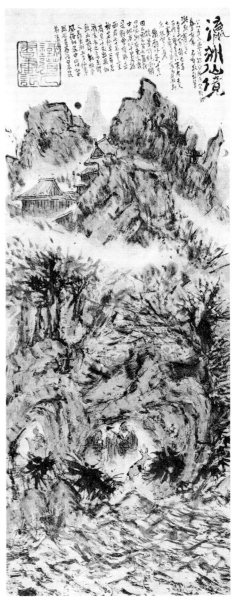

224. "Shrine of Harmonies," by Aoki Shigeru (1882–1911). Oil on canvas. Bridgestone Gallery, Tokyo. H. 181 cm. (71 in.), w. 71.4 cm. (28 in.).
Although the twenty-year-old artist of this painting, Aoki Shigeru, did not leave Japan and may never have seen a real Pre-Raphaelite painting, the sentiment of the drawing, the use of color, and, above all, the decision to include an Oriental (and vaguely satyresque) young man in the composition, seem amazingly in accord with Pre-Raphaelite ideals.*

225. "Realm of the Chinese Immortals," by Tomioka Tessai (1836–1924). H. 132 cm. (51.8 in.), w. 53 cm. (20.8 in.).
Tomioka Tessai was the last and in some ways the most interesting Japanese literati painter. His style was Chinese, and yet the persistent emphasis on surface texture running through his works from first to last fairly shouts artistic independence, making it clear that Tessai felt deeply the necessity for the personal interpretation of literati themes. (See color plate 31.)*

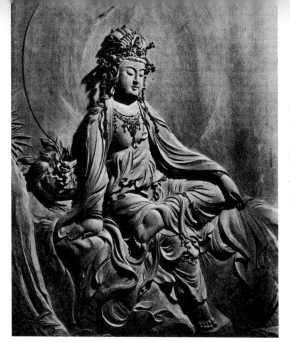

226. "White-robed Kannon," by Ishikawa Kōmei (1852–1913). Detail. Wood relief-carving. Tokyo National Museum. H. 63.9 cm. (25.1 in.), w. 109.8 cm. (43.1 in.).

The creator of this highly elegant version of Kannon was born into a family of professional sculptors living at Asakusa in Edo. He was given lessons in Kanō painting along with his daily training in the family workshop, and eventually became a specialist in ivory carving at the Tokyo School of Fine Arts. It was this example of his work in wood, however, that was sent to the Chicago International Exhibition in 1893.

227. "Monkey," by Takamura Kōun (1852–1934). Wood. Tokyo National Museum. H. 90.9 cm. (35.6 in.).

Kōun was born in the same year and in the same area of Edo as Kōmei. As a boy he was apprenticed to a Buddhist sculptor, and in 1889 began teaching at the Tokyo School of Fine Arts. His portrait of a monkey, which was widely acclaimed at the Chicago Exhibit in 1893 for its stark realism, is stylistically related to similar works among the decorative sculptures at Nikkō, although the idea of isolating in this way a minor item from some larger sculptural context was unusual, and should be seen, perhaps, as a genuflexion towards Western concepts.

228. "Japanese Court Official," by Asahi Gyokuzan (1843–1923). Ivory. Imperial Household. H. 60 cm. (23.5 in.).

Asahi Gyokuzan was a Buddhist priest in Asakusa who was known locally for his uncannily realistic ivory carvings of human skulls until he turned to more ambitious artistic undertakings and began teaching at the Tokyo School of Fine Arts. His figurines show an equal regard for fidelity to natural appearances (and a breathtaking use of materials that verges on the miraculous), but one feels that this has not been the sole aim for Asahi any more than for, say, Houdon, the early nineteenth-century French master of rococo sculptural style whose works Asahi may have known. The "Court Official" was intended for the Paris Exhibit of 1900 but was not completed in time.

229. Porcelain jar with overglaze decoration, by Tomimoto Kenkichi (1886–1963). National Museum of Modern Art, Kyoto. D. 23.6 cm. (9.3 in.), h. 18.3 cm. (7.2 in.).

Tomimoto Kenkichi was perhaps the first Japanese potter to assume the stance, now commonly accepted, of the "potter as artist." He started out making low-fire Raku ware, but came to specialize in porcelains, perfecting along the way a beautiful cobalt-blue underglaze and some unusual overglaze enamels. The technique he developed for firing gold and silver simultaneously was particularly successful. On this jar Tomimoto chose a brilliant red overglaze as background for the gold and silver design. The vessel's refined shape and intricate decoration are typical of Tomimoto's later works.*

230. Large platter, by Hamada Shōji (1884–1978). National Museum of Modern Art, Kyoto. D. 57 cm. (22.4 in.), h. 15.2 cm. (6 in.).

After Hamada Shōji settled in the pottery village of Mashiko north of Tokyo in 1924, he continued to work in the folk-pottery tradition of the area until his death. Mashiko ware is characterized by a thick, high-fire gray earthenware body and heavy applications of iron-bearing glazes. On this large platter Hamada trailed free arcs of black over a tan *namako* glaze ground, producing a work of great simplicity, movement, and power.*

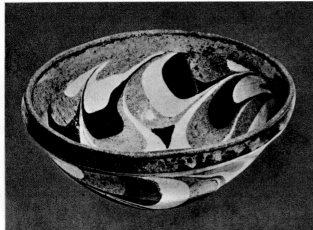

231. *Neriage* bowl, by Kawai Kanjirō (1890–1966). D. 16.5 cm. (6.5 in.), h. 7 cm. (2.7 in.).

Kawai Kanjirō lived and worked in Kyoto, but he always considered himself a provincial *mingei* potter. This small bowl is a work of his youth, before he began experimenting with superimposed glaze designs and mottle forms. Here his use of the *neriage* technique (in which coils or slabs of colored clay are combined) resulted in bold designs of color that emphasize the bowl's basically simple form.*

232. Olympic gymnasiums, designed by Tange Kenzō. 1964.

The photograph shows in the foreground two mammoth gymnasiums, in which swimming events and basketball games of the 18th Olympiad took place, and the compounds of the Meiji Shrine, which enshrines Emperor Meiji, in the background—a contrast of the traditional and the contemporary: a common sight in present-day Japan. Professor Tange of the University of Tokyo, who designed the gymnasiums, is a leading Japanese architect.

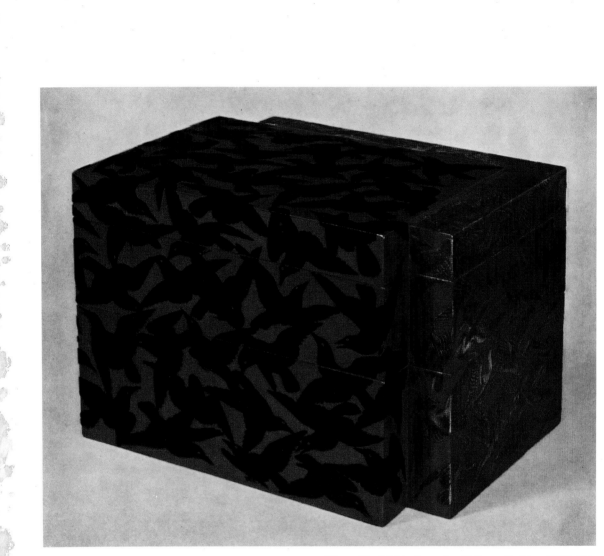

Plate 30. *Maki-e* box, by Shibata Zeshin (1807–91). (See also figure 207.)

Plate 31. "Realm of the Chinese Immortals," by
Tomioka Tessai (1836–1924). (See also figure 225.)

THE ARTS OF JAPAN

SUPPLEMENTARY NOTES

Notes are numbered to correspond with the captions that they supplement.

1. *Azuchi Castle* (安土城址).

The immense *tenshu-kaku*, according to various documents, consisted of storage space surrounded by a massive stone supporting wall on the ground floor, residential quarters with wall paintings (mostly *fusuma-e*) by Kanō Eitoku and his followers on the second, third, and fourth floors, an attic on the fifth floor, an octagonal sixth floor with red lacquered pillars and gilded walls and ceilings, and an eighteen-feet-square room on the seventh floor that was covered inside and out with gold leaf. The walls, pillars, and ceilings of all the rooms were profusely decorated with paintings and carvings. Azuchi Castle served as the model for castles built by military leaders who succeeded Nobunaga, with monumental *tenshu-kaku*, the symbols par excellence of military authority. In the field of painting, Azuchi marked the beginning of the decorative wall paintings, which, from that time on, became an integral part of military, palatial, and religious architecture.

2-6. *Himeji Castle* (姫路城).

A castle was built on this site on the slopes of the mountains Sagi-yama and Hie-yama in 1346, and expanded by Toyotomi Hideyoshi in Momoyama times as part of his military stronghold in southern Honshū. After the battle at Sekigahara in 1600, which turned the tide in favor of Tokugawa Ieyasu, the feudal lord Ikeda Terumasa was placed in charge of the castle. Terumasa expanded the castle and, according to documents located when repairs were conducted recently, it is judged that the major *tenshu-kaku* was constructed during 1608 and 1609. Further renovations were made by Honda Tadamasa, a close associate of the Tokugawa family who was placed in charge of the castle in 1617. The castle is provided with drawbridges, and the winding passageway leading from the front gate to the major *tenshu-kaku* goes through ten gates bordered by massive stone and clay walls.

The exteriors of the buildings, except for the roof tiles, are painted white. Many of the original buildings were subsequently destroyed at the time of the Meiji Restoration in 1868, and the existing structures in the three precincts of the castle compound have undergone extensive restoration in recent years. Nevertheless, the orientation of the castle today, consisting of four *tenshu-kaku* and heavy surrounding walls, retains all the essential features of the original fortress, including an exterior that is visually impressive from almost any vantage point.

7. *Original stone wall of Osaka Castle* (大阪城の石垣).

The interiors of walls surrounding Japanese castles were filled with stone and gravel to insure proper drainage, while the outsides were faced with large stones stacked one on top of the other without the aid of cement or other adhesives. Today, even with the thousands of laborers and advanced modern methods that such projects would require, the total lack of skill and experience needed to build walls of this kind make their reconstruction virtually impossible. This expanse of wall surrounding Osaka Castle has withstood over three centuries of wars and natural disasters.

9-10. *Nagoya Castle* (名古屋城).

The construction of Nagoya Castle was begun in 1610 by order of Tokugawa Ieyasu, the founder of the Tokugawa shogunate. Feudal lords contributed equally to the project in proportion to the size of their annual income. A most striking feature of the castle is the use of golden dolphins on top of the gables of the uppermost roof of the *tenshu-kaku*. The construction of the great stone foundation was supervised by Katō Kiyomasa, a famous warlord who applied methods he had learned from a study of Korean architecture during the Korean expeditions of 1592 and 1597.

The main *tenshu-kaku* is five stories high, has a basement, and is surrounded by smaller towers. The tips of the eaves of these buildings show a prominent upward curve. Besides the crenels

on the battlements, which are disguised so that they do not show from the outside, other defensive measures are built in and cleverly hidden from view, making each of the buildings a self-contained haven of safety. In his desire to have an invincible military stronghold at Nagoya, which was of great strategic importance on the road between Kyoto and Edo, Ieyasu may have been less concerned with artistic effect (there is no question but that Nagoya Castle was more effective as a fortress than Himeji Castle, for example). Still, Nagoya Castle was meant to express the authority of the ruling Tokugawa family, and the very best materials went into its construction. The main residential area of the castle, the *hommaru*, which has been destroyed by fire, was especially representative of palatial castle architecture of the time.

11. *Matsumoto Castle* (松本城).

This stronghold was originally called Fukashi Castle, after the name of the area during the medieval period, and was in the possession of the Ogasawara clan. In 1590 Ishikawa Kazumasa, a feudal lord, was given custody of the area by Hideyoshi, and the present castle was begun. Ishikawa Yasunaga, Kazumasa's son, completed the remodeling of the castle around 1597, with *ishiotoshi* ("rock-dropping") platforms and crenels distributed cleverly and effectively around the sides of the walls. Later, in 1633, Matsudaira Naomasa, a feudal lord in the ranks of the Tokugawa shogunate, added more buildings to the compound. The extant structures include the five-story *tenshu-kaku* and a few small buildings.

When the Japanese borrowed Chinese architectural forms (e.g., Buddhist temples) they modified them little, if at all, often to the extent of retaining the Chinese preference for absolute symmetry. The effect created by the asymmetric arrangement of forms in Japanese castles was thus always noncontinental. But Matsumoto Castle, with its simple forms and severe contrasts of light and dark, is, of all examples of castle architecture, the one in which native tastes are most apparent.

12. *Hikone Castle* (彦根城).

This castle was constructed by Ii Naokatsu, a leading figure in the Tokugawa shogunate, in 1606 (Keichō 11). Tradition has held that the *tenshu-kaku* was built with parts from a castle in nearby Ōtsu, a castle that had been built during the Tenshō era (1573–92). Recent investigations have revealed that most of the interior of the *tenshu-kaku*, including pillars and windows, shows signs of having been previously used, which lends considerable weight to the theory that parts were brought from Ōtsu. Some architectural remnants have also been preserved at Hikone that even make it possible to suggest that the first structure was a five storied castle and that the present three-story arrangement of Hikone Castle is simply a cut-down version of the original.

On the other hand, the exterior of the *tenshu-kaku* seems to have been original in 1606, so that to conclude that the architecture is representative of Tenshō style is untenable. What Hikone lacks in grandeur due to its lessened height is fully compensated for by superb workmanship and design. Bell-shaped windows derived from Zen Buddhist architecture of the Kamakura period are beautifully incorporated into the upper two stories. The combination of hipped-gable *(iri-omoya)* and Chinese curved gable *(kara-hafū)* roofs is unusually effective and was probably one of the first models for the similar roof arrangements of castles at Himeji, Uwajima, and elsewhere.

13. *Nijō Castle* (二条城).

Nijō Castle was first used by Ieyasu in March 1603, when he visited Kyoto after his victory in the Battle of Sekigahara. It is assumed that at least a portion of the construction of the castle was completed by this time. The *ni-no-maru*, an area of the castle comprised of a series of palatial audience halls and chambers, was constructed between 1624 and 1626 for the occasion of a visit by Emperor Gomizunoo. Records also state that at that same time renovations of other buildings were made and the *tenshu-kaku* of Fushimi Castle was moved to the site, and placed in the *hommaru* area. Later, in 1628, the buildings in which Emperor Gomizunoo had been recieved were moved from the castle and presented to the emperor for his *sentō-gosho*, or retirement palace. Likewise, other buildings were gradually transferred to other places, leaving only the *hommaru* and portions of the *ni-no-maru* buildings intact. In 1750 the *tenshu-kaku* was destroyed by lightning and fire, and in 1788 the majority of the *hommaru* burned to the ground, thus leaving only the *ni-no-maru* and the main east and north gates standing. Nijō is also the place where Yoshinobu, the fifteenth Tokugawa shogun, resolved to restore political control of Japan to the emperor, thus ushering in the Meiji era and the modernization of the country. It was originally not called a castle, but was referred to as a mansion or villa, and certainly its features today are more appropriate to these designations.

14. *Uto Tower, Kumamoto Castle* (熊本城宇土櫓).

The straight lines of the roof, simple rectangular windows covered with latticework panels similar to the heavy rain-doors of the most common Japanese house, black frame walls—these are relatively unambitious, provincial features that place Kumamoto Castle in the tradition of medieval fortresses in which defense and not architectural beauty was the prime consideration. The architect of this castle, Kiyomasa (whose other castle designs are among the most forward-looking, even to the extent of incorporating palatial residences in their plans), was in this case obviously working in an older style that is representative of the sturdy, unostentatious castles built far away in the prov-

inces. Most of the castle was burned in 1877 during the Seinan incident in which government forces held this stronghold against an attack launched by the rebel army under Saigō Takamori. This tower *(yagura)* and a few other structures, including gates and stone walls, are the only remaining portions of the castle. The three-tiered, five-story construction was placed on an immense stone wall at one corner of the castle compound. The name Uto comes from the fact that Kiyomasa is said to have used in this tower parts of the *tenshu-kaku* of the castle built in the 1580's at the nearby village of Uto by Konishi Yukinaga, who, like Kiyomasa, was a veteran of Hideyoshi's Korean campaigns and had studied Korean castle architecture.

15. *Screen showing Juraku-dai* (聚楽第図).
Since in the picture the mansions of the Maeda and Gamō families are represented in the place where the temples of Hyakuman-ben and Seigan-ji stood until 1591, it seems feasible to date the screen between that year and 1595, the year Juraku-dai was dismantled or destroyed. The painter is not known, but judging from the consistently *yamato-e* color scheme, depiction of buildings, and manner in which trees and figures are drawn, it seems likely that he was a member of the traditional Tosa school connected with the painting academy of the court.

16–17. *"Views of Kyoto"* (Rakuchū-rakugai) (洛中 洛外図).
The naiveté with which these screens are painted is quite different from the distinctive mannerisms of either the traditional *yamato-e* style associated with Tosa artists in the Imperial Academy or the style of painting done by the Kanō school, which was officially supported by the shogunate and the military class. The artist may have been one of the many townsmen painters who began to prosper in Kyoto and other urban centers during the last years of the sixteenth century. The surface of the painting on these screens has been damaged slightly by fire and some of the pigment has flaked off. There is also evidence in the lower passages of repainting.

18. *The* ni-no-maru *of Nijō Castle* (二条城二の丸).
The buildings of Nijō Castle's *ni-no-maru* are representative examples of *shoin-zukuri*, a style of architecture that originated in Zen temples built during the Muromachi period. The principal room of a building of *shoin-zukuri* features a *shoin* (a type of bay window with low window ledge that can be used as a writing desk), *tatami* (straw mat) floors, sliding doors *(fusuma)*, an alcove with shelves *(chigai-dana)*, and a large recessed wall space for displaying paintings *(tokonoma)*. This arrangement has proved to be quite popular and is today the usual one seen in any "Japanese-style" room. The *shoin-zukuri* concept at Nijō is, however, carried to a palatial extreme, with the rigid rank-

ing and class system within samurai society expressed in architectural terms. The first building from the gate was the waiting room for emissaries, while the second room, the *shiki-dai*, was a reception hall for minor dignitaries. The next two buildings, the *ōhiro-ma* and *kuro-shoin*, were most important, for in them were received guests of highest military rank. The group of rooms in the very rear were residential quarters. Records indicate that the *ni-no-maru* was entirely rebuilt around 1626 when Emperor Gomizunoo visited the castle, but it is assumed that the new buildings were merely more elaborate versions of the originals constructed as part of Tokugawa Ieyasu's Kyoto residence in 1603. Presumably the buildings from Nijō that were subsequently presented to the court in 1628 were similar to these in the *ni-no-maru*.

19. *The principal* jōdan-no-ma *of Nijō Castle* (二条城二の丸上段の間).
The *tokonoma* and *chigai-dana* are located on the far wall in the illustration, with the *shoin* out of the photograph on the left. The *chōdai-kamae*, a series of decorative in-the-wall doors, can be seen on the right wall directly adjacent to the *chigai-dana*. It seems that these doors orginally formed the entrance, between a *tokonoma* and *chigai-dana*, to the private bedroom of a lord. This is the arrangement, at least, of the *shoin*-style apartment at the Kyoto temple of Reiun-in, Myōshin-ji, which tradition says was used by Emperor Gonara (second quarter of the sixteenth century) when visiting the temple. The doors of the *chōdai-kamae* later became purely decorative, and although the room behind them was retained and used as a storeroom (or, as at Nijō, as a hiding place for armed guards), the stationary doors, framed in fine wood and embellished with paintings, gold fittings, and scarlet tassel pulls, were merely auspicious reminders of their original important function.

20. *Nishi Hongan-ji* (西本願寺).
The "Long Desired Temple" (Hongan-ji) built in 1272 by the nun Gakushin, the daughter of the founder of the Shin sect of Buddhism, Shinran (1173–1262), was originally located at Yoshimizu in Kyoto where the large temple of Chion-in stands today. In the fifteenth century, during the lifetime of its eighth-generation priest, Rennyo, the sect became quite popular with the general public; before 1500 an increasing number of believers had made it necessary for the temple to be relocated many times. The prosperity of the sect was assured in 1591 when its leaders received the present site (a gift of about eighty acres, originally) from Hideyoshi. Later, while building plans were under way, Ieyasu determined to block the growth of the sect by ordering its division. Two temples grew up side by side: one on the east, Higashi Hongan-ji (also known as the Ōtani branch), and the other on the west, Nishi Hongan-ji. (The

buildings of the former temple were all destroyed before Meiji times and subsequently rebuilt.) After a fire that leveled Nishi Hongan-ji in 1617, the sect made do with temporary structures until after the completion of an entirely new complex built between 1630 and 1657. Of the extant monuments built at that time, the *taimensho* (also called *ōhiro-ma* and *kō-no-ma*) and the *shiro-shoin* ("white" *shoin*) are the oldest and most impressive.

For many years it has been thought that these two buildings were originally part of Fushimi Castle and had been brought to Nishi Hongan-ji in about 1635. Results of their investigation and restoration by the government in 1959 gave no evidence, however, of the buildings ever having been used before, but proved rather that they were built for the first time in their present location in the 1630's, and, further, that they were originally independent structures and not joined together as they are now. The paintings on the walls of the *taimensho* (and in the rooms adjoining it on the west) and the paintings in the three main rooms of the *shiro-shoin* have been attributed in modern times to various Kanō masters. At least two eighteenth-century accounts attribute all of them to one Hasegawa Ryōkei, an artist who is thought to have been adopted into the Kanō family in the seventeenth century. It should also be noted that the paintings of the *shōzoku-no-ma* (a small dressing room joining the *shiro-shoin* on the east, which may have originally been part of the 1657 *kuro-shoin*) are not mentioned in early records.

Of the other architectural monuments at Nishi Hongan-ji, the Nō stage of the north garden was built in 1581, the Daishi-dō (Goei-dō or Shin'ei-dō) in 1636, the Nō stage of the south garden in 1694, and the *hondō (amida-dō)* in 1760. The *karamon* and *shikidai-no-genken* may possibly have been brought to the temple from Fushimi Castle and the Hiunkaku from Juraku-dai during the construction project of the 1630's. Before the celebration in 1772 of the sect's 500th anniversary, buildings underwent several restorations.

21. Karamon *of Hōkoku Shrine, Kyoto* (豊国神社唐門).
This gate was moved to Hōkoku Jinja, when the shrine was reestablished during the Meiji era (1868–1912), from Konchi-in, a subtemple of Nanzen-ji, where it was used as the entrance gate *(onari-mon)* for the emperors' visits. Temple records state that the gate was acquired from Fushimi Castle when the latter was dismantled in 1622 by order of the Tokugawa shogunate. But according to the diary of the priest Honkō Kokushi (Sūden, d. 1633), it was the *karamon* of Nijō Castle that the temple acquired for an imperial visit that took place in 1627. There is still the possibility that the gate was first erected at Fushimi in 1592 and later moved to Nijō Castle in the seventeenth century. From the standpoint of the bold

designs and somewhat primitive workmanship of the relief sculpture on its doors, its massive *kaerumata,* and the simple but dramatic combination of the hipped-gable and *kara-hafū* forms in its roof, the Hōkoku *karamon* is representative of castle gates made in the initial stages of the Early Modern age.

22. *"Sun and Moon" landscape* (日月山水図).
These unusual screens have been variously dated anywhere between about 1400 to 1700. The use of brightly colored landscape screens is known from earlier times, particularly in such secret Shingon rites as priest or Bodhisattva ordination and anointment *(abhisecana).* The screens from Jingo-ji near Kyoto and Kongōbu-ji at Kōya-san are rare medieval examples. Similar screens seem also to have been painted for Shinto ceremonies and as offerings to Shinto shrines. One such screen, not extant, is recorded as having been painted by Fujiwara-no-Yukihide, an artist in the painting academy of the Kasuga Shrine in Nara during the early fifteenth century. His scroll painting of the *Yūzū Nembutsu Engi* in Seiryō-ji, Kyoto, is typical of late *yamato-e* style, with which the Kongō-ji "Sun and Moon" screens have much in common. Their design is strikingly close to the patterned landscape areas found in such scrolls as the fourteenth-century *Kasuga Gongen Genki-e* now in the Imperial Household Collection.

Color, gold, silver, and gesso on paper.

23. *"Cypress Trees"* (Hinoki) (伝永徳筆檜図).
In the records of the Katsura-no-miya family it is mentioned that *hinoki* were the subjects of some of the wall paintings and *fusuma-e* in the palace of the Sanjō-no-miya family. It has long been supposed that the painting above is a fragment from the sixteenth-century Sanjō palace. In remounting it as a large eight-fold screen the tops and sides and other parts of the painting were cut, making the monumental size of the trees, which are so close in the immediate foreground that they seem to be pressing against the surface of the picture, all the more obvious.

Color and gold on paper.

24. *"Fantastic Lions"* (Karashishi) (永徳筆唐獅子図).
The signature on this painting that reads, "Kanō Eitoku *hōin hitsu*," was written by Kanō Tan'yū in the seventeenth century, thus leaving little doubt as to the painting's authenticity. Kanō Einō, in his *Honchō Gashi* published in 1693, was delighted with what he called the "grotesqueness" *(kaikai-kiki)* of Eitoku's completely original style, which he associated with free, rough brushstrokes. Einō also comments on Eitoku's predilection for working on a grand scale, with large trees "sometimes stretched out over two hundred feet" of wall space and human figures painted nearly life-size.

Color and gold on paper.

25. *"Pheasant and Plum Tree"* fusuma *of Tenkyū-in, Kyoto* (天球院 梅に雉子図).

The temple of Tenkyū-in was built in 1631 by a daughter of Ikeda Nobuteru (as a nun she was known as Tenkyū-in). For many years the *fusuma* paintings decorating its three main rooms were attributed to Kanō Sanraku. In 1929, in an article he wrote for *Tōyō Bijutsu* concerning the paintings attributed to Sanraku at Daikaku-ji, Tsuchida Kyōson, an economics professor at Kyoto University whose study of Momoyama paintings forms the basis for such studies today, reasoned on stylistic grounds that the paintings at Tenkyū-in were by artists in Sanraku's immediate circle and possibly by Sanraku himself. He said in summary that they echo Momoyama tastes but lack the "vigor of that period" and show instead the "calm beauty that one finds in early Tokugawa paintings." One of Tsuchida's former students, Doi Tsugiyoshi, and Yamane Yūzō have in recent years made a case for all of the Tenkyū-in paintings being by Sansetsu, except for a painting of an "Old Pine" that Yamane found behind the main altar and that both scholars agree may be by Sanraku. Sansetsu, who was born in Kyūshū, was Sanraku's son-in-law and legal heir.

26. *"Maple Tree"* fusuma *of Chishaku-in, Kyoto* (等伯筆楓図).

For at least fifty years prior to 1930 the paintings at Chishaku-in were considered Eitoku's masterpieces or else early paintings by Sanraku. In that year, in a *Tōyō Bijutsu* article, Tsuchida Kyōson was "quite alone" in attributing them to Hasegawa Tōhaku, an attribution that was made as early as the late eighteenth century in *Miyako Rinsen Meishozu-e* but which later was dropped, possibly in Meiji times, when "Eitoku became famous, as it were." It was Tsuchida, also, who made the association between the Chishaku-in work and Shōun-ji (see caption 26). Since Tsuchida's time scholars have unanimously accepted the Tōhaku label for the Chishaku-in paintings, adding only that the "Cherry Tree" panels and others may be by Tōhaku's son, Kyūzō. The idea for this may have come from an earlier article of Tsuchida's in which he contrasts the *fusuma* paintings at Myōren-ji with those at Chishaku-in, and suggests that the former, which have a "certain weakness for minutiae," may be by one of Tōhaku's sons, Kyūzō or Sōya.

27. *"Plum Tree and Tree Peonies"* (友松筆梅に牡丹図).

Yūshō's use of gold leaf is also unique since instead of eliminating space it is best read as limitless space, a sun-filled natural setting for trees and flowers. The fact that two unknown painters, Yūshō and Tōhaku, were allowed to compete with government-supported Kanō artists suggests that in the new military society an individual's capabilities were recognized and rewarded accordingly. On each of these screens are the signature, "Yūshō-hitsu," and two seals reading "Kaihō" and "Yūshō." On the basis of certain diaries, including the *Kaihō Yuisho-ki,* it seems that Yūshō, who was a military man's son, may have assumed the role of painter and lay Buddhist priest with strong misgivings, and, before his death, to have blamed himself for not following in the family's military tradition. At forty-one he was in the service of the abbot of Tōfuku-ji, and his association with the other leading Zen temples in Kyoto, including Myōshin-ji, has resulted in most of his paintings being owned by those temples today. His tombstone, however, is located on the grounds of the Tendai-sect temple of Shinnyō-dō in Kyoto.

28. *"Crows on a Plum Tree"* fusuma (伝等顔筆梅に鴉図).

These four *fusuma* paintings are thought to have been part of the interior decoration of Najima Castle at Fukuoka in northern Kyūshū, a castle that was built by Kobayakawa Takakage in the late sixteenth century. Kuroda Nagamasa was given the castle in 1600 and the paintings have been in the Kuroda family since that time. The attribution to Tōgan is based on the knowledge that after about 1590 the artist was in neighboring Yamaguchi in the service of the Mōri family, and, further, that the painting of crows became something of a specialty of Unkoku-school artists in the seventeenth century. Tōgan himself is known best as a painter of Chinese landscapes, however, and it should be noted that many Japanese scholars feel that, on the basis of style, the *fusuma* paintings in the Kuroda Collection are closer to paintings by Yūshō.

29–32. Kōdai-ji maki-e (高台寺蒔絵).

The stationery cabinet and saké pitcher of figures 29 and 30 are two of approximately thirty pieces of lacquerware that were among the household furnishings of Hideyoshi and his wife Kita-no-Mandokoro. The entire cabinet, including the ends of its ten drawers and its close-fitting outer case, is covered in black lacquer over which a bold design of autumn plants has been rendered in various textures of gold. An elegant handle on top of the cabinet protrudes through a slit in the outer case, thus making it easily portable. Pieces of *kōdai-ji maki-e* are often cited as typical Momoyama lacquerware, although in fact they are made with a technical precison that seems more characteristic of later *maki-e*. However, in the tendencies for designs to completely cover the objects and for there to be a total lack of restraint in the grouping of masses of flowers etc., and since none of the designs are rendered in the high relief so popular with later designers, *kōdai-ji maki-e* does possess the major Momoyama traits. The combination of ceramic and lacquer in the spice container set of figure 31 is typical of the freedom with which artists experimented with untried techniques in this period.

33. *Interior of the Sanctuary* (tamaya) at *Kōdai-ji* (高台寺霊屋内陣).

Parts of older buildings built for Hideyoshi, Fushimi Castle in particular, are said to have been incorporated into the structures of this temple, of which five still exist: the entrance gate *(omotemon)*, a covered bridge and walkway known as the Kangetsu-dai, the sanctuary *(tamaya)*, the founder's hall *(kaizan-dō)*, and two unusual tea houses, Karakasa-tei and Shigure-tei. Inside the sanctuary and flanking the main altar are two miniature shrines *(zushi)* housing the wooden statues of Hideyoshi (on the right) and Kōdai-in (Kita-no-Mandokoro; on the left). The *zushi* and the central altar are completely covered with *maki-e*. The doors of Hideyoshi's *zushi* (partially visible in the photograph) are decorated with pampas grass designs on the front and maple branches and chrysanthemums on the back; the paulownia crest of the Toyotomi family is repeated within the open spaces of the design. The doors of Kōdai-in's *zushi* are similarly decorated with pine and bamboo designs. The bannisters and pillars of the altar are decorated with flutes, drums, lutes, and other musical instruments, and the steps leading up to the altar have designs, also in *maki-e*, of small floating rafts and flowers. Inscriptions rendered in fine gold characters, reading "December 5, 1596" and "made by Kōami Kyū," have been found in the decoration. Also, the names "Shinjirō" and "Iemon" in ink were discovered on one of the bannisters. Kyū is the abbreviation of Chōan Kyūjirō, the seventh-generation successor of the Kōami family, and Shinjirō was his third son, thus substantiating the tradition that the *maki-e* of the *zushi* and altar of the sanctuary is the work of Kōami craftsmen (see note 59). The paintings inside the *zushi* and elsewhere in the sanctuary were done by seventeenth-century Kanō artists.

35. Dōbuku (伝秀吉所用辻が花胴服).

In making a *tsuji-ga-hana* reserve pattern, the motif is first stitched with thread and then firmly tied and the material dipped in dye. It was this process that created the patterns on the shoulder and hem portions of the *dōbuku* illustrated here. The positive designs in the midsection had to be done individually, with each color dipped (or possibly painted) separately and the background protected by heavy stitching. It is truly remarkable that the application of this process to such a difficult design was successful, and also that the colors have remained fast over the years.

36. Uchikake (打掛).

This *uchikake* is preserved at Kōdai-ji along with other clothing and accessories used by Kita-no-Mandokoro. The entire garment is covered with hexagonal tortoise-shell patterns filled with abstract flowers, a design that was rendered by means of the painstaking *nuihaku* technique. A stylized shoreline pattern is worked over the light-green

ground in purple and blue thread, and the outlines of the tortoise-shell patterns are filled with silver leaf. At first glance the design appears to be actually woven into the silk, which was the desired effect, since the aim of the craftsman here seems to have been to imitate Ming embroidery and brocade. This is not only a technical distinction, but a stylistic one as well: the floral designs of the garment in figure 34 are equally dense, but they are contained within independent squares of material that have been sewn together (a peculiarly Japanese solution), whereas the allover design of the Kōdai-ji *uchikake* is itself Chinese inspired.

37. *Matching sword set* (朱塗金蛭巻大小拵).

In the late sixteenth century, infantry fighting in units using Western-style rifles and lances made the long and heavy sword *(tachi)* of earlier times (which was worn blade down and suspended from the left side of the body) an inconvenience. In place of them, military men took to wearing two smaller swords, the *uchigatana*, a sword worn with the blade up and tucked under the sash, and a *wakizashi*, or accompanying short sword. By the end of the seventeenth century swords were largely ceremonial, but the quality of their materials and designs remained high.

38. *"Maple-viewing at Takao"* (秀頼筆高雄観楓図).

One seal in the lower left corner of the screen reads "Hideyori." There is little biographical information about Hideyori available. He may have been Kanō Motonobu's second oldest son (although Shōei is usually so designated). He was called Jōshin (which is written three different ways in three different accounts), and died at age forty-seven, or, according to the records of the Nakabashi line of the Kanō school in Edo, at seventy-three. His fame derives solely from this one painting.

39. *"Amusements under the Cherry Trees"* (長信筆花下遊楽図).

Seals reading "Kyūhaku" and "Naganobu" are on each screen. Naganobu, the fourth son of Kanō Shōei is reported to have been placed first under the care of the Honkyō family and returned to the Kanō family only after he was of age, which may account for his being regarded in some Kanō biographies as illegitimate. During the Keichō period (1596–1615) he was one of the major Kanō artists doing commissions for Ieyasu, whom he followed to Edo. Naganobu continued to serve the shogunate until his death at seventy-eight in 1654, but these screens are for all intents and purposes his only surviving works.

42–43. Gion Matsuri (祇園祭山鉾巡行と宵山風景).

The present festival begins annually on July 17 and lasts for a week. In the old days, however, it started on the first and lasted for approximately a month, with some colorful event such as the

mikoshi-arai (washing of the portable shrine) taking place every night. The *Gion Matsuri*, together with the *Aoi Matsuri* on May 15 and the *Jidai Matsuri* on October 22, are the three great festivals of Kyoto. The *Gion Matsuri* is perhaps the most colorful of the three, with traditional customs scrupulously observed exactly as they have been for centuries. Since the event takes place in summer, and since a number of its functions are celebrated at night, the *Gion* Festival is always a time for uninhibited merrymaking.

44. *"Sights In and Around the Capital"* (Rakuchū-rakugai) (永徳筆洛中洛外図).

In the lower left corner of each screen there is a red seal made up of a tripod vessel within a circle. This seal, though unreadable, has been traditionally associated with Kanō Eitoku at least since the seventeenth century. The *rakuchū-rakugai* theme was an innovation of Tosa-school artists. The first use of the term occurs in the *Jitsuryū Kōki* with regard to a pair of screens painted in 1508 for Asakura Sadakage. The earliest extant pair may be those now owned by the Machida family. Although several documents record the fact that a pair of *rakuchū-rakugai* screens by Eitoku was among the gifts Nobunaga gave Uesugi Kenshin in 1574, it has recently been pointed out that the architectural style of buildings and disposition of scenes represented in the Uesugi screens point to a date of some twenty-five years earlier, thus making it likely that the screens were painted well before the time of their presentation.

45. *"Pleasure Quarters at Shijō-gawara"* (四条河原図).

The dating of these paintings is problematical. Because *onna-kabuki* seems not to have been practiced much beyond 1600, most scholars tend to regard the painting as no younger than that. On the other hand, the fully matured form of the Kabuki stage with short *hashigakari* and the two-storied theater boxes depicted in the screens point to a date of 1650 or later. On stylistic grounds the stamped-in-relief patterns on the edges of the gilt clouds and the *ukiyo-e* (Moronobu-like) character of the figure drawing tend to support the later date.

46. *"Hōkoku Festival"* (内膳筆豊国祭図).

Each screen has the signature "Kanō Naizen *hitsu*" and an unreadable seal. In the *Bonshun Nikki* it is recorded that Katagiri Katsumoto presented screens of this description to the Hōkoku Shrine in 1606. The author of the seventeenth-century *Tansei Jakuboku-shū* furnishes a complete personal history for Naizen. When his father was overthrown by Nobunaga, the nine-year-old Naizen (or Shigesato, as he was known then) was placed in a temple in Wakayama where he proved to be exceptionally adept at painting. One of his works so impressed Kanō Shōei that Naizen was invited to join the Kanō family. He was later appointed to the official painting academy on

the recommendation of Hideyoshi himself.

In spite of this information and of his use of the Kanō name, nothing about the Hōkoku Shrine's screens, which constitute the only extant documented work by Naizen, suggests that Naizen was trained in the painting traditions of the Kanō school.

47. Album of Genre Paintings (十二ケ月風俗図帖七月風流踊図).

Other scenes depicted are New Year's Morning (January), Bushwarbler Singing Contest (February), Cockfighting (March), Flower Market (April), Boys' Day Festival (May), Parade of Portable Shrines (June), Moon-viewing (August), Chrysanthemum Festival (September), Maple-viewing (October), Bonfire Festival (November), Children in Snow (December). After a period when it was done only by professional townsmen artists, genre painting seems to have become the specialty also of artists of the Tosa school in the seventeenth century. This album, in the Yamaguchi Collection, is quite similar in every respect to an album of miniature paintings in the Tokyo National Museum by Tosa Mitsunori (d. 1638): Museum number 1264.

51. *"Dancing"* (遊楽図).

The garment worn by the young dancer is an example of what is known as *katasuso* ("shoulder and hem") design, in which the upper and lower portions of the costume are given emphasis by decoration, in this case rendered in the embroidery and gold appliqué technique, *nuihaku*, that came into prominence in the late sixteenth century. The interesting negative and positive pattern of the clouds in the paintings is similar to some in fabric designs of the period. It should be noted that the three paintings in the illustration do not match: they were probably at one time mounted with three other panels on a six-fold screen.

52. *Road through cryptomeria trees, Nikkō* (日光の杉並木).

The site of Nikkō was suggested to Ieyasu as an appropriate place for his *reibyō* by Tenkai, the chief abbot of the largest Buddhist temple at Nikkō, Rinnō-ji. It is interesting to note that although he came to love the area, Ieyasu had never visited Nikkō himself. At that time it was an entirely undeveloped area in the mountains where priests underwent rigorous physical and spiritual training. The forest of cryptomeria trees begins near the bridge over the Daiya River in front of Tōshō-gū and extends approximately twenty-three miles along the thoroughfares *(kaidō)* of Nkkiō, Reiheishi, and Aizu Nishi. There are some 16,000 trees at present. On a monument erected in 1648 by Matsudaira Tadatsuna, a feudal lord, it is inscribed that he donated the cryptomerias and that it took more than twenty years to plant them all. Tadatsuna was directly connected with the construction of the *reibyō* and perhaps con-

ceived the idea of planting the trees when visiting the construction site for the first time.

53. Yōmei-mon of the Nikkō Tōshō-gū (東照宮陽明門).

In the mountainous terrain around Nikkō there are some one hundred architectural monuments of significance, including four that have been designated Important Cultural Properties: the Futaara Shrine, Tōshō-gū, Daiyū-in, and Rinnō-ji. Tōshō-gū, the shrine-mausoleum of Tokugawa Ieyasu, was first constructed in 1617, and reconstructed and expanded in 1636 by the third Tokugawa shogun, Iemitsu. The Yōmei-mon, which is part of a *kairō* encircling the compound, is three *ken* (approximately eighteen feet) wide, has two stories, which reach a height of thirty-seven feet, and a hipped gable and *kara-hafū* roof. All of its pillars and beams are profusely decorated with lacquered and gilded carvings and sculptures. The gate is thought to date from the construction project of 1636, which was supervised by the shogunal architect, Kōra Bungo Munehiro.

54. The main buildings of Tōshō-gū, Nikkō (東照宮社殿).

The interior of the *haiden* consists of two main rooms: the shogun's room at the left and the room at the right for the abbot of Rinnō-ji, who customarily is an imperial prince who has entered the priesthood (see notes 52, 57). The walls of these rooms are decorated with hardwood inlay of phoenixes and with paintings of birds and flowers. Delicate carvings of chrysanthemums with borders in relief decorate the coffered ceiling. The arrangement in which the *haiden* and *honden* of a shrine or temple are joined together by a roofed stone pavement is referred to as *gongen-zukuri*, a style of architecture that became popular in Japan in the late sixteenth century. These buildings at Nikkō are the largest examples in Japan of *gongen-zukuri*. Although the prototype for this style is Chinese, traditional Japanese building methods are also evident in the *honden* and *haiden* of the Nikkō Tōshō-gū, in marked contrast to the Yōmei-mon, which is regarded as purely Chinese in style. The buildings, gates, and other structures at Ieyasu's *reibyō* are kept in scrupulous condition by the government. It used to be the custom to completely renovate them every twenty years.

55. Karamon of the Nikkō Tōshō-gū (東照宮唐門).

This type of gate is a variant of the *mukai-karamon*, or "gate with facing Chinese gables." Its roof differs from those of most so-called Chinese gates of this period (e.g., the one at Hōkoku Shrine, figure 21), which are hipped, with *kara-hafū* arches on only the long sides, in that it is itself in the curved *kara-hafū* shape (as roofs of wall gates often were even in medieval times) and its long (facing) sides are also interrupted by arches. The two round, mica-coated pillars in front have cloud patterns on them in low relief and are inlaid with dark-colored relief carvings of a pair of ascending and descending dragons. The "capitals" of the pillars are sculptured bunches of chrysanthemums. More inlaid carvings of plum, bamboo, peony, and chrysanthemum decorate the panels of the gate doors, and two plum trees embellish the frame of the gate. The underneath side of the eaves is lacquered red with arabesque designs rendered in *maki-e*. The tableau of three-dimensional sculptures above the lintel represents the court of a legendary Chinese emperor. The roof is tiled and capped with two large bronze dragons.

56. Daiyū-in, Rinnō-ji, Nikkō (輪王寺大猷院霊廟).

This shrine is similar in scale and orientation to the Tōshō-gū at Nikkō, but the architecture is less elaborately decorated and is more consistently Chinese in style. What Daiyū-in lacks in sculptural ornamentation is more than compensated for by a greater sense of structural clarity.

57. Ueno Tōshō-gū, Tokyo (上野東照宮).

In 1616, when Ieyasu was critically ill, Tōdō Takatora and the Tendai priest Tenkai visited their old friend Ieyasu and agreed to construct a *reibyō* in Edo where their three spirits could be together after death. Some eleven years later, in accordance with this agreement, Takatora had a Tōshō-gū built on the outskirts of Edo at his estate in the hills of Ueno. Shogun Iemitsu, however, was not pleased with the small scale of the buildings and in 1651 had them reconstructed in the grand style, sheathing their massive forms in gold leaf (most of which has been replaced by lacquered surfaces). The original number of carvings decorating the Ueno Tōshō-gū has also been reduced somewhat, but it is still quite clear that Iemitsu intended that they correspond exactly to those at Nikkō. The *honden* at Ueno is divided into front and rear sections, the latter of which is encircled by a hallway that is done in gold-sprinkled (aventurine) lacquer exclusively. A special Shogunal Offering Hall *(heiden)* is an additional feature. The stone *torii* was donated by Sakai Tadayo in 1633.

58. Tebako (初音蒔絵手箱).

Lacquer craftsmen of the seventeenth century inherited two traditions from their predecessors. The most recent one was the floral-patterned, flamboyant smooth-surfaced tradition of *kōdai-ji maki-e* (figures 29–33). Another was the pictographically restrained relief and inlay *maki-e* of the Kamakura period (Vol. I, figures 177–78). The design of the *tebako* illustrated here (and the *zushi-dana*, figure 59) seems to have drawn from both traditions. To attain the effect of "antiqued" relief sculpture he used what is known as *togidashi maki-e*, a technique whereby the relief design is first worked out in a mixture of charcoal powder and lacquer and then sprinkled with gold or silver dust. When this was dry, a coat of lacquer was ap-

plied, allowed to dry, and, as the final step, the design was polished with charcoal, exposing the original gold color of the highest surfaces in the relief design.

59. Zushi-dana (初音蒔絵棚).
It is recorded that Nagashige, the tenth-generation lacquer master of the Kōami family, spent three years on the articles of furniture that were made for Iemitsu's daughter, Chiyo-no-hime, on the occasion of her marriage to a member of the Tokugawa family in Owari (Nagoya). The first-generation Kōami craftsman, Michinaga, was employed by Ashikaga Yoshimasa, the eighth Ashikaga shogun. Members of the Kōami family served as official lacquerworkers for the Tokugawa shogunate until as late as 1725, the year of Kōami Chōkyū's death. By 1700 other families of lacquerworkers had also won the support of the shogunate, and the Kōamis had lost much of their former prestige. Also by that time, other styles of lacquer decoration had appeared, such as those inspired by the paintings of Ogata Kōrin, which presaged the end of traditional maki-e techniques.

60. Inrō (印籠).
Inrō were introduced to Japan in about the fourteenth century (according to the Honchō Gashi) by Chinese Ch'an (Zen) priests. The Chinese containers were much larger, however, and were used exclusively as cases for the seals (in) and thick red ink with which the priests personalized their paintings and writings. Those carried by medieval samurai were much smaller and usually contained medicine.

61. Katabira (茶屋染帷子).
The kimono worn during most of each year by eighteenth-century Japanese was a complex, colorful affair of dyed (and, less often, embroidered and woven) fabric, but lightweight summer garments remained simple. Kimono materials for both types varied with the social class of the wearer: the common people wore cotton costumes dyed in dark blue by the tie-and-dye or stencil method, while the upper classes favored garments of ramie elaborately designed and dyed in the best indigo blue. The chaya-tsuji dyeing method, supposedly originated by Chaya Sōri in the seventeenth century, was used in the creation of formal clothing for the well-to-do. Completing a complicated design by this process, in which color resistant paste is applied to the negative areas of the pattern on both sides of the fabric before immersion in an indigo solution, can take as long as a full year. The Tokugawa shogunate had specialists in this type of dyeing in its employ.

62–66. Set of sword accessories (一乗作鐔小柄笄).
With the exception of purely ceremonial ones, sword guards (tsuba) in earlier times were made of iron and were designed very simply. But by the end of the seventeenth century, when even the wearing of swords was largely a formality, sword ornamentation had become a matter of almost general concern. Sword accessories referred to as mitokoro-mono were the three pieces (tsuba, kōgai, and kozuka) needed for each sword a man owned. The art of Gotō Yūjō, the first craftsman specializing in mitokoro-mono in the Muromachi period, became so widely imitated that when the last Gotō master, Ichijō, made the set illustrated in figures 62–66 he was but one of thousands of artisans in this field competing for public patronage.

67–68. Hiunkaku of Nishi Hongan-ji (西本願寺飛雲閣).
There are no records describing exactly how Hiunkaku was used, but some of the names of the rooms furnish clues. The funairi-no-ma on the first floor is part of the shōken-den, which translates as "the hall into which one invites wise men." It is of shoin-zukuri with a floor of three slightly different levels. On the second story, shōji windows line one long side of the wall, thus admitting in a great amount of light and giving meaning to the name of the room, kasen-no-ma, or "room for master poets." The tekisei-rō, the "star-picking pavilion," is a small room on the third and uppermost story. From these names one assumes that the main function of Hiunkaku had to do with entertainment; since the interior of the building is rather plain, resembling tea house interiors, the present writer and others have suggested that it was in fact used as a tea house by Hideyoshi.

69. Waka-onna Nō mask (能面若女).
Some of the best sculptors of the late medieval period seem to have turned from carving Buddhist icons to mask making, which thrived as Nō drama grew in popularity. Challenging demands were placed upon sculptors to somehow imbue each mask with a full range of readable emotions suitable to a particular role. Masks used for female roles, for example, often had to seem at once beautiful and grief-stricken (since most Nō plays are tragedies), the result being that the mask usually displayed an ambivalent, mystical emotional quality, as does the waka-onna mask illustrated here. This mask is quite within the iconographic and stylistic tradition established in the fifteenth century by the master-carver Tatsuemon, a tradition that still governs all Nō masks being made today.

70. North Nō stage at Nishi Hongan-ji (西本願寺能舞台).
This is the earlier of two Nō stages at the temple. An inscription reading "ninth year of Tenshō" (1581) is written in ink on the stage itself, and the same date is given in the temple document Hōryū Kojitsu Jōjō Hiroku. The stage is specially placed so that performances could be viewed from the shiro-shoin (see note 20). Compared to later Nō stages, this one is less complex, with the floor and eaves being

low to the ground and of lightweight construction.

71. *Nō costume* (片身替詩歌模様厚板).

Specialists suggest that the style of the characters on this costume is characteristic of early seventeenth-century calligraphy. Gold thread had been used in Japan in embroidery and tapestry brocade for quite some time, but it was not until after the Chinese gold brocade technique was introduced towards the close of the sixteenth century that material lavishly interwoven with gold thread was produced domestically. This type of gold brocade was woven of gold thread made of finely cut gilded paper, which is flat, as opposed to the ordinary round thread, and the expert use of a hooked bamboo stick was required in weaving the threads into the fabric. This type of Nō costume is described as *atsuita* ("thick board"), due to its bulky stiffness.

72–73, 76–77. *Katsura Rikyū* (桂離宮).

It is thought that Katsura-den, the villa of Fujiwara-no-Michinaga (966–1027), was located somewhere in the vicinity of Katsura Rikyū. The name Katsura appears frequently in the literary works of that time, including the *Genji Monogatari*. The founder of the present-day villa and garden complex, Prince Norihito (1579–1629; also known as Kosamaru, Tomohito, and Hachijō-no-miya), was the sixth son of Prince Yōkō-in (Ōgimachi Masahito) and the younger brother of Goyōzei, the fifty-first emperor. In 1588 Toyotomi Hideyoshi adopted the young prince as his legal heir. Later, when Hideyoshi's own son was born, Norihito was reinstated to princehood, and given the title Hachijō-no-miya. He married in 1616, when he was thirty-eight, and construction of the Katsura apartments and garden began four years later. In the same family document that yields this information, mention is also made of earlier outings to the Katsura area, however, so perhaps a summer home of some kind already existed at the site. Prince Norihito died in 1629 at age fifty-one. His son, Prince Noritada, married the daughter of Maeda Toshitsune, the daimyo of Kaga, and they moved to Katsura in 1641. Maintenance of the villa presumably was not adequate after the death of the first prince, and its completion required the financial support of the family at Kaga. Five new *chaya* (rest houses) and the *shinshoin* are recorded as completed in 1647 (the latter for the benefit of a visit to Katsura by retired Emperor Gomizunoo and his wife, Tōfukumon-in). The present form of the garden is also thought to have been generally complete by this time, although there are conflicting theories as to when and how work on each section was done.

In addition to the *shoin* apartments, the Gepparō, and the Shōkin-tei ("Arbor of the *Koto* in the Pines")—the buildings that are discussed in the text, plate captions, and other notes—there are several more of interest: the Manji-tei, or "Swastika-shaped Arbor," is on the west side of the pond near the Shōkin-tei; on the highest elevation of the largest island in the pond is the small Shōka-tei, or "Flower-appreciation Arbor"; directly to the west of this, at the end of a path, is a Buddhist chapel known as the Enrin-dō, which has a tile roof and is conspicuously the only building in the compound not in the new tea house style; across the pond from there is the "Laughter-inclined Cottage," Shōi-ken. All of these buildings can be seen from the *koshoin*. Also on the grounds, near the *shinshoin*, is an area that was used for *kemari*, an ancient game of kickball played by the nobility.

A later member of the family took the name Katsura, and the villa was in that family until early Meiji times, when the last member died and custody of the villa was turned over to the imperial household. Katsura Rikyū covers a total area of approximately seventeen acres. The pond on the grounds utilizes the water from the Katsura River, where dyers washed their fabrics until only recently. Gardeners, many of them women from the Ōhara district northeast of Kyoto, tend the grounds year-round on a voluntary basis.

74. *Shelves in the dressing room of the* shinshoin, *Katsura Rikyū* (桂離宮化粧の間棚).

The rooms of the apartments and tea houses at Katsura have all the features of *shoin-zukuri*, including the built-in shelves known as *chigai-dana*. Those illustrated here are referred to as the *ura* ("rear") *katsura-dana*, due to the fact that directly behind them in the adjacent room is a more famous arrangement of shelves, the *katsura-dana*. Both are designed for convenience as well as beauty. The Chinese-style ink sketches on the patterned paper doors are typical of a kind of painting done by seventeenth-century Kanō artists in the circle of Tan'yū and his brothers.

75. *Carriage entrance, Katsura Rikyū* (桂離宮御輿寄).

A close study of the form and distribution of the aging stone and wood structures at the *mikoshi-yose* of Katsura Rikyū reveals that their primary function was to facilitate the receiving and dismissing of guests. The stone plinth on the porch perfectly accommodated guests' palanquins; the space around it and the circle of uneven stones and walkways in front of the steps made it possible for palanquin bearers to discharge their passengers at the entrance with ease.

78–79. *Shūgaku-in Rikyū* (修学院離宮).

In 1656 Emperor Gomizunoo abdicated the throne, not too long after the famous "purple robe incident" in which his promotion of seventy priests at Daitoku-ji to the high rank of the Purple Robe went unrecognized by the Tokugawa shogunate. He chose for his place of retirement the same area in the hills skirting Mount Hiei northeast of Kyoto that had provided refuge in the past to members of the royal family (most notably Kenreimon-in, the widow of Emperor Takakura and the only surviving member of the Taira Clan

after its destruction by the Minamoto in 1185). With funds supplied by Tokugawa Shogun Ietsuna (who was, ironically, a nephew of the emperor's wife, Tōfukumon-in), Gomizunoo supervised the building of a retirement villa that he named after the district it was in, Shūgaku-in. In 1668 he had an apartment built for his daughter, Princess Ake-no-miya, in the middle area of Shūgaku-in now partly occupied by the imperially supported temple of Rinkyū-ji. The most important buildings at Shūgaku-in today all have connections with those built by Gomizunoo in the seventeenth century: the *kyakuden* of the middle garden is recorded as having been built for Tōfukumon-in in 1677 and moved to Shūgaku-in from Kyoto in 1682; the Jugetsu-kan ("Apartment Blessed with Moonlight") of the lower garden and the Rin'un-tei of the upper garden are among the first structures of the villa Gomizunoo had built (although their present forms are based on reconstructions that were made in 1824 using extant materials). For long periods of time after the death of Gomizunoo Shūgaku-in was allowed to fall into ruin, except for those occasions when later emperors used it. Since Meiji times, however, the grounds and buildings have been under the constant protection of the government.

80–81. *Sa-an, Gyokurin-in, Kyoto* (玉林院蓑庵).
Gyokurin-in was founded in 1598 by one Manase Gyokurin, with a Priest Gesshin as abbot. Sa-an is one of two tea ceremony rooms connected to a mortuary chapel built on the premises in 1742 by the Kōnoike family. The name of the architect is even known: the inscription "tea-house expert [*sukiya-kōshō*] Endō Shōemon Takaakira" was found on a rafter. The three-mat-plus-*nakaita-iri* arrangement of Sa-an (see figure 81) may be the earliest example of its kind; it was commonplace after about 1750.

82. *Tai-an of Myōki-an, Kyoto* (妙喜庵待庵).
Myōki-an was built by Yamazaki Sōkan, a noted poet, in the Meiō era (1492–1501) as his retreat outside the capital. When Hideyoshi stopped there during the Battle of Yamazaki in 1582, it is said that he instructed Sen-no-Rikyū to build Tai-an and to conduct a tea ceremony there. To substantiate this story there exists a map of 1606, in which a tea house, labeled "Tai-an," is shown in close proximity to Rikyū's own residence, and an entire literature associating the tea master with this, his favorite of all *chashitsu*. Tai-an has two rooms, one of which is the tea ceremony room proper. This room is rectangular, with only two *tatami*, and in addition to its *murodoko* (figure 82) has a square sunken hearth in one corner *(sumiro)* and a guest entrance *(nijiri-guchi)*, which at $2\frac{1}{2} \times 2\frac{1}{3}$ feet (a measurement referred to as "Myōki-an size") is exceptionally large for tea houses. The walls of mud and straw are left unplastered, and the room's three windows are covered with plain, opaque white paper. The lumber used for the corner pillars and ceiling of Tai-an is also of the most common type available.

83–84. *Karakasa-tei of Kōdai-ji* (高台寺傘亭).
These tea houses are located uphill and to the southeast of the main buildings at Kōdai-ji. Records invariably maintain that they were moved from Fushimi Castle, but the exact date of their construction is unknown. It became traditional, after about the middle of the eighteenth century, to speak of them as Rikyū-*gonomi chashitsu*—tea houses preferred by Sen-no-Rikyū—and this was often taken to mean that they were Rikyū's own designs. They must in fact be later if they did come from Fushimi Castle, since Rikyū died three years before the castle was begun. The roof of Karakasa-tei is common in what is known as *hōgyō-zukuri*, a style of architecture characterized by a simple building, square in plan, with pyramidal roof topped by an ornament (the *hō* of *hōgyō-zukuri*) similar to those on Buddhist pagodas. The second-story room of Shigure-tei, except for one side that has a *tokonoma*, can be opened to afford a view of the surrounding garden.

85. *Rokusō-an* (六窓庵).
Rokusō-an was one of three nationally famous *chashitsu* in Nara before an Edo artist purchased it from its priest-owners during the political turmoil of early Meiji Japan. Like other religious institutions, Jigen-in and its parent temple, Kōfuku-ji, had fallen on hard times and were selling many of their treasures (Kōfuku-ji's five-storied pagoda was even put up for sale). The artist who bought Rokusō-an had it transported to Tokyo and rebuilt at its present location prior to the establishment of Tokyo National Museum. Then, in 1881, the tea house was restored and expanded by the museum staff under the supervision of Kohitsu Ryōchū, a calligrapher and connoisseur whose credentials included a family line of experts reaching back to the sixteenth century. The building was moved from Tokyo during World War II, then returned and reassembled in 1947. This "building with six windows" is often explained in terms of the Buddhist concept of the "six windows of mankind": eyes, ears, nose, tongue, body, and mind.

86–87. *"Pine Trees"* (松林図).
These screens were formerly in the collection of a family named Fukuoka. No records accompany them, but it seems that the two pairs of seals on each screen (figure 86) reading "Hasegawa" and "Tōhaku" are original. Of all ink paintings attributed to Tōhaku, only those from Ryūsen-an, Daitoku-ji, equal these in quality. The artist's association with priests and tea masters, as well as his appreciation of certain Chinese artists' works, is well chronicled in *Tōhaku Gasetsu*, a collection of conversations Tōhaku had with his friend, Priest Nittō, abbot of Hombō-ji in Kyoto. He obviously was well acquainted with Chinese art

in the shogunal collection and admired particularly the figure paintings of Li Lung-mien (1059–1106) and Liang K'ai (*ca.* 1140–1210); the landscapes and flower and bird paintings of Ma K'uei, elder brother and uncle, respectively, of the more famous masters—whom Tōhaku surprisingly ranks below Ma K'uei—Ma Yüan (*ca.* 1150–1230) and Ma Lin (active *ca.* 1250); all the paintings of two later artists, Mu Ch'i (*ca.* 1220–90) and Yü-chien (possibly the priest Jo-fên rather than the better known Ying Yü-chien). For all of the pioneering work by Doi Tsugiyoshi *(Hasegawa Tōhaku—Nobuharu Dōninsetsu)* and others, much is still unclear about Tōhaku's biography: the theory holding that "Tōhaku" is the name used late in life by the professional portrait painter Hasegawa Nobuharu Tatewaki is generally, but by no means unanimously, accepted by Japanese scholars. It is agreed, however, that the colorful paintings at Chishaku-in (figure 26), Myōren-ji, Sambō-in, and elsewhere are Hasegawa-school works (see note 26).

88. *"The Fifth Zen Patriarch"* (沢庵筆五祖栽松図).
Takuan Shūhō (1573–1645) became the 154th abbot of Daitoku-ji when he was only thirty-five. Emperor Gomizunoo and Tokugawa Iemitsu were among the illustrious persons who received instruction from him in religious exercises, including the kind of intuitive ink play seen here that Zen devotees continue to practice even today. Takuan is also considered the originator of *takuan-zuke,* a distinctively sour turnip hors d'oeuvre.

90. *"Mending Clothes at Sunup"* (松花堂筆朝陽之図).
Like paintings of the "Fifth Zen Patriarch" (figure 88)—which are generally paired with "Sixth Zen Patriarch" pictures—the themes of a priest "mending clothes at sunup" and "reciting the sutra by moonlight" are old favorites in the repertory of subjects painted by Buddhist priests and by dilettante artists and calligraphers of all sorts. Shōkadō's rendition bears a poem by Ryūtan Shūken, the 259th abbot of Tōfuku-ji. Shōkadō, who was born in Nara and was a priest of the Shingon rather than Zen sect, has the reputation of being one of the three great calligraphers of the early seventeenth century. He was a prominent figure in the tea world in Kyoto and knew many artists of the time (including Kanō Sanraku, who stayed with Shōkadō for a while in 1615 at Otokoyama Hachiman Shrine south of Kyoto to avoid the turmoil caused in the capital by the defeat of forces loyal to Hideyoshi's family).

91–92. *"The Poets Ki-no-Tsurayuki and Kakinomoto-no-Hitomaro"* (又兵衛筆貫之 人麿図).
Hitomaro (seventh and eighth centuries), one of the first of the great "Thirty-six Poets," wrote many of the poems found in the famous eighth-century anthology of poetry, the *Man'yō-shū.* The ninth-century poet and court official Ki-no-Tsurayuki is perhaps best known as the author of

the *Tosa Nikki,* a diary describing the return voyage to Kyoto of a nobleman who for some years held the post of governor in a remote province on Shikoku. Works attributed to the professional artist Matabei are usually done in bright colors and in a style that recalls the one well-known work of Kanō Naizen's (figure 46) and also paintings by sixteenth- and seventeenth-century Tosa artists (figure 47). As a boy he probably knew Shigesato Kyūzō (later, Kanō Naizen), whose family served Matabei's father, Araki Murashige. The latter committed suicide in the same year Matabei was born, and in 1600 the young artist (who took his mother's name, Iwasa) went to study painting in Kyoto under Tosa Mitsunori. Naizen, who had been placed in a temple (perhaps along with the infant Matabei) when Araki died, may have entered Kanō ranks at about the same time (see note 46). Since neither of the two artists' works have much in common with official Kanō painting, it seems likely that they both had developed their painting styles before going to Kyoto. Matabei's individuality comes across in the distinctive caricaturelike figure style seen here in his paintings of Tsurayuki and Hitomaro.

93. *Black Raku teabowl (known as* Ayame*)* (黒楽茶碗 銘あやめ).
This teabowl, which has been given the name *Ayame* ("Iris"), is thought to be the work of either Chōjirō I (1516–92) or Tanaka Sōkei, Rikyū's son, and to date from the late 1580's.

94. Nezumi-*Shino teabowl (known as* Yama-no-ha*)* (鼠志野茶碗 銘山端).
The bowl's white clay body was first covered with a reddish slip, high in iron content, and simple tortoise-shell and cypress-fence patterns were scratched into it before the vessel was covered with a thick coat of opaque feldspathic glaze. Firing turned the background to gray tinged with rust color and allowed the white patterns to stand out. The name *Yama-no-ha* may have been suggested by someone who noticed the mountain-ridge contour of the lip while drinking from the bowl. This teabowl and one other, *Mine-no-momiji* ("Mountain Maples"), are among the most famous pieces of *nezumi*-Shino in existence. Other types of Shino include *shiro* (white), *temmoku* (black teabowls in the style of Chien stoneware of the Sung Dynasty), *muji* (plain), *e* (picture, or painted), and *aka* (red).

95. Hori-*Karatsu teabowl* (彫唐津矢来文茶碗).
This bowl is thought to be from one of the numerous Korean kilns established at the turn of the century around Mount Kishi near Karatsu, northern Kyūshū. Deeply incised bamboo patterns and crosses rendered in iron oxide decorate the vessel, which is made of hard and coarse grayish clay covered with a thick layer of feldspathic glaze. The crosses of the design have led some

authorities to believe that the bowl was made for a Christian convert.

96. *Shino water jug (known as* Kogan*)* (志野水指 銘古岸).

The Mutabora kilns at Ōkaya, where this vessel was made, were among the most productive of the thirty or so Shino kiln sites in Gifu around 1600. Over a body of coarse, off-white clay, the maker of *Kogan* applied a thick coating of semitransparent feldspathic (Shino) glaze and a design of grasses and reeds rendered in a solution of "devil clay" *(oni-ita)*, which has a high percentage of iron in its composition. The shape of the vessel, known as *yahazu-guchi* ("arrow-notch neck") because of the similarity of its deeply grooved top to the notch of an arrow, was popular in Momoyama and early Edo times. *Kogan* is especially prized because of the orange scorch marks *(kashoku)* around its lip.

97. *Old Iga water jug (known as* Yabure-bukuro*)* (伊賀水指 銘破袋).

Old *(ko)* Iga kilns were located in the Makiyama and Marubashira areas of Iga province (now part of Mie Prefecture). They were supported by the Tsutsui family until about 1600 and by the Tōdō family later *(Yabure-bukuro* was formerly in the Tōdō Collection). Some authorities claim that marks were made on *ko*-Iga wares prior to firing to obtain cracks in the desired places. Many of the shapes are based on containers made of wood.

99. *Oribe serving dish with clematis design* (鉄線花文織部手鉢).

Half of the inside of the dish is covered with a thick copper-green glaze, thus carrying out in a lackadaisical way the popular *katami-gawari* design seen also in costume, lacquerware, and other arts of the period (see figures 32 and 71). Potters in Mino (Gifu) continued to produce Oribe's ceramic designs long after his death in 1615, with each kiln site developing its own distinctive variety.

100. *"People of Kyoto"* (隆慶作洛中風俗人形 百人一衆).

Ryūkei's abbreviated style of carving may be the sculptural equivalent of the playful ink sketches of figures 88–92, but it seems significant that whereas sketches are done almost by formula ("this is the way one draws a fifth Zen patriarch"), Ryūkei's example of working from living models— a rare thing in Japan before the late nineteenth century—was well ahead of the times.

101–4. *Sumiya* (角屋).

Shimabara, the old red-light district *(yūri)* in Kyoto corresponding to Edo's Yoshiwara, was ordered moved from the eastern part of the city to its present location west of Omiya Street in 1641. Sumiya was one of the many brothels *(ageya)* built there. Until 1681 the entire second floor of Sumiya was, according to records, a single grand hall, so that the interestingly named rooms there now—damask, bamboo-blind, folding fans, mother-of-pearl, etc.—must date from a later time. The obvious reference to tea-house architecture, with *shoin-zukuri* principles carried out in rustic materials in each room (much as they are in the apartments of Katsura Rikyū), makes it appropriate to speak of Sumiya as an example of *sukiya* architecture. A number of rooms are recorded as having been added to Sumiya in 1730, and major renovations, including the construction of a garden copied after the one on the Yabunouchi family estate, were undertaken between 1781 and 1789. A festival for geisha and *maiko* is still held at Shimabara every year on April 21. Sumiya is kept rather as a museum and is open to the public by appointment.

105–6. *Takagamine and Kōetsu-ji* (鷹ヶ峯光悦寺).

Kōetsu's ancestor in the fourteenth century, Myōhon Chōshun, was the first in a long line of Hon'ami craftsmen to serve as officer in charge of the shogunal sword supply. But Ieyasu's support of an artist not of the Kanō school was undoubtedly prompted as much by Kōetsu's strong connections with high-ranking persons in the Buddhist Church: in Kōetsu's generation relatives held important positions within Hokke Buddhism, which at the time was second only to the Zen sect in popularity. In one map of Kōetsu's colony at Takagamine, four Hokke-sect temples are listed along with no less than fifty-five houses bearing names of families in Kōetsu's group, including those of a wealthy merchant, Chaya Shirōjirō, and Ogata Sōhaku, grandfather of Kōrin and Kenzan.

109. *Printed text for the Nō play* Kantan (光悦謡本 邯鄲).

The one hundred Nō plays included in Kōetsu's and Sumikura Soan's books were taken from scripts owned by the famous Kanze school of acting. Soan lived in the village of Saga, west of Kyoto, and the books in question are known variously as *Saga-bon, Kōetsu-bon,* and *Sumikura-bon.* Besides the plays, they included such classics as *Ise Monogatari, Hōjō-ki,* and the poems of the Thirty-six Great Poets. Their publication contributed immensely to the knowledge of classical literature within a broad spectrum of Japanese society. Soan himself came from a family of merchants (mostly traders, shipbuilders, and engineers) who by the early part of the seventeenth century were among the wealthiest individuals in Japan.

113. *"Sekiya" and "Miotsukushi"* (宗達筆源氏物語関屋 澪漂図).

The events depicted in these screens are described in "A Meeting Place at the Frontier" and "The Flood Gauge" chapters of Waley's translation of the *Genji.* The former (illustrated in the top

screen) tells of the chance meeting at the Osaka checking point *(seki)* near Ōtsu between Prince Genji, who is returning from a visit to Ishiyama-dera, and his former love, Utsusemi. In the "Miotsukushi" screen (below), Genji and his followers, having noticed the approaching boat of another of the prince's loves, Lady Akashi, are gathered together on the beach by Sumiyoshi Shrine, clearly excited by the prospect of an encounter. By 1630 Sōtatsu had been given the honorary priest-painter rank of *hokkyō*, a title he used on copies he made in that year of the four medieval picture scrolls of *Saigyō Monogatari* that were in the imperial family's possession. Since he used that title in the signatures on the "Sekiya" and "Miotsukushi" screens also, it is common to date the screens between about 1630 and 1640. They were formerly in Daigo-ji, where some of Sōtatsu's best paintings are still preserved.

114. *"Red and White Plum Trees"* (光琳筆紅白梅図).
The highly conventionalized water motif dominating the center of this two-screen composition is painted in a flat resin-base paint of a dark-blue cast over which curvilinear designs of waves, done originally in silver, are superimposed. The trunks of the plum trees flanking this motif are rendered in black ink wash and light green directly on the gold leaf. Opaque white and red blossoms and tiny green lichen provide a touch of bright color and delicacy that contrasts sharply with the general boldness of the painting. The left screen is signed "Seisei Kōrin," the right one "Hokkyō Kōrin." Both have round seals printed in red ink that read "Hōshuku." (Seiseidō and Hōshuku are two of Kōrin's many *gō*.) The rank of *hokkyō* was conferred on Kōrin in 1701.

115. *Teabowl by Kenzan* (乾山作槍梅文茶碗).
Kenzan's signature is on the teabowl as well as on the box made especially for it. Kenzan was active at his workshop at Narutaki in Kyoto from 1689 to 1712. He spent a good part of his later life in Sano, northeast of Tokyo in Tochigi Prefecture, where he concentrated on painting and calligraphy rather than pottery.

116. *Square ceramic dish by Kōrin and Kenzan* (光琳絵乾山作観鴎図角皿).
Kenzan was most original when experimenting with underglaze techniques. This dish was first covered with an opaque white slip over which the painting was executed in a thin glaze solution of manganese and cobalt that permitted the same full range of tonal variations possible in ink painting. Under a final coating of transparent glaze, the design, including the painted borders, fired brownish black.

119. *"Landscape with Figures"* (大雅筆人物山水図).
Although there is no mention of a date in a bill that accompanied and has been preserved with the painting, the temple (Henshōkō-in) was remodeled in 1761 and it is customary to date the painting around that time. The long-standing attribution to Taiga seems to have been made on stylistic grounds, since the panels have no seal or signature.

120–21. *Paintings by Buson* (蕪村筆峨眉山露頂図・夜色楼台図).
Both scroll paintings have two seals and are signed "Sha-in," a name Buson created using one of the characters of the name he bore as a child and another from the name he adopted after visiting a place in Tango province known as Yosa.

122. *"Porthole Vignettes"* (竹田筆船窓小戯帖).
In 1829, Chikuden, accompanied by his son Josen, traveled by boat from Saganoseki in Ōita (northeastern Kyūshū) to Osaka, and painted five of the scenes he saw along the way. In 1830 he added another picture to the set and made this album, the title of which translates more literally as "Comic Dramas Seen from My Cabin." The first leaf in the album gives the date, April 23, 1829. The leaf of figure 122 (number five in the set) has a seal and three poetic inscriptions written in the classical (Chinese) style, which refer to rigors of the trip and the scenery off Ōsaki Island.

123. *"Winter Clouds and Sifting Snow"* (玉堂筆東雲篩雪図).
The inscription says that the painting is the "work of the drunken Gyokudō Kinshi." There are two seals. Of Gyokudō's drinking habits, Chikuden writes elsewhere that he drank "heavily right from the start" and did not stop "until he was sober."

125. *"Morning at Uji"* (木米筆兎道朝㶚図).
Mokubei, who was the son of a Nawate Street restaurateur in Kyoto, went deaf in middle age, for which reason he sometimes called himself Rōbei, or "Deaf Rice." He was most famous as a maker of *sencha* tea vessels, but in his later years he painted a great deal, gaining renown with his "embroidered" Chinese-style landscapes *(senkō-sansui)* painted primarily in bright red ochre and dark blue. The titles of his "Morning at Uji" picture (of which there are quite a few) are literally translated as "Morning Sunshine on Rabbit Path," *T'u T'ao Chao T'un*, a respectable Chinese painting title (Mokubei mistakenly wrote a non-existent character for "T'un"). But scholars have not failed to recognize the intended Japanese phonetic reading of "Uji" for "T'u T'ao," as well as many other examples of how Mokubei adapted Chinese art to his own situation as an artist in Japan.

129–31. *Paintings by Rosetsu* (芦雪筆猿図・月夜山水図・山姥図).
A group of nine merchant families presented Rosetsu's "Yama-uba and Kintarō"—which is

in the Shinto votive offering form known as *ema*—to Itsukushima Shrine in 1797. The date of 1795 appears on some of the *fusuma* paintings at Daijō-ji. The little landscape (figure 130) is not dated, but is generally considered a late work.

132. *Jar by Ninsei* (仁清作色絵藤花文茶壺).
Korean-style Sue ware was apparently made in the Kyoto area during the Tumulus period (third to sixth centuries A.D.) and kilns were producing everyday wares at Kiyomizu, Otowa, and Mizoro in the city during almost all periods of Japanese history. The Raku ware of Momoyama tea masters was in a special class by itself and had a somewhat limited appeal. Thus it is that the tremendous output of pottery by Ninsei and his disciples in the latter half of the seventeenth century marks the beginning of the production of "stylish" pottery on a large scale in Kyoto. The jar of figure 132 has exactly the same shape as the so-called Luzon jars imported to Japan from the Philippines (where Spanish culture prevailed) by a seventeenth-century Japanese trader known as "Luzon" Sukezaemon. The vessel, which is surprisingly lightweight, is of buff-colored clay. The colorful design was painted over an opaque white glaze.

133. Kosode *with hand-painted design* (伝光琳筆白地秋草模様描絵小袖).
Because of a story of some age to the effect that Kōrin painted this *kosode* on commission for a wealthy merchant family in Edo named Fuyuki, the garment is generally known as the "Fuyuki *kosode*."

134. Furisode (熨斗模様振袖).
By 1700 almost anything was possible in Japanese garment design, so thoroughly had weaving and dyeing techniques been explored. The design of this *furisode* (literally, "swaying sleeves"), a garment traditionally worn only by young girls, is executed in a variety of techniques, including *yūzen* and *shibori* dyeing and gold appliqué. In *yūzen-zome*, a hand-painted dyeing method, the patterns are first outlined with a color-resist of rice paste applied with a paper funnel or a chopsticklike wooden implement, and later filled in with dyes of any color desired. As is often the case, unlimited technical freedom ultimately resulted in well-crafted designs of doubtful artistic value.

135. Yatsuhashi *inkstone box* (光琳作八ツ橋硯箱).
The upper compartment of this double-decked inkstone box contains the inkstone, while the lower compartment was used as a storage place for writing paper. This is an interesting departure from the conventional single-layer inkstone box. The inkstone and water container were fitted into the center of the upper·compartment and the remaining space was used for storing brushes.

139. *"Portrait of Kimura Kenkadō"* (文晁筆木村兼葭堂像).
Bunchō painted this portrait on March 25, 1802, just two months to the day after the death of the subject, Kimura Kenkadō (Kōkyō), an Osaka seal-engraver and student of Chinese literati art in whose home Bunchō had twice visited when traveling from Edo to Nagasaki (in the latter city Bunchō studied with the Ch'ing painter Chia Chang). As a boy, his poet-father had sent him to Kanō Bunrei to learn Kanō painting; he later learned to paint in *yamato-e* (Tosa school), *ukiyo-e*, and Western styles before adopting the Chinese mode for the sketches he made during his many travels. The inscripton on the painting, figure 139, contains the date and the artist's signature and two seals.

140. *"Portrait of Takami Senseki"* (華山筆鷹見泉石像).
A note of poignancy issues from this painting because of the circumstances surrounding its subject. Takami Senseki was Kazan's friend and teacher. They were both known for their familiarity with Western concepts of politics, economics, foreign trade, etc., and were occasional critics of Tokugawa policy. Senseki, however, was also one of the minor government officials at Osaka Castle who in March of 1837 (only about a month before Kazan painted the portrait) were under orders to arrest Ōshio Heihachirō, the scholar-reformer whose followers had protested social inequities by burning and looting wealthy merchants' homes in Osaka. It seems more than likely that Kazan's and Senseki's sympathies were with Ōshio, who chose suicide over silence, a choice Kazan also made in 1841 after being first jailed in the "foreign traitors" prison and then confined to his home for participating in the Shōshi-kai, an association of scholars in opposition to government laws excluding foreigners.

141. *"A Summer Evening"* (守景筆夕顔棚納涼図).
The broad range of subjects in Morikage's paintings include landscapes, flowers and birds, figures, classical and genre scenes, and Buddhist themes. His style, however, was rather consistent, recalling in most cases the black ink and light color tradition of fifteenth-century masters (some of his landscapes could almost pass for Sesshū's), although he quite often included much gold leaf in his compositions and his drawing tends to be fussy. Since "A Summer Evening" is virtually the only Morikage painting that is progressive, it would make more sense if Tan'yū dismissed him not for progressiveness, but for being too consistently old-fashioned, i.e., for not working in the style of Chinese painting espoused by modern Kanō artists.

143. *"A Street in Yoshiwara"* (伝師宣吉原の躰 格子先).

The last in the set of twelve prints from which figure 143 comes bears the name and address of the publishing house, "Yamagata-ya." Many of the oldest *ukiyo-e* prints are printed in black lines only, with coloring, when it appears, added by brush. None of them are signed, and the outstanding ones have traditionally been attributed to Moronobu, although careful study has lately revealed that single prints by Moronobu are rare. Moronobu's date of birth is unclear, but records show that he came from Awa province (Chiba Prefecture near Tokyo) to the new capital in the early 1660's. The artist's rise to fame coincides generally with the careers of the novelist Ihara Saikaku and the playwright Chikamatsu Monzaemon, for whom the floating world held an equal fascination.

144. *"The Actors Nakamura Rikō and Mimasu Tokujirō"* (春章筆里好の奴小よしと徳次郎の奴小万).
Shunshō's "perfect likeness" figure prints, with their startlingly simple compositions and subtle color harmonies (here pale grayish blue, purple, amber, and pink), were very much in demand.

Nothing is known about Shunshō's childhood except that he lived with the Edo publisher Hayashi Shichiemon; he may have studied under Shunsui, one of Miyagawa Chōshun's pupils. Shunshō's paintings and prints were admired for their realism. In particular, his candid portraits of Kabuki actors backstage were a radical departure from the stereotypes produced by Torii artists, the leading designers of actor prints at the time. Genre scenes, with the focus on beautiful women, frequently occupied the artist's attention during the years when, before his death at the age of seventy-seven, he gave up print designing and concentrated on painting. The influence of Shunshō is apparent in the works of almost all later *ukiyo-e* masters.

145. *"A Beauty"* (安度筆立美人図).
Heavy, expensive robes draped loosely over the women's bodies, and faces that seem to be giving both an invitation and a warning—the stately courtesans painted by Kaigetsudō and his followers appealed directly to the sporting instincts of wealthy Edo townsmen as portraits of the traditionally frail and passive Japanese woman did not.

Little of Kaigetsudō Ando is known apart from his name and his exile in 1714. His real name was Okazawa Genshichi and he lived in Edo's Asakusa district. His earliest *bijin-ga* may have appeared on the market by 1703, but for his part as the go-between eleven years later in the love affair of Lady Eshima and Ikushima Shingorō, a famous Kabuki actor, Ando was sent to Ōshima, a penal island, thus bringing an end to his short career. His followers—Anchi, Dohan, Doshin, and Doshū—carried on in his stead, designing a few prints along with the courtesan paintings that were the group's forte.

146. *"Osen"* (春信筆笠森おせん).
Art historians usually give Nishikawa Sukenobu, the Kyoto master who preferred a delicate female type for his *bijin-ga*, credit for having had the greatest influence on the development of Harunobu's art. At age forty-six, in 1770, after bequeathing the technique of multicolor printing to his generation, Harunobu died, leaving an incredible number of prints, almost one thousand of which still exist. Two points about the print, figure 146, are worth noting: the fan Osen holds bears the crest of a famous family of actors, and two of the fans for sale are signed with the names "Shunshō" and "Bunchō," two of Harunobu's contemporaries.

147. *"Night Scene at Shinagawa"* (清長筆美南見十二候 七月 夜の送り).
The Torii school, which Kiyonaga headed after Kiyomitsu died in 1785, was, as noted earlier, primarily devoted to the production of actor prints and theater posters, but Kiyonaga's interests (and certainly his best efforts) lay in the designing of *bijin-ga*. The rather affected poses of his idealized figures, while attractive and even imitated by other artists, were superseded in the public's eye by the more informal, utterly sensual attitudes of Harunobu's women.

148. *"The Fickle Face"* (歌麿筆婦人相学十躰 浮気之相).
The title, the artist's name, and the trademark of Utamaro's publisher, Tsutaya Jūzaburō, are on the print. The other nine prints in this series, *Fujin Sōgaku Juttai*, include women whose faces are "naive," "impatient," "slightly interested," etc. This series, together with another that is similar, *Fujin Ninsō Juppin*, are among Utamaro's best-loved works. Neither his parentage nor birthplace is known. A brief prison sentence in 1804 (for making some historical prints that the government considered insulting; his pornographic prints were not censured as they are now) seriously impaired his creative powers.

149. *"The Actor Ichikawa Ebizō"* (写楽筆市川鰕蔵の竹村定之進).
The only factual information concerning Sharaku: he was a native of Awa province (Tokushima Prefecture), where he acted in Nō plays under the name Saitō Jūrōbei, and for less than a full year, between 1794 and 1795, he designed some 160 prints for the publisher Tsutaya, who had to give up the venture because of the public's unreceptiveness. Part of that unreceptiveness must have had to do with Sharaku's penchant for making the expressiveness of finished print come first, leaving the appealing presentation of individual actors to lesser talents. One gathers as much from the criticism of the time that his designs had "power" but that he did not portray actors "as they really were." Later critics, on the other hand, and Western connoisseurs in particular,

have been generally enthusiastic, seeing his art as the freshest and most original to emerge from the entire gamut of *ukiyo-e*.

150. *"The Waves near Kanagawa"* (北斎筆富嶽三十六景 神奈川沖波裏の不二).
Hokusai was born in a village to the east of Edo, the offspring of peasants. His childhood was a series of foster homes and years of servitude. He first took an interest in picture making while working for the owner of a small neighborhood bookstore. At nineteen, using the name "Shunrō," he was one of the many apprentices in the workshop of Katsukawa Shunshō (see figure 144). When that master died in 1792, he began to pursue an independent course, experimenting with the various styles of *ukiyo-e* print designing and of Chinese, Japanese, and Western painting being done by late eighteenth-century artists. Once his own famous style was established, Hokusai went on to produce a total of works that is one of the largest produced by any artist in the world.

151. *"Rain at Shōno"* (広重筆東海道五十三次 庄野).
Born in Edo, Hiroshige was the son of a fireman assigned to Edo Castle, a post the thirteen-year-old inherited (but refused to take seriously) when his father died in 1809. At sixteen, after one year as a pupil of Utagawa Toyohiro, he was given the name "Hiroshige." His early work was undistinguished and imitative, and it was only after being inspired by Hokusai's landscape prints that he made up his mind about subject matter. He had one series of prints published, *Famous Places in the Eastern Capital*, the year before his Tōkaidō trip. Depicting the fifty-three stations along that busy highway was not an entirely new venture before Hiroshige's time. Moronobu, Hokusai, and others had previously made sketches and pictorial maps of the same route. But no other artist's works possessed the intimacy of Hiroshige's prints. That is not to say that his *Stations* scenes were restricted to actual circumstances, however: the party started out on the trip in August, and must have been in Shōno, which is the forty-sixth station from Edo, in late fall, but the mood of the print is spring, with people scrambling for shelter in a sudden downpour of rain.

152. *Combs and hair ornaments* (櫛・簪・笄).
Women's hair styles went through several interesting stages of development during the Early Modern age, with the period from about 1750 to 1850 seeing the greatest need for ornamental hairpins *(kanzashi)*, colored glass beads, and other items as elements of the complex arrangement of luxurious black hair that was the pride of every Japanese lady of taste.

153. *Blackwood tobacco set* (煙草盆).
Ever since the Tenshō era (1573–92), when tobacco smoking was first introduced to the Japanese, all kinds of "tobacco sets" have been in use.

This very handsome nineteenth-century one is of clear-lacquered wood resembling ebony, which provides a rich background for the delicate hollyhock designs of colored lacquer and mother-of-pearl inlay. As the photograph shows, the engraved pipe, tobacco container, and charcoal brazier are fastened to a section of the set that is handily portable.

157–58. *Watanabe mansion, Niigata* (渡辺邸).
Although their land and much of its revenue was owned by the shogunate (*tenryō* land) and was under the management of the Uesugi clan, the Watanabes managed to amass a personal fortune by selling surplus rice and saké to Osaka merchants. They were typical *gōnō*, farmers whose wealth entitled them to privileges afforded low-ranking samurai. In addition to the mansion, three storehouses and a collection of family valuables have been preserved.

160. *Nabeshima porcelain plate* (鍋島色絵ふさ文皿).
The Lord Nabeshima Katsushige established the first porcelain kilns at Iwayakawachi in northern Kyūshū in 1628. The kilns were moved to Nangawara (1661) and then to Ōkawachi (1675), where production continued until the Meiji Restoration. The Nabeshimas invested much of their wealth in this enterprise, and with good success. The best *irō*-Nabeshima was produced during the Genroku (1688–1704) and Kyōhō (1716–36) eras.

161. Ko-*Kutani* dish (古九谷色絵鳳凰文大皿).
The kilns at Kutani were established by Maeda Toshiharu, the lord of Kaga province (Ishikawa Prefecture). The man put in charge of the project, Gotō Saijirō, reputedly went to Arita in Kyūshū to learn the overglaze enamel technique and to bring Chinese potters, who were in Nagasaki, to Kutani. The kilns fell into disuse in the 1690's.

162–63. *Imari and Kakiemon wares* (伊万里色絵桜婦人図皿・柿右衛門作色絵花鳥文大深鉢).
Kakiemon (1596–1666) was the first Japanese potter to produce *iro-e* ("multicolored picture") wares similar to late Ming porcelains. At nineteen he was making Karatsu pottery under the tutelage of his father, but soon joined forces with the other Kyūshū potters who in the early part of the seventeenth century were developing the Imari porcelain with blue underglaze decoration known as Hizen *some-tsuke* (pottery from Hizen with designs that look indigo-dyed). Even with the red overglaze decoration that was developed somewhat later, Imari ware was generally reserved in appearance until Kakiemon perfected overglaze technique in which a full range of colors was possible.

164. *Hidehira bowl* (秀衝椀).
Fujiwara-no-Hidehira, the twelfth-century ruler of northeastern Japan who built Chūson-ji at

Hiraizumi (Vol. I), is supposed to have fancied bowls of this shape and color combination, hence the name. They are also known as "bowls from Nambu" and "Jōhō-ji bowls," and were considered the specialty of lacquer craftsmen in the Hiraizumi (Iwate Prefecture) area after about 1600.

166. Mitsuda-e *serving tray* (唐人物密陀絵膳).
The subtle color effects of *mitsuda-e* are achieved by applying pigments mixed with perilla oil and lead oxide *(mitsuda-sō)* directly over light-colored (usually green or red) lacquered surfaces. Some early Chinese examples are preserved in the Shōsō-in at Nara.

167–68. *Sculptures by Mokujiki and Enkū* (木喰・円空).
The lives of Mokujiki and Enkū are in some ways quite similar. Both were priests (Mokujiki having become one in 1573, after half a lifetime as a soldier) and both gave vent to a common dissatisfaction with the religion and art of their day by traveling from place to place, carving statues incessantly (and in unusual ways) as they went. But a comparison of their works shows a polarity that is striking, for it becomes clear that for all of the rough-hewn carving Enkū did, his statues are in fact sophisticated, half-realized versions of icons done in traditional styles, whereas the utterly charming creatures by Priest Mokujiki are in a class with provincial sculpture made everywhere in the world: one finds parallels to their naive, oft-repeated solutions to problems of representation in such objects as unrelated to Buddhist and Shinto imagery as carved weathervanes and ships' prows.

169. *Takayama* (高山).
Kanamori Nagachika, whom Hideyoshi named governor of Hida in 1586, tried to restore order to the area after a century-long war by constructing Takayama Castle and inviting craftsmen to come and live in the town. Kanamori's rule lasted for over a century before the entire district was placed under the direct control of the Tokugawa shogunate. By then the town was an independent center of industry and trade, with a population of more than seven thousand people. It is still noted for its production of provincial furniture and handicrafts of excellent quality.

170–71. Ema (絵馬).
Live horses were originally offered to Shinto shrine in appreciation (or anticipation) of a good harvest. The practice gradually changed to accommodate the offering of wooden horses, and then of horses painted on wood. The subject matter was further expanded to include monkeys, lions, snakes, etc., each of which was thought to be in some way auspicious. Other subjects were related in a more personal way to the individual making the offering (for example, a pair of healthy painted

hands from an old woman who was a weaver), thus constituting what was in effect a visual prayer. Small *ema* are either painted by the individual himself or by an *ema* artist, while the large ones are always done by professional artists, with the understanding that the poorer the giver, the smaller the painting, and vice versa. Figure 170 is an example of what is popularly referred to as a Kōfuku-ji *ema* (Nara).

172–73. Ōtsu-e (大津絵).
During the Kan'ei era (1624–44), stalls located along the Tōkaidō near Onjō-ji in Ōtsu, the last station before Kyoto, sold *ōtsu-e* to travelers, with the intention that the Buddhist themes depicted would inspire interest in the religion. However, the pictures soon took on the character of cartoons and satirical drawings, and were regarded merely as souvenirs. Original *ōtsu-e* done in traditionally bold lines and bright colors have now become rare and expensive collectors' items.

177–78. *Sword guards* (鐔).
Hayashi Matashichi (1613–99) originally was a gunsmith, but after he was retained by Hosokawa Tadaoki, the daimyo of Higo province in Kyūshū, he specialized in making sword guards. He developed an openwork technique that earned his creations the name "Higo *tsuba*," and founded the Kasuga school of *tsuba* making, the name being that of the village where Matashichi lived.

181. *Glassware* (ガラス器).
The introduction of glass to Japan came when Francis Xavier presented mirrors and telescopes to the Kyūshū daimyo Ōuchi Yoshitaka in 1549. By 1570, methods to produce glass were introduced and the manufacturing of glass articles began in Nagasaki soon after. These techniques were also brought into Edo and Osaka, but glass manufacture was mostly confined to southern Japan. In the nineteenth century, glassware was being produced on a commercial scale under the auspices of the Nabeshima family of Saga, the Kurodas of Fukuoka, the Mōris of Hagi (Yamaguchi Prefecture) and, most famous of all, the Shimazu family of Satsuma.

183. *"Nagasaki Harbor"* (長崎港).
A combination of Dutch diplomacy and the liberalism of the lord of Nagasaki, Ōmura Sumitada, allowed for a fairly constant, if thin, flow of communication between Japan and Europe even after the last exclusion edict of 1639 was in force. Ōmura, who had himself been a Christian and had encouraged the persecuted to seek refuge in his city, remained cordial to the Dutch segregated on Deshima, a small island within the harbor. Trade between the Japanese and the Dutch (and the Chinese, too, who had a community in the city's outskirts) inevitably resulted in an understanding of things foreign in Nagasaki that was paralleled elsewhere in Japan by idle curiosity

only—a perfectly natural attitude that Kōkan (whose interest brought him from Edo to Nagasaki in 1788) and other serious students somehow outgrew.

194. *"European Woman"* (源内筆西洋婦人図).

There would be little reason to remember Gennai if it were not known from sources other than his few extant paintings that he played such a great part in making Western-style art popular in Japan. The model for this naive little portrait—a Dutch trader's wife, perhaps—may have sat for the artist, although the scratched outline suggests rather that the painting was copied from an engraving.

195. *"Dutch Physician"* (田善筆蘭医之図).

Gold leaf is pasted on a silk screen over which the portrait of a Dutch physician is colorfully rendered. From the signature and inscriptions on the painting, it is thought that Aōdō did the work for donation to the Ukishima Shrine (there are several shrines bearing the same name and it is not clear as to which one is indicated). Aōdō was born in Fukushima in northern Japan, studied painting under Tani Bunchō (see figure 139) and copperplate etching under a Dutch artist. He is mainly known as an engraver and landscape artist; portraits are unusual among his works.

198. *"Heron by the Waterside"* (直武筆橋杭鷺菖蒲図).

Odano Naotake displayed outstanding talent in painting from a young age. He became keenly interested in Western-style painting when Hiraga Gennai was invited to Akita and he received instructions in the theory and methods of the new art that the latter had learned from the Dutch in Nagasaki. Naotake also associated with Japanese scholars of Dutch (mainly physicians) during his tenure in Edo. He gave instruction in Western-style painting to the lord of his province, Satake Shozan, and was the leading figure in Akita *yōga* of the time.

199. *"Camellia and Java Sparrow"* (曙山筆椿に文鳥図).

The development of Western-style painting (*yōga*) in Akita came quite by accident. When Shozan invited Hiraga Gennai (see figure 194 and page 241) to come there from Nagasaki in 1773, he wanted Gennai to help him improve the production of Akita copper mines. But when the latter began teaching one of Shozan's retainers, Odano Naotake (see figure 198), the oil painting techniques he had learned from the Dutch, Shozan, too, became interested, and began to paint in the same manner. In this little painting Shozan has used a composition of one of the bird-and-flower pictures by Ch'en Nan-p'in, the Ch'ing painter who visited Nagasaki in 1731, but in order to give a sense of weight to the forms, he has incorporated the heavy shading that he appreciated in European copperplate etchings and aquatints.

202–4. *Mampuku-ji* (万福寺).

Mampuku-ji was founded by Zen Priest Yin-yüan (1592–1673), who came from a temple with the same name in Chinese characters located at Huang Po-shan in Fuchow. He was invited to Japan by Ōbaku patrons of the Kōfuku-ji in Nagasaki. Known as Ingen in Japanese, he was accompanied by some twenty disciples from China and remained in Nagasaki until the following year. He moved to Osaka, and in 1658 was invited to Edo by Shogun Ietsuna, who gave Yin-yüan land in Uji for a temple. The floor plans, distribution, and interiors of Mampuku-ji's buildings generally followed the pattern of Chinese Zen temples known to the new priest. A visitor to the temple can sense its strangeness even today, for this style of architecture, like the sect itself, did not prove popular. But it is a strangeness that is altogether pleasant as one walks along the symmetrically laid out stone paths, observing the priests in their odd Chinese robes, the wind droning away in the giant pines that crowd the walled compound.

208. *Tokyo Imperial Palace* (皇居).

The Imperial Palace, which was Edo Castle before the Meiji Restoration in 1868, is built on the site of an estate that was first owned by an Edo family in late Heian and Kamakura times. The powerful Uesugi clan took over the area during the Muromachi period, and Ōta Dōkan, one of their retainers, built a castle on the estate in 1457. The next owners were the Hōjō, who were there in the sixteenth century until Tokugawa Ieyasu took possession of the castle and remodeled it in 1590. The latest and largest version of the castle was completed in 1640, while Iemitsu was shogun. At that time there were a total of thirty-eight gates, thirty-six checkpoints, and inner and outer moats surrounding the castle. The residential area had three major buildings and covered approximately 650 acres. The buildings were destroyed by fire five times and reconstructed each time before the palace's nearly total destruction in World War II. Today, of the original complex, only this portion of the inner moat and some of the gates exist.

209. *"Kannon, Bodhisattva of Compassion"* (芳崖筆悲母観音).

This work, done just before Hōgai's death, possesses the traits found in all of his paintings, of firm ink outline and dramatic shading in ink and light color. Hōgai was the son of an artist in Yamaguchi. He came to Edo and studied painting under Kanō Shōsen-in, the reigning master of the school's Kobiki-chō branch. Using the name "Shōkai," Hōgai painted until political turmoil in the city prior to the Restoration made it impossible, and then resumed his work after receiving encouragement from Ernest Fenollosa and Okakura Kakuzō. With their support, Hōgai and Hashimoto Gahō established the Kanga-kai, the association that spearheaded the movement encouraging Oriental (as opposed to Western) painting. Hōgai also

helped establish the Tokyo School of Fine Arts, although he died before its departments were in full operation. Gahō (who was the son of a Kanō artist at Kobiki-chō) carried on without his old friend as chairman of the school's Japanese-style painting department.

211. *"Fallen Leaves"* (春草筆落葉).
Shunsō, a native of Nagano who graduated at the top of his class from Tokyo School of Fine Arts, was an artist of exceptional talent. He discarded the linear style of ink painting he was taught as a child and developed a style of his own, which changed little as he grew older and which many of his contemporaries adopted. It was dubbed *mōrōtai-bossen* by his critics for the absence of outline and substitution of full-color, light-and-shadow modeling that was its most noticeable trait (see page 264). Shunsō was a member of the Japan Art Institute in the first generation of students under Okakura's guidance.

212. *"Rain and Mountains"* (大観筆山四趣 雨).
Yokoyama Taikan, whose real name was Hidemaro, was born in Mito, Ibaragi Prefecture. He studied with Hashimoto Gahō at the Tokyo School of Fine Arts, graduated with honors in 1893, and stayed on as an assistant professor of painting. With Kanzan and Shunsō, Taikan left the school to assist Okakura in establishing the Japan Art Institute, and after 1913, when Okakura died, until his own death in 1958, occupied the highest position in "loyalist" art circles as the director of the institute.

213. *"Ishiyama-dera in Moonlight, Autumn"* (紫紅筆近江八景 石山秋月).
In his relatively short lifetime Imamura Shikō stubbornly but quietly went his own way, painting in a manner that is sufficiently unlike those of his contemporaries for him to seem outside of mainstream loyalist groups, even the small one he helped to establish, Kōji-kai ("The Red Children"). This painting is from a series the artist, who was from Yokohama, did of the "Eight Views around Lake Biwa."

214. *Sketch for a portrait of Okakura Kakuzō* (観山筆天心先生画稿).
Kanzan, a native of Wakayama, did not at first deviate markedly from the Kanō style of painting, which he had studied under Hōgai and Gahō (see figures 209–10), the two Kanō-school reformers of Japanese-style painting during the Meiji era. But in his mature works Kanzan came close in his preference for bold compositions of traditional subjects painted with icy precision to the styles of Taikan (see figure 212) and Shunsō (see figure 211), his colleagues in the loyalist movement led by Okakura.

217. *"Preparation"* (古径筆髪).
Kobayashi Kokei began to study painting at the age of twelve in his home province of Niigata. When he was seventeen he came to Tokyo to continue his study and within two years became his teachers' leading pupil. Coming as he did from a provincial *yamato-e* background, Kokei was anxious to find new directions for traditional Japanese styles and techniques. In 1918 he began to discard established conventions of drawing and to replace them with "realistic" Maruyama-Shijō draftsmanship. Time spent in Europe from 1922 to 1923 had a profound effect on Kokei, bringing him, ironically, to an appreciation of Chinese art: the early Chinese paintings in the British Museum were so impressive that he spent much of his time copying them. After returning to Japan, he taught at the Tokyo School of Fine Arts and maintained a leading position among latter-day "loyalists."

218. *"Yoritomo in a Cave Hideout"* (青邨筆洞窟の頼朝).
A native of Gifu, Maeda Seison was involved in revitalizing the Japan Art Institute after Okakura's death. He was an eloquent interpreter of loyalist painting ever since 1916, when he produced his startlingly original "Scenes of Kyoto" series of ink paintings.

219. *"Autumn Willow"* (華岳筆秋柳図).
Murakami Kagaku emerged from the Kyoto atelier of Takeuchi Seihō (see figure 221), where he was trained in the Maruyama-Shijō painting style. He was one of the founders of the National Creative Painting Association (*Kokuga Sōsaku Kyōkai*) in 1918. Highly introspective and independent, he later withdrew from all painting associations, refusing to owe allegiance to any one art movement. His works are not surprisingly varied in subject matter and style, although his fame at the moment rests on a large group of paintings with Buddhist themes.

220. *"The Colors of Rain"* (玉堂筆彩雨).
Gyokudō started his career as an artist at the age of fourteen, with a teacher in Kyoto. Later, impressed by the atmospheric effects in the works of Hashimoto Gahō (see figure 210), he went to Tokyo and his idol's studio. For a while he worked in Gahō's version of Kanō painting, but soon found the Kanō use of line too rigid for his purposes. He discovered what he wanted in contour rather than line, and in light washes of clear color. A landscape painter, Gyokudō avoided fanciful and severe traditions, and finally worked out a solution with the single theme of man living close to nature, rendered in a lyrical but highly realistic fashion derived from Western etchings and aquatints and Murayama-Shijō-school paintings. His paintings are in no way revolutionary, but they have a simple, readily accessible beauty that has been immensely popular.

221. *"After the Rain, Sunshine"* (栖鳳筆雨霽).

Takeuchi Seihō was only fourteen when he came under the influence of Shijō-school painting in Kyoto. A trip to Paris in 1900, after he was well established as a master of that tradition, worked a great change on his art, bringing to his attention the color magic of paintings by Turner and Corot. When he returned he experimented until his death with stronger colors and broader brush-strokes, arriving at what he termed a synthesis of Western and Chinese landscape traditions. He taught in Kyoto's Art Academy *(Shiritsu Bijutsu Gakkō)*.

222. *"Spring Field"* (浅井忠筆春畝).

In 1876 the Japanese government established the Industrial Art School *(Kōbu Bijutsu Gakkō)*, the first official school offering courses in the techniques of Western painting. Asai Chū entered the school the year it opened, studying with Antonio Fontanesi. When the latter returned to Italy two years later, Asai and many other students left the school. In 1898 he became a professor in the Tokyo School of Fine Arts, where he maintained a studio in competition with the "new" school of Kuroda Seiki. During Asai's European sojourn from 1900 to 1902, the muddy palette he had been using was replaced by a lighter one. Upon his return to Japan, he left Tokyo for Kyoto, where he became a leading art figure. His last years were devoted mostly to teaching.

223. *"By the Lake"* (黒田清輝筆湖畔).

Kuroda was born in Kagoshima and adopted by his uncle, Count Kuroda Kiyotsuna, who sent him to Paris before he was twenty to study law. The boy's interest in art interrupted those plans, however, and prompted him to study painting under several artists, including the French Academy's Raphael Collin, who not only instructed him but also introduced him to famous people in the Parisian art world. Returning to Japan in 1893, Kuroda opened his own school the following year, and three years later formed the Hakuba-kai ("White Horse Association"). From these two groups came some of the leading painters of the next generation. Kuroda was appointed professor of the Tokyo School of Fine Arts in 1897, and in 1910 became the first member of the Imperial Household Committee on Western-style painting. He was appointed to the Imperial Art Academy in 1919, and in 1923 became its president. In 1920 he was elected to the House of Councillors of the National Diet.

224. *"Shrine of Harmonies"* (青木繁筆わだつみのいろこの宮).

It has never been the case that the full spectrum of a foreign culture's art at any given time has been appreciated in Japan. One finds three major influences in Japanese *yōga* around 1900: the paint-ings of the Barbizon group (T. Rousseau, J. F. Millet), the Pre-Raphaelites (Rossetti, Burne-Jones), and, at least for Kuroda Seiki, "conservative" Impressionists. From a Western point of view, the second group, with its love of the mysterious and exotic, would seem to have been the logical choice for an Easterner to make, as seen in Aoki's painting. Aoki, who was born in Kuru-me, Kyūshū, graduated from the Tokyo School of Fine Arts in 1904. He died young and his name was almost forgotten until rediscovery in the postwar period.

225. *"Realm of the Chinese Immortals"* (鉄斎筆・洲仙境図).

Chinese-style literati painting, which was virtually the only type of painting to go through the Meiji Restoration without change, ultimately died when, in the streamlining of the Japanese educational system under the Meiji reforms, the modern ideas of the Western world were emphasized over the traditional ones of classical Chinese and Japanese literature. The book by Odakane Tarō, available in an English translation by Money Hickman, is heartily recommended to those readers who may wish to know more about Tessai's life and work.

229–31. *Contemporary potters* (富本憲吉 浜田庄司 河井寛次郎).

Tomimoto Kenkichi's first efforts as a potter resulted in large part from the inspiration and stimulation provided by his friend Bernard Leach, the well-known English potter and author who in 1912 had already started his own workshop. At first both Tomimoto and Leach were ridiculed for trying to throw their own pots: that was a job for "craftsmen," whereas the "potter" was supposed to apply decoration or just supply the design. But dedicated potters everywhere soon joined the two men in insisting that the potter was an artist whose duty was to create a vessel from start to finish.

Hamada Shōji accompanied Leach to England in 1920 and the two worked together at St. Ives, Cornwall. When Hamada returned, he established his now internationally famous kiln at Mashiko. Hamada had graduated from Tokyo Engineering College with Kawai Kanjirō, and for a time they both were engineers at the Kyoto Ceramic Research Institute. Later, as professional potters, they joined Dr. Yanagi Sōetsu in setting up the Mingei Association, whose aims were the preservation and encouragement of Japanese folk art. Tomimoto refused as a matter of principle to join the organization, but his lifelong dedication to porcelain making as a folk ceramic is proof enough that he was not opposed to the association's aims. The Japanese government honored all three men by naming them Living National Treasures.

CHRONOLOGY OF JAPANESE ART
FROM THE SIXTEENTH CENTURY

1549–51 Jesuits led by Francis Xavier active in Kyūshū and the Kansai.

1560–63 Gaspar Vilela in Kyoto and Sakai.

1564–87 Luis Frois in charge of Jesuit Mission; an estimated 150,000 Christian converts.

1566 Jukō-in, Daitoku-ji, established; Kanō Eitoku the artist of its *fusuma* paintings according to eighteenth-century picture book of Kyoto.

1576 Azuchi Castle built for Oda Nobunaga; Eitoku and his followers in charge of interior decoration.

1582 Azuchi burned by forces of Akechi Mitsuhide, assassin of Nobunaga.

1583 Toyotomi Hideyoshi begins construction of Osaka Castle; Eitoku, Sanraku, etc. in charge of interior decoration.

MOMOYAMA PERIOD (1586–1615)

1586 Hideyoshi begins Hōkō-ji Daibutsu-den in Kyoto.

1587 His Juraku-dai completed (*karamon* at Daitoku-ji possibly from there).

1588 Unkoku Tōgan paints the *fusuma* at Ōbai-in, Daitoku-ji.

1590 Hideyoshi rebuilds the Imperial Palace. (Eitoku dies, age forty-eight, while painting in the new buildings, which were distributed to various temples when the palace was rebuilt in 1611; the *hōjō* of Nanzen-ji and Ninna-ji's Goei-dō may have been among the buildings given.)

1591 Sen-no-Rikyū ordered to commit suicide.

1592 Hideyoshi's Korean expedition.

1594 Fushimi Castle built for Hideyoshi.

1596 Lacquered portable shrines now at Kōdai-ji finished by Kōami craftsmen.

1597 Matsumoto Castle in Nagano built.

1598 Hideyoshi dies, age sixty-three.
Hōkō-ji rebuilt.

Sambō-in buildings and garden finished at Daigo-ji.

1599 Hideyoshi's *reibyō* (Hōkoku-byō) built in Kyoto.

1600 Battle of Sekigahara.
Kangaku-in established at Onjō-ji, Shiga, probably with a building from the palace. (Kōjō-in nearby built the same way in the next year.)

1602 Tokugawa Ieyasu has Nijō Castle built.

1603 Ieyasu becomes shogun.

1604 Seventh commemorative celebration at Hōkoku Shrine in honor of Hideyoshi.

1605 Kōdai-ji built for Hideyoshi's wife, Kita-no-Mandokoro.

1606 Hikone Castle built by Ii family.
Hon'ami Kōetsu active in Kyoto.

1607 Kitano Shrine built.

1608 Ikeda Terumasa rebuilds Himeji Castle on large scale.

1609 Date Masamune has Zuigan-ji built in Matsushima.

1610 Work on Nagoya Castle begun for Ieyasu.
Hōkō-ji rebuilt again.
Hasegawa Tōhaku dies, age seventy-two.

1611 Ieyasu rebuilds the Imperial Palace. (Ninna-ji *hondō* and Daitoku-ji's Chokushi-mon, probably from there, given when palace was next rebuilt.)

1612 Kanō Tan'yū moves to Edo.

1614 Saihō-ji's Shōnan-tei built.
Kanō Sanraku paints *ema* at Myōhō-in.
Karatsu pottery becomes popular.

EDO (TOKUGAWA) PERIOD (1615–1867)

1615 Osaka Castle burned, Toyotomi family destroyed.
The Yoshimura mansion built near Osaka.
The artists' colony at Takagamine

established by Kōetsu.
Kaihō Yūshō dies, age eighty-three.
1616 Kanō Naizen dies, age forty-seven.
1617 Ieyasu's *reibyō*, Tōshō-gū, built on Mount Kunō, Shizuoka.
1618 Unkoku Tōgan dies, age seventy-two.
1620 Work on Katsura Rikyū begun.
1623 Tokugawa Iemitsu becomes shogun.
1624 Kanō Ikkei writes *Tansei Jakubokushū*, first "history" of Japanese art.
1625 Tokugawa Hidetada establishes Kan'ei-ji in Edo.
1626 Nijō Castle *ni-no-maru* apartments built.
1628 Nabeshima pottery made in Arita in Kyūshū.
1630 Sōtatsu paints *Saigyō Monogatari* scroll.
1633 Nishi Hongan-ji *shoin* begun.
Kiyomizu-dera *hondō* rebuilt.
Nagoya Castle interior decorated by Kanō artists.
1635 Kanō Sanraku dies, age seventy-seven.
1636 Nikkō Tōshō-gū begun.
Daitoku-ji *hōjō* remodeled.
1637 Iwasa Matabei goes to Edo.
Hon'ami Kōetsu dies, age eighty.
1639 Japan closed, Dutch and Chinese at Nagasaki.
Shōkadō Shōjō dies, age fifty-six.
1640 Kanō Tan'yū paints *Tōshō-gū Engi*.
1643 Kohō-an tea house built at Daitoku-ji.
The making of Iga pottery revived in Mie.
1644 Nagasaki's Sōfuku-ji built.
1645 Katsura Rikyū finished.
Western methods of printing taught in Nagasaki.
Miyamoto Niten dies, age sixty-two.
1650 Iwasa Matabei dies, age seventy-three.
Kanō Naonobu dies in Edo, age forty-four.
1651 Kanō Sansetsu dies in Kyoto, age sixty-two.
1653 Iemitsu's *reibyō* at Nikkō, Daiyū-in, completed.
1654 Ōbaku Zen priest Yin-yüan (Ingen) arrives in Nagasaki.
1655 Best Kutani pottery being made in Ishikawa.
1657 Nishi Hongan-ji *kuro-shoin* built.
The potter Nonomura Ninsei active in Kyoto.
1659 Shūgaku-in Rikyū finished.
Mampuku-ji established in Uji by Yin-yüan.
1660 Sakaida Kakiemon perfects procedures for making overglaze decorated Imari porcelains.
1674 Kanō Tan'yū dies in Edo, age seventy-three.

1675 Work begun on major buildings of Mampuku-ji, Uji.
1680 Tokugawa Tsunayoshi becomes shogun.
1681 Sumiya in Kyoto completed.
1691 Kanō Einō publishes *Honchō Gaden*.
Tosa Mitsuoki dies, age seventy-five.
1693 Einō publishes *Honchō Gashi*.
1694 Hishikawa Moronobu dies in Edo, age seventy-seven.
1699 Ogata Kenzan active as potter.
1701 Ogata Kōrin given *hokkyō* title.
1703 *Yūzen* dyeing process perfected, supersedes all other techniques in popularity.
1705 Tōdai-ji Daibutsu-den rebuilt.
Kaigetsudō Ando active at Asakusa, Edo.
1713 Kanō Tsunenobu dies, age seventy-eight; no change in Kanō painting from this point until *ca.* 1800, when Ch'ing academic styles were adopted.
1716 Tokugawa Yoshimune becomes shogun.
Ogata Kōrin dies, age fifty-nine.
Torii Kiyomasu dies, age thirty-four.
1717 Shimizu Ryūkei carves genre figures of wood.
1729 Torii Kiyonobu dies, age sixty-six.
1731 Ch'en Nan-p'in arrives in Nagasaki, teaches painting.
1743 Ogata Kenzan dies, age eighty-one.
1750 Ike-no-Taiga visits Gion Nankai in Wakayama.
1759 Maruyama Ōkyo experiments with Western perspective drawing using European picture boxes.
1765 Multicolor print process *(nishiki-e)* developed.
1770 Suzuki Harunobu dies, age forty-six.
Western engravings being distributed through Nagasaki.
1776 Ike-no-Taiga dies, age fifty-four.
1783 Yosa-no-Buson dies, age sixty-eight.
1791 Kitagawa Utamaro's best *bijin-ga* prints published.
1792 Katsukawa Shunshō dies, age sixty-seven.
1795 Maruyama Ōkyo dies, age sixty-three.
Tōshūsai Sharaku active.
1799 Nagasawa Rosetsu dies, age forty-five.
1803–4 American and Russian ships arrive at Nagasaki.
1806 Kitagawa Utamaro dies, age fifty-four.
1811 Goshun dies, age sixty.
1822 Aōdō Denzen (Nagata Zenkichi) dies, age seventy-six.
ca. 1823 Katsushika Hokusai's first "Fuji" series published.
1828 Sakai Hōitsu dies, age sixty-eight.

1832	Hiroshige's "Fifty-three Stations of Tōkaidō" series published.
1841	Watanabe Kazan commits suicide, age forty-nine.
1849	Hokusai dies, age ninety.
1853	Commodore Perry arrives in Japan.
1854	Imperial Palace in Kyoto rebuilt.
1857	Western Painting Academy established with Kawakami Tōgai in charge.
1858	Hiroshige dies, age sixty-two.

MEIJI PERIOD (1868–1912) Establishment of the Imperial Palace in Tokyo; competition between adherents of Western and traditional styles of painting, sculpture, and architecture.

1871–81	Government-supported Industrial Art School (Kōbu Bijutsu Gakkō) in operation, staffed by Westerners E. Chiosone, J. Conder, A. Fontanesi, A. Giovanni, etc.
1878	Ernest Fenollosa arrives as lecturer at Tokyo Imperial University. Fontanesi leaves Japan.
1882	Industrial Art School closed. Exhibition of paintings in Tokyo excludes Western-style works.
1884	Fenollosa and Okakura Kakuzo organize the Kanga-kai for traditional art. Another painting exhibit excludes Western works.
1887	Tokyo School of Fine Arts (Tokyo Bijutsu Gakkō) established, with only traditional styles taught; Western styles prohibited in Kyoto art schools.
1888	Kanō Hōgai dies, age sixty-one.
1889	Tokyo School of Fine Arts in full operation. Meiji Art Exhibit of Western-style painting in Tokyo. First issue of Kokka published.
1890	Fenollosa leaves for Western countries.

1893	Kuroda Seiki returns from Paris. First graduation exercises of Tokyo School of Fine Arts. International Exhibition in Chicago.
1895	Heian Shrine in Kyoto rebuilt. Katayama Tōkuma completes Kyoto National Museum.
1896	Western painting taught at Tokyo School of Fine Arts.
1898	Okakura dismissed from the Tokyo School of Fine Arts; Taikan, Kanzan, Gahō, Shunsō, and others follow him; his Japan Art Institute (Nihon Bijutsu-in) for "loyalist" art established.
1900	International Exhibition in Paris. Pamphlets on loyalist painting published by Shunsō and Taikan.
1904	International Exhibition in St. Louis.
1906	Branch of the Japan Art Institute established in Kyoto. Okakura active in loyalist art circles.
1908	Fenollosa dies in London, age fifty-six. Gahō dies, age seventy-four.
1909	Bernard Leach arrives in Japan. Katayama Tōkuma builds Akasaka Rikyū in Tokyo.
1911	Shunsō dies, age thirty-eight.
1913	Okakura dies, age fifty-two.
1914	The Japan Art Institute continued by Taikan and Kanzan, but Western-style painting on the increase.
1921	Large group of artists sympathetic to Western styles leaves the Institute.
1922	Frank Lloyd Wright builds the Imperial Hotel in Tokyo. Small number of artists supporting purely traditional art.
1924	Kuroda Seiki dies, age fifty-nine.
1930	Shimomura Kanzan dies, age fifty-eight.
1932	First issue of Bijutsu Kenkyū published.

SELECTED BIBLIOGRAPHY

Akiyama, Terukazu. *Japanese Painting*. 1961. Reprint. London: Macmillan, 1977.

Alex, William. *Japanese Architecture*. New York: George Braziller, 1963.

Anesaki, Masaharu. *Art, Life and Nature in Japan*. 1933. Reprint. Westport, Conn.: Greenwood Press, 1971.

Bushell, Raymond. *Collectors' Netsuke*. New York and Tokyo: John Weatherhill, 1971.

Cahill, James. *Scholar Painters of Japan: The Nanga School*. 1972. Reprint. New York: Arno Press, 1975.

Cultural Properties Protection Commission, ed. *Kokuhō Jiten* (National Treasure Dictionary). Tokyo: Benridō, 1961.

de Bary, William Theodore, ed. *Sources of Japanese Tradition*. 2 vols. New York: Columbia University Press, 1958.

Doi, Tsuguyoshi. *Momoyama Decorative Painting*. New York and Tokyo: John Weatherhill, 1977.

Dumoulin, Heinrich. *A History of Zen Buddhism*. New York: Pantheon Books, 1963.

Engel, Heinrich. *The Japanese House: A Tradition for Contemporary Architecture*. Tokyo and Rutland, Vt.: Charles E. Tuttle, 1964.

Fenollosa, Ernest F. *Epochs of Chinese and Japanese Art: An Outline History of East Asiatic Design*. 1921. Reprint. 2 vols. Gloucester, Mass.: Peter Smith Publisher.

Fontein, Jan, and Hickman, Money. *Zen Painting et Calligraphy*. Boston: New York Graphic Society, 1970.

French, Calvin L. *Shiba Kōkan: Artist, Innovator, and Pioneer in the Westernization of Japan*. New York and Tokyo: John Weatherhill, 1974.

Fujioka, Ryoichi. *Tea Ceremony Utensils*. New York and Tokyo: John Weatherhill, 1973.

_____. *Shino and Oribe Ceramics*. New York and Tokyo: Kodansha International, 1977.

Grilli, Elise. *The Art of the Japanese Screen*. Tokyo and New York: John Weatherhill, 1970.

Hall, John Whitney. *Japan from Prehistory to Modern Times*. New York: Dell, 1970.

Harada, Minoru. *Meiji Western Painting*. New York and Tokyo: John Weatherhill, 1974.

Hayakawa, Masao. *The Garden Art of Japan*. New York and Tokyo: John Weatherhill, 1973.

Hayashiya, T.; Nakamura, M.; and Hayashiya, S. *Japanese Arts and the Tea Ceremony*. New York and Tokyo: John Weatherhill, 1975.

Henderson, Harold G., and Minamoto, Hoshu. *An Illustrated History of Japanese Art*. Kyoto: Hoshino, 1939.

Hillier, J. *The Uninhibited Brush: Japanese Art in the Shijo Style*. London: Hugh M. Moss, 1974.

Hirai, Kiyoshi. *Feudal Architecture of Japan*. New York and Tokyo: John Weatherhill, 1973.

Hosono, Masanobu. *Nagasaki Prints and Early Copperplates*. New York and Tokyo: Kodansha International, 1978.

Hurtig, Bernard, ed. *Masterpieces of Netsuke Art: One Thousand Favorites of Leading Collectors*. New York and Tokyo: John Weatherhill, 1973.

Itoh, Teiji. *Traditional Domestic Architecture of Japan*. New York and Tokyo: John Weatherhill, 1972.

_____. *Kura: Design and Tradition of the Japanese Storehouse*. New York and Tokyo: Kodansha International, 1973.

Jenkins, Donald. *The Ledoux Heritage: The Collecting of Ukiyo-e Master Prints*. New York: Japan Society, 1973.

Jenyns, Soame. *Japanese Pottery.* New York: Praeger Publications, 1971.

Kato, Shuichi. *Form, Style, Tradition: Reflections on Japanese Art and Society.* Berkeley and Los Angeles: University of California Press, 1971.

Kawakita, Michiaki. *Modern Currents in Japanese Art.* New York and Tokyo: John Weatherhill, 1974.

Kidder, J. Edward. *Japanese Temples, Sculpture, Paintings, and Architecture.* London: Thames and Hudson, 1964.

Kitagawa, Joseph. *Religion in Japanese History.* New York: Columbia University Press, 1966.

Lane, Richard. *Masters of the Japanese Print.* London: Thames and Hudson, 1962.

Leach, Bernard. *Hamada, Potter.* New York and Tokyo: Kodansha International, 1975.

Lee, Sherman E. *Japanese Decorative Style.* 1961. Reprint. New York: Harper and Row, 1972.

_____. *Tea Taste in Japanese Art.* 1963. Reprint. New York: Arno Press, 1975.

Matsushita, Takaaki. *Ink Painting.* New York and Tokyo: John Weatherhill, 1974.

Metropolitan Museum of Art. *Momoyama: Japanese Art in the Age of Grandeur.* New York: Metropolitan Museum of Art, 1975.

Michener, James A. *The Floating World.* New York: Random House, 1954.

Mikami, Tsugio. *The Art of Japanese Ceramics.* New York and Tokyo: John Weatherhill, 1972.

Miller, Roy Andrew. *Japanese Ceramics.* Tokyo: Toto Shuppan, 1960.

Mizoguchi, Saburo. *Design Motifs.* New York and Tokyo: John Weatherhill, 1973.

Mōri, Hisashi. *Japanese Portrait Sculpture.* New York and Tokyo: Kodansha International, 1977.

Munsterberg, Hugo. *The Arts of Japan.* Tokyo and Rutland, Vt.: Charles E. Tuttle, 1956.

_____. *The Ceramic Art of Japan.* Tokyo and Rutland, Vt.: Charles E. Tuttle, 1964.

_____. *Mingei: Folk Arts of Old Japan.* Boston: New York Graphic Society, 1965.

Muraoka, Kageo, and Okamura, Kichiemon. *Folk Arts and Crafts of Japan.* New York and Tokyo: John Weatherhill, 1973.

Murase, Miyeko. *Byobu: Japanese Screens from New York Collections.* Boston: New York Graphic Society, 1971.

Naito, Akira. *Katsura: A Princely Retreat.* New York and Tokyo: Kodansha International, 1977.

Narazaki, Muneshige. *The Japanese Print: Its Evolution and Essence.* New York and Tokyo: Kodansha International, 1966.

Noma, Seiroku. *Japanese Costume and Textile Arts.* New York and Tokyo: John Weatherhill, 1975.

Odakane, Tarō. *Tessai: Master of the Literati Style.* New York and Tokyo: Kodansha International, 1965.

Okakura, Kakuzo. *The Book of Tea.* 1906. Reprint. New York: Dover Publications.

Okamoto, Yoshitomo. *The Namban Art of Japan.* New York and Tokyo: John Weatherhill, 1972.

Okawa, Naomi. *Edo Architecture: Katsura and Nikko.* New York and Tokyo: John Weatherhill, 1975.

Ota, Hirotaro. *Japanese Architecture and Gardens.* Tokyo: Kokusai Bunka Shinkokai, 1966.

Paine, Robert T., and Soper, Alexander. *The Art and Architecture of Japan.* Rev. ed. New York: Penguin Books, 1974.

Papinot, Edmond. *Historical and Geographical Dictionary of Japan.* 1910. Reprint. Tokyo and Rutland, Vt.: Charles E. Tuttle, 1972.

Roberts, Laurence P. *A Dictionary of Japanese Artists: Painting, Sculpture, Ceramics, Prints, Lacquer.* New York and Tokyo: John Weatherhill, 1976.

_____. *Roberts' Guide to Japanese Museums.* Rev. ed. New York and Tokyo: Kodansha International, 1978.

Rosenfield, John M., and Shimada, Shujiro. *Traditions of Japanese Art: Selections from the Kimiko and John Powers Collection.* Cambridge: Fogg Art Museum, 1970.

Rosenfield, John M.; Cranston, Fumiko; and Cranston, Edwin. *The Courtly Tradition in Japanese Art and Literature: Selections from the Hofer and Hyde Collections.* Cambridge: Fogg Art Museum, 1973.

Sansom, George. *Japan: A Short Cultural History.* Rev. ed. Englewood Cliffs, N.J.: Prentice-Hall, 1962.

_____. *A History of Japan, 1615–1867.* Stanford: Stanford University Press, 1963.

Sato, Masahiko. *Kyoto Ceramics.* New York and Tokyo: John Weatherhill, 1973.

Seattle Art Museum. *Ceramic Art of Japan: One Hundred Masterpieces from Japanese Collections.* Seattle: Seattle Art Museum, 1972.

_____. *International Symposium on Japanese Ceramics.* Seattle: Seattle Art Museum, 1973.

Shimizu, Yoshiaki, ed. *Japanese Ink Painting from American Collections: The Muromachi Period.* Princeton: Princeton University Press, 1976.

Stern, Harold P. *Birds, Beasts, Blossoms, and Bugs: The Nature of Japan.* New York: Harry N. Abrams, 1976.

Suzuki, Daisetsu T. *Zen and Japanese Culture.* Princeton: Princeton University Press, 1959.

Swann, Peter. *An Introduction to the Arts of Japan.* Rev. ed. New York and Tokyo: Kodansha International, forthcoming.

Takahashi, Seiichiro. *Traditional Woodblock Prints of Japan.* New York and Tokyo: John Weatherhill, 1972.

Takeda, Tsuneo. *Kanō Eitoku.* New York and Tokyo: Kodansha International, 1977.

Tange, Kenzo, and Gropius, Walter. *Katsura: Tradition and Creation in Japanese Architecture.* New Haven: Yale University Press, 1960.

Terada, Toru. *Japanese Art in World Perspective.* New York and Tokyo: John Weatherhill, 1976.

Tokyo National Museum, ed. *Pageant of Japanese Art.* 6 vols. Tokyo: Toto Shuppan, 1952.

Ueda, Makoto. *Literary and Art Theories in Japan.* Cleveland: Press of Case Western Reserve University, 1967.

Varley, H. Paul. *Japanese Culture: A Short History.* New York: Praeger Publications, 1973.

Warner, Langdon. *The Enduring Art of Japan.* 1952. Reprint. New York: Grove Press, 1958.

Yamada, Chisaburoh, ed. *Decorative Arts of Japan.* New York and Tokyo: Kodansha International, 1964.

_____. *Dialogue in Art: Japan and the West.* New York and Tokyo: Kodansha International, 1976.

Yamane, Yuzo. *Momoyama Genre Painting.* New York and Tokyo: John Weatherhill, 1973.

Yanagi, Soetsu. *The Unknown Craftsman.* New York and Tokyo: Kodansha International, 1972.

Yashiro, Yukio. *2,000 Years of Japanese Art.* New York: Harry N. Abrams, 1958.

_____, ed. *Art Treasures of Japan.* 2 vols. Tokyo: Kokusai Bunka Shinkokai, 1960.

Yonezawa, Yoshino, and Yoshizawa, Chu. *Japanese Painting in the Literati Style.* New York and Tokyo: John Weatherhill, 1974.

Yoshikawa, Itsuji. *Major Themes in Japanese Art.* New York and Tokyo: John Weatherhill, 1975.

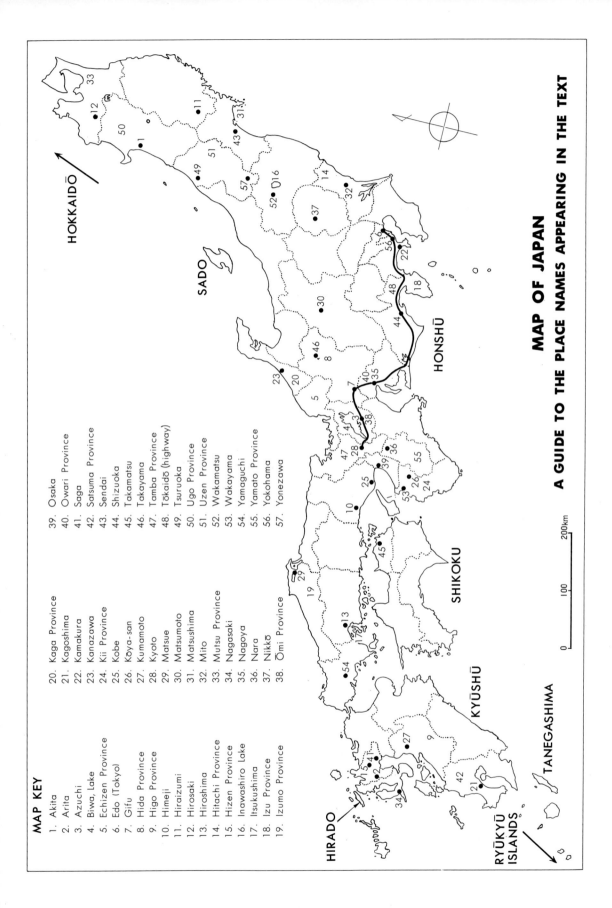

MAP KEY

1.	Akita
2.	Arita
3.	Azuchi
4.	Biwa, Lake
5.	Echizen Province
6.	Edo (Tokyo)
7.	Gifu
8.	Hida Province
9.	Higo Province
10.	Himeji
11.	Hiraizumi
12.	Hirosaki
13.	Hiroshima
14.	Hitachi Province
15.	Hizen Province
16.	Inawashiro Lake
17.	Itsukushima
18.	Izu Province
19.	Izumo Province
20.	Kaga Province
21.	Kagoshima
22.	Kamakura
23.	Kanazawa
24.	Kii Province
25.	Kobe
26.	Kōya-san
27.	Kumamoto
28.	Kyoto
29.	Matsue
30.	Matsumoto
31.	Matsushima
32.	Mito
33.	Mutsu Province
34.	Nagasaki
35.	Nagoya
36.	Nara
37.	Nikkō
38.	Ōmi Province
39.	Osaka
40.	Owari Province
41.	Saga
42.	Satsuma Province
43.	Sendai
44.	Shizuoka
45.	Takamatsu
46.	Takayama
47.	Tamba Province
48.	Tōkaidō (highway)
49.	Tsuruoka
50.	Ugo Province
51.	Uzen Province
52.	Wakamatsu
53.	Wakayama
54.	Yamaguchi
55.	Yamato Province
56.	Yokohama
57.	Yonezawa

HOKKAIDŌ

SADO

HONSHŪ

SHIKOKU

KYŪSHŪ

HIRADO

RYŪKYŪ ISLANDS

TANEGASHIMA

MAP OF JAPAN

A GUIDE TO THE PLACE NAMES APPEARING IN THE TEXT

0 100 200km

INDEX

Deshima, 302 n. 183
dōbuku, 290 n. 35, fig. 35, capt. 36
"Dog" (Sōtatsu), fig. 111
Doi Tsugiyoshi, 289 n. 25, 295 n. 86–87
dolls. *See* "People of Kyoto"
doma, capt. 156
Dutch, 241, capt. 183, 302 n. 183, 303 n. 195, 303 n. 199
"Dutch Physician" (Aōdō Denzen), 303 n. 195, fig. 195
dyeing, 38, capt. 35, 290 n. 35, capt. 61, 293 n. 61, 151, 299 n. 134, capt. 179, 241

Edo: art of, 10, 185–87; artists from, in provinces, 219; contrasted with Kyoto, 145, 148; development of, 185; glassware at, 302 n. 181; Sakai compared with, 148
Edo Castle, 15, 91, capt. 136, 303 n. 208, 262
e-dokoro. See Shogunal Painting School
ema, 298 n. 129–31, 302 n. 170–71, figs. 170–71
Endō Shōemon Takaakira, 295 n. 80–81
engraving, 240, 303 n. 194, 303 n. 195
Enkū, 113, capt. 168, 302 n. 167–68
Enrin-dō, 294 n. 72
Etchū province, 215
"European Kings Fighting on Horseback," 240, fig. 190
"European Woman" (Hiraga Gennai), 303 n. 194, fig. 194
"Evening Snowfall" (Yosa-no-Buson), 298 n. 120–21, fig. 121
Expressionists, German, capt. 149

fabric. *See* costumes and fabrics
"Fallen Leaves" (Hishida Shunsō), 304 n. 211, fig. 211
"Famous Places in the Eastern Capital" (Andō Hiroshige), 301 n. 151
"Fantastic Lions" (Kanō Eitoku), 34–35, 288 n. 24, fig. 24
farmers. *See gōnō*
farmhouses, capt. 75
Fenollosa, Ernest, 263, 264, 303 n. 209
festivals, 67–68, 290 n. 42–43, figs. 42–43, capt. 46
"Fickle Face, The" (Kitagawa Utamaro), 300 n. 148, fig. 148
"Fifth Zen Patriarch, The," (Takuan Shūhō), 296 n. 88, fig. 88, 296 n. 90, 297 n. 100, capt. 131
"Fifty-three Stations on the Tōkaidō" (Andō Hiroshige), capt. 151, 301 n. 151
Fillmore, President, 261
flower arrangement, 110, 216
folk arts (*mingei*), 114, capt. 180, 266, capts. 230–31, 305 n. 229–31
Fontanesi, Antonio, capt. 222, 305 n. 222
founder's hall. *See kaizan-dō*
fresco painting, 240
Frois, Luis, 11, 238
Fujin Ninsō Juppin (Kitagawa Utamaro), 300 n. 148
Fujin Sōgaku Juttai (Kitagawa Utamaro), 300 n. 148
Fujiwara-no-Hidehira, 301 n. 164

Fujiwara-no-Michinaga, 294 n. 72
Fujiwara-no-Yukihide, 288 n. 22
Fukashi Castle, 286 n. 11
Fukuoka family, 295 n. 86–87
Fumai, 216
funairi-no-ma (boat docking room), 109, 293 n. 67–68, fig. 68
furisode, 299 n. 134, fig. 134
Furuta Oribe, 114, capt. 99, 297 n. 99, capt. 115, capt. 189
fūryū–odori, 71
Fushimi Castle, 33, capt. 16; and Kanō Eitoku, 34; and Karakasa-tei and Shigure-tei, capt. 83, 295 n. 83–84; and *karamon* at Hōkoku Shrine, 288 n. 21; and Kōdai-ji, 290 n. 33; and Nijō Castle, 286 n. 13; and Nishi Hongan-ji, 287 n. 20
Fushin-an, 111
fusuma and *fusuma-e*, 285 n. 1, 33–34, 287 n. 18, 147
Futaara Shrine, 292 n. 53
Futagawa-*yaki*, capt. 180
"Fuyuki" *kosode*, 299 n. 133

Gakushin, 287 n. 20
Gamō family, 287 n. 15
Gamō Ujisato, 240, capt. 190
gardens, 110, 112, 216
geisha, 297 n. 101–4
genkan (Nijō Castle), capt. 18
genre painting, 68–69, capt. 38, capt. 46, 291 n. 47, capts. 48–49; Dutch, 239; and Kobayashi Kokei, capt. 217; swords depicted in, capt. 37; theme of, capt. 137; and *ukiyo-e*, 187–88. See also *namban* screens
Gepparō, fig. 76
German Expressionists, capt. 149
Gesshin, 295 n. 80–81
Gion-bayashi, capt. 43
Gion Matsuri, 68, 290 n. 42–43, figs. 42–43, capt. 44, 219
Gion Nankai, 214–15, 242
glassware, 302 n. 181, fig. 181
Glover, T. B., 265
gō: defined, 242
Goei-dō (Nishi Hongan-ji), 287 n. 20
gold, 36–38, capt. 15, 93, 94
Golden Pavilion, 36
Gomizunoo, Emperor, 286 n. 13, 287 n. 18, 112, 294 n. 72, capt. 79, 294 n. 78–79
Gonara, Emperor, 287 n. 19
gongen style, 92, 292 n. 54
gōnō, 219, 301 n. 157–58
Go-Sanke, 214–15
Gosenshū, capt. 110
Gosho (Imperial Palace, Kyoto), 34, capt. 17, 69, 70, capt. 46, 112
Gotō family, 95
Gotō Ichijō, 95, capts. 62–66, 293 n. 62–66
Gotō Saijirō, 301 n. 161
Gotō Yūjō, 293 n. 62–66
Goyōzei, Emperor, 33, capt. 15
Gregory XIII, Pope, 238, 239
Gyokurin-in, capt. 80, 295 n. 80–81

Kōrin. *See* Ogata Kōrin
koshoin, 111, 294 n. 72, fig. 72, capt. 76
kosode, 38, capt. 51; in Kaga-*yūzen*, fig. 179; by Ogata Kōrin, 299 n. 133, fig. 133
Kōtō-in, 218
Kōya-san, capt. 40, 214, 266
kozuka, 293 n. 62–66, figs. 62–66
Kūkai (Kōbō Daishi), 91
Kumamoto, 218
Kumamoto Castle, 15, 286 n. 14, fig. 14
Kumano Shrine, 214
Kumashiro Yūhi, 243
Kurashiki, fig. 154
kura-yashiki, capt. 154
Kuroda family, capt. 8, 289 n. 28, 302 n. 181
Kuroda Kiyotsuna, 305 n. 223
Kuroda Nagamasa, 289 n. 28
Kuroda Seiki, 262, 305 n. 222, 305 n. 224; "By the Lake," 305 n. 223, fig. 223
kuro-shoin, 287 n. 18, 287 n. 20
kushige, fig. 165. *See also* combs and hair ornaments
Kusumi Morikage: "A Summer Evening," 299 n. 141, fig. 141
Kutani ware, 301 n. 161, fig. 161
kuyōmon, capt. 178
kyakuden (Shūgaku-in), 294 n. 78–79
Kyōgen, 187, 214
Kyōgoku family, 216
Kyoto: amusement centers of, 70, capt. 45; as art center, 10; artistic values of, 145, 148; artists from, in provinces, 219; crafts of, 150, 151, capt. 132, 299 n. 132; festivals at, 290 n. 42–43, figs. 42–43; and *rakuchū-rakugai*, 69; and Takayama, capt. 169
Kyoto Ceramic Research Institute, 305 n. 229–31
"Kyoto *Maiko*, A" (Hayami Gyoshū), fig. 215
Kyoto National Museum, 266
Kyō-*yūzen*, capt. 179

lacquerware, 94–95; folk art, 114; in Kaga province, 215; *kōdai-ji maki-e*, 37, 289 n. 29–32, capts. 29–32, 292 n. 58; and Kōetsu, 146, capt. 110; and Kyoto, 151; *mitsuda-e*, capt. 166, 302 n. 166; in northern Japan, 217; and "Sun and Moon" screen, 288 n. 22; in Takayama, 219; and Tokugawa shogunate, 293 n. 59
"Ladies under the Wisteria Tree," 69, fig. 41
"Landscape with Figures" (Ike-no-Taiga), 298 n. 119, fig. 119
Leach, Bernard, 305 n. 229–31
letter box, 289 n. 29–32, fig. 32
Liang K'ai, 36, 295 n. 86–87
Li Lung-mien, 295 n. 86–87
literati, 149, 150, 190, capt. 139, 214, capt. 206; in Meiji era, 263, 305 n. 225; Tomioka Tessai as last of, capt. 225
Loti, Pierre, 265
"Lotus and Waterfowl" (Sōtatsu), capt. 111, fig. 112
"Lotus Scroll" (Hon'ami Kōetsu), fig. 107
loyalists, 262–64; Imamura Shikō outside mainstream of, 304 n. 212; Kobayashi Kokei as

leader of, 304 n. 217; and Shimomura Kanzan, 304 n. 214; and Yasuda Yukihiko, capt. 216; Yokoyama Taikan as leader of, 304 n. 212
Luzon jars, 299 n. 132
"Luzon" Sukezaemon, 299 n. 132

Ma Ch'i, 295 n. 86–87
Machida family, 291 n. 44
Madame Chrysanthemum (Pierre Loti), 265
"Madonna and Child Surrounded by Fifteen Scenes from the Life of the Virgin," 240, fig. 192
Maeda family, 287 n. 15, 215, capt. 161
Maeda Gen'i, capt. 26
Maeda Seison: "Yoritomo in a Cave Hideout," 304 n. 218, fig. 218
Maeda Shigehiro, capt. 187
Maeda Toshiharu, 301 n. 161
Maeda Toshiie, 213, 215
Maeda Toshimasa, 215
Maeda Toshinaga, 215
Maeda Toshitsune, 294 n. 72, 215
maiko, 69, capt. 51, 297 n. 101–4, capt. 215
maki-e: on box by Shibata Zeshin, capt. 207; on comb cabinet, capt. 165; demise of traditional techniques of, 293 n. 59; on *inrō*, 95; in Kaga province, 215; *kōdai-ji maki-e*, 37, 289 n. 29–32, 290 n. 33, capts. 29–32, 292 n. 58; and Koma Kansai, capt. 60; in Kyoto, 151; lacquer paste, capt. 189; at Nikkō Tōshō-gū, capt. 54, 292 n. 55; on saddle, capt. 188; on *tebako*, capt. 58, 292 n. 58; on *zushi-dana*, capt. 59. *See also* Glossary, Vol. I
maki-e box (Shibata Zeshin), fig. 207
Makiyama, 297 n. 97
Ma K'uei, 295 n. 86–87
Ma Lin, 295 n. 86–87
Mampuku-ji, 242, 243, 303 n. 202–4, figs. 202–4
Manase Gyokurin, 295 n. 80–81
Manji-tei, 294 n. 72
Man'yō-shū, 296 n. 91–92
"Maple Tree" (attributed to Hasegawa Tōhaku), 35, 289 n. 26, fig. 26, 295 n. 86–87
"Maple Viewing at Takao" (Kanō Hideyori), 68, 290 n. 38, fig. 38
"Marsh Willows and Birds" (Matsumura Goshun), fig. 127
Marubashira, 297 n. 97
Maruyama Ōkyo, 150, capt. 127, capt. 131, 242; "Pine Trees Covered with Snow," fig. 126
Maruyama Ōzui, 150
Maruyama school, 150
Maruyama-Shijō schools (the Maruyama [Ōkyo] and Shijō [Matsumura Goshun] schools), 151, 263, 304 n. 217, 304 n. 219–20
Mashiko, capt. 230, 305 n. 229–31
Mashiko ware, capt. 230
Matsudaira clan, 216, 217
Matsudaira Fumai, 216
Matsudaira Hideyasu, 216
Matsudaira Naomasa, 286 n. 11
Matsudaira Tadatsuna, 219 n. 52
Matsue, 216
Matsumoto Castle, 15, 286 n. 11, fig. 11

tea, 243

teabowls, 94

tea ceremony (*cha-no-yu*), 109–11, capt. 77, capt. 83; and folk arts, 114; in Kaga province, 215; of Kobori Enshū and Fumai, 216; and Kōetsu, 146; in Owari province, 214; and *sencha* ceremony, 243, capt. 205; and Shino ware, capt. 96; and Shōkadō Shōjō, 296 n. 90; and Sōtatsu, capt. 111; at Tai-an, 295 n. 82; at Takagamine, capt. 106. *See also* Sen-no-Rikyū

tea houses (*chashitsu*), 109, 110–11; Gepparō, 294 n. 72, fig. 76; and Hiunkaku, capt. 67, 293 n. 67–68; at Kōetsu-ji, capt. 106; Rokusō-an, 295 n. 85, fig. 85; Sa-an, 295 n. 80–81, figs. 80–81; Shōkin-tei, 111, 294 n. 72, fig. 77; and Sumiya, 297 n. 101–4; Tai-an, 295 n. 82, fig. 82

tea kettles, 214. *See also* kettle hanger

tebako, 292 n. 58, fig. 58. *See also* comb cabinet

Tekisui-en, capt. 67

temmoku, 296 n. 94

tempera painting, 240

Tenkai, 291 n. 52, capt. 57, 292 n. 57

Tenkyū-in, 289 n. 25

tenryō, 219, 301 n. 157–58, capt. 169, 302 n. 169

tenshu-kaku: at Azuchi Castle, 11, capt. 1, 285 n. 1; at Hikone Castle, 286 n. 12, fig. 12; at Himeji Castle, 285 n. 2–6, fig. 6; at Matsumoto Castle, 286 n. 11; at Nagoya Castle, 15, 285 n. 9–10, figs. 9–10; at Nijō Castle, 286 n. 13, capt. 17; at Osaka Castle, 14, capt. 7; and Uto Tower, 286 n. 14

textiles. *See* costumes and fabrics

Thirty-six Great Poets, capts. 91–92, 296 n. 91–92, 297 n. 109

Thirty-six Views of Mount Fuji (Katsushika Hokusai), capt. 150

tie-and-dye technique. See *tsuji-ga-hana*

tobacco set, 301 n. 153, fig. 153

Tōdō Takatora, capt. 57, 292 n. 57

Tōfuku-ji, 289 n. 27, 296 n. 90

Tōfukumon-in, 294 n. 72, 294 n. 78–79

togidashi maki-e, 292 n. 58

Tōhaku Gasetsu, 295 n. 86–87

Tōkaidō, 214, 301 n. 151, 302 n. 172–73

tokonoma: defined, 287 n. 18, 111; at Nijō Castle, 287 n. 19; at Shigure-tei, 295 n. 83–84; at Tai-an, capt. 82; in Yoshimura mansion, capt. 155

Tokugawa Hidetada, 91, 185, 214, 239

Tokugawa Hideyasu, 216

Tokugawa Iemitsu, 91, 92, 94, 292 n. 53, capt. 56, 292 n. 57, 293 n. 59, 185, 303 n. 208

Tokugawa Ienari, 218

Tokugawa Ietsuna, 112, 294 n. 78–79, 242

Tokugawa Ieyasu: and Edo, 185; and Edo Castle, 15, 303 n. 208; and Kanō Naganobu, 290 n. 39; and Kōetsu, capt. 105, 297 n. 105–6; and Nagoya Castle, 15, 303 n. 208; and Nijō Castle, 14, capt. 13, 286 n. 13; and Nikkō, 291 n. 52; originally a Matsudaira, 216; *reibyō* of, 91, 92–94, capt. 57, 292 n. 57; rise to power of, 213; and the Shin sect, 287 n. 20

Tokugawa Nariaki, 215

Tokugawa shogunate (*bakufu*): art collection of, 295 n. 86–87; Buddhist sculptors under, 266; and castle construction, capt. 2; and dyeing, 293 n. 61; establishment of, 185; and Go-Sanke, 214–15; and imperial family, 111; Kanō school patronized by, 186, 190; and Kōetsu, 146; and Nikkō Tōshō-gū, 94; opposition to, 261, 262; and patronage of lacquerworkers, 293 n. 59; and "purple robe incident," 294 n. 78–79; social restrictions imposed by, 148–49, 186–87, 219; and Takayama, 219; and *tenryō*, 219, 301 n. 157–58, capt. 169, 302 n. 169. *See also* Glossary, Vol. I (*bakufu*)

Tokugawa Yoshimune, capt. 57

Tokugawa Yoshinao, 214

Tokugawa Yoshinobu, 286 n. 13

Tokyo, 262, capt. 208. *See also* Edo

Tokyo National Museum, capt. 85, 295 n. 85, 266

Tokyo School of Fine Arts: and Aoki Shigeru, 305 n. 224; and Asahi Chū, 305 n. 222; and Asahi Gyokuzan, capt. 228; establishment of, 263, 303 n. 209; and Hishida Shunsō, 304 n. 211; and Ishikawa Kōmei, capt. 226; and Kobayashi Kokei, 304 n. 217; and Kuroda Seiki, 305 n. 223; and Takamura Kōun, capt. 227; and Yokoyama Taikan, 304 n. 212

Tomimoto Kenkichi, 305 n. 229–31; jar by, fig. 229

Tomioka Tessai: "Realm of the Chinese Immortals," 305 n. 225, fig. 225

torii, 92, 292 n. 57. *See also* Glossary, Vol. I

Torii Kiyomitsu, 300 n. 147

Torii Kiyonaga, 189; "Night Scene at Shinagawa," 300 n. 147, fig. 147

Torii school, 189, 300 n. 144, 300 n. 147

Tosa Mitsunori, 291 n. 47, 296 n. 91–92

Tosa Nikki, 296 n. 91–92

Tosa school, 287 n. 15–17, 291 n. 44, 291 n. 47, 296 n. 91–92, capt. 137, capt. 139

Tōshō-gū, 91; at Nikkō, 92–94, 291 n. 52, 292 n. 53–56, figs. 52–55, 113, capt. 117; at Ueno, 292 n. 57, fig. 57

Tōshūsai Sharaku, 189–90; "The Actor Ichikawa Ebizō," 300 n. 149, fig. 149

Toulouse-Lautrec, 189

Tōyō Bijutsu, 289 n. 25–26

Toyotomi Hidetsugu, 33, capt. 15

Toyotomi Hideyori, 15, capts. 39–40, 213

Toyotomi Hideyoshi: and Christianity, 238, 239; defeat of family of, 296 n. 90, 185, 213; at Daigo-ji, 69, capt. 40; *dōbuku* of, capt. 35; and festivals, 68, 69–70, capt. 46; and Fushimi Castle, 33; and genre painting, 70; and gold, 36–37; and Himeji Castle, 13, 285 n. 2–6; and Hiunkaku, 293 n. 67–68; and Juraku-dai, 32–33, capt. 15; and Kanō Naizen, 70, 291 n. 46; and Kōetsu, 146; and Korean ceramics, 114; lacquerware of, 289 n. 29–32; and Osaka Castle, 14, capt. 7; in Portuguese clothes, 240; and Prince Norihito, 294 n. 72; *reibyō* of, 91–92, 93; and Sen-no-Rikyū, 110; and the *sentō-gosho*, capt. 26; and the Shin sect, 287 n. 20; sword set presented by, capt. 46; and Tai-an,

Japanese Arts Library

In 1966 the Shibundo publishing company in Tokyo began an unprecedented series of monthly publications on Japanese art entitled *Nihon no bijutsu* (Arts of Japan). Prepared with the cooperation and editorial supervision of the Agency for Cultural Affairs and the three great national museums in Kyoto, Nara, and Tokyo, the series is written by leading Japanese scholars for a general audience, each issue devoted to a single aspect of Japanese art. Now totaling over 140 issues, this monumental series presents a comprehensive, detailed picture of Japanese art unequaled in Japanese publishing history—and now available to the English-reading public. Entitled the Japanese Arts Library, the English edition is being translated by scholars of Japanese art under the overall editorial direction of John Rosenfield of Harvard University. Abundantly illustrated and adapted for the Western reader, the Japanese Arts Library is an outstanding event in English-language publication.

Published titles
1. *Shino and Oribe Ceramics*
2. *Japanese Portrait Sculpture*
3. *Kanō Eitoku*
4. *Pure Land Buddhist Painting*
5. *Bugaku Masks*
6. *Nagasaki Prints and Early Copperplates*

In preparation
Kutani Ware
Japanese Folk Arts
Early Ink Painting
Tempyō Sculpture
Hasegawa Tōhaku
Blue-and-White Wares
Japanese Textile Dyeing
Early Temple Architecture
Japanese Swords
Traditional Japanese Houses
Shoin-style Architecture
Jōgan Sculpture